# MUSIC, THE BRAIN, AND ECSTASY

# MUSIC, THE BRAIN, AND ECSTASY

## How Music Captures Our Imagination

## ROBERT JOURDAIN

AVON BOOKS ◆ NEW YORK

AVON BOOKS
A division of
The Hearst Corporation
1350 Avenue of the Americas
New York, New York  10019

Copyright © 1997 by Robert Jourdain
Front cover illustration by Christine/Alicino/Photonica
Inside back cover author photograph by Christine Blanchy
Published by arrangement with the author
Visit our website at **http://www.AvonBooks.com**
ISBN: 0-380-78209-X

Published in hardcover by William Morrow and Company, Inc.; for information address Permissions Department, William Morrow and Company, Inc., 1350 Avenue of the Americas, New York, New York 10019.

The William Morrow edition contains the following Library of Congress Cataloging in Publication Data:

Jourdain, Robert.
    Music, the brain, and ecstasy : how music captures our imagination / Robert Jourdain.
        p.      cm.
    Includes index.
    1. Music—Psychology.   2. Music—Physiological aspects.   3. Music—Philosophy and aesthetics.   I. Title.
ML3830.J68      1997                                                                                 96-27344
781'.11—dc20                                                                                              CIP
                                                                                                         MN

First Avon Books Trade Printing: March 1998

AVON TRADEMARK REG. U.S. PAT. OFF. AND IN OTHER COUNTRIES, MARCA REGISTRADA, HECHO EN U.S.A.

Printed in the U.S.A.

OPM 10  9  8  7  6  5  4  3  2  1

TO MY PARENTS,

*Bernice and Melvin Jourdain*

# Acknowledgments

By having written a book that spans so broad a compass, I find myself indebted to hundreds of scholars and thinkers and friends who over the years have shown me, each in his or her own way, that music is a key to the deepest secrets of our minds. I owe much to the many participants in the 1995 music perception conference at Berkeley's Center for New Music and Audio Technologies, particularly David Wessel and Diana Deutsch. Many thanks also to Robert Osserman, Janet Adelman, Judy Frank, Wendy Martin, and Jedd Harris for hours of interesting discussions, and to Norman Rabkin for a particularly incisive reading. I am also deeply indebted to Goodwin Sammel and other piano teachers of years past who taught me hundreds of things about music that words can never express yet are everywhere between the lines in these pages. Thanks also to those who worked assiduously to move this project from disheveled manuscript to well-groomed volume, including my agent, Katinka Matson, and my editor at William Morrow, Henry Ferris. Finally, most of all, thanks to Gayle Greene, who steadfastly provided encouragement and astute commentary throughout this project's long gestation.

# Contents

# Introduction

It is night and the vacant cavern is dim, chilly, still. A few animals have arrived before the others, bustling about the immense expanse beneath the cavern roof sixty feet above. From time to time a cry echoes through the chamber and the flurry of activity increases. And then, all at once, a herd of two thousand shuffles in.

It is a highly territorial species and each animal seeks out its rightful station in the cavern. Those of highest status roost farthest in; others withdraw to murky corners near the entrance. Outside, they had cooed and preened, dominated and submitted, but all that is finished now. It is time to nest. Deep in the brain, structures as ancient as a brontosaurus announce, "It is safe here. You can relax. But do not sleep, for something is about to happen." Pulse rates drop, blood pressure slackens, breathing lightens.

The cavern visitors are a species of tool users, and when a group of a hundred more enter—individuals with distinctive black and white coloration—they carry oddly shaped wooden boxes and metal tubes to the front of the chamber, where they sit together. Abruptly, the dominant male struts in, climbs to a position above all others, and performs a triumph display. His arrival is greeted by much hooting and clatter.

Then silence. In two thousand brains the frontal lobes take command: there is to be no coughing, no spitting, no loud yawning, and for that matter no vocalizing or fighting or mating. The cavern darkens, muscles relax, touch receptors quiet, and much of the brain dozes off. But in the

auditory cortex of these two thousand brains, spontaneous neural activity has increased—a sign of heightened expectation. When the dominant male suddenly commences an elaborate display, swinging his forelimbs to and fro, nerve cells fire in cascades. It has begun.

Sound. Glorious sound. Sound of a kind little encountered outside the cavern, each tone a choir in itself, pure and enduring. Patterns ascend to gyrate in midair, then fold into themselves and melt away as even grander designs soar. A wall of a hundred sounds hurls toward eager ears, ricocheting about the cavern roof and muffled by 150 tons of flesh below. Joined by thousands of minute reverberations, tones rain down upon the audience from all sides, funneling into ears to climb from vibrating air to trembling membrane to oscillating bone to pulsating fluid to surging electrochemical discharges that spurt like fountains toward an expectant brain.

Some of the animals are left stultified; a few have even fallen asleep. Many covertly vocalize in communication with themselves. But most are overpowered by the sound. At first it conveys circumspect pleasure. Then delight. Then amazement. Then elation. For something is emerging from the patterns, something between the tones that is unheard yet is as substantial as any sound. Voices hurl together; bass tones rise above a furious sweep of treble; the sound lowers its horns and charges. Deep within, there's a tightening, a verging, a sensation of release from gravity's pull. Ecstasy.

*Exstasis. Ex*-for "outside," *stasis* for "standing." Sounds that leave you standing outside yourself. Sounds like those that called Ulysses to the Sirens' rocks. Sounds whose potency lies beyond pleasure and even beyond beauty. Sounds that reveal to us truths we have always known yet won't be able to recount when the last echo has subsided.

But *how*? How can music make sense to an ear and brain evolved for detecting the approaching lion or tracking the unsuspecting gazelle? The sense of hearing is 300 million years old. Complex music has existed only one hundred-thousandth as long. What is it that our brains have learned to do to themselves in so short a time? What makes a distant oboe's wail beautiful? Why is one chord "happy," another "sad," another "anguished"? How can sounds that are a feast to some ears be a sickening meal

to others? Why are some individuals ravaged by music and others indifferent? And how is it that of billions of brains that have known and enjoyed music, only a handful have been able to invent the music of ecstasy?

Such questions are hardly new. You'll find them asked in Plato, in Kant, in Nietzsche. But it's only in the last century or so that scientists have taken music into their laboratories. First came *acoustics,* the science of sound itself; then *psychoacoustics,* the study of how minds perceive sound; then *musical psychoacoustics,* a vast discipline scrutinizing every aspect of musical perception and performance. In parallel, brain science has inched along, the biologist's tortoise pitted against the psychologist's hare. Slowly, grudgingly, a knot of billions of nerve cells has given up some of its secrets. Today, scientists can watch as an ear dances in time to a waltz, and they can observe parts of the cerebral cortex "light up" as Mozart saunters through.

Over ten chapters we'll venture from trembling air to quavering consciousness. Our journey begins quietly—indeed, soundlessly—in the muddy depths of Jurassic seas. It ends in the equally muddy depths of modern philosophy. What lies between is unfailingly fascinating. We begin with two background chapters on how the characteristics of musical sound and musical hearing limit what music can become. Then come three chapters about how such sounds are combined into the basic devices by which melody, harmony, and rhythm work their magic, focusing on how such devices arise from properties of the human brain. With this accomplished, the next three chapters can consider how a brain assembles musical devices into vast hierarchies of sound as it composes, performs, and listens to music. Only then, in the last two chapters, can we turn to the questions that haunt us most: how it is that music takes hold of us, rattles us to the core, and somehow speaks to us in a way that words cannot. Unavoidably, the question arises: *who,* or *what,* is it that is moved by these sounds? There is more at stake here than a pretty tune. Again and again we will come up against cutting-edge issues in musicology and neuroscience alike, issues that are beginning to yield a new conception of the human mind. We begin . . .

FROM SOUND . . . Philosophers ask whether a falling tree makes a sound when no one is present to hear it. No one? A tree crashes in the ears of

crickets and frogs and snakes and owls and hedgehogs and bats and bobcats. But it crashes differently for each; for the philosophers have a point: *sound* (as opposed to *vibration*) is something that a mind *does*. To understand how this is so, we'll look at the tortuous evolution of the ear and at nature's vast diversity of ear designs. We'll see how primitive parts of the brain first make sense of sounds. And we'll find out what our own ears can and cannot perceive, and what happens to them through age and disease.

...TO TONE...Musical sound rarely occurs naturally, and *beautiful* musical sound occurs more rarely still. This chapter explains the structure of musical sounds, examines how our brains process them differently from ordinary sounds, and explores the mystery of beauty in musical timbre. Along the way, we'll see how musical instruments have evolved to meet particular requirements of our auditory systems. We'll delve into psychophysics to see the limits and the irregularities of musical perception. And we'll take a first look at the brain's auditory cortex, where music first enters the realm of conscious experience.

...TO MELODY...Music begins only when tones are arranged in a sequence. But if melody is music's most basic experience, it is not a simple one. Every dimension of music is present in a "simple" melody: rhythm, harmony, dynamics. In this chapter, we'll see how scales combine with rhythms to make melodies. We'll ponder how children develop a knack for melody, and whether certain features of melody are built into our brains. Ultimately, we'll take on a question that has puzzled composers for centuries: Why are some melodies so haunting and others not?

...TO HARMONY...To our ears, music has a certain inevitability as it progresses from chord to chord and key to key. Break the rules of harmony, and music is jarring, even painful. It would seem that we have tailored music to our brain's nature. But it is a *learned* inevitability that we experience, for the harmonic systems of distant cultures can sound just as inevitable to other peoples even though such sounds clash in our ears. This chapter explores how our harmonic system works and describes its

centuries-long evolution. We'll investigate how the brain processes harmonic relations, the biological basis for consonance and dissonance, and the usefulness of alternative harmonies. We'll also take a look at the mysterious phenomenon of absolute pitch and its effects on music perception.

...TO RHYTHM...When feet start tapping, people say that music's "got rhythm." But there's much more to rhythm than regular beat. This chapter explores the two basic kinds of rhythm and the many ways we respond to them. We'll look at theories of how the brain gives rise to the sensation of rhythm, the relation of rhythm to physical movement, its development in childhood, and the limits of rhythmic perception. Along the way, we'll ponder whether some kinds of music have "got rhythm" more than others.

...TO COMPOSITION...Combine a highly evolved ear, high-tech instruments, and a powerful harmonic system, and you may still have nothing more than the racket of teenagers jamming in a garage. Good music requires good composition. Yet great composers are even rarer than great painters or writers. Exactly what is a brain up to when it creates original music, and why is it so difficult a task? For nearly two centuries, scientists (and pseudoscientists) have measured the skulls and brains of great composers, sometimes raiding graveyards to do so. Researchers have interviewed composers about how they work, studied their personalities, and followed the progress of child prodigies. Musical imagery and musical memory are central to these studies, and they are the focus of this chapter as we stalk the Muse's lair in the brain.

...TO PERFORMANCE...Nothing is quite so demanding of a brain as musical performance, which involves the choreography of hundreds of muscles, eyes moving across instrument and score, ears following every nuance, written symbols decoded and interpreted, several kinds of memory churning, emotions summoned and deployed, whole passages planned and administered, everything reciprocating to elicit a particular style, and all this without the various activities colliding. It's no wonder that it takes so long to learn an instrument well and that truly great musicians are so rare.

In this chapter we'll consider the brain at work during performance, what it can and cannot do, and how things go wrong. We'll contemplate the notion of musical talent and why some musicians get no better while others never stop improving.

...TO LISTENING...For every musical style there is a style of musical expectation. Various cultures, social strata, and personality types make different demands of music. Some people use music as a stimulant, others as a tranquilizer; some seek intensity and beauty, others distraction and clamor; some demand symbolism of the world about them, others delight in pure abstraction. This chapter looks at the many ways that people use and regard music, and how various emphases on rhythm, melody, harmony, words, and symbols engage the brain differently. We'll focus on the brain's ability to attend and anticipate, and on how experience tailors our ears to particular musical genres.

...TO UNDERSTANDING...While many people believe that music is a universal language, cognitive scientists argue over whether music is a language at all. If music has meaning, then what does it refer to? Does music have a grammar? What is its vocabulary? In asking whether music functions like language, we'll consider whether the distribution of musical skills in the brain parallels those for spoken language. Along the way, we'll take a close look at various kinds of *amusia,* the loss of musical ability through brain damage.

...TO ECSTASY When music transports us to the threshold of ecstasy, we behave almost like drug addicts as we listen again and again. What's happening in music that drives us right out of our skins? Why is some music "emotional" and some music "intellectual"? And how is it that sound can give us pleasure we seem to feel in our bodies? This chapter regards musical knower and musical known in light of modern theories of emotion and pleasure. You may leave this chapter with new ideas not only of what music is, but of what *you* are.

*Music, the Brain, and Ecstasy* requires no prior musical or scientific knowledge. Essential background is spoon-fed along the way, and there's a short glossary of essential terms at the end, should you lose track. What *is* required is a willingness to stretch your mind to every dimension that music occupies, to think like a paleontologist, a neurophysiologist, an acoustician, a psychophysicist, a musicologist, a composer, a performer, a sociologist, a linguist, and a philosopher. It's easier than it sounds, and you'll leave this book with quite an education. Be assured, music will never seem the same again.

# From sound...

On a balmy summer's afternoon, beneath a weeping willow beside a pond, a solitary flutist draws a deep breath and begins to play. Within the glistening tube, a column of air rattles in protestation of its confinement, its cries fanning upward to ears perched on branches, downward to ears nestled in burrows, outward to ears immersed in water.

A paramecium patrols the ooze at the pond's edge, searching, ingesting, dividing, fleeing. Although its entire being is expressed in but a single cell, this protozoan knows much of the world. A light-sensitive spot fills its days with brightness and darkness and shades of gray. Chemical mechanisms let it smell what is near and taste what it encounters. Collisions with its surroundings are felt and acknowledged. But the paramecium senses no more of the flute's sweet warble than we do of the radio waves that pass through our bodies. It spends its life in silence, or more correctly, in *soundlessness*, for silence is the delicious muffle of an auditory system in repose, and an animal lacking an auditory system can no more know silence than one born blind can know darkness.

Circling the paramecium are multicellular behemoths—flatworms and

mites and rotifers—whose tissues, simple organs, and nerve nets flaunt distinguished ancestries. The first 80 percent of life's three-and-a-half-billion-year evolution went into building such creatures. Primitive? Yes. Yet their complex eyes, their sensitive touch, their versatile chemical receptors are the bedrock that one day would support the appreciation of a Sargent watercolor, a Balanchine Tarantella, a glass of fine Margaux. But nowhere in these estimable beasts is there so much as a hint of the possibility of knowing a Mozart quartet.

Even with two hundred million years' evolution more—still soundlessness. For a jellyfish or a sea anemone, an octopus or a sea slug, a starfish or a sea urchin, the ocean's swooshes and gurgles are felt but not heard. Insects fared little better. A few species developed ears, but hardly of the sort that could one day evolve to accommodate a symphony. Such an ear would have to wait until animals developed backbones, and even then this newfound sense would pass its infancy minding little more than the bass tones of thrashing prey.

Hearing, it seems, is the *difficult* sense—slow to evolve, repeatedly undercut by evolutionary developments, reliant upon the most intricate and fragile mechanical structures in the body. It was forged through hundreds of millions of years of natural selection as countless lineages perished from detecting a predator too late, finding no mate, or overlooking a meal hidden nearby. Hearing was a late bloomer, following upon already well-developed vision and touch and taste and smell. Yet we take for granted the experience our ears provide. For us, sound is self-evident, complete, inevitable. But for most of nature's countless billions of ears, sound is something much less than it is to us.

Less? But doesn't sound exist independently of the ears that listen to it? It depends on what you mean by "sound." In physics, sound is indeed nothing more than vibrations. But in psychology, sound is a kind of experience a brain extracts from its environment. Where the physicist finds energy, the psychologist finds information. A physicist can precisely measure a volume of sound, but no psychologist would have the faintest idea how to assay a quantity of music. Although both professions lay claim to the study of sound, it is actually *the sensation* of sound that concerns the

psychologist. A physicist will tell you that the rattlings of air molecules are much the same to any ears, whether those of a frog or a cow or a human. But a psychologist will warn that the sensations derived from those vibrations vary greatly among species.

Consider nature's first musician, the cricket. Its "ears" consist of thinnings on its front knees that vibrate only at certain frequencies made by rasping cricket legs. It's tempting to think that crickets sound to each other as they sound to us. But they experience nothing like our sensation of sound. In their world, particular frequencies elicit particular stock behaviors, almost like a flip of a switch. So there's no need for their brains to analyze sounds the way ours do. If your human brain could somehow listen within a cricket's head, you'd encounter nothing like the serenade of cricket chirps you enjoy on a summer evening. Rather, an impulse to move in a particular way would arise, and when it became strong enough, legs and wings would snap to. That's all there is to it—no backdrop of wind through pine needles, no trickle of a nearby stream, no haunting echoes. A cricket can hear, but its experience is soundless by our standards.

Birds make better musicians. They chirp and chitter, trill and twitter, honk and hoot. Such sounds consist of many frequencies all ringing at once. Because the same frequencies occur in different calls, a bird can't distinguish one squawk from another by resorting to the cricket's ploy of listening for particular frequencies. Rather, it identifies sounds by sensing a vast range of frequencies and analyzing their structure. A bird's brain traces every rise and fall in a sound's contour, spots peaks and valleys, searches for patterns of repetition, and, in songbirds, relates successions of sounds. Many birds do this so well that they can recognize each other's individual voices. There are even regional dialects. The same cognitive faculties that let birds recognize each other are available for listening to the world at large. And so, in their own way, birds hear every cricket chirp, every rustling leaf, every falling tree.

Yet birds, even songbirds, have no experience of music. A few notes of birdsong no more make a melody than a few words make a poem. Even the half-hour-long calls of whales, nature's divas of the deep, consist of monotonous repetition. When sometimes we descry a snip of a melody in

the song of a sparrow, or a wisp of harmony in the chanting of whales, it is *our* brains, not theirs, that have discovered an opportunity to be musical. We admire a bird's tonal warble but not a crocodile's noisy bellow. Yet both animals communicate equally well using much the same architecture of ear and brain. Human voices are also tonal, and sometimes we communicate much like songbirds. Listen to a woman summoning her children home: *Ga-bri-ELLL-laaa . . . A-lex-ANNN-derrr . . .* The voice is musical, but we don't call this music.

One reason we hear music when animals don't is that our brains are able to manipulate patterns of sound far more complex than those the brain of any other animal can manage. We model patterns upon patterns upon patterns—right up to a movement of a symphony. Successive tones are linked to form melodic fragments, and then whole melodies, and then phrases, and then long passages. Simultaneous tones are integrated into intervals, intervals into chords, and chords into harmonic progressions. Patterns of accentuation are charted as rhythms. Shifts in intensity meld into crescendos and decrescendos. As our brains encode these relations, the sensations of sound arise. It's not that our brains assemble a web of relations into music and then "hear" it. Rather, hearing *is* the act of modeling such relations.

Play a waltz to a goldfish and watch what happens. Nothing. Its ear can sense all of the essential frequencies, and its brain probably starts piecing together the individual notes in the same way as our own. But two notes in sequence register as two entirely separate events in the goldfish's life. The goldfish isn't smart enough to detect the relation between the notes, and so it finds only random sounds. Where we find the beginnings of melody, it finds *relationlessness*, noise.

You'll never see a goldfish twitching in time to a waltz, because it is not a waltz's notes, but rather relations between those notes, that make a body want to dance. It's these relations—intangible, resistant to observation, difficult to describe and classify—that *are* music, not the atmospheric vibrations that jiggle out of musical instruments. The vibrating molecules that convey music from an orchestra to our ears don't "contain" sensation, only patterns. When a brain is able to model a pattern, meaningful sensation

arises. When a brain isn't up to the job, nothing occurs, and an animal's experience of the world is that much less than our own.

"Heard melodies are sweet," wrote Keats, "but those unheard are sweeter." Although we say that someone has "a good ear for music," credit actually goes to a good *mind* for music—a mind that can hear simultaneous melodies, simultaneous rhythms, even simultaneous harmonies. Only the most basic mechanisms for recognizing individual sounds are "hard-wired" into our nervous systems. Every other aspect of listening is partly or entirely conditioned by learning. Like the goldfish, a less well trained mind hears only music's simpler relations. Also like the goldfish, that mind has no way of knowing what it is missing out on, rather like a color-blind man inspecting a Monet. We are all to varying degrees deaf to some genres of music, particularly those of remote cultures.

In the chapters ahead, we'll trace music's rise from atmospheric vibrations to the experience of a complex symphony. We'll see how the brain learns to model the relations that form melodies, harmonies, and rhythms. We'll consider how the nature of these relations varies between cultures and musical styles. And we'll ponder why some brains are so much more adept than others at perceiving or creating musical relations. Ultimately, we'll ask what is going on in our brains when music grabs hold and rattles us to the core.

When music dissolves into ecstasy, it transports us to an abstract place far from the physical world that normally occupies our minds. So it may seem peculiar that we begin our journey toward understanding music's powers by exploring the vibrating bones and pulsating tissues of the ear. But to understand the ear is to begin to understand how the sensation of sound is built up by a mind, hammered together dimension by dimension. And to understand (as best we can) how sound alights on the ear of a cricket or fish or bird is to understand how remarkable our primate ears are.

## Sound

Question: How many drunks does it take to make a martini? Answer: One to hold the flask and any number more to shake him. They line up,

each rigidly grasping the shoulders of the next from behind, with the drunk at the head of the line holding the martini flask. Then the drunk at the rear goes to work shaking his neighbor, whose passive jigglings are passed on to the next in line, who in turn jiggles the drunk standing before him, and so on until the martini flask gets shaken. Standing to the side, you'd see the pushings and pullings ripple down the line.

This is how music travels to our ears, with the guy at the rear acting as a vibrating object and the martini flask as an eardrum. All the drunks between are molecules, usually of air, that are whipped back and forth as they pick up a pulse of energy coming their way, pass it on to other molecules, then start the cycle over again. A molecule vibrates 20 times a second for the lowest pitch we can hear (a frequency of 20 cycles per second), and up to 20,000 times a second for the highest. The harder the molecules are pushed, the harder they'll shove at an eardrum and the louder a sound appears. Yet even at a rock concert the motions are microscopic. In responding to the faintest sound we can hear, an eardrum moves by only the width of a hydrogen atom.

But how can every sound of an orchestra move through the air at the same time? Again, picture the line of drunks, but this time with several people jostling the unfortunate fellow at the rear. One shakes him twice a second, another three times, another five. Their motions combine in various ways. At some moments, all push or pull at once, sending a strong thrust down the line. More often, some pull as others push, such that their efforts partially cancel. At one instant, a lot of pushing and only a little pulling ends up as just a little pushing. A moment later, pushes exactly equal pulls and there is no motion at all. All of the shakings add together into a complex temporal pattern that jiggles toward the martini flask.

As a choir of brasses fills the air, a trumpet blasts out many frequencies of sound at once, each a *component* of the overall sound. Every air molecule is battered at every frequency so that it is nudged back and forth against the next molecule in an incomprehensibly complex pattern. This pattern of pushes and pulls is conveyed from molecule to molecule right up to waiting eardrums, setting them vibrating in the same way. A trombone blazes beside the trumpet, and the composite pattern of its many vibrations

are incorporated into the motions of the same molecules of air that the trumpet has excited. Indeed, every air molecule in a concert hall sums every vibration from every instrument into one frenzied dance. Think of what a remarkable device it would take to watch that dance and infer from it every one of the original vibrations. Yet that—and more—is precisely what an ear does.

# Ears

Be careful about what you call an "ear." That rubbery mass of bulges and folds, butt of jokes and bane of art students everywhere, is just a device to funnel sound to the real ear—the *inner ear*—that lies buried deep in your head. The jutting *outer ear* is called a *pinna,* the Latin word for "feather." Some animals use their pinnae for threat displays, for radiating body heat, even for swatting flies. But a pinna's main job is to amplify sound by funneling it into the ear canal. The ear trumpets once used by the hard-of-hearing were nothing more than giant artificial pinnae.

One person in four has a slight bump on the upper rim of his or her pinnae, believed by Darwin to be the last vestige of the pointed ears of our mammalian ancestors. Pinnae are a relatively late evolutionary development. You'll never see a fish or amphibian or reptile or bird with pinnae, although many birds have special sound-directing feathers, the best being the "ear flaps" sported by some owls. The ultimate pinna must be the barn owl's cone-shaped face, which funnels sound to its ear canals. This bird's whole head is an "ear."

Sound, including musical sound, is altered the instant it strikes your pinnae, for the pinnae enhance certain frequency ranges. Our pinnae are too small to reflect the long waves that constitute low-frequency sound; they boost only high-frequency components, thus making music a bit "sweeter" than it would be otherwise. Pinnae also *resonate* to slightly amplify a range of frequencies (we'll take a close look at resonance in the next chapter). These frequencies cover roughly the top octave of a piano keyboard. Not accidentally, they are those most important for perceiving speech. The inch-long ear canal also resonates to boost these frequencies. Stand before a source of high-frequency sound, such as a waterfall or

pounding surf, and gently place your fingers over your pinnae without blocking the entrance to the ear canal. As you alternate between covered and uncovered pinnae, you'll find that the high-frequency hiss fluctuates but bass tones go unchanged.

Music slams into an eardrum at the end of the ear canal and abruptly changes costume. Until this point it has traveled as a pressure wave through air; now it proceeds as mechanical motion. Just beyond is the air–filled *middle ear* (Fig. 1.1), where three odd–shaped bones, the *ossicles*, are strung from ligaments so that the eardrum pushes against the first (the *malleus*, or "hammer"), which yanks at the second (the *incus*, or "anvil"), which shoves the third (the *stapes*, or "stirrup") into an opening to the fluid–filled inner ear where neurons (nerve cells) await. Just like the air molecules that have transported music to the eardrum, these minuscule bones vibrate in a complex pattern that at any instant embodies every frequency contained in every note.

Many of us would gladly do without a middle ear. It's home to earaches, chronic infections, and all sorts of squeaks, pops, and fuzzy feelings that accompany a sudden change in altitude. It seems odd that nature would devise such a troublesome contraption just to move vibrations from one membrane to another. Why doesn't the eardrum lead directly to the inner ear? The answer lies in the different mechanical properties of a gas like air and a fluid like that found in the inner ear.

If you shout down to someone swimming under water, you probably won't be heard. Less than 1 percent of the sound gets through. That's because air molecules vibrate easily as sound waves pass through them, whereas water is denser and its molecules are slowed as they slide together. As air quivers against the water surface, water molecules can't keep up with the air molecules' nimble dance. Instead of following the air's graceful lead, the water molecules collide with their partners or pull away just as they should approach. What's needed to bring the partners in step is a way of amplifying the force delivered to the sluggish water molecules. That's what the middle ear is for. The ossicles concentrate the energy falling on the eardrum to only one-sixteenth as much area at the opening to the inner ear. The first two ossicles form a lever to add a bit more amplification.

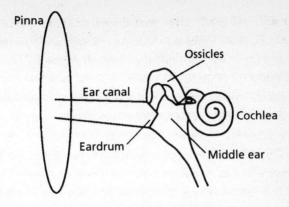

*Fig. 1.1. Cross section of the ear*

Thanks to the middle ear, the lion's share of sound energy striking the eardrum is transmitted to the fluid in the inner ear.

Not every creature requires pinnae and a middle ear. Fish have no need at all, since sound skips easily from water to tissues that are themselves mostly water, exciting the inner ear along the way. Many kinds of fish are made buoyant by a *swim bladder*—an oblong, gas-filled balloon in their bellies—and this has been put to work reflecting and concentrating sound. When sound strikes the gas in a swim bladder, it sets tissues jiggling all the way to the inner ear. By evolving vertebrae into sound-conduction rods, some species extended their hearing up to about 8,000 cycles per second, an octave above the highest note on a piano. Place a goldfish's bowl atop a piano and the goldfish will hear every note. But keep a shark as a pet and you'll have to play Bartók. Lacking a swim bladder, it would hear only the bottommost notes of the keyboard.

Hearing collapsed when fish made their way onto land some 370 million years ago. Without a middle ear to transmute airborne sound, the inner ear had to rely on vibrations arriving from the ground, particularly through the jaw—just the way snakes accomplish their (very poor) hearing today. But the jaw was destined to leave the ground when early amphibians developed legs. Fortunately, certain fish had developed breathing sacks in the millions of years spent at water's edge prior to coming on land, and

some of these would evolve into middle ear chambers. Simultaneously, a stronger jaw developed as its hinge moved forward, thereby freeing bones at the rear to become ossicles. The first middle ears had only a single straight bone reaching from inner ear to a patch of outer skin that functioned as an eardrum. This single-ossicle design is still found in all amphibians, reptiles, and birds. Only mammals add hammer and anvil ossicles, evolved from other obsolete jaw parts to boost frequency range.

Like the pinna and ear canal, the middle ear ossicles boost music's middle frequencies. By sizing the ossicles to resonate at these frequencies, evolution gave speech priority over other sorts of sounds. Many mammals emphasize a range an octave higher—perfect for sensing a predator brushing against tall grass. Bats have minuscule ossicles that magnify the ultrahigh frequencies they broadcast to make their way around in the dark. Kangaroo rats take the opposite tack with ossicles so large that each middle ear chamber is as big as the rat's entire brain, boosting the subtle bass tones of an owl's wing beats or a snake's slithers.

The middle ear is also designed to keep music *out* of your head. The ossicles gladly transport a string quartet to the inner ear, but at a rock concert they slam on the brakes. Two tiny muscles grasp the ossicles, one pulling toward the eardrum, the other toward the inner ear. These muscles are always mildly contracted to hold the ossicles in place, but they reflexively tighten when a dangerously loud sound arrives, preventing as much as two-thirds of the sound's energy from reaching the delicate inner ear. The reflex begins within a hundredth of a second of the onset of the sound but can take as much as half a second to reach full force, so it's useless for sudden sounds like gunshots. And the muscles are exhausted by long exposure to loud noise. It's for this reason that there's a society for deaf rock musicians.

Your ears also resist just the music that they should hear best: a song from your own throat. When you speak or sing, sound travels not only from your lips to your pinnae, but also straight through your head to the inner ear. In a sense, you hear yourself twice, once through the ear canal and once through bone. Bone conduction makes the sound louder than it would be otherwise, and changes the frequency content. This explains why

we don't recognize tape recordings of our own voices. A recording contains only part of the voice you normally hear. No one else can ever hear your voice as you do.

Our own talking or singing overwhelms the ear with a lot of racket that we don't especially need to hear, and in so doing it masks important sounds—the distant rumble of a charging bull, for example. To reduce the din, the middle ear muscles tug at the ossicles with every word we speak, precisely following the intonation of each syllable. There's evidence that the muscles are active when we subvocalize (that is, when we talk to ourselves) and even when we dream. The muscles are also at work in animals as they roar or howl or whinny or bleat. Some bats make brief bursts, inaudible to us, that are as loud to their ears as a blaring electric guitar. As they cry out, their ear canals close and massive muscles shut down their middle ear. These lucky beasts have earlids.

## The Inner Ear

When music completes its journey along the ossicles, it undergoes yet another change of costume, this time to a pressure wave in fluid. It is about to enter the inner ear, the *real* ear, the ear that converts the sound's vibrations into information a brain can use. Till this point, sound has been processed; now it will be sensed. Here, sound arrives at its retina, everything before having been a sort of lens.

But an analogy to vision misses an important point. Only a single particle of light (a *photon*) is required to draw a response from a receptor cell in your retina. Sensitive, indeed! But light does its work by prodding individual molecules; it's oblivious to the turmoil of pulsing blood and straining muscle. The ear is quite as remarkably sensitive, but from pinna to receptor cell the entire process is necessarily *mechanical,* for sound is the mechanical bumping of molecules together. This means a mechanical device is needed to convert vibrations to nerve impulses. This contraption must be tiny, almost flimsy, so that it can jiggle very fast. Yet it mustn't be torn to bits by the blows any organism suffers from time to time as it struggles through its life.

Nature answered these needs by encasing the inner ear, and the middle

ear too, in the hardest bone in the body, the *petrous temporal bone*. In this small area of your skull, barely a half inch across, is a labyrinth of chambers and canals lined by membranes. Also found there is the entire *vestibular system,* the sensors used for balance. Their cohabitation is no accident, for, as we shall see, the two systems are related, are, in fact, physically connected.

Our inner ears are the concert halls of our nervous systems, where music fans out to an eager audience of thousands of neurons. Three narrow chambers an inch and a half long are stacked on top of each other. The whole assemblage is coiled three and a half times for compactness, and so is named by the Latin word for snail: *cochlea.* The last of the middle ear ossicles prods a membrane that sends a pressure wave down the length of the topmost chamber, nudging the thin membrane below to cause the entire middle chamber to vibrate. On the floor of this chamber rest row after row of neurons embedded in an elaborate structure called the *organ of Corti,* a realm of bridges, tunnels, and fleshy spires shown in Figure 1.2.

At last, after having made it through pinna, ear canal, eardrum, ossicles, middle ear muscles, and cochlear fluid, music meets the nervous system. The organ of Corti consists of groupings of special neurons called *hair cells,* with one *inner hair cell* and three or four *outer hair cells* repeated again and again along the length of the chamber. Each grouping is most sensitive to a different frequency of sound—treble tones at the entrance to the cochlea, bass tones at the end of the spiral. Minute hairs project from the hair cells, some of them prodding a gelatinous sheet floating above and hinged to one side (the *tectorial membrane*). As music's vibrations spread through the surrounding fluid, the membrane supporting the organ of Corti waggles up and down, hairs bend, and hair cells fire—the stronger the motion, the more rapid the firing. At that moment, music leaves the physicist's world of vibration and enters the psychologist's world of information.

Touch comes to us through square yards of skin, vision through square inches of retina, but the organ of Corti stands at but 1/250th of an inch. It is dwarfed by the cochlear chambers. A mere 14,000 receptor cells spawn the 32,000 nerve fibers that leave the cochlea and make their way toward the brain. By comparison, an eyeball's retina presents 100 million receptor

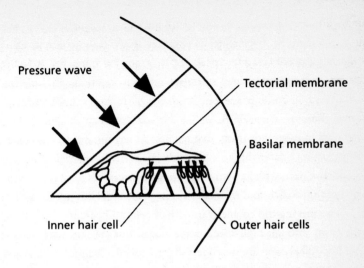

*Fig. 1.2. Cross section of the organ of Corti*

cells to the world, and an optic nerve carries their information over a million fibers. Such numbers say little about the intensity of experience. After all, only a few hundred pain receptors can leave you stooped in agony. But it is remarkable that, in a brain composed of billions upon billions of neurons, this slender channel gives rise to so much of our experience of the world.

Just a glance at a photo of the organ of Corti leaves you marveling that it doesn't collapse with a baby's first fall. But its structures have so little mass that they can hardly move against the relatively viscous fluid that surrounds them. The hair cells do not jiggle wildly and the supporting membrane does not flutter like a sheet drying on a line. It is a subtle organ serving a subtle sense. Tunneled into bone, with the middle ear muscles guarding the entrance to its burrow, the cochlea leads a quiet life.

It's not fully understood how the cochlea processes even the simplest sound, let alone a concerto. You might expect that a 10,000-cycle-per-second sound would stimulate only one neuron tuned to just that frequency, and that would be that. The neuron would communicate to the brain the message, "I hear a frequency component at 10,000 cycles per

second, and it's this loud." However, all but the very faintest sounds stimulate *many* neurons. A pressure wave travels down the cochlea, its energy lifting the organ of Corti to a peak and then quickly falling off. A 10,000-cycle-per-second sound may stimulate neurons tuned all the way from 1,000 to 11,000 cycles per second, with the most rapid firing occurring in neurons closest to the peak. As we'll see in the next chapter, a musical tone can consist of twenty or thirty frequencies. At any instant, an ensemble of instruments inundates the cochlea with hundreds of different frequency components, each with its own peak along the organ of Corti, each causing many neurons to fire, and each overlapping others. All this just for a chord!

Music striking the cochlea's inner hair cells is dispatched immediately to the brain through high-speed nerve fibers. But the outer hair cells respond less quickly and are much less sharply tuned. Their job is to average information between adjacent frequencies and between adjacent moments, to supply a slowly changing backdrop against which instantaneous information from the inner hair cells is analyzed. Although outer hair cells originate only about 15 percent of the nerve fibers leaving the cochlea, their information is all-important, for inner hair cells go out of tune when outer hair cells are selectively destroyed. In fact, the outer hair cells allow finer frequency discrimination than the cochlea's mechanics ought to permit. It's these cells that take the first steps in making sense of hundreds of hair cells firing in response to a single frequency.

We tend to think of the cochlea as a sort of flesh-and-blood microphone plugged into the brain, faithfully conveying every note of a piano sonata to a brain that will *then* go about listening. But the brain starts processing sound even at this level by projecting nerve fibers to cochlear neurons to control their responsiveness. One function of these fibers is to mask sounds made by the body, such as heartbeat or eyelid movements (try listening for them in a quiet room—they're louder than you think). The system has also been shown to be especially active in animals just before they call out, so this system may block the sound of an animal's own voice, just as the middle ear muscles do. Most important, the system appears to shape sensory input. There's evidence that damage to the system interferes with the ability to hear sounds through background noise, such

as a conversation at a raucous party. If the flow of information from coch-
lear neurons is the first step in *hearing,* these feedback circuits from the
brain are the first step in *listening.*

Earth's first listeners were unlikely candidates: fish. A school of fish
can skitter and pirouette in near-perfect unison because a chain of pressure-
sensitive cells called the *lateral line organ* stretches along each side of a fish's
body, sensing every nearby movement of friend or foe. Hundreds of mil-
lions of years ago, parts of the lateral line gradually migrated to the interior
of fishes' heads where they became the basis of the *vestibular system,* the
organ of balance. To monitor turns in any direction, three canals developed
at right angles to each other, one fronting the world just ahead, one facing
to the side, one paralleling the ocean floor below. In addition, sacks evolved
adjacent to the canals to monitor the fish's movement from place to place.
On the floor of each sack, neurons projected hairs into a layer of gelatin
seeded with tiny calcium balls. When a fish accelerated, the balls would
press against the hairs and the neurons would fire to tell the fish's brain
just how fast it was moving. Now a fish could exert fine control over its
stops and starts—just the thing for weaving through reefs or for sparring
with rivals.

And then evolution took a momentous twist. Low-frequency vibra-
tions passing through a fish's body, vibrations from mortal battles and slap-
ping waves, began to jiggle the calcium balls and excite the hair cells. The
effects must have been subtle at first, and may have been an unwelcome
interference. But worthwhile information was arriving through these vi-
brations, information from afar and of a different sort than the water dis-
placements sensed by the lateral line. It was *sound.*

For the first time in three billion years of evolution, animals began to
hear—*really* hear, and not just detect particular sounds. Gradually a gamut
of hair cells evolved. Sounds would no longer merely exist or not exist,
but took on a life of their own by rising, falling, pulsing, warbling. It was
only a matter of time before sensitivity would increase and frequency range
would expand. The brain evolved to accommodate every improvement,
and gradually it went beyond just sensing sounds and began to analyze,
interpret, identify.

But identify what? Other fish, of course! Biologists once doubted that fish could hear at all. When they looked for an inner ear, all they could find was a vestibular system. Fishermen thought they knew better, but scientists believed it was direct vibrations to the lateral line that lost the day's catch. And there was that other problem: why *should* fish hear? In laboratories, fish were serenaded with violins, trumpets, and whistles. No response. Only later would modern electronic gear let scientists listen closely to the fish's world. Sure enough, it turned out that many species call to each other, but in ways so strange, and with sounds so odd, that it took a long time to know what to look for. Having no lungs to bellow out their cries, fish circumspectly grind teeth or grate bones together. Others tighten muscles to strum their swim bladders. It's these "vocal" species (including your goldfish) that have evolved the best hearing by developing sound-carrying extensions from swim bladder to head.

Although some fish can hear every note of a symphony, they lack a true inner ear. It was only in amphibians that a sack dedicated solely to hearing branched out from the vestibular system. The first inner ears, like those found in frogs today, were merely a pouch containing clumps of neurons sensitive to narrow frequency ranges, driven by a single ossicle. Reptiles later regained the broad frequency range that was lost when fish emerged from primordial seas. Birds would push this design further, extending sensitivity up to about 10,000 cycles per second. Yet birds don't hear each other's songs nearly so well as we do. For that, nature had to devise the three-chambered cochlea found in all mammals. All in all, it took some 500 million years—well over a hundred million generations of animals—to evolve from the first hint of sound to an ear that can fathom *Don Giovanni*.

## Hearing Loss

Given its complexity, it's not surprising that the ear has many foes: a blow to the head, exposure to intense noise, bacterial infections, biochemical damage by drugs, or a spell of too little oxygen. Worse, there are few options for repairing the cochlea when damage is severe, for the body cannot spawn new nerve cells as it does cells of bone or muscle or skin.

Perhaps most dismaying is that our cochleas, like the rest of us, inevitably wear out as the years go by. In a process called *presbyacusis*, the upper limit of our hearing declines as we age. It's not that hair cells devoted to high frequencies necessarily die. Rather, cells become less and less sensitive until one day they no longer encounter sounds strong enough to excite them.

The decline is well under way by the age of forty, by which time the ear is only a tenth as sensitive at its highest frequencies. This is to say that a high-frequency sound must be ten times more intense for it to seem as loud as it had twenty years before. By the age of eighty, the decline amounts to the difference in volume between a whisper and a jackhammer. Thus to hear the highest sounds made by a musical instrument would require that those sounds somehow be played as loud as a jackhammer. Since they cannot be, you no longer hear them.

The practical effect of presbyacusis is that over a lifetime you lose about one-half cycle per second per day from the roughly 20,000-cycle-per-second range you were born with. In your forties, a year's loss amounts to only about 160 cycles per second. Later, presbyacusis gallops along, whittling the top frequency from, say, 16,000 cycles per second to 13,000 in a decade, then to 10,000 in the next, then to 7,000, and then . . .

Yet concert halls are filled with gray-haired musicians and conductors. They're able to work despite presbyacusis because, of the many sounds that make up a musical tone, the fundamental sound resides relatively low in the frequency range of our hearing. The top note on a piano, which is about as high a note as any instrument can play (organs excepted), is centered just above 4,000 cycles per second, and few of us live long enough for presbyacusis to descend that far. What's lost to the ears is not "the notes" but tonal richness, particularly the effervescence of high notes. Imperceptibly, day by day, the oboe's sizzling wail flattens, muffles, deadens. For a conductor with advanced presbyacusis, an orchestra's balance changes and he or she may have to work from memories of how instruments sound to younger ears. For a soloist, the loss of penetrating treble may lead to new interpretations focused on midrange or bass.

The decline of high-frequency hearing would be little problem for

non-musicians were it not that the most important speech sounds—consonants—largely fall in this range. Much of the hiss of an "s" rings out far above a piano's top note. Vowels, on the other hand, are centered in a piano's upper octaves. Most of a word's sound energy lies in its vowels, but consonants are all-important as dividers that let the brain distinguish one vowel from the next. Chimpanzees howl out all sorts of vowels, but they can't articulate their lips and tongues well enough to make consonants. Attempts to devise an all-vowel spoken language for chimps have failed, for everything blurs together. And that, alas, is what happens to our perception of speech as presbyacusis encroaches and consonants fade.

A dubious virtue of presbyacusis is that fading hearing leaves you less likely to notice that you're also losing your ability to discriminate between adjacent frequencies. Every half step along a musical scale, as from F to F-sharp, entails a jump in frequency of about 6 percent (from 100 cycles per second to 106, for example). A healthy young ear can sense differences in frequency of about 1 percent for tones centered roughly an octave below middle C, and 0.5 percent for tones an octave or two higher. So there's no problem hearing the difference between the steps along a keyboard, or even the quarter tones found in some non-Western music.

But again at about the age of forty, things start to slide. By one's sixties, discrimination at all frequencies is only about a third to a quarter as good as formerly. Where before you could discriminate by a half percent, now it's 2 percent. For octogenarians, discrimination around middle C is accurate to only a quarter step, and at low C it's off by a full half step—B no longer sounds very different from C, nor C from C-sharp. Nonetheless, a combination of long experience and bluster has allowed many a great musician to go on performing in old age.

And then there is pathological deafness, the deafness not of aging but of an ear under assault. A lucky minority of the afflicted suffers *conductive deafness*—deafness in the middle ear that often is caused by a buildup of extra bone where the ossicles meet the inner ear. Everything continues to work properly, but less sound gets through. A hearing aid can set matters right by boosting incoming sound to overwhelm the sticky connection. Paradoxically, the direct passage of the sound of one's own voice to the

cochlea is strengthened, not weakened. The afflicted speak more softly to maintain the sound at its accustomed level, thereby encouraging others to lower their voices so that they're even harder to hear. Aggravation runs high.

It is damage to the inner ear, however, that is a horror to any music lover. It's usually called nerve loss, but nerve malfunction is often closer to the mark. In the simplest case, a section of the organ of Corti stops working, particularly along the high-frequency regions closest to the opening to the middle ear. Prolonged exposure to loud sound is the prime culprit in this kind of mechanical destruction. The result often is a sort of accelerated presbyacusis—that is, accelerated aging. Those who think their ears are "just fine" after rock concerts may not have to wait till they turn eighty to learn otherwise. Hearing aids help only so much, since they boost all frequencies evenly, distorting the balance of any kind of sound.

But much more is at stake in cochlea damage than loss of frequency range. In a syndrome called *loudness recruitment,* cochlear hair cells lose their sensitivity to sound at low or medium intensities but continue to respond normally at high intensities. Rising sounds remain faint up to a point and then they blast away as if by a sudden twist of a volume control. Beethoven suffered loudness recruitment until he went totally deaf. He could hardly hear an orchestra from the stalls, but on the podium some sounds would charge at him, making fiascos of his last attempts at conducting. He wrote of how people would raise their voices when he couldn't hear them, but complained that "if anyone shouts, I can't bear it." By making all kinds of sound abrupt and harsh, loudness recruitment's most common symptom is irritability—a trait for which Beethoven was famous.

Finally, there is the ear gone mad. The entire tuning of the cochlea can be thrown off, particularly when the whole cochlea suffers organic damage. High frequencies may be perceived at lower pitch while lower frequencies creep upward. This was the fate of the French composer Gabriel Fauré late in life. Even worse are the results of Ménière's disease, in which the cochlea becomes bloated with fluid. Voices can sound like Donald Duck and music blurs together until there are no breaks between the notes. The afflicted can't distinguish between the sounds of various instru-

ments, and in the worst cases, music is described as sounding like dropping tin cans or hammers striking an anvil. There are worse fates than going deaf.

## Localizing Sound

Almost all of our auditory experience is devoted to identifying things: a faucet dripping, a spoken word, a clarinet's warble. We're far more interested in *what* sounds are than in *where* they are. Minds like ours map the world so effectively that the locations of sounds are of little concern. We already know perfectly well where the faucet is. It's usually only in settings like busy streets and dark alleys that we become conscious of a sound's location and may even strain to fix its position accurately. But evolution's priority was to find out where sounds come from rather than what they are. There's not a lot of point in distinguishing the sound of prey or predator when you can't tell which way to approach or flee. Localization is so important that our ears do it in a half-dozen ways. Indeed, it is the primary concern of the most primitive parts of the auditory brain.

Localization is also important in our experience of music. In a concert hall, reverberations reach our ears from all directions, and we localize each. Sounds arriving directly from the stage normally are loudest, so we tend to experience music as coming from that spot. But myriad echoes, some pronounced, most too subtle to distinguish, turn what would be a wallop of sound into an embrace. By surrounding us, music is transformed into an environment we inhabit, a world we are at the mercy of. Take a performance outside so that there are no walls to return reverberations, and music is reduced to one presence of many in the world rather than a world in itself.

When a beam of light enters your eyes, its position on the retina reveals its point of origin. To see is to localize. But in hearing, sounds coming from every direction funnel into a narrow ear canal, all approaching the eardrum from the same angle. It is as if nature had thrown away its opportunity to localize sound. Yet we can tell a sound's position not just when it is to the left or right, but when it's at our feet or overhead or behind.

We all have muscles for moving our ears, a hand-me-down from re-mote primate ancestors. Today these muscles are useful only for amusing children or confounding creationists, but once they were the primary means of localizing sounds. Watch a deer foraging in the woods. Its horn-like pinnae are in constant motion, as easily turned to the rear as forward. The pinnae scan the world for sounds much as the deer's eyes scan for sights. The two pinnae move independently, and sometimes they'll orient in opposite directions to cover a full 360 degrees. When something sig-nificant is heard, both pinnae turn toward it, making minute adjustments until as much of the sound can be gathered as possible. Once that's done, information regarding the pinnae's muscles tells the brain about the pin-nae's orientation, thereby telling the sound's direction. Sometimes you'll find a deer *staring* with its ears.

Humans can target sounds this way too, but we do it by turning our heads until the sound arrives equally at each ear. More often we let our brains do the work by comparing differences in a sound as it arrives at the two ears. Sounds appear the same at both ears only when they approach from straight ahead or overhead or behind. Otherwise, sounds reach one ear a sliver of a second later than the other. This disparity provides infor-mation for calculating the sound's angle of approach. Disparity in the tim-ings of a sound wave's pushes and pulls at the two ears lends further information. These "time-of-arrival" mechanisms work best for low fre-quencies for which neurons in the brain can fire in lockstep with a sound's vibrations.

We also localize sounds by comparing their intensity at each ear. Again, a sound appears the same when it approaches from front or rear, but not when it comes from the side. Sounds diminish little in the short distance from one ear to the other, but the head blocks high-frequency components, casting a sort of shadow. Our brains notice both the absence of these com-ponents and the decline in overall intensity. The degree of difference tells the sound's angle. Since this mechanism works best for high frequencies, it nicely complements the low-frequency advantage of time-of-arrival mechanisms. Localization is best in the middle frequencies where the two kinds of mechanism overlap.

Think of how a bugle heard from a far-away hilltop sounds different from one nearby. Besides fixing a sound's direction, our brains do their best to establish its distance by seeking cues about what has happened to the sound during its approach. The most important cue is the loss of high-frequency parts of a sound, which fall off rapidly as a sound travels through air. From experience, our brains learn the characteristics of particular sounds at various distances. Quite unconsciously, we carry around a bank of memories of such things as how loud a dog barks, and how a dog's bark sounds nearby as opposed to far away. Such cues can be deceiving, and we're often unsure of our judgments. Still, it takes an advanced brain to interpret distance cues, and probably few animals do it as well as we.

We are able to zero in on sounds coming from nearly every direction. Yet the mechanisms that compare sound at the two ears can only tell that a sound is, say, 30 degrees to the left, but not whether it is 30 degrees to the front or rear, or whether the sound comes from above or below at that angle. It's the pinnae's many folds and protrusions that add the extra dimension. They're designed so that high-frequency sounds bounce from one fold to another, traversing a pinna differently for each direction of approach. In a complex, little-understood manner, a pinna produces myriad tiny echoes whose delays add up in different ways to indicate a sound's location. The little tab of flesh that juts out at the opening to the ear canal (the *tragus*) catches reflected sound and guides it toward the eardrum. Sounds are altered differently when they approach from the rear, since the backs of our pinnae block high frequencies.

As every art student knows, there's no such thing as a "standard" pinna, any more than there's a standard mouth or nose. Everyone's pinnae are as unique as his or her fingerprints (line up some friends and compare!). So a pinna's reflection distances, and thus its reflection times, vary from person to person. We learn through experience how the effects of our pinnae correlate with the placement of sounds in the world.

The spatialization of sound takes place below the threshold of awareness. The pinnae's reflections, and the disparities of sound between the two ears, are heard yet are inaudible. We simply find that, embedded in our experience of a sound, there's a sense that a violin is "there, to the left" or

"behind me and above." Yet if the process is subtle, the result is powerful. Try facing a nearby babbling stream in quiet woods. Its many sounds will stretch out far to the left and right. With eyes closed, bend and cover your pinnae in various ways to hinder their normal operation. As you do so, the sonic breadth of the world will collapse before you. The experience is a bit like switching your hi-fi from stereo to monaural mode. Repeat this experiment in a concert hall (if you don't mind some questioning glances) and you'll find that music's spaciousness fades away, almost as if the concert had moved outdoors.

We localize musical tones less well than most sounds. Our ears have an easier time with natural sounds that constantly change and that are spread across many frequencies. Because so many factors bear upon our localization skill, it varies with direction and frequency. Broadly speaking, on the horizontal plane we can detect differences in position of about 1 degree for sounds up to about 1,000 cycles per second (two octaves above middle C), and 2 degrees for higher frequencies. But when a sound approaches from above, we localize to 4 degrees at low frequencies and much less well at higher frequencies—so much less that we're flummoxed by sounds from straight overhead.

Humans are quite good at localizing sounds, but we're not the best. Nature's champion localizers are owls. Some manage 1-degree accuracy in all directions by having evolved asymmetrical skulls that place one ear higher than the other so that sounds from above and below arrive at slightly different times. Most mammals localize less well than we, partly because smaller heads make for smaller differences between the ears. Fish have the toughest time of all, since sound moves from water right through their heads at four times its speed in air, greatly reducing inter-ear differences. Yet many fish can tell a sound's direction fairly well, apparently by having evolved direction-sensitive hair cells.

Considering all the ways we localize sound, it's easy to understand why two loud speakers in a living room fail to capture the spaciousness of a concert hall. In recording a symphony, microphones pick up reverberations coming from all parts of the hall as well as sound arriving directly from instruments. But when you play back the recording, all of the hall's

reverberations approach you from the front. The reverberations are then *re*-reverberated around your living room, producing a muddle. Little improvement comes from making a recording with microphones all around a concert hall and then playing the sound back through speakers on all sides. After all, a person sitting in a concert hall uses only two microphones to listen to a symphony—his or her ears. But unlike mechanical microphones, ears treat sound from every direction differently.

If recorded music is to sound spatially authentic to our ears, what's needed are microphones with pinnae. It sounds like a preposterous idea, but in fact it's been done for years. You just sculpt a life-size head with typical pinnae and embed ordinary microphones at the ends of the ear canals. The head blocks high frequencies and creates the appropriate delays between the ears, and the pinnae make the usual reflections. Position the head at the best seat in a concert hall and perform an opera. Then listen to the recording through in-ear headphones so that the sound isn't re-reflected through a room and about your pinnae. The effect is magical. A whisper behind the ear is heard *just there* behind the ear. Alas, few recordings have used this technique because it only works well with headphones, and because engineers like to work with dozens of microphones to adjust an orchestra's balance. If music's spaciousness is important to you, there's no alternative to a good concert hall.

## Primitive Hearing

When the ear has done its job and nerve impulses spurt toward the brain, you might think that nature has done enough work, that music has been "heard" if not yet listened to. But sound has only begun its journey to understanding, and an arduous itinerary is in store before it makes itself known to higher brain centers.

For most of us, it is the glistening rumple of cerebral cortex that comes to mind when we think of the brain. Open a skull and cortex is what you see. But cortex is only the brain's outer surface (cortex means "bark" in Latin). Much older parts of the brain lurk beneath, and they are at work in all that we do. Of course, it is cortex that has expanded over tens of

millions of years to make mammals increasingly intelligent. We humans have much more cortex than our nearest primate cousins, and it clearly underlies our intellectual skill. So it's only natural to assume that cortex must be where we "listen," where we "see," where we "are." There's much truth in this notion, and the cortex will be our focus in chapters to come. But animals possessing little or no cortex negotiate the world reasonably well, and among their talents is keen hearing.

As the spinal cord emerges from the topmost vertebra, it thickens and abruptly becomes much more complicated. This part of the brain—the *brain stem*—is the oldest and most cluttered. In the cerebral cortex above, neurons are organized along a two-dimensional surface, much to the convenience of researchers. But in the brain stem, groups of millions of neurons crowd together in three-dimensional jumbles called *nuclei*. Each nucleus is intricately connected to other nuclei or to other parts of the brain, forming a nearly impenetrable knot that neuroscientists have only begun to unravel. Figure 1.3 diagrams auditory nuclei in the brain stem.

Music makes its way through this ancient maze, jumping from nucleus to nucleus, as it travels from cochlea to cerebral cortex. At each step, the brain stem observes relations within sounds, such as that a sound is rising in frequency, or that it is growing louder. However, the main concern of this part of the auditory brain is the localization of sound—something not essential to music, but a priority in an animal's survival.

As sound departs the cochlea, it is chopped to pieces with each of its many aspects shunted off to its own neural circuitry. The first stop is the *cochlear nucleus,* where auditory nerve fibers branch toward three divisions, two concerned with localization and one that seems to relate a sound's frequency components. Here, and in nearly every nucleus right up to the cortex, neurons are found arranged along an axis with those responding to lowest and highest frequencies at opposite extremes, just like in the cochlea. But every frequency map represents a different aspect of music. One map might compare a tone's time-of-arrival differences at each frequency. Another compares the relative loudness of frequencies at each ear. And a third map might model relations between simultaneous frequencies, or might

*Fig. 1.3. Auditory areas in the brain stem*

follow changes in such relations from moment to moment. Higher in the
nervous system, the information from these maps will converge to create
the composite experience of a flute's warble or a clarinet's honk.

The brain's first business is to link input from the two ears and to test
for differences in the sound they hear. A collection of nuclei called the
*olivary bodies* perform this job. Researchers have found neurons in these
nuclei that fire only for particular differences in intensity or only for timing
disparities of a certain duration. Such specificity shows that these nuclei do
much of the work required to localize sounds, encoding spatial relations

that flow onward toward the cortex. In owls, olivary neurons have been found that fire only for particular angles between a sound source and the owl's orientation.

Owls? Owls may hoot quite nicely, but they don't have much of a musical life. What about *our* brain stems? Prepare yourself for frustration. What we know of the brain at this nitty-gritty level derives almost entirely from animal studies. Particularly for the brain stem, you simply can't do research without doing damage. So experiments on humans are out of the question.

Even under laboratory conditions, it's terribly difficult to monitor functioning neurons deep in the brain while preserving the surrounding neurons with which they interact. Neurons the size of a pinpoint often make hundreds of connections with other neurons quite some distance away. There's no way to unravel this tangle. So researchers probe blindly for neurons that exhibit interesting behavior and then laboriously deduce how they work with others. Detailed mappings of every kind of neuron in every kind of behavior aren't yet available and won't be for a long time.

Well before linking a symphony's tones together into chords and melodies, our brains plot every tone's spatial position on a common map. This occurs within a pair of bumps at the back of the upper brain stem, the *inferior colliculi* (Latin for "lower mounds"), where lower pathways converge. Here, sources of sounds are tracked as they move through space, with some neurons firing only for movement in particular directions. It's only at this level that sound becomes useful, allowing prey to avoid predator, or predator to capture prey. The inferior colliculi play an important role in directing an animal's pinnae. And they make rich connections with more than twenty locations in every part of the brain, including many that are primarily concerned with moving an animal through the world. It may seem odd that the auditory system reaches directly to brain structures concerned with controlling muscles. But nature's priority is not to listen and interpret; it is to hear and react.

Just above the inferior colliculi are a second pair of bumps called the

*superior colliculi*, where sound meets sight and touch. Parts of the superior colliculi map visual experience much as the inferior colliculi map auditory experience, controlling eye movements just as the inferior colliculi control ear movements. But deeper layers of the superior colliculi go beyond visual processing to meld information from every sensory system into a map of the surrounding world, a map that follows a bizarre topography that includes the entire body surface, and thus every direction in space. It's as if at this point the primitive brain arrives at a sort of worldview. Researchers are stumped as to how the superimposed maps of the various senses are related.

Although the brain stem's main concern is localizing sound, it is also at work defining and shaping sounds. Low in the brain stem, neurons tend to fire throughout a tone's duration. Closer to the cortex, they fire intensely only when a tone starts and stops. It's as if the brain stem is finding a sound's edges and sharpening them so that they'll be instantly clear to the cortex waiting above. For music this means that the brain stem helps identify individual notes within the blooming confusion that pours forth from the cochlea.

Meanwhile, other pathways in the brain stem process sound in a manner that no one really understands at all. In this *diffuse ascending system,* neurons seem not to be organized by frequency, and they respond relatively slowly, as if they were more concerned with averaging the experience of many moments than with reporting the latest sonic event. Researchers have generally neglected these pathways, instead directing their electrodes toward neurons that exhibit familiar conceptions of sound. But the diffuse system communicates with parts of the cerebral cortex especially concerned with attention, memory, and learning—all of which are essential to our comprehension of music.

Only humans have brains that can be trained to penetrate layer upon layer of sonic relations. But even in our advanced brains, the brain stem probably can't make much sense of a few notes in sequence. The simplest melody requires cerebral cortex. Much of this book is concerned with how cortex comprehends ever more elaborate and protracted structures. But

before we take on symphonies or even simple melodies, we need to consider the simplest musical structure: the *tone*. For, unlike the ordinary sounds that we've considered so far, a single note from a violin or oboe is packed full of complex but elegant relations. That is the subject of the next chapter.

From sound...

. . . to tone . . .

Lumbering along on its hind legs, with a thick tail and paddle-like hands, *Parasaurolophus* stood at more than three times the height of a man and weighed three tons. It was perhaps the most majestic of the hadrosaurs, a family of dinosaurs that evolved late and thrived right up to the great extinction sixty-five million years ago. By a child's gory notions of dinosaur excellence, the hadrosaurs were a dull lot—peaceful vegetarians who lacked slashing teeth and gnarled armor. In fact, all hadrosaurs looked pretty much alike but for the crests atop their heads. Some species donned forward-jutting spikes; others sported fins or helmet-like affairs. But it was *Parasaurolophus* that was most nobly crowned, with a five-foot-long tube arching from its nostrils to well beyond the back of its head.

Paleontologists pondered long and hard about *Parasaurolophus*'s hollow crest. What was it for? Hadrosaurs were originally (and probably errone-ously) thought to have passed their days feeding on the muddy bottoms of swamps and rivers, so a reasonable guess was that *Parasaurolophus* employed its crest as a snorkel. But it turned out there was no opening at the end. Other hypotheses fared little better. Some investigators thought the crest

was for air storage or that it served as a sort of air lock to keep water out of the dinosaur's lungs. Others suggested that it was used to push foliage aside. And then one day someone had a bright idea. He bought some plastic pipe and glue, fashioned a crude, life-sized *Parasaurolophus* crest, and with one deep breath demonstrated the crest's true nature: it was a trumpet.

Well, not exactly a trumpet. It was a *resonator*—a closed vessel for amplifying particular frequencies—that *Parasaurolophus* used to trumpet its cries far and wide. Hadrosaurs were highly social creatures (they're celebrated for having built nests and tended their young), so large groups probably bellowed in chorus. What a racket! Males had larger crests than females, and some paleontologists suspect males battled for their harems solely by visual and sonic display. Hadrosaurs may have been smart enough to identify each other through their trumpet blasts. Excavation of their giant skulls has revealed thin, delicate middle ear bones—a sign of acute hearing, which in turn indicates an acute brain.

# Tones

What makes *Parasaurolophus* interesting is that it produced not just any old sounds, but musical sounds—*tones*. Its crest was one of the first musical instruments. As we'll see in a moment, musical tones are formed from particular patterns of sound produced only by the vibration of certain simple shapes. Such shapes hardly ever occur naturally. Wind may occasionally whistle and brooks may sometimes babble melodiously, but nature mostly makes noise. Evolution certainly has more important work to do than devise pretty sounds—except, that is, when animals have something to say to each other.

When an animal calls out to others of its species, it generally makes the loudest sound it can. A big sound travels farther and it works better as a threat. Of course, animals make sound in many ways: birds chirp, snakes hiss, crickets rasp, dolphins click, alligators slap water, fish scrape bones, rattlesnakes shake their tails, gorillas thump their chests. But the most effective sound producers focus their efforts on just one pitch to make a sound that travels farther and seems louder than if the same energy were spread across many frequencies. Such sounds don't come from jiggling a

large mass of flesh the way a pig snorts with its snout. That merely makes noise, because a snout has many physical components and each vibrates at its own frequencies. A better ploy is to pull a thin sheet of tissue taut and excite it by a steady flow of air. Shape it just right, add resonating chambers above, and you've got the voice of Pavarotti.

Simple shapes like strings, tubes, and gongs make beautiful sounds because they vibrate in simple ways. Consider a guitar string. When it's plucked, the entire string swings back and forth at a particular frequency— say, 100 cycles per second. If you hold down the string at midpoint so that it's divided into two segments half as long, each segment vibrates at a frequency that's twice that of the whole string, or 200 cycles per second. Similarly, dividing the string into thirds gives triple the original frequency, fourths gives quadruple the frequency, and so on.

It's easy enough to see how shorter string lengths give higher frequencies. But strings also generate these sounds in a way that's not at all intuitive. For even when a string is undivided it produces the same higher frequencies, albeit at lower intensity than the string's *fundamental frequency* (its *"fundamental"*). Pluck a guitar string and the whole string vibrates at the fundamental frequency, the top and bottom halves vibrate independently at double that frequency, the three thirds vibrate at triple the frequency, and so on. The string wiggles wildly as all these motions combine.

These higher-frequency sounds are called *overtones* (or *harmonics*, or *partials*). In many musical instruments, but by no means all, the first overtone is less than half as intense as the fundamental, and subsequent overtones are softer still. So we tend to identify a tone by its lowest and loudest component. An ideal string would produce an infinite number of overtones, but in the real world most musical sounds possess twenty or fewer, with the highest overtones too weak to be audible. Part of the reason that a saxophone sounds different from a violin is that the intensities of the two instruments' overtones differ.

When sounds are arranged in an orderly pattern of overtones, the result is a *tone*. Tones please our ears in a way that single-frequency sounds can-

not. Behind their beauty lies simple arithmetic. Consider all notes named "A" on a piano keyboard. The A found two octaves below middle C has a frequency of 110 cycles per second. Frequency doubles from octave to octave, so an octave higher the frequency is 220, then 440, then 880. For reasons we'll consider in Chapter 3, all multiples of a base frequency have the same quality, the same "aura." Even to untrained ears, all A's resemble each other, and so do all C's and G's and B-flats.

Now, think of the progression of overtones. If the A at 110 cycles per second is the fundamental frequency, then its strongest overtones include 220, 330, 440, 550, 660, 770, and 880. Of these, the frequencies 220, 440, and 880 are all A's. So the brain finds great coherence in the sound it hears. What's more, the overtone 330 is halfway between the two A's at 220 and 440, just as the overtone 660 is halfway between the two A's at 440 and 880, making the sequence of overtones even more orderly. All are related as multiples of the fundamental, or as halves or quarters.

Our brains can easily make sense of these tidy relations. If the distances between overtones were uneven, a brain presumably would need to work harder to model relations among the parts of a tone, or might fail to detect relations and would find only noise. Figure 2.1 provides a visual analog. Consider how easily you can grasp the geometry of the overtone pattern shown in part (a) of the figure; it would be simple to recreate this pattern from memory. But the irregular pattern of part (b) is more challenging and would be much harder to redraw. In the first case our brains find order; in the second, relative disorder.

Because musical tones are constructed from orderly sequences of overtones, every note is actually a *chord*, one that ranges across several octaves above a note's fundamental frequency. Yet our brains register only a single entity. This happens partly because most of a tone's energy usually lies in the fundamental, and partly because the fundamental is buttressed by the most important overtones. When the fundamental is an A, the quality of "A-ness" is reinforced again and again as that note is repeated at each octave above. As we'll see when we look into the phenomenon of perfect pitch, our brains are much better at identifying the quality of an A than at de-

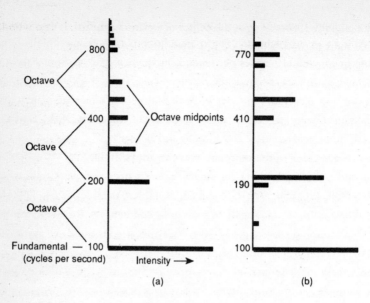

*Fig. 2.1. The geometry of overtones*

tecting which octave an A resides in. So every overtone that is an A tends to meld with the fundamental. Overtones must be on target if they are to fuse properly. Laboratory work shows that when a lower overtone deviates from its proper pitch by only a few percent, it abruptly juts out and is heard as a separate sound.

Higher overtones crowd together in the fourth octave above the fundamental, where there's an overtone at just about every step along the scale. Here the simple relations found among lower overtones break down and sounds clash. Fortunately, these overtones tend to be much less intense than the first half dozen. But they can muddy base tones noticeably, since for these tones the higher overtones fall in the frequency range at which our ears are most sensitive. Conversely, high notes tend to be poor in overtones because instruments have trouble vibrating at very high frequencies. At the top of its range, a flute can produce a pure fundamental with no overtones at all—it becomes a whistle. We prefer tones with neither too little nor too much energy in their overtones, and these are

the midrange tones lying at the center of a piano keyboard. It's no wonder that most of music's notes occupy these middle frequencies.

Most of us pass our entire lives without realizing that we're hearing many sounds in every musical tone. We fail to hear a tone's components largely out of inattention, just as we glance at a tree without noticing its individual branches. You can train yourself to hear individual overtones. Sit at a piano and strike a note at midrange, then softly play the note an octave above, which is the first overtone. When you play the first note again, your brain will know where to look for the overtone. Some people claim to be able to pick out a dozen overtones this way, but you're doing well if you manage just a few.

A tone's overtones fluctuate in intensity as the tone starts up, is sustained, and then decays. Often the fundamental quickly rises to full intensity and the various overtones unobtrusively follow. But sometimes lower overtones rush out first, gradually making way for the tardy fundamental. And in certain cases the fundamental is actually weaker than its overtones throughout a tone's duration. Just as overtones arise irregularly, they also fade away at different rates as a tone subsides. These patterns of onset and decay impart to every instrument a distinctive sound, its *timbre* (pronounced "*TAM-ber*"). The patterns vary with pitch and loudness, so the sound of a low murmur on a trumpet is quite different from that of a high blast.

## Resonance

Sixty-five million years after *Parasaurolophus* last trumpeted, members of the species *Homo sapiens* are to be found blowing air through resonators of their own (sometimes still to attract members of the opposite sex). Like *Parasaurolophus,* we also have natural resonators in our heads, and we use them in much the same way, to shriek or threaten or beckon. However, our apparatus became far more elaborate as it evolved for speech, and a happy by-product of that evolution is the ability (with training) to sing a Rossini aria. Most other musical sounds come from resonators we've invented.

Because music lives and dies by resonance, it's worth pausing for a moment to consider how resonance works. A sound wave does its best to

set an object vibrating. But objects can be stiff and massive, causing them to repel sound. Nonetheless, for any object there are certain frequencies at which it gladly joins in the dance. These are the object's *resonant frequencies*. Of the many frequencies that make up an approaching sound, resonant frequencies are sustained while all others tend to be damped. Resonances vary by an object's size and shape, the material it is made of, and other factors. Massive objects resist rapid vibration, so they tend to resonate at low frequencies. Conversely, small objects favor high frequencies. The complex shape of a violin makes for many strong resonances; a kettledrum's simple form creates fewer.

It's easy to understand how resonances arise. Imagine pushing a child on a swing. You must push at just the right interval, an interval that depends on the length of the swing's chains (and not on how hard you shove). The tentative five-year-old and the daring ten-year-old both travel back and forth in the same time, although the larger child travels farther and thus faster. When your timing is just right, each push you give amplifies the child's motion by imparting a bit more energy and sending the swing a little higher. In a sense, you've found the swing's resonant frequency, the frequency at which it naturally pitches back and forth. Sound waves vibrate objects much in the same way, and a sound wave is similarly amplified when the wave's pulses match one of an object's resonant frequencies.

Now, picture yourself pushing the swing blindfolded so that your timing is off. Occasionally you'll push at the right moment and will add momentum to the child. But more often you'll push a little too soon and will take away momentum as you go against the child's motion. This is the situation for sound waves of frequencies other than the resonant frequency. Objects tend to damp them.

Hardly a sound wave comes your way that isn't altered by resonance. We speak of "the sound" of clattering plates or slamming doors, but it's largely the resonances of plates and doors that we hear. Resonance is essential to music; indeed, musical instruments are basically resonance machines. And speech, whether a singer's warble or a politician's whine, is wholly reliant on resonance. As we saw in Chapter 1, even the ear resonates in various ways, modifying sounds as they arrive.

We've all played instruments like bells and castanets that are nothing more than resonators. They're easy enough to play, but the sound quickly dies away. For continuous sound, an instrument must be separated into two parts: a part that generates sound waves—such as a violin's strings—and a part that receives the sound waves and resonates—a violin's body.

When you listen to a violin, you're hearing chemical energy in the violinist's muscles transformed into sound. The energy enters the violin by scraping a bow against strings. Not much sound comes to your ear directly from the strings, where the surface area is too small to push at very much air. But the strings are strung across a bridge (the thin slat pushing the strings away from the instrument's surface) and this transmits the string vibrations to the body of the violin, where a much greater surface area presses against more air to make more sound. The violin body transmits best the frequencies it resonates at, while damping all others. Some of a violin's characteristic sound, its timbre, is attributable to its strings, and some to the resonances of its body.

Without resonance, music (and, for that matter, speech) could never have evolved. Sounds just wouldn't have been loud enough to be worth the trouble of making them. Certain electronic pianos prove the point. Conventional pianos use a thick sheet of spruce, the *sounding board,* as a resonator. For authentic touch and timbre, some electronic pianos are built like an ordinary piano in every respect except that they substitute microphones and amplifier for the sounding board. With the electronics turned off, you can strike the keyboard at *fortissississimo* but still will hear only a dull muffle. That's all the sound a piano's strings can manage on their own.

Our ears revel in complex sounds, so we've designed musical instruments that resonate across wide ranges of frequencies. These resonance bands are called *formants.* A clarinet's main formants boost sound waves between 1,500 and 1,700 cycles per second and 3,700 and 4,300 cycles per second. A trombone has only one formant, from 600 to 800 cycles per second. An instrument's formants remain the same for high notes and low notes alike, so sometimes the formants emphasize a tone's fundamental frequency, sometimes low harmonics, sometimes high harmonics. This helps explain why an instrument sounds different across its range.

From these simple notions it's easy to categorize every kind of musical instrument. There are instruments that are struck and instruments that receive energy continuously. In the first group (the *percussives*), some have resonators, such as the tubes hanging below a xylophone's bars, while others, like chimes, simply *are* resonators. In the second group, sound always originates apart from the resonator. For all the world's mechanical complexity, there are only two sources of sound in these instruments, forming the great divide between *strings* and *winds*. Of course, in string instruments it's taut strings that make the sound that is subsequently resonated. The longer and heavier the string, the deeper the fundamental frequency at which it vibrates.

Wind instruments also rely on something long and thin: a column of air. Air pushed through a tube is at higher pressure than air outside, and the resulting column vibrates much like a violin string. The column fits snug in its tube, so it can't waggle back and forth. But the patterns of air compression in the column resemble those of a vibrating string. As with a string, an air column's fundamental frequency depends on its length. The length can be altered in a number of ways to jump to a different fundamental (that is, to a different note). In the simplest method, holes along the instrument are covered or uncovered, with various combinations resulting in air columns of different length. The woodwinds work this way. The other approach, used by the brasses, is to change the length of the tube in which the column develops. Trumpets and horns manage this by using valves to redirect the column through varying lengths of tubing. Trombones simply telescope the same bit of tubing to different lengths.

A column can be twisted into any form without much changing the sound it makes. Brass instruments are tied into knots merely to make them manageable (a straightened French horn would be twelve feet long). Despite an air column's twists and turns, it also behaves much like a string in producing overtones. As the whole length of the column vibrates at a fundamental frequency, the top and bottom halves also vibrate at the first overtone, the three thirds vibrate as the second overtone, and so on. The relative strengths of the various overtones vary with the shape of the air

column. Instruments with a conical bore, such as the oboe or saxophone, have a fairly even distribution of overtones. But the cylindrical bore found in flutes and clarinets strongly suppresses all even-numbered overtones. Among brasses, the flared bell boosts high-frequency overtones to produce a bright sound. From top note to bottom, the brasses vary more than any other kind of instrument in overtone content.

Percussion instruments make the most complex sounds of any instrument. Unlike strings or air columns, which are essentially one-dimensional, a drum membrane extends in two dimensions and vibrates in many ways. Drums have a fundamental frequency that corresponds to the in-out vibration of the entire membrane. But many other frequencies blare out to drown the fundamental in noise. Yet a blast of noise is just what most drums are for. In snare drums there are wires (*snares*) lying against the lower membrane to make the most furious rattle possible. At the opposite extreme, a kettledrum employs a hemispheric resonator to boost the fundamental and impart a distinct tone to every beat.

Energy can't come out of a musical instrument unless energy goes in. The simplest way to impart energy to an instrument is to whack it, and that's just what's done with percussion instruments. But for continuous sound, a steady flow of energy must be applied. Actually, it's not a *continuous* flow of energy that's needed. Because sound waves consist of a train of pushes and pulls, a musician needs to impart a spitfire series of impulses to an instrument. On stringed instruments, this is done by coating a bow with sticky resin so that it grips and deforms a string as the bow hairs pass by. The string catches, is pulled a bit, slips back, catches again, and so on many times a second. The length of the string determines how far it travels before slipping, and thus the rate at which the string vibrates (the actual mechanics are quite complicated). If you were to apply energy continuously to a string, pushing the string but not letting it slip, you'd merely break it.

Wind instruments also require a train of energy pulses, and they manage it with a reed. The most familiar sort of reed is a thin sheet of cane that vibrates between pursed lips. A single such reed fits against a mouthpiece in a clarinet or saxophone, or two reeds flap together in an oboe or

bassoon. Reeds can also be made of metal, as in harmonicas or organ pipes, or they can be made of flesh, as when a player's lips sputter at the mouthpiece of a brass instrument. A flute uses the most remarkable reed of all: an *air reed* formed from the jet of air blown by the flutist. The jet jams its way into the barrel of the flute, is deflected a moment later when the flute can accommodate no more air, and then jams its way in again when a pressure drop in the flute allows it, fluttering back and forth.

The rate at which a reed vibrates matches a tone's fundamental frequency. But how do players manage to control their lips well enough to achieve the desired vibration rate? Much of the work is done by the instruments. When a sound wave reaches the end of an instrument's air column, it encounters an abrupt drop in pressure that reflects the wave back toward the mouthpiece, where it pushes apart the player's lips. Since the length of the air column determines the rate at which it vibrates, the reflections arrive at the reed at just the right frequency, and so the reed is brought into sync with the instrument's vibrations. In a sense, the instrument plays the player while the player plays the instrument.

There's one other kind of reed that all of us have mastered: vocal cords. There's nothing very cord-like about vocal cords and they're more properly called *vocal folds*. They consist of thick side-by-side membranes that vibrate when they're pulled taut and excited by a rush of air from the lungs. A change of tension alters the frequency of vibration. You can easily feel the difference in tension in your throat when you sing high and low notes in alternation. The vocal cords produce a strong fundamental and an evenly graded series of harmonics, but the sound is nothing like a human voice. For that you need the resonating chambers formed by the throat, mouth, and nasal passages.

What makes the human voice the most versatile of all instruments—and the least understood—is that its resonances can be continuously altered by movements of the larynx, jaw, tongue, and lips. The vocal tract produces several formants (resonance ranges), of which the lowest two are quite strong. Various combinations of formants generate the vowel sounds that are the mainstay of the singing voice (consonants consist mostly of non-tonal noise). When both the first and second formants are set at about

1,000 cycles per second, the vocal cords' buzz becomes the "ah" in "balm." Lower the first formant to 400 cycles per second and raise the second to 3,000 and you'll hear the "ee" in "beet" instead. In a singing voice, the third and fourth formants are much stronger than in spoken speech, intensifying upper harmonics to make a richer sound. Interestingly, the formants in women's voices are only two steps above men's even though women's voices tend to be about an octave higher. This explains why a choir of sopranos sound "deeper" on the same note than a choir of boys, whose smaller heads have higher resonances.

## Loudness

A lot of heavy scraping and pounding and blowing goes into playing musical instruments, but less than 1 percent of that energy emerges as sound. Acoustic power, like electrical power, is measured in watts, and every instrument has a maximum power output. The greater the energy of an instrument's vibration, the harder it batters the air and so the farther eardrums are prodded. A violin or flute or clarinet puts out only a twentieth of a watt at its loudest. A tuba manages a fifth of a watt; a trumpet, a third; a typical piano, almost a half. The champions include the trombone at 6 watts, cymbals at 10, and a bass drum at 25. An orchestra belts out 67 watts at full blast.

This seems like very little energy to fill a hall. Think of a sixty-watt light bulb. But incandescent bulbs are also only about 1 percent efficient, so it takes about a hundred of them to produce an equivalent measure of light. While this much light would only dimly illuminate a concert hall, an equally energetic surge of sound can blast an audience to the threshold of hearing damage. This is further testament to the sensitivity of the cochlea. The loudest sound in recorded history, the explosion of the Indonesian island of Krakatau in 1883, was heard 2,800 miles away—truly music of the spheres.

Of course, sound waves weaken as they fan out through the air. A sound's intensity at a particular distance from its source is measured in *decibels* (named after Alexander Graham Bell, inventor of the telephone). On the decibel scale, 0 represents the faintest sound an ear can sense, 10

represents a tenfold increase in this intensity, 20 represents a hundredfold increase, 30 represents a thousandfold increase, and so on. A whisper is typically heard at about 30 decibels, a normal conversation at 60, a heavy truck at 90, and a jet takeoff at 120. The entire range of hearing from the threshold of sensation to sound so loud that it is no longer audible is about 150 decibels, a difference in energy level of one to one quadrillion.

Obviously, the upper limit to hearing does not *seem* a quadrillion times louder than the faintest wisp of sound. Decibels measure only the physical pressure of sound waves, not a brain's interpretation of loudness. For one thing, the ear is more sensitive to some frequencies than others. Played softly, a low-frequency tone must have ten times the energy of a midrange tone to sound as loud, and almost a hundred times the energy at higher volumes.

Our ears are most sensitive to high tones, which require only a fraction the energy to sound as loud as a midrange one. This sensitivity results partly from the resonances in the ear canal and middle ear that we considered in the last chapter. Although these resonances probably evolved to aid language perception, they also benefit music by intensifying treble tones. At higher frequencies still, sensitivity drops off dramatically. Although hearing nominally stops at 20,000 cycles per second, research has shown that we actually can detect sound waves to 40,000 cycles per second—but only at decibel levels that would be dangerously loud at lower frequencies.

Such comparisons of the ear's relative sensitivity are measured in *phons* and are referred to as *loudness level*. Although response varies considerably between individuals, this is an objective scientific measure. Not so the *subjective* measure of loudness, the *sone*. On the scale of sones, 2 sones seem twice as loud as 1 sone, and 60 sones seem three times as loud as 20. But what exactly does "twice as loud" mean? The answer is, whatever a listener wants it to mean. A subject hears a tone and is allowed to set the volume of a second one to "twice" or "half" the level of the first. Numerous measurements from many subjects are averaged into the sone scale. Responses are inconsistent, so it's a shaky measure. A subject may judge tone B as being twice as loud as tone A, but not A as being half as loud as B.

Very broadly speaking, it takes roughly a tenfold increase in loudness

level (phons) for a doubling of subjective loudness (sones). Since music unfolds over roughly an 80-decibel range from 30 to 110 decibels, we subjectively hear an eight-to-one difference in subjective volume from the softest to the most thunderingly loud—only this much from a hundred-million-fold increase in sonic energy. Music is necessarily confined to this range. Background noise masks music when it's any softer than 30 decibels, while higher decibel levels approach the threshold of pain.

Paralleling this dynamic range are the seven levels of dynamic markings commonly found in scores: from *pianississimo* (*ppp*) for *very, very soft* to *fortississimo* (*fff*) for *very, very loud*. Musicians typically waver over a 6-decibel range when playing a passage at supposedly constant volume. At 6 decibels per level, an instrument ideally would sound over a 42-decibel range to achieve seven distinct dynamic levels. Yet on many kinds of instruments, even professional musicians manage only about a 15-decibel range between their softest and loudest playing. No matter what the score requires, they can play at only three contrasting levels (most woodwinds can manage only two).

All in all, the physics of musical instruments fortuitously matches the biology of our ears. Aided by a concert hall's reverberations, a large orchestra puts out just about as much sound as we can comfortably and safely hear. Roughly ten times as many instruments would be required to double the subjective loudness of the most earsplitting *fortissississimo*. In the court music of ancient China, orchestras of over a thousand players were assembled to produce a sound loud enough to be heard in heaven. Today we do something similar at rock concerts, perhaps more in the spirit of communing with hell.

Loudness is music's least flexible dimension. Our fine-grained perception of pitch bestows nearly a hundred individual notes with which to build melodies and harmonies. Our precise judgment of timing lets us construct elaborate patterns of rhythm. But our blunt perception of loudness permits no scale of fine shades of loudness that could be woven into interesting patterns of loudness variation. Typically, loudness is useful only for crude contrasts: a passage is played loud, then soft, then loud again. In fact, much early music, and most popular music, goes along at constant

volume from start to end. It's only in the art music of the last two centuries that composers have consistently explored find shadings of loudness (music's "dynamics"), and then only to modulate the emotional impact of melody and harmony and rhythm, and not as an independent musical construct.

## The Evolution of Instruments

An afternoon passed in a museum of musical instruments is a bit like a visit to a graveyard. Hundreds of varieties of instruments lie entombed in glass cases, nameless and forgotten. There are viols of many sizes with varying numbers of strings, dozens of flutes that differ by only a key or two, and exotic brasses flaunting extraordinary feats of plumbing. Standing back to survey such a collection, the visitor is left with the distinct impression of having witnessed something much like it before—in a museum of natural history. Most instruments gradually evolved from less sophisticated ancestors (although a few, like the saxophone, were abruptly brought into the world by an inventor's hand). In fact, it's possible to draw an evolutionary tree for instruments, just as you would for animal species. From ancestral brasses there evolved trumpets, trombones, horns, and tubas. In turn, the tuba radiated into bass, baritone, and tenor models, the Sousaphone, the euphonium, and other variants few people have seen or heard.

Like the vast majority of animal species that have existed over time, the vast majority of instruments had their day and are now extinct. The monster tubas enjoyed their Jurassic Period in the late nineteenth century. Animal species die out when they cannot adapt to a changing environment; instruments disappear when they cannot adapt to the demands of changing musical style. And so the delicate tones of the viol gave way to the stridency of the violin as concerts moved from the drawing room to the concert hall, and as audiences began to favor the heroic over the introspective. Similarly, when continents touch, more capable animals invade the territories of others and drive them to extinction. The equivalent for musical instruments is the coming together of cultures. Instruments like the Scottish bagpipes or the Japanese shamisen have been crowded out of their natural environ-

ment and continue to exist only in isolated pockets or in the musical equivalent of zoos: historical performances.

How is it that today's standard instruments triumphed over their predecessors? Do their qualities tell us anything about the nature of our ears? Superficially, instruments appear to have been selected more for ostentation than refinement. Compared to their ancestors, surviving instruments are loud, have wide frequency ranges, and display relatively constant timbre from bass to treble. Only when these criteria have been met have more subtle qualities played a role in instruments' survival. If individual instruments have been successful for these ignoble reasons, it's because they have to work well with others in large ensembles. To be heard, each should favor its own range of resonant frequencies, and it must be loud enough to avoid being masked by other kinds of instruments. A trumpet does well in an orchestra; a ukulele would not.

An instrument's destiny also is linked to economic considerations. Musicians have to eat, and so they study instruments that earn money. But composers avoid writing for instruments that have few players, which means there's no repertory by which to earn money, and so musicians don't learn the instrument. Economics can push even established instruments toward extinction. It costs almost nothing when a painter adds just one vivid dab of vermilion to a canvas. But think of what happens when a composer does the same by adding a single flourish for harp at just the right spot in a symphony. In every performance, a musician sits idle until the few notes arise. There are individual tones in famous compositions that have cost a small fortune over many decades of performance. But again, a sort of natural selection comes into effect when orchestra committees decide they can't afford a piece, and so it is not played, and so less-common instruments are not used, and so players of the instrument starve or switch, and so the instruments end up on museum walls.

We all know that big instruments make low sounds, and small instruments make high ones. Slight changes in an instrument's size make for sharper or flatter sound. So how is the exact size, and thus the exact tuning, determined? The answer is: *arbitrarily*. Once a single note has been fixed, all the others fall in line. For centuries the reference tone has been the A

above middle C. This is the sound that rises from an oboe when an orchestra tunes. Today this A is usually pegged to 440 cycles per second, but it has not always been. Before the invention of the tuning fork in Handel's day, orchestras tuned over a wide range and middle A was pitched lower than today, at about 420 cycles per second. This amounts to nearly a half-step difference from the modern tuning, such that what was once played as A would have been an A-sharp if played by the current standard.

Consequently, today we perform all compositions from the time of Beethoven and before roughly a half step higher than intended. Sopranos must reach that much higher in a Mozart aria, and many of the great violins of Stradivarius and Guarnarius have had to be reinforced internally so that they won't collapse under the 12 percent increase in string tension required to lift the pitch of their strings. This change in tuning also means that we play pre-Romantic compositions in a different key than they were written. Remember this next time someone tells you that C-sharp minor was the perfect choice of key for opening the *Moonlight* Sonata.

The shift in the tuning standard arose from a long rivalry between strings and woodwinds. You can't do much to raise the pitch of an oboe, but a violin's strings can always be tightened a bit further. By tuning just a little sharp, strings take on a brightness of sound that grabs the listener's attention—and steals it from the woodwinds. In response, craftsmen made higher-pitched woodwinds. So the strings tuned higher still, and on it went. By the middle of the twentieth century, middle A had risen as high as 465 cycles per second in some orchestras. Yet musicians would play in Prague one day and Los Angeles the next. A clamor for an international standard led to the 440 compromise.

## Concert Halls

One musical instrument appears in nearly every program: the concert hall. True, a hall makes no sound of its own. But it acts as an extension to every instrument by reverberating sounds, selectively enhancing or absorbing various frequencies as it does so. Take the hall away and the sounds of instruments are reduced to a shadow of our expectations.

Conductors do their best to understand a concert hall's acoustics, and

they tailor their performances accordingly. If a hall sustains bass poorly, parts of the orchestra will have to work all the harder. Heavily damped rooms can wreck a performance by making musicians strain to play louder. It's no accident that many of the best orchestras have evolved in the world's best halls. Soloists also "play to the room." Even individual instruments may be adapted to a hall, as when organs are laboriously tuned pipe by pipe to complement the surrounding space.

Concert halls are important because sound quickly loses intensity as it fans outward in all directions. By the time an orchestra's sound travels from stage to front row, its energy spreads to an area of 300 square yards or so; by the back row of a large hall it would stretch to 30,000 square yards if there were no walls to contain the sound. Your ears gather energy from only a few square inches. This means that, lacking artificial amplification, sound coming directly from an orchestra amounts to hardly a hundred-thousandth of each instrument's total sonic energy when you've a good seat, and a mere ten-millionth when you're far back.

Or course, our hearing can reach much farther than a concert hall floor. But merely identifying sounds is not enough. Music must attain a certain volume if it is to overwhelm. It's the concert hall's job to provide that volume by reflecting sounds back to a listener's ears again and again. In a sense, the hall reuses sounds. Large outdoor concerts succeed only by boosting sound electronically and adding phony reverberation.

Acousticians distinguish between three kinds of sound in a concert hall. First, there's *direct sound*, which comes straight at you from the stage. Then there's *early sound*, resulting from the first reflections to reach your ears, normally from the ceiling or side walls. And finally, there's *reverberation*, which gradually builds and decays as sound waves ricochet off every surface. As a rule, the energy in direct sound and early sound together should exceed reverberated sound. The less reverberation a room offers, the more "definition" it has. But too much definition makes for a "dry" room, and so a balance is sought. The acoustician's dilemma is that a room that is ideal for one kind of music will be awful for another.

Early sound doesn't count as reverberation because our brains tend to combine it with direct sound. In a phenomenon called the *precedence effect*,

any reflection that follows direct sound within roughly a twentieth of a second isn't heard separately; instead, it boosts the volume of the original sound. The ear can readily distinguish delays of a thousandth of a second, so the precedence effect isn't a matter of two sounds blurring together. Rather, our brains have evolved to ignore a sound's reflections, thereby simplifying the world the brain must make sense of.

The precedence effect is sometimes put to work in concert hall design. Electronic amplification is often required for sufficient direct sound in large halls where some seats are far from the stage and where there's lots of reverberation. But the public doesn't much want to look at loudspeakers on stage, particularly after paying a small fortune to hear "true" sound. So speakers are concealed above or beside the stage. When speakers put out more volume than the instruments themselves, sound appears to arrive from offstage. But by adding a slight electronic delay to make the speaker sound appear as a first reflection, the precedence effect takes over and the brain adds the speaker sound to the direct sound it has already localized on stage. Magically, the instruments sound louder without changing apparent position. (Incidentally, you shouldn't feel *too* disillusioned by the use of speakers in "authentic" concerts. Very accurate reproduction is achieved through elaborate and costly systems, sometimes using scores of amplifiers, each devoted to a narrow band of frequencies. The "true" sound of instruments is more likely to be distorted by bad hall design).

A hall is said to be "intimate" when first reflections arrive very early—within a fiftieth of a second. This quality is much prized in chamber music performances, but it simply can't be attained in very large halls. With sound moving at roughly 1,130 feet per second, "intimacy" requires that first reflections travel only about twenty feet farther than direct sound. Walls and ceiling must not be far from the listener for this to happen. Large halls are foes of early sound, especially when balconies block it altogether. Many halls have panels hanging from the ceiling to increase early sound. But listeners show a marked preference for first reflections arriving from the sides rather than overhead. A disparity in music's time of arrival at the two ears enhances the sense of surround, of embrace. Research shows that the

best seats in the house often are about sixty feet from the stage and some-
what off-center.

Reverberations—that is, reflections arriving too late to be melded into
direct sound by the precedence effect—are relatively rare in nature, and
our brains have not evolved a special mechanism for overlooking them.
Like musical sound itself, reverberation is a minor aspect of our natural
experience that we have magnified into art. Much music becomes lifeless
without reverberation. Early recordings lacked reverberation and they
sound off kilter, as if the music were played in the wrong style. Indeed,
some Late Romantic music simply doesn't work outside halls with long
reverberation times, where hundreds of reflections add up to the "big
sound" such music requires.

Reverberation also provides an unnoticed backdrop that gives mean-
ing to harmonic transformations. As we'll see in chapters to come, the
brain sustains memories of music that has just passed by, and it draws re-
lations between these memories and the sounds it hears at the moment.
Reverberation supports this process, helping the brain to remember bygone
sound longer, and thereby making possible more complex, extended har-
monies. Orchestral sound could never have evolved from a Haydn sym-
phony to Debussy's *La Mer* without the parallel development of ever larger
concert halls with ever longer reverberation times.

Sounds leap from a concert hall stage and zigzag around as if in a giant,
three-dimensional pinball machine. A portion of a sound's energy is ab-
sorbed with every collision, the amount depending on the material. Carpet
absorbs high frequencies but reflects low frequencies. A glass window does
the reverse. Poured concrete or polished stone absorbs almost no sound at
any frequency. Human bodies, on the other hand, suck up two thirds of
the sound striking them. In fact, the audience is one of the most important
acoustic components of a hall. Even the air plays a significant role in damp-
ing high-frequency reverberations.

Acousticians regard a sound's reverberation as having stopped when
the sound drops to one millionth of its original intensity. This rule of thumb
provides the basis for measuring a hall's reverberation time. For chamber

music, a one-second reverberation is ideal; for a Mozart concerto or a Spartan contemporary composition, a second and a half; for a Mahler symphony, as much as two and a quarter seconds. Some cathedrals resound with seven-second reverberations, time enough for three measures of music to unfold. Orchestras blur in this environment and small ensembles all but vanish, but church music for organ and chorus has evolved to suit these circumstances, employing long reverberations to evoke an aura of eternity.

Ideally, a sound's reverberation quickly rises to a peak and then smoothly dies away. In bad halls, reverberation may dip and rise several times as it fades. Worse, a hall's back wall can return a separately heard echo, or *flutter echoes* may arise as parallel surfaces enlist sounds in a game of Ping-Pong. Concavities can focus reverberation on some seats while leaving others dry. Any of these defects may distort sound by boosting some frequencies while damping others.

Audiences tend to notice a hall's characteristics only when things go wrong, and then it is criticism that reverberates well: architects have built good halls before, so why not now? But a bit of forbearance is due. A baroque interior is ideal for splitting sound into thousands of reflections, but that is not the style of our time. Yet appalling acoustics sometimes result from the austere (and affordable) forms of modern architecture. Relatively small changes in a hall's shape can have enormous acoustic consequences. Moreover, new materials don't always perform in practice as they do in the laboratory. Newfangled techniques that alter wall coverings in order to "tune" halls to the music at hand have been more expensive than successful. The truth is that it's much better understood why some halls work badly than why some work well. Short of copying a proven design brick by brick, every new hall is a gamble.

Of course, these days most serious listening takes place not in concert halls but in living rooms, where music fares less well. The walls are so nearby that early sound arrives almost instantly, making for great intimacy. But direct and early sound tends to be overwhelmed by reverberation as sound clatters back and forth between surfaces, so definition is poor. Worse, reverberation has no buildup, and it lasts but half a second—a

quarter of the desirable time for a Brahms symphony. For this reason, recordings are often spiked with bogus reverb.

Your living room also deforms sound because it presents so much surface area (of walls, furniture, or whatever) relative to the room's volume. Resonances from these surfaces distort the sound. This explains why your singing sounds better in a bathroom than on stage: the room adds resonances to your voice that your throat cannot, and the tiles create an illusion of vocal power by reflecting rather than absorbing sound. You wouldn't sound nearly so good elsewhere in your house, where common building materials selectively absorb sound. Wood paneling gobbles up bass tones, for example, while drapery feasts on treble. It's easy to see why cheap headphones can sound better than expensive speakers. They stop a room from wrecking the sound.

There's mystery in room acoustics. A room makes musical sound much more complex. Pure, easily localized tones are engulfed by a deluge of reflections flowing from all quarters. At every moment in a big hall, all notes played in the prior two seconds land on your ears as a cluster of faint dissonances. With so complicated an analysis to perform, both harmonic and spatial, the brain ought to be overwhelmed. Yet we *prefer* this muddle, seeking out concert hall seats where sound is most complex.

But as we've seen, it's a highly structured muddle that we desire. We want spatial complexity, but with a clear sound source. We want instruments to blend yet still want to hear them individually. We want reverberations to rise quickly and fall off evenly, just like an instrument's tones. And we want the right balance between direct sound for localization, very early reflections for "intimacy," early sound for "definition," strong reverberation for "big sound," and long reverberation for "warmth."

## How a Brain Hears Tones

Although the notes of a symphony arrive at our ears as a jumble of frequency components, our brains are able to match up related overtones and perceive them as individual tones, even as a tone warbles in pitch or drowns in a flood of reverberations. The brain-stem nuclei we encountered

in the last chapter are no match for such complexity. It takes cerebral cortex to do the job.

The long journey from the cochlea to the brain ends on a patch of cortex called *primary auditory cortex*, which is situated on the temporal lobe at both sides of the brain. This area is partly portrayed in Figure 2.2, with the rest residing on the temporal lobe's inside surface.

In Chapter 1 we saw how the cochlea's orderly layout of frequencies is preserved in the various auditory pathways through the brainstem. Primary auditory cortex is organized similarly, with a long series of thin bands that correspond to particular frequencies from bass to treble. It all seems wonderfully elegant: a sound of pure frequency enters the ear and a moment later that frequency's cortical band "lights up." But matters are not nearly so simple. A loud tone of nearly any frequency will activate almost the entire primary auditory cortex. The frequency-specific bands merely indicate points of maximum response, much like positions along the cochlea. So the sequence of bands is nothing like a piano keyboard lying along the side of your brain. A neurophysiologist would be hard put to identify an incoming chord through patterns of firing neurons.

Close up, the cortex divides into six layers in most parts of the brain, each layer populated by its own distinctive tangle of neurons. This celebrated "gray matter" is only about a quarter-inch thick. A much greater volume of "white matter" courses beneath. It consists entirely of filaments projecting from one neuron to another, sometimes at close range, sometimes to matching cortex on the opposite side of the brain, sometimes in bundles to other regions of the same hemisphere. These interconnections are mind-bogglingly complex, with most brain regions intricately connected to most others.

Yet neurologists have come far in descrying order within this labyrinth. Perhaps the most important insight of recent years has been that much cortex, if not all, is organized as a honeycomb of columns a few neurons wide that stretch from top to bottom through the six layers. In primary visual cortex, individual columns process information from specific points on the retina. In somatosensory ("touch") cortex, a column responds to

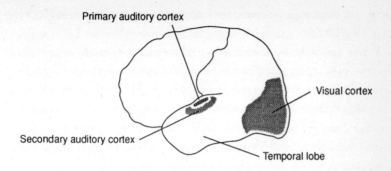

*Fig. 2.2. Auditory cortex*

sensation at a particular location on the skin. And in primary auditory cortex, individual columns respond most strongly to specific frequencies of sound. Columns may well be the most basic units of information processing in the cortex.

Much recent research has been devoted to puzzling out the precise roles of columns in various kinds of cortex. This involves the painstaking labor of inserting minute electrodes into individual neurons in a living brain, then casting an image on the retina, or a tone on the cochlea, to see how a column's neurons respond. Such work must of course be confined to non-human subjects (mostly cats are used). Since animals are not musical, this important research technique can be employed only to study basic perceptual mechanisms. Scientists can locate a column attuned to middle C easily enough. But finding a group of columns maximally responsive to "Singin' in the Rain" is out of the question.

Like neurons elsewhere in the brain, most auditory neurons fire constantly, even amidst silence. It is changes in background firing rates that are significant. Neurons begin responding to an incoming sound after a mere hundredth of a second. Some answer to raw frequency information. But most are concerned with changes in sound, firing only when frequency or intensity slides upward or downward. Other neurons become active only when a sound repeats at a particular rate.

These findings, buttressed by data from other sensory systems, suggest

that the brain pigeonholes sounds not just into frequency bands, but also by rough levels of intensity and duration, and by levels of *change* in frequency and intensity and duration. These categorizations are sometimes surprisingly crude, as if the brain can afford only enough cortex to monitor a small number of levels for each aspect of sound. Investigators sometimes describe these levels as "channels," each channel served by its own system of columns. Yet our actual perceptual abilities exceed the crude resolution of such channels. Somehow our brains interpolate between channels, melding their output into fine-grained experience.

The neurons of primary auditory cortex do not merely fire one to another in merry exuberance. Much activity is devoted to inhibiting the action of other neurons. By so doing, cortex simplifies incoming auditory data, sharpening the edges of important components and suppressing noise. This means that auditory cortex selects only certain features for further processing. These features provide the raw material for modeling higher-order relations in adjacent *secondary auditory cortex*. Without such simplification, the brain simply couldn't muster the capacity to make sense of complex auditory scenes, whether the whoosh of a wind-swept forest or the blare of a brass band.

Some 85 percent of primary auditory neurons also exhibit a phenomenon called habituation. The longer these neurons are stimulated, the less they respond. This means that without constant renewal of a sound (or renewal of attention to a sound) we deafen to it. This comes as no surprise to psychologists, who have long known that the brain is ultimately only interested in change. When an image is fixed on the retina in a way that eye movements cannot scan it, we go blind to the image in only a few seconds. Something similar no doubt happens with sound. So it is no surprise that music becomes more intense with minute alterations of timing and loudness and pitch. A real violin tone is "richer" than a synthesized one partly because it gives auditory cortex more to respond to; a violin vibrato is richer still.

Primary auditory cortex also displays a first glimpse of what we ambiguously call "memory." As we'll see in chapters to come, auditory cortex is active during short-term memories in which aspects of auditory percepts

*short term memory of a phrase*

are prolonged. Without such memories we'd be unable to pull together the parts of an unfolding phrase, whether musical or spoken. A simple laboratory experiment proves the point. When a baboon has been trained to compare two tones a second apart, 65 percent of its auditory neurons actually increase their activity during the intervening second, in which the first tone is "held in memory."

Although primary auditory cortex is complex and only partly understood, its orderly arrangement by frequency seems to hold out promise that the brain, and ultimately every facet of mind, can be dissected and categorized and understood. In a sense, primary auditory cortex offers a sort of snapshot of approaching sound in which different aspects have been sorted out and measured.

Relation modeling begins in earnest in the secondary auditory cortex that surrounds primary cortex. This cortex is "secondary" in the sense that it receives most of its input from primary cortex, rather than from the cochlea and brain stem. It consists of separate "maps," some laid out by frequency like primary auditory cortex, others organized mysteriously. Each map is tailored to analyze a particular aspect of sound. The number of maps varies by animal. A primitive mammal like a mole appears to have only one; a cat, three. Bats have maps devoted just to their sonar systems. How many secondary auditory maps we humans possess is still unknown, but it is likely to be many more than any other animal, owing to our special evolution for perceiving and generating language.

But what good are fragments of sound? Our subjective experience is of a highly integrated sweep of sound. And so somehow the brain must reassemble the sound components detected by auditory cortex. It does this by modeling relations between the various features—frequency, intensity, location, rates of change—and then relations among those relations, and so on. It is wrong to conceive of this process as ending in a finished, integrated "picture" of the sound that is then experienced by some other part of the brain. Rather, it is the act of modeling deep relations among sound components that constitutes our final comprehension.

Our brains are large, but not infinitely so. There are limits to the relations a brain can detect. We may easily grasp a whole musical phrase

as a single understanding. But our instantaneous comprehension cannot begin to bridge an entire symphony. In principle, evolution might have endowed us with more and more maps for modeling deeper and deeper relations. But we evolved to survive, not to play the piano. Every addition to cortex exacts a significant biological expense.

Ounce for ounce, brain tissue is the third most consumptive of energy in the entire body, after that of the heart and the kidneys. The average human brain burns 22 percent of total caloric intake, and it doesn't matter much whether the brain is busying itself with nuclear physics or gin fizzes. This means that the tripling of the size of our brains over that of our closest primate cousins has required that we find over 10 percent more food to survive. In nature, population size always pushes against the availability of food. Lean years abruptly eliminate organisms that do not manage their calories well. Expansion of the brain makes sense only when the additional neurological material endows an organism with considerable survival advantage. Such considerations apply as much to the auditory system as to any other part of the brain. And so it was the daily concerns of *Homo erectus* that decided what auditory cortex can and cannot easily perceive, and hence what music can and cannot become.

One way of economizing cortex is to *lateralize* its functions, localizing them predominantly on one side of the brain. Basic functions for perception and movement require two patches of cortex to serve the two sides of the body. Thus both left- and right-side primary auditory cortex are designed almost identically in order to process input from the right and left ears. But higher-level analysis can make do with only one cerebral representation. So secondary auditory cortex has been free to specialize in various ways in the left and right brain. A hundred-million-fiber bridge between the two hemispheres, the *corpus callosum,* allows the two halves of the brain to share the results of their diverse labor.

While primary auditory cortex focuses on the properties of individual sounds, secondary cortex is particularly concerned with the relations between multiple sounds. Right-brain auditory cortex focuses on relations between *simultaneous* sounds. It ferrets out hierarchies of harmonic relations. The right brain has no advantage over the left when pure-frequency

sounds are heard. But it comes to the fore when tones rich in overtones arrive. It is also particularly adept at analyzing the highly harmonic vowel sounds of language.

In contrast, secondary auditory cortex of the left hemisphere targets the relations between *successions* of sounds. It is concerned with hierarchies of sequencing, and it plays a prominent role in the perception of rhythm. Not surprisingly, the left brain is also the seat of language, sequencing networks of ideas into chains of words.

Neuroscientists are far from understanding how temporal phenomena are represented in cortex. Yet it's clear that auditory cortex does not act as a sort of tape recorder, pigeonholing each incoming sound as it arrives. If this were the case, reversing a sound sequence would reverse the pattern of neurological activity it produces. But it doesn't: research shows that reversed sounds generate a unique response. This implies that auditory cortex does not consider individual sounds in isolation. Instead, it always interprets sounds within the context of what has preceded.

The brain has been called the last frontier. But to say "frontier" may be going too far. The first explorers have barely established a foothold on this expansive continent. From shore's edge they have encountered a dense, nearly impassable jungle of conceptual ambiguity and experimental obstacles—a level of complexity never before encountered by questing minds. Still, scientists have valiantly pushed forward, sometimes with little idea of what they're seeking, but always certain that El Dorado lies ahead. In chapters to come, we'll see what they've learned about how three pounds of neurons can make sense of melodies and harmonies and rhythms, transmuting them into ecstasy.

# 3

## From sound...
### ...to tone...
# . . . to melody . . .

It was 1985 and Paul McCartney wanted his songs back. Like so many struggling young performers, the Beatles had signed themselves into near-bondage in their first contracts with recording companies, and McCartney had lost ownership of many of the tunes that had sprung from his heart. Now 251 Beatles songs were on the auction block, including favorites like "Help" and "Let It Be," to be sold as part of a vast library of 40,000 tunes, most of them obscure, but some authored by big names like Little Richard and the Pointer Sisters. McCartney's company, MPL Communications, quickly found itself in a bidding war against several rivals, and the price was rising. Frantic efforts were made to raise sufficient cash to stay in the game. But all was for naught. In the end, a lone individual snapped up the entire catalog, producing out-of-pocket a sum approaching fifty million dollars. The buyer's name: Michael Jackson.

Bought for a song? Some would say so. A popular melody can earn a fortune in royalties (as McCartney would well have known, having himself acquired rights to soppy standards like "Sentimental Journey" and "Autumn Leaves"). Every time a popular song is played at a public event,

broadcast on the radio, or debased as Muzak, pennies trickle along a stream of agents to the song's owner. No tune is so profitable as one that seems to belong to no one. The most valuable song in the world is "Happy Birthday to You."

"Capitalist excess!" we cry, protesting that melodies we hum in traffic and wail in the shower should be the common property of mankind. Yet the ownership of song is nothing new. Anthropologists have long been acquainted with traditional cultures in which songs are privately owned, traded, bequeathed, or bestowed as gifts (Pacific Northwest Indians are one example). In these societies, to sing a song illicitly is to invite the severe punishments due to thieves. This is robbery not of mere money but of the magical powers that songs confer.

It is a curious fact that you can file a copyright on a melody, that you can own a particular pattern of sound. You'd meet with only laughter if you requested a copyright on a rhythmic pattern or a harmonic progression. Such things are considered too basic to warrant protection. But melodies are different. Each is a unique invention in sound, a clever machine that tilts and turns the levers of our minds to produce a quintessential sensation. As is true of so many clever inventions, the workings of a great melody are inexplicably simple yet not at all obvious.

If melodies are so valuable, why not just sit at a piano and spin out patterns of notes until something profitable pops up? After all, how many combinations can there be among the twelve tones in an octave?

Quite a few, actually. This is an instance of the old chimpanzee-in-the-basement-of-the-British-Museum problem, which asks, "How long would it take a chimpanzee sitting in the basement of the British Museum to accidentally reproduce an entire Shakespeare play by randomly pecking away at a typewriter day after day?" The correct answer is: a very, *very* long time. Just the forty keystrokes of Hamlet's notable observation "To be or not to be, that is the question" would keep the poor chimp busy for a trillion trillion trillion trillion years (based on the number of typewriter keys taken to the fortieth power). If you've doubts, try it and see.

And melodies make Shakespeare look simple. A melody is not just a sequence of notes, but of notes of varying duration and varying accentu-

ation. So the number of possible eight-bar melodies is inconceivably vast. Just like strings of characters, only a few of all possible melodies make much sense to our brains. Shorten a particular note, or shove it away from the downbeat, and even the strongest melody will die as surely as Hamlet muttering "Do be, or not do be, dat is . . ." No composer has time to try out even a tiny subset of variants. Nor is there any sense in having a supercomputer generate melodies at the customary blinding speed, for who can spare a billion years to judge the results?

Composers have sometimes sought melodies by chimpanzee methods. On occasion Mozart would select melody notes by rolling dice, Schumann by manipulating anagrams, Cage by tossing I Ching coins. Weber discovered the outline of a melody in the contour of upturned furniture; Villa-Lobos traced one in the skyline of Rio de Janeiro. But these were acts of whimsy. There is no record of a spell-binding melody discovered by such contrivance.

A great melody is magic—magic for its sheer power, and magic because somehow a brain has unearthed it from amidst zillions of possible bad melodies. Thousands of new melodies are offered to the listening public every year, yet only a few strike our fancy. When a really good melody emerges, one that digs deep and just won't let go, we celebrate the event by listening to it over and over.

In this chapter we'll explore how melodies make sense to brains, and why some melodies are so much better than others. Scientists have pondered these questions for more than a century now, and composers far longer still. Many sensible hypotheses have been advanced, sometimes buttressed with impressive evidence. But every hypothesis has met with objections, often coming from musicologists who complain that principles we would like to regard as "universal" sometimes are not observed in non-European cultures, and sometimes not even in Europe's own musical history. Lacking such principles, we have no idea how to derive great melodies analytically from rules and formulas. When it comes to the production of melodies, we are still at the hunting-and-gathering stage.

The quest for universals in melody design is important to our larger concern of how music takes hold of us and gives us pleasure. So musical

universals will be our focus for the next three chapters as we consider first melody, then harmony and rhythm. But where to begin? The "Hallelujah Chorus," daunting in its complexity, is hardly the best starting point. Better to commence with "Mary Had a Little Lamb" and build from there.

## How Children Hear Music

When Ms. McGillicutty's kindergarten class makes its musical debut at the annual school fair, doting parents have their work cut out for them. The trick is to maintain an appreciative smile without letting it widen into a full-blown guffaw. It's hard to maintain composure when the children's every move is a parody. They're out of tune, out of sync, out of just about everything except good intentions. Although they've only a short string of notes to get through, five-year-olds aren't up to the job. Parents tend to assume that the problem is a lack of vocal control, and indeed that is an important factor. But beneath it all, the kids just don't understand how to put a melody together. This shows how conceptually difficult melodies really are.

Merely to sing "Mary Had a Little Lamb," a child's brain needs to have absorbed much of its culture's tonal system. Admiring parents tend to attribute more musical ability to their children than is actually there. Children plead, "Sing me 'Mary Had a Little Lamb,'" and give every appearance of bopping along in eager appreciation. But their enthusiasm may be undiminished when the same words are sung to a different melody. For most young children, "music" is largely an experience of language, language distorted in its intonation and rhythm. Pure musical experience branches off from language only gradually as children become proficient in one aspect of music after another.

Even a newborn has a musical life of sorts. The infant's initial response to musical sound is to turn toward it defensively. But by one month a baby can distinguish between tones of different frequency. (This and other facts of infant psychology are deduced by monitoring subtle changes of heartbeat as a child is aroused by changes in its surroundings.) By six months, the infant responds to changes in melodic contour. But interestingly, there's no reaction when a melody is transposed up or down in pitch. This fact

makes it clear that, rather than just memorizing a particular sequence of tones, even a baby's brain perceives a melody as a system of relations between notes.

As any parent can wearily testify, musical life is well under way by six months. Many of a baby's gurgles and squeals are obvious experiments in tone production. Recent research has shown that, even at two months of age, some infants can replicate the pitch and melodic contour of their mother's songs. When infants begin to babble during the middle of their first year, a kind of spontaneous singing arises. Of course, it's hard to sort out which parts of babbling are music and which parts are nascent language. Language has its own built-in musicality (the *prosody* we'll consider in later chapters). But between twelve and eighteen months, just as babbling turns to discrete words, infants start to elongate vowels in a way that is clearly musical. Gradually, something quite unlike language arises, something the infant is likely to belt out using random syllables instead of words. It is *song*.

Devoted parents may divine a budding Mozart in their child's early musical efforts, but there's far to go before the child can really be said to be making music. She'll repeat the same melodic figure again and again, holding its overall contour, but distorting the intervals between tones by stretching them wide during one repetition, then flattening them the next. All the while the average pitch level wanders drunkenly up and down. This means that young children lack awareness of the harmonic relations nested within melodies. For them, melody is just a contour, a ride on a vocal roller coaster.

It's only at about the age of three or four that most children give up blathering whatever sounds come to mind and start duplicating the music of the culture in which they find themselves. It dawns on them that music is built of discrete steps and timed in discrete durations. Until this time, they'll identify quite different melodies as being "the same" so long as contours match in their ups and downs. But now they begin the difficult task of learning to remember precise intervals and durations.

Of course, our brains are perfectly capable of perceiving the sliding pitches children sing. Slides are heard in the "sing-song" of spoken lan-

guage, and they sometimes appear in music (the technical term is *portamento*), but usually only as expressive deviations from fixed pitches, or as occasional sound effects. Music ceases to make sense to our brains when it contains many slides. With sounds bobbing up and down between random frequencies, and no obvious beginnings and endings for individual notes, there is no more structure to grasp than in swirling water. Music requires tones of fixed pitch and duration. These provide the anchor points between which a brain discovers the relations, and the relations among relations, that draw together a musical edifice. It is no surprise that ethnomusicologists have never found a culture that crafts its music primarily from sliding tones.

## Categorizing Tones

Children have so much trouble reproducing melodies because they lack a stable understanding of the individual tones that constitute melodies. This may seem odd considering how auditory cortex automatically processes sounds, detecting starts and stops, following frequency contours, and assembling overtones into unified notes, all without a smidgen of conscious effort. But there is a difference between sensing a sound and recognizing one. Recognition is just that: *re*-cognition, experiencing something that a brain has encountered before and learned to perceive as a distinct identity.

We recognize tones by categorizing them. The word "categorize" usually refers to complex identifications, as when we classify dolphins with mammals rather than fish. But there's another kind of categorization, one not of identity but of *position*. Our brains subdivide a range of possible frequencies (or intensities or durations or timbres) into a number of compartments. Rather than keep track of a very large number of discernible positions along the range, our brains economize by tracking only a small number of subranges, each a "category." Anything falling reasonably near the center of a subrange is regarded as an equally valid instance of that category.

Imagine sorting through knickknacks by grouping them in piles along the length of a shelf. You might start with three piles, one to the left, one to the right, one in the middle. Objects slightly off-center from these po-

sitions are still seen as members of the nearest pile. You might increase the number of piles to five by adding midpoints at center-left and center-right and still would have no trouble keeping track. But adding four more midpoints among these five positions makes it much harder to cope. Now there are positions like center-left-right and left-right-center. A further subdivision to seventeen positions is quite beyond us. Although we can readily set our eyes upon a hundred points along the shelf, we cannot remember each point as a distinct, identified position to which we can effortlessly return our attention.

Such is the distinction between discrimination and categorization. A brain can readily discriminate the difference between some thirteen hundred pitches within the range of frequencies we use as the basis for musical tones. But a brain cannot maintain thirteen hundred pitch categories, identifying one as G-flat-flat-sharp-flat, and the next as F-sharp-flat-sharp-sharp.

We're similarly limited in our ability to recognize colors. Anyone who has ever gone shopping for house paint has been through the agonizing experience of selecting a color from sheets of small sample squares, each of a slightly different hue and intensity. You can easily discern that the squares differ. But if asked to put aside the samples and then identify a patch of color, you'd probably come up with no better description than "beige." It's not just that you can't remember the names of all those beiges on the sample sheet; you can't remember the variations among the colors themselves. Your brain can perceive the differences but it can't categorize them (at least not without a good deal of practice). This means that your brain can't reliably *remember* individual hues, even for only a few seconds.

When we listen to musical tones, we divide the range of pitches in an octave (its *pitch space*) into only a dozen positions or "categories." Although under laboratory conditions we can distinguish perhaps thirty shades of pitch within a category, in the rough and tumble of music performance we hear most such pitches as being the same note. When a note comes in dead center, we deem it to be perfectly in tune. But even when the tone's frequency is somewhat higher or lower, our brains still categorize it as being an instance of that note. Only at the borders between the divisions of pitch

space can a note waver between categories. Such "out of tune" notes leave our brains in a state of consternation and even agony.

We perceive speech in the same way. A considerable range of sounds passes for the consonant "b." But at a certain point the category for "b"-ness is left behind and we begin to hear a "v" instead. This flexibility means that the speaker need not be precise in his pronunciation, and can take liberties with intonation and expression. Without such perceptual categorization, both speech and music would be quite impossible.

By limiting the number of tones in an octave, categorization also reduces the number of possible distances between tones (intervals) to a manageable number. This in turn reduces the number of possible chords our brains may encounter while following music. Although composers sometimes feel confined by the relatively small number of available tones and intervals and chords, the system is simple enough that almost anyone can comprehend it without special training. But it is not so simple as to be trivial. It takes years of experience for a child to acquire a quite small number of categories to the point of automaticity.

Categorization simplifies musical memory as well as perception. As we'll see in Chapter 6, there's little that's "photographic" about memory. A brain understands the world by reducing perceptions to categories, and it recalls past experience by reconstructing it from categorical memory. So categorization is not merely a shortcut we take to simplify music. Categorization is at the heart of nearly all our mental activity, and hence all our musical activity.

Without perceptual categorization the world would be a very confusing place indeed. A dog with a short tail would bear no relation to a dog with a long one. In fact, every discernibly different dog would seem like a species unto itself. The same is true of melodies. When music is performed, many notes are played out of tune (the wavering voices of singers are particularly inaccurate). But we don't hear varying performances as different pieces. In fact, we seldom notice that the tunings of individual notes deviate from moment to moment.

Consider what this means. When we listen to music, we're relatively inattentive to the exact pitches entering our ears. Instead, we focus on our

own categorizations of sounds. This suggests that even our "immediate experience" of music has less to do with the raw sensation of sounds arriving from the external world than with an awareness of our minds at work interpreting those sounds.

## Cutting Up Pitch Space

We call a system of tonal categorization a *scale*. Like the scale found at the bottom of a wall map, a musical scale provides units of measure, but for pitch space rather than geographical space. The basic unit is called a *half-step* (or a *semitone*). Every key along a piano keyboard represents a half-step. From C to C-sharp is a half-step, and so is from E to F. In the scale system we're accustomed to in the West, there are twelve half-steps (and twelve piano keys) in any octave, say, from middle C to the C above.

The precise frequencies used for scale tones are unimportant. If a violinist retunes middle A from 440 cycles per second to 450, your brain will adjust its categorizations accordingly. And so it is the relative distances between frequencies that the brain categorizes. Every time you sing "Happy Birthday to You," you'll probably begin on a different pitch. This means that you don't require the rare skill of *absolute pitch* (the ability to identify precise frequencies) in order to comprehend music. Research has shown that we're so oblivious to precise pitch that we take no notice when the tuning of a piece is very slowly raised or lowered as it is performed.

Most people who have played a musical instrument regard scales with dread, recalling interminable hours practicing A major, then G minor, then B-flat major, up and down, up and down. Like a straight line, scales seem featureless and inherently tedious. They are about as interesting to behold as a brick. But this is just the point. Scale tones are the building blocks for all music (except for the rawest of percussion music). Like all building materials, the choice of scales is important in determining what can and cannot be constructed. You can't very well write a Western opera with a Chinese scale, or a Chinese opera with a Western scale.

In principle, we can categorize pitch space any way we like. Instead of eighty-eight keys along a piano keyboard, the same span of frequencies might be divided into eighty notes, or one hundred. But there are good

reasons for having exactly eighty-eight notes. The divisions of pitch space are far from arbitrary. Some aspects of the scales we use are clearly determined by the way our brains interpret sound. Other aspects also suggest a biological basis, but not of such potency that they cannot be overridden by training. And further aspects are merely a matter of historical happenstance. Hence the world's many cultures categorize pitch space in very different ways. The traditional scales of Madras are quite different from the traditional scales of Vienna, and neither have much in common with the scales of New Guinea.

It's important to understand how scales are constructed. This may sound like a hopelessly arcane concern, but it is packed with controversy: Does the choice of scale tones limit what music can become? Are some cultures' scales inherently more powerful than others'? Are more potent scales yet undiscovered? At stake here is the issue of whether music gains its power over us by exploiting innate mechanisms for perceiving sound. In short, are some scales better designed than others for leading us to ecstasy?

The one undisputed universal in scale design is a phenomenon called *octave equivalence*. Recall that octaves are formed by doublings of frequency. Middle C doubles the frequency of low C, and high C doubles middle C. What's interesting is that we call all three notes "C." Conceivably, we could name them C and J and R. But somehow tones separated by octaves sound so much alike that we regard them as different versions of the same sound. We're so accustomed to this arrangement that we fail to ask why it should be.

Octave equivalence lets us transpose music up and down by octaves without changing key or dramatically altering harmony. In fact, the subjective equivalence of tones divided by an octave is so strong that singers sometimes believe they are singing the same note when they're actually an octave apart. Even musicians endowed with sure-fire absolute pitch are liable to assign a note to the wrong octave, even while naming it correctly.

Without octave equivalence, middle C would have little in common with high C, and each of a piano's eighty-eight tones would reveal a unique identity. We'd start naming notes from A to Z, and would need many

more symbols to complete the series. A scale would start at one end of the keyboard and end at the other without repeating. And our brains would have to learn to hear not just the relationships between C and E, and C and G, but also those between C and M, and M and X.

Happily, octave equivalence saves us from such daunting complexity, and thereby makes harmonic music possible. Our brains need identify only as many tones as are found within a single octave. Each such tone has its cousins in other octaves. C relates to E much the same in any octave, and more important, the two tones maintain this relationship even when they're spaced two or three octaves apart. So the interval from middle C to middle E carries much the same quality as the interval from middle C to high E, or from middle C to higher E. Lacking this trait, it would be nearly impossible to relate the treble tones of a flute to the bass tones of a bassoon, and musical possibility would be greatly diminished.

Although scientists have long speculated about the basis of octave equivalence, no one really knows why doubled (or halved) frequencies sound the same. The standard explanation for middle C sounding like every other C is that all C's are basically the same sound. Think back to the discussion in Chapter 2 of the overtone series that accompanies every musical tone. Usually, most of a note's energy resides in the fundamental frequency that defines it, but many higher frequencies also sound out with lesser intensity. Of the many overtones that accompany middle C, the first, third, and sixth respectively fall on C's that are one, two, and three octaves above. So, ideally, every C contains many other C's, and the difference between low C and middle C and high C is merely a matter of emphasis upon the various overtones.

The problem with this argument is that pure-frequency sounds stripped of all overtones still exhibit octave equivalence. A good deal of computer-generated music consists of such sounds and, though displeasing to the ear, it still makes perfect sense harmonically. Moreover, octave equivalence operates even when tones are three or more octaves apart so that their overtones don't overlap.

Octave equivalence is the only truly universal harmonic phenomenon. No ethnomusicologist has ever found a culture where tones an octave apart

aren't regarded as similar (the only discrepancy: certain Australian aboriginal groups that never sing in octaves, but seldom range outside a single octave). There's even evidence that other mammals hear octaves this way. Vibrating objects, including the throats of animals, produce strong overtones one, two, and three octaves above a sound's fundamental frequency. So it should come as no surprise that our brains interpret frequency doublings as unities.

## Building Scales

There is one other interval between tones that appears to be universal, or nearly so, and it is crucial to engineering scales, and hence to making melodies work. This is the frequency found exactly midway in an octave. For an octave stretching from 440 cycles per second (middle A) to 880 (high A), the midpoint is the E at 660. Most ethnomusicologists believe that this middle note is found in the music of all cultures, suggesting that the brain may be inclined to categorize it. There's some controversy over this matter, since many pre-technological cultures make tones only through song, and song can meld with speech in ways that make tonal analysis ambiguous. Even in the West, we no longer tune instruments exactly to the mid-octave frequency, for reasons we'll consider in a moment. But virtually all music comes close enough to this point to mark it as a second "natural" relationship among positions in pitch space. Even if the octave midpoint is not neurologically predestined, we seem to be disposed toward finding it and using it.

The mid-octave tone provides the first note of the several that fill an octave to make a scale. All other notes in the world's vast panoply of scales vary both in number and in the pitches they occupy. Yet the choice of scale tones is not entirely arbitrary. Notes of roughly the same pitch tend to crop up in the scales of widely dispersed cultures. When Egyptologists recently made playable replicas of flutes found in Pharaohs' tombs, they found that the flutes produced much the same sequence of scale tones we use in the West today.

The octave midpoint is key to partitioning an octave-wide range of frequencies into the twelve perceptual categories we call C, C-sharp, D,

D–sharp, and so on. Scale building begins by selecting a frequency that will be called "C," doubling it to form an octave, then halving the octave to obtain G. The G is then doubled into an octave, which in turn is halved to produce D. D is used as basis of the next octave, and on it goes until twelve tones have been produced. The midpoint of the last octave arrives back at the starting point, C. So the process leads to the twelve-note scale quite neatly.

Well, *almost* neatly. The new notes are spread over a large range of frequencies; but thanks to octave equivalence they can be halved in frequency until all fall within the starting octave to make a continuous scale. That much is simple. A greater problem is that the final addition to the series does not actually return precisely to the starting point. Although the discrepancy is small, it has bedeviled theoreticians for centuries. A scale constructed this way is known as a *Pythagorean scale*. In principle it dates back to the ancient Greek philosopher Pythagoras, who sought to relate musical harmony with the supposedly perfect harmony of the heavens. The discrepancy of the last note in the series must have come as hard news. For centuries, scholars, monks, and scientists struggled to eliminate the discord, but to no avail. There appears to be no simple, mathematically elegant means of generating a simple, mathematically elegant scale.

You might protest that this way of building a scale makes no sense in any case, that if G is the midpoint of an octave built on C, then the midpoint of the octave subsequently built on G ought to take us back to where we started from, to C. But frequency increases ever faster (logarithmically) with rising pitch. We think of a scale's midpoint as residing precisely halfway within an octave. But because frequency rises faster and faster from the bottom to the top of an octave, the frequency midpoint actually coincides with a scale's seventh note instead of the sixth note at the middle. This disparity between the physical and musical centers of a scale provides the basis for generating twelve notes.

As the Pythagorean scale is spun out from octave divisions, the first additions generally seem harmonious and "consonant," but the last seem ill-fitting and "dissonant." We'll consider consonance and dissonance in the next chapter. For now, it's important to understand that our ears tend

to reject the last five tones added to the scale. And so instead of writing melodies and harmonies that make equal use of all twelve notes of the Pythagorean scale, we confine ourself to just seven tones. For example, a composition in C major focuses upon the notes C, D, E, F, G, A, and B, all of which are relatively consonant with the starting note, C. Notes like F-sharp and E-flat are excluded. Their dissonance is said to add color to music, and so these tones are called *chromatic*. Playing all twelve tones in a row generates a *chromatic scale*.

An abridged scale of just seven tones is a *diatonic scale, dia* for "through," and *tonic* in reference to the scale's first note, its *tonal center*. So diatonic scales consist of notes that are harmonically closest to the scale's first note. One reason for this consonance is that the overtones of these notes are more likely to overlap than those of the excluded notes, such that notes "fuse" to support each other like interlocking blocks. The selection of seven notes, rather than six or eight, is more or less arbitrary, but it tends to fill in all parts of an octave, leaving no large gaps. This means that no range of pitch categorization goes unutilized.

A pure Pythagorean scale was used in the West for almost two thousand years, as much for the way it is constructed as the way it sounded. It is a geometer's delight, with the most important intervals formed by simple frequency ratios. The fifth note of a diatonic scale is set to exactly 3/2 the frequency of the first, the fourth note at 4/3. And the simpler the ratio, the more consonant the tone (to ancient ears, at least). Astronomers would compare these ratios with patterns in the sky, certain of having discovered the music of the spheres.

There is actually more than one kind of Pythagorean scale. The gaps left by the five excluded tones can be distributed in various patterns to produce seven different scales, and these form the classical *church modes* that bore fancy Greek names like Phrygian and Mixo-Lydian. All were once used in Western music. Each mode has its own peccadillos, and some are loaded with discord. With time, we've settled upon just two of the seven, the Ionian and Aeolian modes, which today we call the major and minor scales. Both kinds of scale are conducive to building extended harmonies, and they work well in combination. But they are not heaven-sent. In

particular, the minor scale requires some jiggering of its last note to make it sound good.

These details do not add up to a pretty picture. We derive twelve scale tones through an elegant but inexact procedure. Then we more or less arbitrarily strip out five of the tones because they don't sound so good. This leaves us with seven possible scales of which we're happy with only two, one of which must be modified to please our ear.

And these two scales still don't really work.

The problem is that music based on a particular Pythagorean scale sounds good only in the key from which scale notes are derived. A scale starting with C produces pleasing C-major chords. But move to any other key and the distances between the steps of the scale change slightly. An interval of four half-steps (a major third) is a little wider in one key, a little narrower in another. And these disparities increase in remote keys. This means the brain must alter its categorization of intervals with every change in key. Notes sound out of tune until the listener adjusts to the new key, and *everything* sounds out of tune when key changes rapidly. Under these circumstances, a D-sharp in one key is not the same note as an E-flat in another (the two are identical in today's music, of course). And so complex harmonic development is rendered all but impossible.

Musicians and scientists long sought a way around these obstacles. One approach was to build special musical instruments, such as a harpsichord with fifty-three keys per octave to handle any change of key. A more practical ploy was to tinker with the scale itself. Beginning about 1450, composers starting fudging the Pythagorean scale to make it more flexible. The new scales worked better, but still far from perfectly, and composition continued to be confined to closely related keys.

By the seventeenth century, composers had had enough. It was the dawn of the Baroque period and they wanted to do baroque things in their music. And so they turned to a perfectly obvious solution to the inharmonicity problem. They simply retuned their instruments so that all notes were equally spaced, evening out the distances between notes so that each would rise in frequency by the same 5.9 percent as the note before. These adjustments put an end to simple fractional ratios between the notes of a

scale. Even the crucial mid-octave tone was nudged slightly off center. The resulting scale is called *equally tempered*, "tempered" in the same sense that materials are tempered to make them more malleable.

The tempered scale is the perfect scale—it is perfectly out of tune. The tuning errors of the Pythagorean scale are spread evenly among all keys so that a nearly imperceptible dissonance is always present. In adopting this system, composers bit the bullet and accepted the fact that a flawlessly harmonious scale is impossible.

There was no giant theoretical leap in getting to the tempered scale, but the *perceptual* leap must have been huge. To this day, some string quartets tune to an older system when circumstances allow, claiming agony when they must return to tempered tuning. Indeed, the reason it took so long for the tempered scale to rise to preeminence was that musicians everywhere were screaming, "You can't tune a viol like that!" But no less an authority than Johann Sebastian Bach retorted, "Oh yes, you can." He went on to prove it by composing his seminal work *The Well-Tempered Clavier*, a collection of preludes and fugues for the tempered harpsichord, one for every major and minor key. Besides writing some phenomenally good music, Bach showed that what was gained in musical possibility through equal temperament far outweighed what was lost in sonic elegance. Hardly anyone has looked back since. Obscure though this innovation may sound, it made possible nearly all of what we regard as music today—not just Chopin and Debussy, but also Duke Ellington and Eric Clapton.

One reason the tempered scale was finally deemed acceptable was a growing taste for dissonance. As ancient attitudes about the "perfect" music of the spheres lost their grip, composers became less obsessed with simple musical symmetry, and their music focused less upon the beauty of individual tones and intervals. The future lay in elaborate harmony and flashy dynamics. At about the same time, the harpsichord took on greater importance as a member of large ensembles and an essential tool for composers. Because harpsichords can't be easily retuned, once they were committed to equal temperament other instruments were forced to fall in line.

The acceptance of the equally tempered scale was the most important

innovation in music since the invention of polyphony (multiple, inter-woven melodies) in the thirteenth century. Suddenly, a composer could write anything he liked without danger of unintended discord. For two centuries thereafter, harmony would become the obsession of Western music as composers explored every nook and cranny of this newfound land.

## Non-Western Scales

We have become so accustomed to our scales that any deviations from them sound out of tune or downright dissonant. There's a certain right-eousness in our attitude toward our scales, an arrogance that increases as the Western scale system colonizes much of the non-European world (partly by means of the inherent tunings of musical instruments we export). So its hard to realize that there are other useful ways of cutting up pitch space. When we hear "exotic" music from other cultures, we assume that it is entirely the music's structure that is "exotic," not realizing that the tones themselves bear alien relationships.

Is the Western scale intrinsically superior? Or, along with Pepsi-Cola and blue jeans, is it spreading merely by the prestige of affluence? The world's scales differ in only two ways: the number of tones they use and the distances between those tones. The Western scale uses twelve equally spaced tones. Elsewhere, a scale might have six irregularly spaced tones. Might one scale be a better building material for music?

For starters, why twelve subdivisions in an octave? Why not five or twenty or two hundred half-steps? As we've seen, a very large number of steps is untenable for the simple reason that the brain cannot categorize so finely. Many experiments have been made with quarter-step ("quarter-tone") scales that double the number of divisions in pitch space, placing an intermediate tone between C and C-sharp, and so on. Both laboratory studies and concert hall experience have shown that the brain can handle such fine divisions of pitch space only with difficulty. Quarter tones appear to be about the limit. Scales of twenty-four steps are found in the Middle East, and of twenty-two steps in India. Finer subdivisions of pitch space have not appeared in any of the world's diverse musical cultures.

Conversely, scales having fewer than twelve steps are quite common. The extreme case is the two-note scale by which some Australian aborigines chant to and fro. Far more prevalent are the five-tone pentatonic scales found around the globe, particularly in Asia. Often the five tones cling closely to the tunings of the Pythagorean scale. And so they can be regarded as stripped-down versions of our diatonic scale, with only the most consonant tones in play. Children's xylophones are often confined to a pentatonic scale so that any combination of notes is pleasing. Chopin's marvelous "black-key étude" shows what can be done in so limited a scale. And melodies built on pentatonic scales are easy to sing. You'll find them everywhere: in folk songs, spirituals, jazz, and pop music of all kinds.

But non-Western scales sometimes adhere to decidedly non-Pythagorean tunings, their tones distributed across pitch space without apparent rhyme or reason. When an odd scale shows up deep in the Amazon, it is easy to dismiss it as "primitive." Yet such scales also appear in exacting, highly developed music like the *gamelan* music of Bali and Java. Its *slendro* scale has five tones spread almost evenly across the octave—a scale to which its instruments are meticulously tuned. Clearly, Pythagoras did not have a monopoly on pitch space.

It is appealing to our egalitarian instincts, and certainly politically correct, to ordain that all scales are created equal, that good music is as readily constructed from one scale as from another. By the simplistic logic of some, if one kind of scale is inherently superior to another, then so must be the music based on those scales, and therefore so must be the civilization of one culture over another. The equally simplistic reaction is to proclaim all musical scales necessarily equal because all cultures are equal—"equal" in that all judgments are arbitrary and relative. Yet it's conceivable that the human brain has specific talents that a scale may or may not accommodate. How can we be sure that one scale is not inherently superior to another? And why mightn't a poor scale undermine a culture's musical prospects?

The supposedly "logical" derivation of the Western scale has sometimes been mocked as mere numerology, as faith in the inherent beauty of simple numbers and fractions. The Pythagorean scale certainly provides arithmetic simplicity, and it was originally devised in the ancient world by

none other than a fanatical numerologist. Universal truth was to be conveyed through the voice of the perfect scale.

To this day, a debate rages over whether the Pythagorean scale and its derivatives are inherently superior to other scales. There's even a name for this belief: *Pythagoreanism.* Opponents of Pythagoreanism make several kinds of argument. The first objection can be succinctly summed up as *So what!* Arithmetic is arithmetic, music is music, and the burden of proof for the existence of an important relationship between the two rests upon those who claim it. Just because a system is neat and orderly does not mean that our nervous systems necessarily comprehend that order in a musically meaningful way.

Opponents also point out that there is no evidence of an innate preference for particular intervals (other than octaves) among children. That there is great variation among individuals in their skill at perceiving intervals is taken as further proof that such skills are learned, and are not an inherent property of the brain. Perhaps most important, untrained listeners show no advantage for perceiving intervals we regard as consonant. We're equally accurate in our discrimination of all intervals.

Another line of argument is that a true Pythagorean scale is hardly ever used anywhere on the globe. If it truly reflects properties of our auditory systems, this scale should frequently appear among traditional, pre-technological cultures. But just the opposite is the case. Pythagorean relations appear mostly in the scales of highly elaborated musical traditions. And even then, the Pythagorean scale is virtually always employed only in a modified form that, while solving certain harmonic problems, greatly upsets the scale's arithmetic elegance.

Some even question whether scale structure matters very much. In the West we use only one tuning system to construct all major and minor keys. But Indian music theoretically offers thirty-five tunings, of which ten are commonly used and another ten less frequently. Has the average Indian listener really assimilated twenty tonal systems? Indonesian gamelan music is even more perplexing. The tunings of the five notes of the common slendro scale vary slightly from orchestra to orchestra, and can be changed

only by hammering and filing the instruments. These discrepancies are intentional, allowing every gamelan orchestra to bring a unique harmonic personality to the stage, much as an actor brings his unique style to Hamlet. This suggests that our brains gladly accommodate any tuning system.

Yet the mystery of Pythagoreanism goes on despite these objections. The obvious argument in its favor is that, by encouraging the overlap of overtones, the Pythagorean scale is the only one that complements the overtone series. Scale tones "fuse" to support each other, and dissonance is avoided. Indeed, the world's many non-Pythagorean scales are often rendered on relatively primitive instruments whose tones are laden with non-harmonic noise that fogs the overtone series and thereby obscures Pythagorean relations. Interestingly, when Western musicians tune their instruments to the standard tempered scale, they tend to make tuning errors in favor of the Pythagorean system, as if drawn to the fusion of overtones.

To the claim that the fusion of scale tones is merely a matter of stylistic preference, it can be countered that music brings order to sound, and any underlying factors that contribute to disorder place music at a disadvantage. In short, if scale tones are the building blocks of music, they had better be as square as possible if you want to build very high. That our tempered scale throws the Pythagorean tones slightly out of tune is unimportant because the tunings remain close enough to be categorized as Pythagorean, and it is to categorizations and not precise tunings that we attend.

Proponents also argue that Pythagorean tuning cannot be arbitrary, because versions of it are found all over the world. Take the twenty-two step scales of some Indian music. Musicological analysis has shown that harmony is sustained in such music by what amounts to a hidden twelve-step Pythagorean scale. The additional tones are employed for ornamental deviations that waver around the core tones (much as Western composers make use of the five non-diatonic tones to embellish the scale's basic seven). Significantly, Indian musicians do not play the twenty-two steps in a row as "a scale." And Indian musicians endowed with absolute pitch have trouble identifying the non-Pythagorean tones, demonstrating that their categorization scheme may actually be limited to the Pythagorean model.

It also can be argued that it is not particularly important whether the brain bears an innate propensity to hear Pythagorean relationships. What matters is that these relationships are inherent in music built on a Pythagorean scale, and this gives the brain something clear-cut to observe. Music built on a less well organized scale spawns less orderly relations and so is put at a disadvantage. In this view, non-Pythagorean scales may be less suitable for building a rich system of reciprocating harmonic devices. Composers working with such scales must labor harder to devise deep musical relations, their melodies will prosper more by contour than harmony, and ultimately their music will go less far.

Consider Roman numerals. The ancient Romans could count perfectly well, but they represented numbers in an unwieldy form. Numbers like VI and IX are represented by more than one digit. This makes for lots of confusion when one number is written above another for purposes of addition or multiplication. The system defeats the idea of a place value for ones and tens and hundreds. Worse, it makes the discovery of the zero, the empty placeholder, very unlikely. There's no question about it; Arabic numerals, with place values and zero, allow a superior organization of arithmetic. You can take mathematics much further with it. And it shows. Despite the impressive engineering successes of the Romans, their technology was ultimately circumscribed by the lack of a mathematical system in which to express physical laws. Perhaps an unwieldy scale similarly impedes musical development by hampering harmonic development.

In this regard, a particular virtue of the Pythagorean scale is its intermediate number of tones. Twelve subdivisions of pitch space seem to be just about the right number. There are enough tones to drive the brain to the limits of what it can easily categorize, but not beyond. At the same time, the scale provides a large enough number of tones to build a rich harmonic system.

Might a better scale yet lie undiscovered? It all depends on what you mean by "discovery." Millions of violin students have played trillions of notes out of tune, and thereby have inadvertently created every imaginable scale. But a scale is more than an invention. It is a *standard,* a socially agreed upon way of regarding pitch space. As with all standards, such as the sym-

bols of an alphabet, a large investment must be made in learning it to the point of automaticity. Only then can a standard show its worth. So a scale is not a scale until a mind has learned to spontaneously categorize it. Even then, a scale's potential is revealed only after composers have tried out its myriad possible harmonic relations over the course of centuries. If there is a better scale, it is probably already before our ears. We just don't realize it.

## What Makes Melodies Work?

We've explored scales at such length because ultimately they are the most basic form of melody. A scale may be boring to listen to, but it makes sense to our ears, and this cannot be said of any less organized line of tones. Sometimes long stretches of scales appear in larger melodies; they can be quite musical when supported by clever harmony. But it's only when scales have been cut to bits and carefully reassembled in contrasting patterns that we begin to use the word "melody."

Most work on melody, both scientific and musicological, has been based on the tunes found in classical Western music of the "common practice" period spanning the Baroque, Classical, and Romantic periods of the eighteenth and nineteenth centuries. The very different sounds of the Middle Ages and the Renaissance, and of the Impressionists and the Modernists, have generally been neglected. Confining musical research to Bach, Beethoven, and Brahms might seem overly restrictive, particularly in light of how few people listen to such music today. Yet nearly all Western popular music is built upon this tradition, so this research ought to satisfy most readers' conception of melody.

But not everyone's. Many of the world's cultures subscribe to very different notions of melody. Although few Westerners sit down for a serious listen, most of us have heard a good deal of singing that makes little sense to our ears. Think of the chants of North American Indians, the vocal music of India and the Middle East, or the gravelly intonations of Tibetan monks. None of these sounds have much in common with a song by Franz Schubert or Cole Porter or Bob Dylan.

There is really only one common feature among such diverse kinds of

melody, and that is *contour*. As we've seen, a child's first musical experience is of melodic contour. And laboratory studies show that untrained adults discern contour almost as well as professional musicians. So contour is central to our experience of melody.

A graceful melodic contour can strike as pleasing a balance as a line in a Picasso drawing. Psychologists have long sought to understand why some contours give pleasure while others jangle, and why we group a melody's notes as we do rather than in hundreds of other possible ways. Despite decades of effort, investigators still describe melodic contours using concepts coined by the Gestalt psychologists early in this century. The Gestaltists formulated a number of rules describing how we make sense of the world visually, rules that work just as well in explaining how we assemble melodic fragments into whole tunes. For example, the *Law of Completeness* states that our minds prefer complete patterns. Melodic skips interrupt smooth contour, and so there are few of them. The *Law of Good Continuation* states that a mind will automatically unite two lines lying along the same trajectory. The same is true of melodic fragments.

At first glance, Gestalt laws can seem trivially obvious. Yet their obviousness attests to their validity. Melodies that consistently contradict these laws are not found anywhere in the world. But the Gestalt laws have their limitations. They only help explain melodic contour and say virtually nothing about how harmony and rhythm buttress melody.

Ultimately, contour alone does not meet our definition of melody. Though we may listen respectfully to the wavering chant of a New Guinea tribesman, we are not content for long. To our ears such music is "out of tune" and "out of time." And this tells us that we expect much more from melody than mere contour, that we demand additional dimensions and are satisfied with nothing less.

The most important such dimension is harmony. Indeed, one way of conceiving of melody is as harmony in flight. Imagine a series of chords played in succession, with interesting harmonic transitions from chord to chord. Then imagine the notes of each chord played one after another so that they are arrayed across time. Because your brain automatically remembers recent notes, the sense of harmonic progression is not lost and you

continue to hear the chord changes. Of course, actual melodies seldom consist of simple successions of chord tones. Other notes intervene to join chord tones into continuous melodic lines. But musical analysis shows that the most prominent tones in a melody tend to belong to chords of the prevailing harmony. So even a thin, unaccompanied melodic line provides harmonic experience.

An interesting experiment demonstrates the power of harmony in melody. When a random tone is inserted between each note of a well-known tune, most listeners have no trouble recognizing it (so long as it's played rapidly). This indicates that the relations we hear in a melody are not primarily the note-to-note relations of contour, but rather the relations between melody notes and a prevailing harmonic center (we'll consider these *tonal centers* in the next chapter). For example, while a melody is in E major, we tend to hear its notes as offsets from the tonal center E. These relations carry through even when random notes have been interleaved. So we continue to hear a melody though its contour has been obliterated. The importance of harmony is also attested to by research showing that people have trouble learning melodies that are harmonically ambiguous.

Melody is made of rhythm too. A melody's notes form a pattern of varying durations with some notes made more prominent by accentuation. This pattern is extremely important to our understanding of melody. Notes that fall on downbeats and at other important rhythmic junctures usually become the most important notes in a melody. It's at these positions that melodic contour tends to change direction, and at which harmony tends to make its most dramatic moves. A well-known melody can be rendered unrecognizable just by shifting it across bar lines by a beat so that accentuations fall in different places. Research has shown that rhythmic pattern is so important to the perception of melody that many well-known melodies can be identified just by hearing their rhythm tapped out in a single pitch (recognition is much poorer in the converse case, where the proper tones are used but all notes are made the same length).

The notion of melody is clouded by the idea of a *theme*. Often in classical music, and sometimes in jazz, there is no well-defined, easily sung melody, but instead a series of melodic fragments. These fragments

are repeated, modified, and intertwined to form a long melodic landscape that is more difficult to grasp than a simple tune. The difficulty is attributable partly to the sheer size of these musical structures. They can persist for many minutes, compared to the thirty-second span of a typical melody.

More important, melodic fragments tend to lack a self-contained harmonic life of their own. They instead rely on the harmonic support of accompanying chords. Sing "Jingle Bells" in a minor key and it sounds all wrong. But melodic fragments can be led through endless harmonic permutations without objection, for they have no particular harmonic allegiance. This flexibility allows themes to be developed into towering edifices.

Yet there are drawbacks. Thematic development can only be comprehended by those possessed of a good ear for harmony, and a musical memory strong enough to hang on to fragments over many bars until they meet related elements. Without these skills, the brain fails to perceive extended melodic relations. And so we often hear the complaint that classical music "has no melody." This can be just as true of the art music of other cultures, such as the ragas of India, which most Indians pass over in favor of the short, contour-oriented melodies of popular music. When melodic themes take on new forms, even music critics miss the boat: "Does anybody for a moment doubt that Debussy would not write such chaotic, meaningless, cacophonous, ungrammatical stuff, if he could invent a melody?" (this about *La Mer*).

Of course, art music is full of delightful short melodies. But on account of their resistance to extended development, they tend to appear disproportionately in shorter works, particularly during the Romantic period of the nineteenth century: Schubert, Schumann, Chopin, Tchaikovsky. Interest in melody goes in cycles. But there's been a general long-term trend away from short melodies and toward thematic development. This has occurred partly as the focus of art music shifted from voices to instruments. But it has also arisen from the desire to build ever larger musical structures. And so Wagner mocked Rossini for writing "*the naked, ear-delighting, absolutely-melodic melody,* that is, melody that was just melody and nothing

else." Musicologists point out that most composers become less "melodic" and more "thematic" as they grow older and take on more ambitious projects.

## Melody and the Brain

Clearly, a "simple" melody makes great demands on a brain, which must not only track the melody's contour, but also must deduce the prevailing harmony. Where in the brain are melodies heard?

In earlier chapters we've encountered brain centers that perform specific functions for sensing and sequencing sound. But melody is too complex to reside in a lone brain center. The knee-bone-is-connected-to-the-thigh-bone neurology of the basic auditory system is now behind us, and matters become more complicated and less clear-cut.

In the last chapter we witnessed a right-brain superiority for identifying tones. This expertise applies to melody too. The link was discovered by playing melodies to each ear separately and testing how well the melodies are perceived or remembered. It turns out that the left ear, which channels primarily to the right brain, displays clear superiority. So the right hemisphere excels in making sense of melodies. Later work with electroencephalograms and brain scans confirmed this analysis, and zeroed in on auditory cortex. Further confirmation came from brain surgery. Sometimes much of the temporal cortex is removed to subdue life-threatening epilepsy. In most cases, melody perception is undermined when the right temporal lobe is excised, but not the left.

But why the right hemisphere? We saw in Chapter 2 how the right hemisphere is especially concerned with detecting relations between a tone's harmonics, and how in animals it favors the analysis of vocalizations like hoots and growls. Harmonic analysis is the natural role of right-hemisphere auditory cortex. Because melodies are based on harmonic relations among the tones of a scale, the right-brain advantage should come as no surprise. True, a melody is unlike a chord in that its notes are spread over time. But sensory cortex is able to integrate a few seconds' experience, "remembering" tones (or remembering, at least, categorizations of tones) for a few seconds after the tones have faded. Because the right hemisphere

favors holistic, integrative analysis in all its functioning, it is just the place you would expect to find melodies assembled.

This does not mean, however, that *only* the right hemisphere is active in melody perception. As we saw in Chapter 2, the left hemisphere also works at harmonic analysis, but with less zeal. More important, the left hemisphere is prominent in analyzing the rhythmic patterns found in melodies (a topic we'll turn to in Chapter 5). So it's incorrect to think of melodies as channeling into the right hemisphere and being perceived there and nowhere else. As in all aspects of music perception, several parts of the brain are at work.

There is a twist in the neurology of melody perception, a twist that says much about just how complicated music perception really is. Research shows that professional musicians favor not the right, but the *left* hemisphere for perceiving melodies. The musician's right ear (which mainly serves the left brain) is the stronger. One explanation could be that left dominance naturally accompanies musical talent, and that talent encourages professional training. But research has shown that this is not explanation enough. Rather, cerebral dominance for melody "migrates" from right brain to left brain as the individual acquires musical training.

Professionals are lateralized differently from ordinary listeners because they acquire additional, quite different skills for melodic analysis. Rather than just hear a melody as a unified contour, they also break the melody into a sequence of fragments bound together by abstract relations. The right hemisphere is probably no less active when professionals listen to melodies; it is just that left-hemisphere activity is bolstered to the point of dominance. Thanks to these abilities, professionals do much better at recognizing brief fragments of melodies, and at telling whether a melody's pitches make harmonic sense.

It's these sorts of left-hemispheric skills that endow professionals with superior memory for melody. Significantly, they do no better than ordinary listeners when presented melodies from unfamiliar musical traditions. This implies that professionals bring an acquired library of musical devices to their listening, a library that most people lack. With experience this kind of understanding may become the dominant experience of melody. Thus,

two listeners may smile in mutual appreciation of a melody, not realizing that the experience of one runs much deeper.

It's likely that left-brain dominance for melody is necessary to grasp the sort of extended, highly developed themes discussed earlier in this chapter. Melody of this kind requires a strong memory for events that passed many seconds, even minutes, before. At best, unaided auditory cortex maintains a fleeting ghost of tones-gone-by that lasts only a few seconds. Longer-term memories, and longer-term understanding, require the abstract reduction performed by the left brain. When we speak of a "deep" understanding of music, it is to deep, many-layered hierarchies of reduction that we refer. We'll return to this theme in chapters to come.

## The Ideal Melody

What makes a good melody? Textbooks on composition technique offer many rules, all of which are in perfect accord with the principles we've just encountered. If you compare these rules to a favorite melody, you'll find that they almost always apply. Here are the most important:

• Nearly all notes in the melody are to be chosen from the seven-note scale upon which the melody is based. When any of the remaining five chromatic notes are used, they generally should appear in positions that are unaccented and unemphasized so as not to undermine the prevailing harmony.

• Most of a melody's notes should be adjacent scale notes. Jumps should be few, and large jumps rare.

• To avoid monotony, individual notes should not be repeated too much, particularly at emphasized positions in a melody.

• Harmonic resolutions, such as the *cadences* that we'll consider in the next chapter, should occur at points of rhythmic stress in a melody.

• Similarly, rhythmic accentuations should highlight the melody's contour. Changes in melodic direction should generally fall at rhythmically important junctures.

• A melody should have only one instance of its highest tone, and preferably also of its lowest tone. The highest tone should never be a tone that naturally tends toward a higher one (such as the seventh note of the melody's scale).

• Jumps should always land on one of the seven scale tones, not on one of the five chromatic tones. The ear always hears a jump as emphasized (that is, the brain is more attentive to jumps, since they define the boundaries of submelodies), so jumping to a chromatic tone violates the rule about never emphasizing these tones.

• Conversely, a melody should never leap *from* a chromatic tone. The dissonance of a chromatic tone creates tension in need of release. Yet jumps increase tension, and so contradict this need.

Studies of hundreds of actual, successful melodies have confirmed the validity of these rules. Melodies that break them are likely to be awkward or downright ugly. Yet while rules can point out bad melodies, they can't predict good ones. Many a drab melody observes every rule. Others break an important rule and somehow gain by it. Think of the song "The Girl from Ipanema." The rules would deem it monotonously repetitious, but we hear it as wondrously soothing.

The rule about using mostly contiguous tones is particularly interesting. Research has found that this principle is observed in all kinds of melodies. Typically, about half of all melody notes are adjacent, and another third fall within three or four half-steps (a minor or major third). This demonstrates that successful melodies rely on a sense of line, which is to say that contour always plays an important part in their perception.

Notice that all of these standard rules concern the harmonic aspects of melody. Changing a single note in a melody can undermine it by intro-

ducing harmonic flaws. Yet a melody can as easily be undone by changing the duration of a note. Textbooks are mysteriously silent about rhythmic rules for melodies. In that harmony depends on rhythmic emphasis, and rhythm is reinforced by harmony, it's clear that the rules listed above are inadequate.

Nonetheless, the coincidence of harmony perception and melody perception in the right brain suggests that harmonic structure is the key to great melody. Harmonically ultraconservative melodies like "My Old Kentucky Home" are mortally boring. Much pop music does little better, with simple resolutions at regular intervals, and an ever-so-predictable finish on the starting tone. By comparison, great melodies usually twist around difficult, racking harmonies. Their most prominent moments invariably coincide with startling harmonic shifts. Textbooks sometimes advise music students to first write a melody and then "harmonize" it by seeking supporting chords. What a mistake.

To see how these rules apply to an actual melody, let's take a close look at Henry Mancini's "The Pink Panther," which is shown in Figure 3.1. We'll be returning to this theme in future chapters, so it's important to take a moment to examine it carefully. Even if you can't read music, you should be able to follow the melodic contour by observing its distinctive groupings of notes. While this clever tune may not be the pinnacle of musical attainment (it's been chosen partly because just about everyone knows it), it illustrates many important points about how music works.

We're accustomed to hearing "The Pink Panther" played by a sprightly saxophone. Because the tune mimics a panther creeping along (on only two legs in this case), it is intentionally written with many stops and starts, its notes clumped together with pauses between. Rhythmically, it is very different from the more common one-note-to-a-beat plan of many melodies (think of Beethoven's "Ode to Joy"). Yet, however disjointed this melody seems, it is, like many tunes, little more than a scale rising and falling—in this case, the E-minor scale.

The melodic contour tentatively begins its rise in the first bar. Then it abandons its effort and starts over in the second bar, using the same notes but moving more quickly. The contour climbs upward through the second

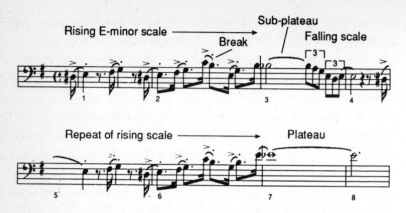

*Fig. 3.1. Melodic contour in "The Pink Panther"*

bar, briefly peaks and slides (more feline hesitation), then plateaus for two beats at the start of the third bar before quickly sliding back down the scale. This four-bar phrase then repeats almost note-for-note, but with an important shift in harmony that we'll consider in the next chapter.

In keeping with the first rule listed above, every note but two in this fragment is selected from the seven tones of the E-minor scale (E, F-sharp, G, A, B, C, D-sharp, E). The only exceptions are the B-flat that marks the summit of the melody's contour in the third bar, and its cousin in the seventh bar, an E-flat. Because these notes are not part of the E-minor scale, they sound relatively dissonant—all the more so by being held for so long. Notice that these two notes break the rule about placing non-scale tones in accentuated positions. Mozart would have felt less comfortable with these notes than a modern jazz composer does.

The other melody rules are faithfully observed. As bouncy as this tune seems, it largely moves between adjacent scale tones. To keep the melody interesting, there's minimal repetition of individual tones. When there are jumps, they always land on scale tones. And when the melody moves away from the non-scale tones (the dissonances in the third and seventh bars), it does so without jumping.

Moreover, the melody's contour is in sync with rhythmic accentuations. The melodic contour effectively starts on the downbeat of the first

bar, and then restarts on the downbeat of the second. It peaks on the downbeat of the third bar. And it resolves back to the starting note at the start of the fourth bar. Within the prevailing rhythm, these are the theme's strongest, most attention-grabbing moments.

You may have noticed that the highest note in the first four-bar phrase is not the long-held dissonance that effectively acts as the melodic peak. Instead, the highest note flies by two beats before. Since it is heard only briefly, this note doesn't change the overall form of the contour. But it has the effect of deemphasizing the peak that follows; rather than rising to a pinnacle, this melodic fragment steps down to its plateau. Why not make the long-held peak the highest note, thus maximizing the melodic effect?

Mancini holds back because he is building a larger, eight-bar phrase and he does not want it to climax too soon. Although the fifth through eighth bars mirror the first four, they employ a higher-pitched dissonance as the long-held note (an E-flat instead of a B-flat). This time, the peak is actually on the highest pitch in the melodic line. Mancini builds larger structure in this way.

Had Mancini merely repeated every note of the first four bars, there would be no new information and the music would start to become boring. Instead, the listener remembers the first dissonance when he hears the second, expects the first dissonance to be repeated, and so hears the second as a divergence from it. That divergence constitutes new information. Although the two dissonances are divided by four bars, at higher levels of comprehension the brain hears the upward transition from the first dissonance to the second as if they were adjacent notes. Because nearly every other note in the first four bars is exactly repeated in the second four, the rising pitch of the dissonances is the only changing relation the brain has to observe. But this relation is so strong that the second four bars become an advancement of the first four, and not mere variation.

As melodies go, "The Pink Panther" sounds a bit unconventional. It's a long way from "Silent Night." Yet it follows the same rules observed by Mozart and Mendelssohn. And so mass audiences can readily grasp it. This tune's novelty rests mostly in its rhythmic features, which we'll consider in Chapter 5.

That a handful of rules prevail in diverse melodies suggests that there might be a perfect melody, a sequence of tones that optimizes every aspect of melodic perception. Does this tune lie yet undiscovered? The answer comes as a resounding no. Variations in harmony and rhythm change the relative importance of the rules. And in any case, there is too much variability among individual minds and personalities—in the degree of training, in cultural background, and even in hour-to-hour mood—for one melody to triumph always in every mind. We need lots of melodies, thousands of them, to accommodate the myriad hues of human existence.

# 4

From sound...
...to tone...
...to melody...

## . . . to harmony . . .

Even to a Parisian of the Belle Epoque, in so very modern a year as 1889, the approach to the Champs de Mars must have been breathtaking. Throngs of well-dressed men made their way, propping up women in bustles and precarious headgear. Before them lay pavilions of far-off lands, replicas of exotic temples, reconstructions of ethnic streets and market-places. It was the Exposition Universelle, a vast world's fair celebrating the centenary of the French Revolution. Soaring above was the most remark-able (and most controversial) sight of all—a 984-foot tower designed for the fair by Alexandre Gustave Eiffel, its eighteen thousand wrought-iron girders clenched by a million rivets.

But it was an altogether different technology of hammer upon metal that interested one visitor, an up-and-coming composer by the name of Claude Debussy. By his side was his colleague Paul Dukas (best remem-bered today for his *Sorcerer's Apprentice*). Together these two very different composers hurried past the Central Colonial Palace and on to the Annamite Pavilion, where a most unusual concert was planned.

Two years earlier, the Paris Conservatoire had received a collection of

sixteen Javanese musical instruments, a *gamelan* of glistening gongs and xylophones meticulously forged from bronze that was first poured molten, then hammered hot and cold, then filed until squarely in tune. With an ancestry reaching back thousands of years to the Bronze Age, these instruments were a marvel to behold. But no one had a clue how to play them properly. At most, a mallet could be swept across a xylophone to reveal a misshapen scale quite unlike anything that had ever echoed through the streets of Paris.

To be sure, there had long been reports of this exotic harmony. As early as 1580, Sir Francis Drake, afloat off the coast of Java, had described in his ship's log a kind of music "which though it were of a very strange kind, yet the sound was pleasant and delightfull." But it would be three centuries before a European could comprehend gamelan music well enough to draw upon its ideas.

What Debussy heard that day was affirmation of an idea: that our minds can make sense of, and be pleased by, chord progressions that sound entirely dissonant within the confines of traditional Western harmony. He saw that the many harmonic styles of European music are but minor variations on an underlying mindset, that further innovation called for a leap to a radically different harmonic paradigm. But what would that paradigm be? The sound of the gamelan gave Debussy a starting point. His acquaintance Erik Satie would later write that Debussy "was very deliberately seeking a way that wasn't easy for him to find." But soon he would adopt a six-step *whole-tone* scale akin to the five-step Indonesian *slendro* scale he heard that day, using it to fashion harmonic progressions radically different from those of Bach and Beethoven and Brahms.

To his annoyance, Debussy would one day be likened to the Impressionist painter Claude Monet, whose color schemes shimmered like Debussy's harmonies. A better comparison might have been to Paul Cézanne, who was the first to flatten three-dimensional shapes and thereby pave the way for Picasso and the Cubists. Debussy would take the ideas he garnered from the gamelan performance that day and do the same for music, steering a centuries-old harmonic system toward the brink.

Harmony in music makes a good analogy with space in painting. In-

deed, some musicologists have described harmony as music's third di-
mension, its *depth* dimension (with the breadth of time and the height of
pitch space as the first two dimensions). Just as the spatial dimensions of
breadth and height are easily viewed as they cast a pattern upon the
breadth and height of the retina, time and pitch height are easily observed
by cochlea and brain stem, making simple rhythms and melodies easy to
hear. Conversely, spatial depth is much harder to perceive or imagine; it
requires lots of complicated processing. The same is true of harmony,
which requires long acquaintance before we can look deep into it. Many
people appear to be limited to only a shallow bas-relief in their experience
of harmony.

Significantly, harmony became elaborate in Western music at about
the same time that perspective was introduced into painting during the
Renaissance. Four hundred years later, harmony fell into crisis (in art music,
at least) at the same moment that the Cubists dismembered perspective.

As we shall see later in this chapter, the history of harmony parallels
the development of harmony perception in children. Western music slowly
progressed from melodic contour to harmonic melody to pure harmony,
maturing in seven centuries as every child does in about seven years. An
overview of how we came to today's harmonic system tells much about
which aspects of music are most fundamental and which most difficult,
and so reveals much about the brain's talents and priorities.

## The Birth of Harmony

The harmony of virtually all the music we hear, whether Chopin or
Elvis, is rooted in chants sung by medieval Christian monks. The earliest
examples of these chants would hardly be regarded as music by today's
standards. They consisted of a single melodic line wavering up and down
by a half-step or two, without dramatic leaps, with nearly every note held
long, and with no beat but for the natural rhythm of spoken language.
Early chant was really nothing more than adorned prayer in which certain
vowel sounds were accorded fixed pitch. It was words rather than tones
that mattered most to its singers.

In time, vocal range expanded toward high notes and low notes that

not all singers could manage. And so chants were separated into two or more vocal lines—*parts*—that were identical in every way but for being separated by several steps. Parts were usually divided by half an octave to form intervals considered most consonant and "perfect."

This way of singing prayers, called *organum,* continued for hundreds of years. But starting in the eleventh century, the individual parts of organum began to go separate ways. The upper part was often made more complex than the others, taking on more embellishments. And lower parts began to follow their own melodic line, sometimes moving in contrary directions to the treble. Still, all voices remained synchronized upon the same words. It was not until the thirteenth century that the most crucial development took place. Particularly at Notre Dame Cathedral in Paris, a group of church composers wrote music in which voices shifted out of sync and moved independently across time for long stretches, though alternately falling back into unison in the older style.

To medieval ears this new music sounded revolutionary, and rightly so. Chant had become multimelodic—*polyphonic*—with several independent lines sung simultaneously. Sometimes these lines were identical but were sung several beats apart. The resulting form, called a *canon,* is familiar to every schoolchild who has ever sung "Frère Jacques" in rounds. But the ultimate destiny of polyphony was to allow each voice complete freedom of movement. Diverse combinations of sounds would inevitably result.

Although early polyphony provided the basis for today's harmonic system, it cannot be said that composers yet thought harmonically. They continued to approach music as melody. Their concern was to avoid the disharmonies that spring up at every turn when voices are overlaid. As there was little useful theory to guide them in this task, they proceeded by trial and error. Progress was slow, partly owing to periodic attacks from the church, which complained that polyphony made the prayers sung in chants unintelligible, and worse, that it threatened to incite church congregations to emotionalism and pleasure.

At about the same time, the church organ was rapidly developing toward the capable instrument we know today. The organ was often used to accompany organum, perhaps conferring its name. At first the organ

probably just contributed a single parallel line, but soon doublings in octaves and fifths would have been added. As composers accompanied the choir, patterns on the organ keyboard may have helped suggest a striking new idea: the chord.

Rather than conceive of music as ever-moving voices interwoven across time, composers began to think in terms of tones stacked atop one another, each combination of tones having its own identity. It is not that music had never before been heard this way, of course. Brains cannot help but detect relations among simultaneous tones. But previously, chordal relationships had been simple and had been subordinated to the difficulties of fitting one melody against another.

Now composers began a centuries-long transition toward conceiving music vertically rather than horizontally. Emphasis shifted from the melodic relations among successive tones to the harmonic relations of simultaneous tones. By the sixteenth century, harmonic experimentation had become all the rage.

Prior to the invention of linear perspective in Renaissance Italy, spatial depth was created by overlapping objects and by making more distant objects smaller. Artists most certainly had a notion of depth, but they didn't know how to depict it effectively. More important, artists simply couldn't imagine the potential artistic power of depth. They focused on other aspects of depiction, blithely unaware of the revolution to come. Then, when the reemergence of Euclidean geometry suggested how to create the illusion of depth, painting changed overnight, and perspective became the obsession of many painters for some decades. Something similar happened with harmony. Early composers had scant premonition of its possibility. The music they wrote seemed to them as complete as music could be. And then they saw the light.

Harmonic development was hastened by the rise of secular music during the Renaissance. Once cheap printed sheet music first appeared in about 1500, musical ability quickly became a mark of refinement. Soon every parlor sported a clavichord or a harpsichord. But polyphony was difficult for amateurs, and too severe for the new optimistic worldview. What was wanted was simple, expressive song accompanied by instru-

ments. To the Renaissance imagination, this was the musical style of ancient Greece and thus worthy of emulation. By 1600 the new style would give birth to opera, that great melting pot of musical ideas. Composers responded eagerly to the new sensibility (not least to deepen their pockets), writing volumes of new music with sometimes wild harmonies. This new music overshadowed polyphony but did not bury it. In fact, after the initial blossoming of polyphony, it would enjoy two more golden ages, one led by Palestrina in the mid-sixteenth century, one led by Bach in the early eighteenth century. But there was no turning back.

For all the wild experimentation, harmony remained largely informal and uncodified. Many composers paid little attention to harmony and were content to write a melody and supporting bass and then have apprentices fill in the parts between, just as artists would turn over the details of a painting to their underlings. And so it was said that you could "drive a coach and four between the treble and the bass" in the scores of the composer Grétry.

One constraint, which we considered in the last chapter, is that the scales of the day readily led to discord, a problem that would not be adequately solved until the early eighteenth century. Renaissance composers tried hard to write music that moved harmoniously among far-flung keys, but failed. They anticipated harmony's potential, but didn't yet know how to get at it.

Modern harmony began with the Baroque period, starting from roughly 1600. The word *baroque* derives from a Portuguese word referring to misshapen pearls. True to its name, Baroque music wavered (in the minds of later critics) between the Gothic and the grotesque. In contrast to the flowing, interwoven textures of the Renaissance, Baroque music is devoted to contrast, with rapid alternation between loud and soft passages, between different instrument groups, between fast and slow tempi, and between solo and orchestral sections. It is self-consciously high-tech music that was designed to dazzle. It still dazzles us today.

Harmonic innovation was pushed along further by the composers of the Classical period, notably Haydn, Mozart, and Beethoven, and then reached its pinnacle with the early Romantic composers of the mid-

nineteenth century, such as Schumann, Chopin, and Liszt. Their music lived for harmony, so much so that to copy a composer's harmonic style became tantamount to plagiarism. Such specialization was unthinkable barely half a century earlier, when Mozart and Haydn would rob each other blind for harmonic ideas and think nothing of it. Harmony had moved from its supporting role in concert music to center stage.

And then it began to collapse.

The quest for harmonic uniqueness pressed innovation forward. But where was left to go? By 1850, composers had tried out seemingly every combination of chords. Originality now lay in only two directions. A composer could increasingly employ the five chromatic tones outside the tonal scale. Or he could wander among foreign keys for longer and longer periods. Both of these ploys served only to weaken tonality (the dominance of tonal centers). Both demanded a keener, more disciplined ear on the part of the listener, and a well-developed musical memory that would somehow support a sense of key when the music itself did not. Because most listeners are not so sophisticated, the new music soon came under attack as being impenetrable.

The growing power of the symphony orchestra was an important factor in the dissolution of classical harmony. Following the 1830 debut of Berlioz's radical *Symphonie Fantastique,* composers increasingly paid attention to orchestral textures and effects. By the end of the century, they had learned to mix the sounds of instruments with such virtuosity that timbre became an important organizing force in music, so much so that a return to a particular timbre could have as strong an effect as a return to a previous key. Revolutionaries like Wagner and Mahler took to writing almost exclusively for orchestra so that abundant timbral resources would always be available. Tellingly, much of their music cannot be effectively rendered through a piano transcription.

Harmony was correspondingly freed. Composers could use the new timbral devices to buttress harmonic transitions that might otherwise be incomprehensible. The mark of the age was harmonic *elongation.* A century earlier, Mozart's music was filled with harmonic excursions packed into self-contained eight-bar periods; an entire movement of a sonata might sail

by without ever venturing into a second key. But by the late nineteenth century, Wagner would prolong harmonic resolutions for entire acts of his operas in seemingly endless modulations from key to key, against only the faintest hints of a tonal center.

Classical tonality has been described as containing the seeds of its own destruction. From the time that Bach popularized the tempered scale, composers sought harmonic innovations that would exceed the listener's expectations. With every adjustment by the listener's ear, harmonic novelty had to be ratcheted up a bit further. Harmonic adventure became an essential component of musical pleasure. Clearly, this could not go on forever. The listener increasingly was asked to perceive the most subtle hints of harmonic action and to remember hierarchies of key changes over periods of many minutes.

And then Debussy heard the gamelan at the Exposition Universelle and the future of harmony was writ clear. After long experimentation, he began composing music that deliberately shunned the usual tonal architecture, avoiding chords that gravitated toward tonal centers. By employing the six-step whole-tone scale, he avoided the harmonically crucial forth and fifth tones of the traditional diatonic scale, and thereby made it impossible to listen to his music as one would listen to Mozart or Wagner.

Debussy knew he was playing with fire. Other composers of the day, such as Richard Strauss, had also pushed classical harmony beyond conventional limits, and with appreciable success. Open-minded listeners quickly learned to enjoy this new music. But what would happen to music if it continued along this path? It was clear that the new music was buttressed by the listener's knowledge of earlier genres. Could a brain unschooled in Mozart make sense of the new music?

While music had changed, brain structure had not. The brain's powers of harmonic discrimination had been pushed to their limits, as had the powers of short-term memory that maintained tonal centers long after they had faded from the aural stage. Music became harder and harder to appreciate. In the view of some critics, it had become altogether inappreciable.

And so by the dawn of our century, a full-blown crisis was at hand. If harmony continued its march toward abstraction, it would collapse. Re-

action was varied and complex. Debussy refused to go further, and Strauss panicked and retreated into earlier forms. But a new generation of composers pressed on. They divided into two schools: those who modified the classical system and those who abandoned it entirely. The first approach led to the "neoclassical" response of Stravinsky and others in which further harmonic freedom was made possible by restricting other aspects of music to traditional structures and forms. The second, radical approach was to entirely discard classical tonality in favor of a new harmonic system launched by the Austrian composer Arnold Schoenberg, a system dubbed *serialism*.

The ambition of serialism is to discard tonal centers entirely. There are a number of approaches, but the basic objective is that every note of the twelve-step chromatic scale should be repeated as often as every other. This undermines the probability relations of classical tonality, where the first and fifth scale notes are heard often and the non-diatonic tones hardly at all. In serialism, all twelve notes of the chromatic scale are given equal weight. The result is sometimes called "atonal," although Schoenberg preferred the term "pantonal." Gone are the pleasures derived from a straightforward resolution of harmonic tension.

Ironically, Schoenberg saw himself as a conservative, not as the bombthrower he is often taken for. He believed that traditional harmony had to be replaced if music was to continue to evolve. Not everyone saw it that way. The German-American composer Paul Hindemith derided the idea that audiences could shed their deeply accultured system of musical expectations, a system that is constantly reinforced through listening to music by earlier composers. Hindemith felt that listeners would bring tonality to music whether Schoenberg and his followers liked it or not, writing of the serialists that

> they rather avail themselves of the same trick as those sickeningly
> wonderful merry-go-rounds on fair grounds and in amusement parks, in
> which the pleasure-seeking visitor is tossed around simultaneously in
> circles and up and down and sideways in such fashion that even the inno-
> cent onlooker feels his insides turned into a pretzel-shaped distortion.

*The idea is, of course, to disturb the customer's feeling of gravitational attraction by combining at any given moment so many different forms of attraction that his sense of location cannot adjust itself fast enough.*

Serial music has also drawn frowns from many a perceptual psychologist. Lacking tonal centers, the listener loses the anchor points for hierarchies of intervals. Worse, serialist theory discourages repetition of any kind, causing short-term memory to buckle before its demands. Not surprisingly, laboratory studies have consistently shown that even professional musicians do poorly on tests of any kind that employ serial music. There's considerable evidence that many serialist techniques, such as playing sequences backward or upside down, make musical structures unidentifiable. What a composer's intellect can imagine is not necessarily something that a listener's auditory system can perceive.

Today, concert audiences obediently sit through music by Schoenberg and his followers, but few enjoy it. Although there's much that's interesting in this music, people simply do not find it harmonious. It hurts their ears. Yet harmony has always been about *not* hurting ears. It is the science of combining sounds so that they "go well" together. Pleasing combinations of sound stand in marked contrast to an infinitely larger number of combinations that do not at all "go well" together and that cause us to grimace and flee (or ought to).

## Dissonance

We call sounds that go well together *consonant;* the rest are *dissonant.* Like descriptions of heaven and hell, science is not nearly so adept at explaining consonance as it is dissonance. Dissonance arises from three quite different sources, one based in neurology, one in acoustics, and one in music theory. Let's consider each in turn.

The neurological explanation of dissonance focuses on the inner ear, the cochlea. Recall from Chapter 1 that a loud pure-frequency sound stimulates a wide range of receptor cells along the cochlea's basilar membrane. The membrane is most deformed, and the receptors most activated, at the point along the membrane associated with the particular frequency. But

receptors on either side also fire. This range of activation is called the *critical band* for the sound. It has been found that two frequencies form a dissonant interval when their critical bands overlap. By falling so close together along the cochlea, the two sounds upset each other's perception.

This phenomenon goes far in explaining why tones close in frequency are dissonant. The half step from middle C to C-sharp is very dissonant; the two half steps from middle C to D, somewhat less so. Dissonance flags only at three half steps, from C to D-sharp (a minor third), where the second tone falls entirely outside the critical band of the first. For lower frequencies, however, the cochlea crams a broader range of frequencies into a critical band, and tones need to be farther apart to avoid dissonance. At the bottom end of a piano keyboard, tones as much as a fifth apart (seven half-steps) are dissonant. Harmonious music can hardly be written in this frequency range, and composers normally keep bass tones well separated.

A second kind of dissonance is rooted in a simple physical phenomenon called *beating*. A pure sound of, say, 100 cycles per second rises to maximum intensity 100 times a second. A second sound of 102 cycles per second peaks 102 times. When the two sounds are combined, their moments of maximum intensity are generally out of sync. But at regular intervals the maxima of each sound coincide—twice per second in this case. Around these moments, the combined force of the two sounds pushes at your eardrum especially hard and you hear a momentary intensification of the sound, a beat. These beats can be individually audible up to about twenty per second; at higher frequencies they fuse into a grating roughness, a sort of auditory friction.

You can experiment with beating by playing the same note on adjacent strings of a guitar. As you slide one note out of tune, you'll hear a phantom pulse in the background. Slide back into perfect tune and the pulse disappears. Violinists bring their instruments into tune with others by listening for beats. Similarly, piano tuners employ a tuning fork to tune just one string and then use beats to cross-tune the rest.

Not all dissonances are created equal. Those formed by widely separated notes are weaker than those of notes close together. The two half-steps from middle C to middle D create a biting dissonance. But when an

octave is inserted to stretch the interval from middle C to *high* D, the dissonance is less intense. According to the principle of octave equivalence, which states that tones an octave apart are tonally identical, this shouldn't happen. But the critical bands of the two tones no longer overlap, and beating becomes less noticeable. Composers must always consider such effects as they design their harmony.

The dissonance produced by beating and by critical band interference is magnified by the interactions of the overtones that accompany every musical tone. Although individual overtones may be faint, in aggregate they can constitute an appreciable portion of a tone's total energy. Since every overtone of every note melds into a complex sound wave, there's a large number of interactions between overtones, and these tend to increase overall dissonance. Violins produce prominent overtones, and when we say they have a "rich" tone we mean a tone tinged with complex dissonance. A clarinet has relatively weak overtones (no even-numbered overtones at all), so we describe its tone as "pure" and lacking in dissonance.

A tone's high-numbered harmonics, which fall more than three octaves above the tone's fundamental frequency, are so close together that they create dissonance of their own, quite apart from interactions with other tones. Treble notes usually have few high overtones, since most instruments simply can't vibrate quickly enough to produce them. But bass tones tend to produce a full series of overtones, increasing their tendency toward dissonance. This is one reason why a bassoon sounds quite different from an oboe, though the two instruments are closely related.

Overtones go far in explaining why certain intervals are consonant or dissonant. The tones that form consonant intervals have many overlapping overtones. Tones of dissonant intervals are less well aligned. Intervals that bring about both a clash of critical bands and a riot of beating overtones are particularly jarring. We saw in the last chapter how the shift to a tempered scale met considerable resistance. It's no wonder. By slightly detuning the notes of the scale *in different directions,* overtones were thrown out of alignment to create all sorts of critical band conflicts. Somehow we've learned to overlook a level of dissonance that Renaissance ears could not bear.

The third kind of dissonance originates from the harmonic relations between notes of the scale. It is *structural*. Any given chord can move to only a limited number of others with agreeable consonance; other combinations lead to grating discord. Movement is easy among chords built on the first, fourth, and fifth notes of a scale. Chords built on other notes require a more cautious approach. Sometimes the notes of a chord must be arranged in a particular order from top to bottom to make a graceful transition to some other chord. Or a chord may combine with another chord only when preceding chords have prepared the transition.

There is no real science of chordal relations. Yet there are plenty of textbooks that teach about chords. In the last chapter we encountered standard rules for writing melodies. Following these rules does not ensure a good melody, but breaking them invites a bad one. The same is true of the rules of harmony. But while rules for melodies fill a page or two, those for harmony fill whole volumes.

"Rule" is perhaps a misnomer. There are really no more than guidelines. Harmony textbooks report the most frequently employed harmonic sequences of the eighteenth and nineteenth centuries, the so-called common practice period. That Bach, Beethoven, and Brahms favored these chord progressions is deemed evidence enough of their inherent musicality. For contrast, textbooks regularly point out unacceptable harmonic patterns. Try them out and—sure enough—they sound awful.

Yet any good harmony text begins by explaining that the only hard-and-fast rule for harmonic progressions is that any chord can be followed by any other. This is not whimsy. Even in common practice music, examples can be found of almost any combination of chords. Somehow, combinations that almost always sound dissonant occasionally sound consonant.

The reason is *context*. In the last chapter we saw how the perception of melody is served by the same areas of the brain's right hemisphere that analyze steady-state harmonic relations. Although the notes of a melody occur one after another, auditory cortex maintains fleeting memories of tones long enough to relate them to others occurring a moment later. This is no less true of the multiple, parallel melodies (voices) that generate harmony.

Every chord swims in an undulating sea of harmonic context. There is no considering the effects of a chord, or of a change of chord, apart from what has preceded it.

Ultimately, dissonance is noise, a lack of order, a state of relationlessness; and consonance is the avoidance of noise, the presence of order, a richness of relations. Critical-band dissonance occurs when the cochlea is prevented from making an orderly assessment of frequency components. Beating dissonance occurs when frequency components are in disorderly alignment. Structural dissonance occurs when chords are combined in ways our brains have difficulty modeling.

There's not much we can do about the dissonance of beating and of critical-band conflicts. We have to accept a certain amount of dissonance in order to have flexible scales at our disposal. But structural dissonance is another matter altogether. It varies greatly by the listener's acculturation and formal training. If a composer can find a new way of structuring chord progressions, one chord may resolve to another in what is blissful consonance for that system, although the same progression is deemed dissonant in traditional harmony. But only someone versed in the different harmony will hear it that way. The hidebound (and culture-bound) listener will make traditional sorts of anticipations, and these will clash with the differing harmonic paradigm. It's for this reason that some classical music fans find delight in the outwardly discordant harmonies of Bartók and Stravinsky while others complain bitterly of injured ears. (Note that much contemporary music generates a good deal more dissonance through critical bands and beating than does earlier art music. The listener must overlook this dissonance in favor of the newfound structural consonance.)

Dissonance is hard to tack down even in classical Western harmony. The overall dissonance of a piece cannot be measured simply by tallying the relative number of dissonant intervals formed by chords and melodic lines. It matters where dissonances occur in music. When a dissonance falls at a point of harmonic arrival—a point often emphasized by rhythmic accentuation—the dissonance will clang in your ears. Yet the same dissonance will hardly register when it occurs at a less conspicuous position. The context formed by previous chords also affects the strength

of an individual dissonance. Hundreds of interrelations are at work. And so there are no simple rules that tell a composer how an unfamiliar combination of tones will sound. He simply has to sit down at a piano and try it out.

## Tonality

If good harmony were merely a matter of avoiding dissonance, the composer's task would be much simplified. Music can be made consonant by keeping to the seven scale tones of the prevailing key and by building only simple chords. Yet music written along these lines is no more harmonious than a blank canvas is balanced. Harmony needs dissonance just like a good story needs suspense.

In storytelling, suspense is created by leading a character from initial safety to increasing peril. A good plot wavers back and forth between relative security and danger, returning to complete repose only at the conclusion. There are moments of extreme tension as bullets fly, but these do not last long, lest the audience become too accustomed and lose its sensitivity. The story's drama lies not so much in the extremes of great tension and repose as in the experience of passing between them. Like a roller-coaster ride, what matters is not how high you go, but how far you dive.

The same is true in music. A tonal center is established in the listener's mind and becomes associated with harmonic normalcy. This center becomes the anchor point from which all tones and intervals and chords are measured and compared. It is a constant reference point, a sort of pull of gravity. Adept composers tease the listener with the tonal center, pulling away from it and then promising again and again to return, but always holding back. Only after lengthy expeditions in other harmonic realms, realms that orbit lesser tonal centers, is the listener granted release from his agony. Inferior composers make quick, perfunctory returns to tonal centers, or travel so far from them that the listener hardly recognizes them when finally brought home. The trick is to find just the right balance between reinforcing tonal centers and violating them.

A tonal center is defined by a scale. A piece written in the key of G major is oriented toward the G-major scale. The first note of the scale, G,

becomes the tonal center. In general, a melody written in G major is felt to return to home base when it comes back to the note G.

Chords that go well with G major tend to use only the seven notes of the G-major scale, and not the five others available within an octave. The most consonant chords are those built on the note G, and a return to these chords constitutes a return to the tonal center. Conversely, chords emphasizing the five non-scale tones pull the listener especially far from the tonal center. Laboratory work shows that we remember such chords less accurately than more consonant ones. They can be a burden for our minds to carry.

The first note of a scale is not the only one that is harmonically important. A scale's fifth note (the octave midpoint) also exerts a strong pull, as do the third and forth notes. These scale tones tend to appear more often than others in musical phrases, particularly at stressed positions. So there is a range of probabilities that particular scale tones will occur, with the first note of the scale having the highest probability.

A tonal center also establishes probabilities that tell which notes are most likely to follow a given tone. For example, the last note of a scale (say, B in C major) tends very strongly toward the scale's first note. Such probabilities are constantly in flux, and vary by musical style. They are probably determined to some degree by the Pythagorean relationships we considered in the last chapter. But they are at least as strongly determined by acculturation to musical norms. A chord change that is "inevitable" to Western ears might make no sense at all to Indonesian ears.

Tonal centers are established and maintained by repetition. This is particularly true at the beginning of a piece, or the start of a passage where key has changed. Listen carefully to a favorite tune and you'll probably hear the same note again and again, particularly at points of rhythmic or structural emphasis. In the extreme case, a tonal center can be maintained by a *drone*—an instrument that sounds the tonal center continuously throughout a piece. Scottish bagpipes boast a raucous drone, Indian sitar music a more subtle one. In much Baroque music, a *continuo* consisting of a harpsichord, and sometimes a cello or bassoon, continuously plays patterns of chords rooted in the underlying tonal center. Actually, every genre

of music makes occasional use of drones simply by holding tones for many bars.

The more strongly a tonal center is reinforced, the farther a composition may safely wander from it. The listener will maintain his anticipations in the central key for quite a while so long as no other key is suggested too strongly. Once the listener's ear is well anchored, the composer can dispense with heavy-handed repetition, renewing the tonal center by the mere hint of a closely related chord. And so the composer is freed for harmonic adventure.

Harmony that is "close" to the tonal center is relatively consonant; harmony "far" from it is especially dissonant. The distance is determined by how many notes two scales (and thus two keys) have in common. Only one note differs between the C-major and G-major scales, and so little tension is created in moving between the two keys. At the opposite extreme, the C-major and F-sharp-major scales have only two notes in common, and transitions between their chords tend to be dissonant. There's abundant laboratory evidence that we perceive near-key progressions more quickly and accurately than others. Harmony is easy to follow (and often banal) when chords move merely from one adjacent key to the next.

In principle, one tonal center dominates an entire piece. A piece beginning in G will normally end in G. But along the way harmony can shift to many other keys. Often these deviations are momentary and the basic tonal center is maintained. But sometimes harmony *modulates* into an entirely different key and stays there for a while, establishing the new key as an interim tonal center. And so our minds switch to a different base line for measuring harmonic relations. In this way, we may experience a hierarchy of tonal centers as we listen to harmonically complex music.

Our minds step among tonal centers just as they step among scale tones in a melody, deriving comparable pleasure. It is this motion through a sort of "harmonic space" that elevates harmony to the status of a third musical dimension, adding depth to the two basic dimensions of pitch space and time. Harmonically simple music that revolves around a few chords all in the same key fails to lead the listener on such a journey. It sounds "flat" to those accustomed to journeying deep into tonal hierarchies.

Of the many possible combinations of simultaneous tones, one sounds especially consonant: the *triad* consisting of the first, third, and fifth notes of the prevailing scale. The C-major triad consisting of C-E-G is so harmonious to modern ears that we're apt to call it the "C-major chord," even though many other less pleasing combinations of notes can as easily be assembled from the C-major scale. Triads are at the heart of the harmony we are accustomed to.

There's long been controversy over just why the triad came to dominate almost all the music we like. It was not always this way. Until the fourteenth century, the middle note of the triad was considered unequivocally dissonant. One scientific argument in support of the triad is that it reflects the structure of the overtone series. When C is played as the tonal center of a C-major scale, its overtones include the C above, then G, then C again, then E, then another G, and yet another C. And so you have the notes of the triad. One problem with this argument is that the E representing the triad's middle note is fairly high in the overtone series and not very prominent.

Perhaps the power of triads lies not so much in their inherent qualities as in the structure they impose upon the scale. Each of the three primary triads—built on the first, fourth, and fifth scale tones—has a complement with which it overlaps and moves to gracefully, and these complements fall on the sixth, second, and third scale tones, respectively. So triads impose a system of chords, a sort of grid overlaying the scale, that makes it easy to move about harmonically, with fluid movement between the three main triads, and then on to their complements. Only the seventh scale tone remains as the odd man out. Its triad is inherently dissonant and wants nothing more than to resolve back to the scale's tonal center.

A return to a tonal center is called a *cadence.* The most common, the *authentic cadence,* is heard at the close of almost all popular music, and much art music as well. It is nothing more than a progression from a triad built on the fifth note of a scale back to the triad built on the first. The less common *plagal cadence* (heard in the "Amen" that ends church hymns) moves from the fourth scale note back to the first. Cadences are most evident at the ends of musical phrases, but many partial cadences are also

hidden within phrases. By using modified versions of their basic chords, partial cadences hint at the tonal center without actually returning to it. A tonal center loses its pull without such constant reinforcement.

Once a tonal center and its system of triads have been established, music can travel in many directions along a vast web of permissible transitions from chord to chord. But relatively few chord progressions work very well. Most Western music is built on variations of a few dozen standard progressions. With experience, our brains acquire a vocabulary of these common progressions ("schemata," in the parlance of cognitive psychology). Halfway through hearing them, we anticipate their endings. They are musical clichés. But a talented composer can take advantage of this fact by encouraging the listener to anticipate a standard ending yet writing something different. When the chord anticipated and the chord actually heard are aptly chosen, the contrast can be blissfully excruciating.

Overlapping overtones make triads easy to perceive. But otherwise, we have no good reason to believe that the brain bears an inherent advantage for hearing the triads at the core of our harmonic system. A good deal of non-European music sounds strange to our ears less for using different scales than for lacking triadic progressions. Is our devotion to triads entirely arbitrary, a mere cultural proclivity? In the last chapter we asked similar questions about our choice of a modified Pythagorean scale. Because our triads arise naturally from this scale, the arguments are much the same. No, our brains are probably not tailored to triads. But yes, triads are a particularly fruitful and flexible way of organizing simultaneous tones, and so provide the brain with a rich system of relations to learn to listen for.

To watch the power of triads in action, let's take another look at Mancini's "The Pink Panther" (Fig. 4.1), whose melodic contour we considered at the close of Chapter 3. This tune is based on the E-minor scale, and so its tonal center is the note E, and its main triad is the E-minor triad, or E-G-B. As is often the case, the melody begins on the tonal center (that is, on E—the preceding short note merely ornaments it). After rising to a relatively dissonant note in the third bar, the tune resolves back to the same E at the start of the fourth bar. Then it takes off on another excursion, and when it finally reaches resolution again in the ninth bar, it is again to the same E.

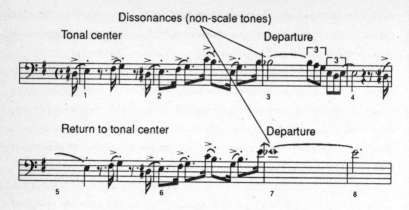

*Fig. 4.1. Harmony in ''The Pink Panther''*

Notice that the notes of the E-minor triad are everywhere. Five of the eighteen notes in the first four bars are E's, four are G's, and two are B's. So only three of the twelve tones of the octave make up 60 percent of the notes in this melody. It's by this inconspicuous repetition that a sense of key is established and maintained.

The importance of the·E-minor triad becomes even clearer when you consider that its notes are the ones that are most heavily accented and prolonged. The melody consists largely of pairings of a short note falling just before a beat, followed by a longer note that falls right on a beat (da-Dah!, da-Dah! . . . ). In each pair, the first notes prepare the ear for the second, which our brains register much more strongly. In this melody, *all* of these accented notes are taken from the E-minor triad.

There's more to the harmony here than just the E-minor scale. The melody arrives at a long, strongly accentuated dissonance in the third bar, and again in the seventh bar as the first four bars are repeated. There's a chord change at these dissonances, nominally to C major for the first, then to F major in the second. These harmonic shifts follow a pattern common to much popular music, moving from the triad built on the first step of the scale to the triad built on the sixth step, then to the second step, and finally back to the first.

The two dissonances in the melody are not taken directly from these

triads, but rather from an extra note added on top of each triad (a "seventh"). We hear these extra notes played in prominent, strongly accentuated positions in the treble. But at the same time we hear the less conspicuous and much more stable tones of the underlying triads in the bass. So the dissonances naturally arise from underlying consonance, making them relatively mild. Composers are not generally free to use just any non-scale tone as a dissonance. It's by employing harmonically related dissonance that composers can gracefully resolve the tensions that dissonance creates.

The harmony of "The Pink Panther" is trivially simple. Four bars of Beethoven would be much more challenging, and four bars of Schumann or Debussy, overwhelming. Such harmony-driven music normally employs harmonic progressions that are far more complicated than the one shown here. And such music often packs many chord changes into a single bar. With many chords echoing in short-term memory, new chords may form prominent relations with several others. Such music also tends to undergo harmonic transitions gradually rather than by discrete chord changes, with several parallel lines adding chord tones at different moments, sometimes with purposeful ambiguity. People who don't know how to listen to such music complain that it "has no harmony" because there are few sharp harmonic transitions to observe (just as they complain that it "has no melody" because melody is dispersed as a theme, or that it "has no rhythm" for want of a steady beat). For their part, composers write complex harmony only by instinct. It is simply too complex for textbook rules to be of much help.

## Relative Pitch and Absolute Pitch

How does the brain go about perceiving chords and cadences? In earlier chapters we saw how harmonic analysis is focused in the auditory cortex of the right brain. Overtone-rich tones are processed predominantly in this hemisphere. By comparison, pure-frequency tones are processed equally on both sides of the brain. Intermediate cases, such as the overtone-poor notes of the flute, are lateralized less than those of other instruments. Behind our harmonic skills are tens of millions of years of evolution applied

to identifying animal calls, and hundreds of thousands of years applied to decoding vowel sounds in spoken language. Such sounds change their harmonic content as they unfold, and this has meant that our brains have had to become expert in following harmonic transitions.

We are all more or less equally adept at perceiving the harmonics of individual sounds. This is to say no more than that the sound of a nightingale, or the sound of the word "muse," falls much the same on every human ear. But this is not what musical harmony is about. It has to do with following complex transitions among clusters of discrete tones. And this means that intervals between tones must be remembered from moment to moment so that comparisons can be made. This skill varies greatly among individuals, so much so that many people are essentially deaf to complex harmony. Unable to detect its deeper relations, they find only a spattering of tones where a keen ear would unearth gorgeous patterns.

At the heart of harmonic sensitivity is the ability to accurately perceive and remember distances between tones—*intervals*. We do this by categorizing distances in pitch space. Just as we categorize individual frequencies as aligning with one of the twelve notes of the Western scale, we categorize varying distances between notes as instances of particular intervals. Because such measurements are relative to any starting point in pitch space, this ability is called *relative pitch*.

Although most of us master relative pitch, it is a hard-won skill. A pre-schooler learns to handle melodic contour and simple meter fairly well, but has little sense of harmonic relations until about the age of five. Prior to that age, a child will constantly shift key while singing a favorite tune, quite unaware of the resulting cacophony. Studies show that while young children can detect key changes, they lack all sense of near and far keys— that is, of relative consonance and dissonance. This understanding does not set in until seven or eight; it's around this age that children begin to discriminate between major and minor keys. By ten a child can follow two parallel voices, and is able to recognize cadences. Full harmonic comprehension begins only at about the age of twelve, if ever.

Some people have too poor an ear for intervals to make much sense of music. Roughly 5 percent of the general population can't hear that

intervals in a familiar tune have been altered by a half-step. These are *monotones,* popularly known as the *tone deaf* (or more diplomatically as *uncertain singers*). Monotones can hear an interval's notes perfectly well, of course, but they can't categorize the interval effectively. For reasons not yet understood, their measurements across pitch space are imprecise and unstable.

There are indications that the tone deaf really do suffer from a kind of physical deafness, but of a kind originating in the brain rather than the ears. Studies have shown that tone deafness runs in families and thus may be genetic in origin. Family life sets the conditions of musical life, of course, so nurture as well as nature may be at work here. But tone deafness is proportioned among family members in ways that indicate inheritance, possibly through a single dominant gene. It may even be a musical counterpart to dyslexia (disordered reading). Like dyslexia, tone deafness appears predominantly in males.

In sharp contrast to relative pitch is *absolute pitch* (or *perfect pitch*), a phenomenon that has been much studied but remains mysterious. In the world of an absolute-pitcher, every sound has personality. A dog howls in E-flat; an air conditioner chants in F-sharp minor; a car's tires sing out the exact speed. At its best, absolute pitch makes each tone in a chord stand out as distinctly as a peach and a pear and a plum in a bowl. D's possess an aura of D-ness, G's an aura of G-ness, each as intrinsic to the sound as whiteness is to snow. Some absolute-pitchers find unique character in individual keys like G minor and F-sharp major. Though there are only twelve tones in the Western scale, most of us just can't find twelve unique qualities among them. We are stricken by a sort of color blindness for sound.

Absolute pitch is reputed to be a skill you either have or you don't. But there is really very little that is absolute here. Only a minority of absolute-pitchers can produce exact tones on demand; most can merely identify them when heard. Many absolute-pitchers can recognize tones solely within a range of a few octaves. Often they succeed only with certain instruments, usually of the kind they themselves play. Some manage only with the particular instrument they practice on daily. It appears that an

instrument's individual notes can be distinguished by their harmonics and noise content, so much so that absolute pitch fails when notes are stripped of this information by playing them softly. Apparently musicians unconsciously learn to spot these cues. Research indicates that piano tones are generally the easiest to identify, followed in turn by strings, woodwinds, brasses, and voices.

Research has shown that many people who appear to possess absolute pitch actually don't. They identify tones by quickly judging offsets from a fixed reference tone kept in memory, a sort of phantom tuning fork. Many musicians who make no claim to absolute pitch carry such a tone in their minds and use it for tuning their instruments. Some apparently are able to judge intervals from this tone so quickly as to be unaware of doing so, leaving the impression of absolute pitch. But they find no characteristic aura in individual tones.

True absolute-pitchers know no such limitations. They'll instantly recognize any tone of any instrument, or even pure frequencies generated by a synthesizer. The very best can instantaneously identify every note in a complex chord. Generally speaking, the faster the recognition, the truer the sense of absolute pitch. No one really knows how many true absolute-pitchers there are. Many studies have been made, but few have adequately accounted for the specious forms of absolute pitch. Although results vary, it's clear that only a tiny fraction of a percent of the general population is endowed with the real thing (1 in 10,000 in one study). Perhaps 5 percent of conservatory-trained musicians are absolute-pitchers.

The key to absolute pitch is early training—*very* early training. One study found absolute pitch among 95 percent of those who started music study at the age of four or younger, but among only 5 percent of those who began between twelve and fourteen. It's probably because of its early, effortless appearance that absolute pitch was long regarded as a "natural gift" rather than an acquired skill. The importance of early training is demonstrated by the observation that those with only partial absolute pitch are more accurate for sounds of the instrument they played earliest, even if much more time was later invested in a different instrument. But just an

early start may not be enough to acquire absolute pitch. Some investigators believe that young children must be drilled in identifying tones if they are to acquire true absolute pitch, since standard music training emphasizes only relative pitch.

True absolute pitch is probably unattainable after childhood. Those who pursue it later in life, usually by listening to tones for hours on end, report mixed results. Some have shrugged in failure; others claim a partial and not always reliable success. The newfound skill tends to ebb away once practice ceases, indicating that it is not true absolute pitch that is learned. Significantly, those who learn absolute pitch by artificial means are less accurate in their identifications after listening to music, while true absolute-pitchers are made more acute.

Absolute pitch is as much a quandary for philosophers as it is for neuropsychologists. Is there really such a thing as F-sharpness? The analogy to color, and to color blindness, doesn't really make sense. Whatever the color red may "be," it corresponds to a particular range of wavelengths of light, just as an adjacent range corresponds to the color orange. The brain finds distinct color experiences within the two ranges. If we were to begin referring to the spectrum differently, so that what we called "red" extended from the middle of normal red to the middle of normal orange, our brains would not obligingly regard the reddish orange at the center of the new range as a distinct color. But we do just this with absolute pitch. As we've seen, the tuning of instruments has shifted markedly over centuries. Mozart's D is not our D. Yet somehow the absolute-pitcher hears quintessential D-ness in today's D just as Mozart did in the D of his time.

The difference in flexibility between hearing and vision can be accounted for by the difference in the ways the cochlea and retina operate. The perception of color is a complicated matter, but neurologically it begins with to three distinct kinds of receptor cells in the retina, one for each primary color. When a receptor for blue is stimulated much more than nearby receptors for red and green, we see blue. As we saw in Chapter 1, the cochlea is designed quite differently, with a long stretch of receptors tied to a range of frequencies. Broadly speaking, every point in the cochlea

is as important as any other. There are no F-sharp detectors in the cochlea the way there are blue detectors in the retina. So pitch is as relative biologically as it is psychologically.

The neurology of absolute pitch has long been obscure. It's hard to gather data on so rare a phenomenon. Using new brain scan technology, researchers recently claimed to have found the locus of absolute pitch in the left brain, smack dab in the region most credited with the comprehension not of music but of language. We'll take a look at this part of the brain in Chapter 9 when we consider the relationship between music and language. For now, suffice it to say that this language area is an important point of asymmetry between the two sides of the brain, and a feature unique to human beings. Significantly, Maurice Ravel lost absolute pitch when he suffered brain damage in this area and his language skills dissolved.

But what does absolute pitch have to do with language? One possibility is that structures specialized for identifying speech sounds are brought into play. These are crucial to achieving a perfect accent in a language, which, like absolute pitch, is hard to come by after childhood. It appears that the developing brain undergoes critical periods during which various aspects of language must be acquired if they are to be perfect.

Absolute pitch is sometimes held up as the ultimate musical endowment, an emblem of superior musical skill, of initiation into a secret society. What else are we to think when we hear how the four-year-old Mozart would correct his father's violin tuning? Yet while absolute pitch is useful for getting musical imagery down on paper, some composers have done quite well without it, including Schumann, Wagner, and Tchaikovsky (significantly, all three lacked intensive musical training in early childhood). Nor is absolute pitch of particular value to musicians—not even to singers, whose instrument offers no reference point for proper tuning. The alliance of relative pitch with memory for recent tones is enough to keep musicians in tune. Batteries of music aptitude tests have found no strong correlation between absolute pitch and other musical skills.

Well-developed absolute pitch is not an unmixed blessing. As we age, our cochleas shrink slightly, often leading to a gradual rise in perceived pitch. What sounds like middle C in youth takes on the quality

of C-sharp or even D in old age. Since all pitches rise together, we don't realize that our ears have been retuned. This process, called *paracusis*, has no effect on the cortex, where memories of absolute pitch go unchanged. So arriving tones can clash with expectations. Senior absolute-pitchers sometimes lament that their favorite compositions, memorized from many hearings, sound out of tune, or arrive in the wrong key. When pianist Alicia de Larrocha was asked if she possessed absolute pitch, her response was telling:

> I used to have it. Unfortunately, with age, little by little it's going. Until a few years ago, I could say exactly the notes, chords, intervals, everything. But now, ah, we have to accept the things we don't like, and sometimes I know that I am hearing the pitch a little higher; so I have to figure out and say, it has to be an A.

Whatever the drawbacks of absolute pitch, its very existence is astonishing. We're accustomed to the idea that some kinds of experience belong only to a few, such as identifying antiques or comprehending Swahili. But these are advanced skills built from simpler ones. Absolute pitch appears to be as basic a perceptual skill as there can be. It is as if a lucky few walk through a world bearing an extra dimension. Might our brains be capable of other forms of little-known experience if only culture would nurture them?

## What More Can Harmony Be?

Music would hardly have come into being had absolute pitch been necessary for perceiving tonal centers. Luckily, we can quickly tune short-term auditory memory to the first tones of a performance, then maintain that tonal framework to the final bar without any idea of exactly which notes we are hearing. If on another day we hear the same composition in a different key, we won't notice.

The relativism of pitch perception is paralleled by the relativism of tonal centers. As a brain follows a complex composition through a hierarchy of tonal centers, it obligingly moves its baseline of perception. While

scale tones are defined as *offsets* from a scale's first note, harmony is built upon offsets from the offsets of scales, and offsets from offsets from offsets. Harmony is inherently complex, inherently intellectual, inherently difficult. As we've seen, it is the last aspect of musicality to mature in the young, and tests show that many people never achieve harmonic sophistication. Not surprisingly, harmonic depth is rare in popular music, even when rhythm and melody are reasonably well developed.

This is not to say that music can go without harmony altogether. Melodies rely on scales, and scales upon underlying harmony, so harmony resides in all music except the purely percussive. It is a question of degree. Ethnomusicologists sometimes bicker over the presence or absence of harmony in the music of other cultures. Yet tonal centers are usually plain to hear. Again, it is a question of degree. Is the tonal hierarchy only one or two layers deep? Or does it extend to five or six levels?

Despite the efforts of the atonal composers, "harmony" virtually always means "tonality," the design of music around tonal centers. Tonality is so much a part of our musical understanding that few people can imagine music without it. Musicologist Richard Norton points out that

> [traditional] tonality easily accounts for all the popular music of the last
> two centuries—from the waltz, brass-band music, operetta, and the Vic-
> torian hymn in the nineteenth, to American band music, ragtime, jazz,
> blues, swing, rock, country and western, reggae, easy listening (black
> and white), soul, and the Broadway musical in the twentieth. There is
> no form of popular music in the modern, industrialized world that exists
> outside the province of mass tonal consciousness. It is the tonality of the
> church, school, office, parade, convention, cafeteria, workplace, airport,
> airplane, automobile, truck, tractor, lounge, lobby, bar, gym, brothel,
> bank, and elevator. Afraid of being without it while on foot, humans
> are presently strapping it to their bodies in order to walk to it, run to it,
> work to it, and relax to it. It is everywhere.

Yet just as the Western tonal system colonizes much of the globe, some musicologists are claiming that it is exhausted. They believe that

through centuries of experimentation, composers have discovered every useful relationship our scale system has to offer. Prior to the twentieth century, every generation of composers would invent new harmonic devices, would integrate them with the old, and would develop a new sound in the music of their time, a sound that the public would eagerly embrace after some initial resistance. In the twentieth century, composers have done the same, sometimes augmenting traditional tonality, sometimes fleeing to atonality. But after decades of dutiful performance of their works, audiences have yet to embrace the new harmonies as they have in the past.

What has gone wrong? We've seen how research has cast doubt on the perceptibility of atonal music. But even tonal harmony must have its limits. All technologies ultimately run out of steam—which is only to say that there are limits to what brains can readily make sense of. If composers are yet to discover fundamentally new harmonic constructs that our brains will accept gladly, the only answer may lie in adopting new, unexploited scales. But scales take centuries to settle into the common imagination. A concertgoer in New York is no more likely to take to a new scale system than to adopt a steady diet of gamelan music.

Fortunately, harmonic pleasure has never depended upon sheer numbers of harmonic devices. Were that the case, Handel's music would seem impoverished beside Debussy's. Many of the most stirring passages in Beethoven's symphonies are built on trivial harmonic constructs found in any textbook. Placed in the right context, the simplest harmonic devices can still be the most powerful. Just a straight line of scale tones can pull you to pieces—but again, only with the right harmonic backdrop. And so the path to further harmonic innovation may lie more in finding new ways of structuring harmonic context, and less in renovating scales or building new kinds of chords. New life may await harmonic devices we already know well. Perhaps the next breakthrough will come not when another European composer affects the sounds of Indonesia, but when an Indonesian composer embraces the sounds of Europe.

# 5

From sound...
...to tone...
...to melody...
...to harmony...

# ...to rhythm...

At eight o'clock in the evening, beneath the gloomy skies of a Viennese winter, a crowd gathers at a concert hall. They have come to observe a Christmas ritual, a performance of *The Nutcracker*. In twos and threes, and then in a great rush, well-dressed concertgoers pass through polished marble corridors and on to a vast hall ribbed by balconies and crowned by chandeliers gleaming upon carved paneling. Despite its antique façade, this building embodies the spirit of the modern world, telling of carefully calculated blueprints, of precision machine tools, of giant ships transporting stone from afar, and (through recent modifications) of computer-simulated acoustical analysis.

At the same moment of the same day, another group assembles to enjoy music. They gather not in Vienna but some thirty-five hundred miles to the south in central Africa. There, it is the end of a long tropical day, the crops have been tended, the cattle brought in from pasture. A hundred peasants have assembled in the courtyard of their village. They arrive from no farther than surrounding huts constructed from simple materials gath-

ered locally. It is a traditional, pre-technological society of the kind where most of the world's music is made and heard even today.

In Vienna, the musicians assemble on stage toting a panoply of intricate instruments. These have been meticulously crafted by specialists wielding precision tools. Every curve of wood and metal has been studied by physicists, every varnish and alloy carefully selected from among thousands. The musicians are equally well molded. Most have at least fifteen years of formal musical training, and they practice day and night. Before them a cleanly printed score presents meticulously composed music encoded in an elaborate notation system. The music is so complex that the musicians themselves cannot coordinate its performance, so a conductor stands before them, "playing" the music's deep structure as the musicians render its details.

But to the south there is no stage, no ensemble of professional musicians, no conductor, not even a proper audience. The instruments are crudely fashioned from nearby trees and imperfectly tuned. The players are ordinary villagers who have learned their instruments informally; the very idea of a conservatory would be incomprehensible. Just about everyone participates one way or another, if only by clapping hands. There is no composer and no score. They perform from memory.

At the same moment in north and south alike, the music begins.

*In Vienna,* the "Miniature Overture" begins. A few audience members discreetly and soundlessly tap their toes in time: ONE-two, ONE-two, ONE-two.

*In the African village,* a drummer slaps out the pattern ONE-two-three-four-five-ONE-two-three, ONE-two-three-ONE-two-three-four-five. Bystanders bob up and down in excitement.

*In Vienna,* it is time for the "March": ONE-two-three-four, ONE-two-three-four.

*In the village,* a second drummer thumps ONE-two-ONE-two-three-ONE-two, ONE-two-ONE-two-three-ONE-two over the differing pattern of the first drummer.

*In Vienna,* the hall is atwitter with the "Dance of the Reed Flutes": ONE-two, ONE-two.

*In the village,* women begin to interweave song with the drumming, entering and exiting in constantly changing patterns.

*In Vienna,* as *The Nutcracker* draws toward its close, French horns holler out the "Waltz of the Flowers": ONE-two-three, ONE-two-three.

*In the village,* a last drummer joins the melee: ONE-two-three-FOUR, ONE-two-three-FOUR, overlapping the others but starting on a different downbeat. The festivities continue far into the night.

What's going on? Everything about the Vienna concert is taken to the highest degree of refinement—the concert hall, the instruments, the score, rehearsals, the training of the musicians. The music itself burgeons with elaborate melodies and harmonies and orchestration. Yet in its rhythmic development it seems to rival a baby banging a spoon on a pan. Meanwhile, despite a lack of technological sophistication, the African villagers appear to have developed rhythm to its apex. Few of the Viennese musicians could match their rhythmic skills.

But not so fast. People like to say, "My music's got rhythm!" Yet there's little general agreement on the meaning of the word. Rockers may feel kinship with African drummers, yet the larger rhythms of most rock music are no more complicated than those of a waltz. (Significantly, recordings of actual African drumming sell few copies.) Even much jazz is rhythmically simple. Nonetheless, people everywhere claim to be overwhelmed by the rhythm of the music they enjoy, often because they associate rhythm with drums, and the drumming in their music is very loud.

In this chapter we'll consider two very different notions of rhythm. On one hand, there is the familiar idea of rhythm as patterns of accentuated beats. These patterns may vary from moment to moment, and they can be modified by syncopation and other devices to make them more interesting. This is the predominant "rhythm" of most popular music the world over. Its hallmark is the incessant beating of drums. Musicologists refer to this type of rhythm as *meter.*

The second conception of rhythm is quite different, so different that at first glance it can seem to have nothing to do with rhythm. There is a kind of rhythm we generate all day long, the rhythm of organic movement. It is the rhythm of the runner and the pole vaulter, the rhythm of cascading

water and howling wind, the rhythm of the soaring swallow and the leaping tiger. It is also the rhythm of speech. This kind of rhythm lacks the repetitive, evenly paced accentuations of measured rhythm. In music it is built up by a succession of irregular sonic shapes that combine in various ways like the parts of a painting, sometimes hanging in exquisite balance, sometimes joining forces to gyrate or plunge or swirl. For want of a standard term, call it *phrasing*.

The two conceptions of rhythm are sometimes referred to as *vocal* (for phrasing) and *instrumental* (for meter). Phrasing is "vocal" because it naturally arises from song, and thus from speech. Meter is "instrumental" in that it derives from the way we play musical instruments, which generally permit greater speed than the voice, and finer temporal accuracy. One is the rhythm of the throat, the other the rhythm of the hands. When an ethnomusicologist working in the Indonesian island of East Flores found a succession of nine time signatures (nine different meters) in what he took to be ten bars, he was trying to impose the rhythm of meter upon what was actually the rhythm of phrasing. Conversely, playing a drum unmetrically can feel as unnatural as speaking words in time to a metronome. Figure 5.1 shows meter and phrasing in "The Pink Panther."

Music could hardly exist without both kinds of rhythm. Meter gives order to time. It organizes small groups of notes, and sometimes larger ones, and thereby provides a sort of grid upon which music is drawn. On the other hand, phrasing imparts a kind of narrative to music. It is the

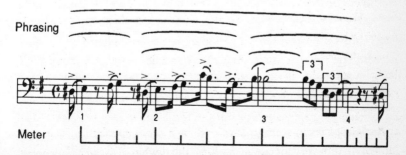

*Fig. 5.1. Meter and phrasing in "The Pink Panther"*

mechanism by which a composition can play out a grand drama. Broadly speaking, meter organizes musical time on the small scale while phrasing organizes it on the large scale. Without meter, music takes on the static quality of Gregorian chant. Without phrasing, music becomes repetitious and banal. Yet as we shall see, when one kind of rhythm is emphasized, it tends to obscure the other. The two kinds of rhythm are not entirely at peace with each other.

## Chunking

Music provides us with the longest sonic objects our brains ever encounter. A brain requires some way of breaking these objects into pieces so that it can analyze them piecemeal. It can't wait until the end of a ten-minute composition to figure out what happened. And so a brain is always on the lookout for clues about where musical objects begin and end.

What we call "rhythm" exists in music to help the brain in this task. Rhythm draws lines around musical figures. A sequence of rhythmic markers tells the brain: "This is the beginning, or the end, of a musical object." Thus the brain knows that it has acquired all the information it needs to understand a particular musical figure, that it has taken in a mouthful and it is time to swallow.

Without rhythmic markers, the brain would quickly be overwhelmed by a multitude of observations. Even the notes of a simple melody can be grouped in many ways. Consider the song "Twinkle, Twinkle, Little Star." It follows a four-beat meter, opening with the words "Twinkle . . . twinkle . . . little . . . star" carried each by its own beat. Once a brain has heard the tones of all four beats, it integrates them into an arching melodic fragment. Then comes the next metrical period of four beats, "How I . . . wonder . . . what you . . . are," integrating them into a descending fragment. With two such fragments on hand, the brain searches for deeper relations, finding a cycle of rising melodic tension in the first bar and release in the second, a harmonic progression away from the tonal center and back again, and matching patterns of sub-beats (two syllables, two syllables, two syllables, one syllable). The importance of rhythmic markers in making sense of all this is demonstrated by singing the passage in three-beat groupings: "Twin-

kle . . . twinkle . . . little / star . . . how I . . . wonder / what you . . . are . . . up above . . ."

Notice that there's more than accentuations holding together the musical groupings of this song. We insert a slight pause at the end of each phrase; there's an important chord change at the start of the second grouping; and further clues are given by the syntax of the words. These are all rhythmic markers. They cut up a torrent of notes into bite-size chunks that our auditory systems can process. Fittingly, psychologists call this grouping activity *chunking*.

Chunking is often hierarchical, with small chunks grouped into larger chunks, and so on, until quite large musical objects are formed. We comprehend the smallest chunks more or less instantly. But the largest chunks do not come together until a long sequence of events is complete. Comprehension remains tentative until everything suddenly snaps into place. It is easy to observe this phenomenon in our perception of language. Our brains grasp individual words as they appear, but not yet the meaning of a whole sentence. Yet we achieve some degree of understanding before the sentence is completed by formulating partial understandings of phrases and subphrases: "If Mary has time" . . . "I'm going to ask her" . . . "to bring over" . . . "her guitar." A similar hierarchy of understanding unfolds as we listen to complex music. Rhythmic markers simplify our perception of such hierarchies, and thereby make them possible.

# Meter

Rhythm is often likened to the beating of a clock, suggesting that it is concerned with measuring temporal durations. This is indeed the case. The brain's purpose in measuring time is not unlike its purpose in measuring intervals across pitch space. Pitch intervals provide the basis for detecting relations that define chords and harmonic progressions, and that establish a sense of key. Similarly, our brains measure the lengths of individual sounds and the silences that fall between them, seeking patterns among these durations, and then patterns of patterns. Music can exist in the absence of strict temporal patterning (Gregorian chant, for example). But without temporal patterning, music is robbed of an entire dimension.

Yet time is not so readily gauged as pitch space. In observing pitch space, our brains naturally perceive octaves that can be subdivided to form scales. Once a brain has become accustomed to a culture's scale structure, it can use the scale's pitches as a framework for perceiving any composition that comes its way. Every half step from note to note will be exactly 5.9 percent higher in frequency than the note below; the interval from C to G will always entail the same proportional frequency change.

But time presents no natural unit of measure akin to an octave, no ironclad tick-tock of a neurological clock that can be subdivided into smaller units, into a sort of temporal scale. It is easy enough to categorize a whole note as two half notes, a half note as two quarters, a quarter note as two eighths. But this hierarchy tells nothing about how long any of these notes actually lasts. An eighth note might endure a half second in one composition but only a tenth of a second in another. So the brain cannot approach a composition with fixed notions of temporal durations the way it can for pitch distances. It must stretch or shrink its temporal categorizations to fit the individual composition. This it does primarily through meter.

At the core of meter is *pulse,* an unceasing clock-beat that rhythmic patterns overlay. Idealized, pulse exists as the steady recurrence of contraction and relaxation, tension and release, every beat a renewal of experience. When a brain begins to sense a train of pulses, it continues to anticipate them even when individual pulses disappear into silence, or into notes held long. Yet a train of pulses must be continually reinforced lest the brain's anticipation of them wane. Much as musical harmony requires constant repetition of tonal centers, musical rhythm needs constant reiteration of the underlying pulse. Just a few seconds' lapse and the listener can become lost.

Psychologically, pulse constitutes a renewal of perception, a reestablishment of attention. It is a basic property of our nervous systems that they soon cease to perceive phenomena that do not change. Pulses keep unchanging phenomenon alive. This process of renewing attention comes so naturally to us that our nervous systems add pulse where none is found. Sing a note quickly and you'll make a single vocal motion. But draw out

the tone to many seconds and you'll find yourself adding a subtle accentuation every second or so, almost as if you were counting out the tone's length. To hold a steady monotone you'll have to fight this natural tendency to divide long experiences into shorter ones.

Music sounds like machine-gun fire when every pulse is as loud as every other. And so certain pulses are made more prominent by accenting them. Typically, every second or third or fourth note is played louder, causing our brains to automatically form groups of two or three or four beats, each group starting from the accent. In essence, our brains measure distances through time as groupings of beats. Music in three-beat meter is usually specified as being in "3/4 time," meaning that it is parceled in groupings of three beats, each a quarter note long.

Our perception of meter hinges on prime numbers. Recall that a prime number is one that cannot be evenly divided by any other whole number (except 1). The number 3 is prime and can't be subdivided, so we grasp three-beat meter whole: ONE-two-three, ONE-two-three. But 4 is divisible by 2, and so we tend to hear four-beat meter as two groups of two beats, with lighter accentuation at the start of the second pair: ONE-two-Three-four, ONE-two-Three-four.

What about meter of more than four beats? The number 5 is also prime, so it can't be subdivided evenly. A brain perceiving five beats as two followed by three, or three followed by two, would strain to constantly readjust its scope. So the brain tries to grasp the five beats as a whole. But five beats runs much longer than the two-and three-beat periods to which we're accustomed, and many listeners can't manage it. They complain that music written in 5/4 time "has no rhythm." Although instances of five-beat meter have appeared throughout the history of Western music, even professionals can have a hard time with it. At the premiere of Ravel's ballet *Daphnis and Chloé,* which contains long passages in 5/4, dancers managed to keep time only by counting out loud the impresario's name:"Ser-ge Dia-ghi-lev, Ser-ge Dia-ghi-lev." Seven-beat meter is even more challenging.

Most Westerners have so much trouble with extended meters that even some musicologists have declared them incomprehensible. But much

of the world revels in metrical complexity. In fact, it is the absence of complex meter in the West that is anomalous. Wherever music emphasizes complex meter, ordinary people learn to perceive it, even *additive meter* that alternates between, say, groups of three beats and four.

An even greater perceptual challenge is posed by *polyrhythm*. Poly-rhythm might more accurately be called "polymeter," since it's made by playing more than one meter at a time. There can be three beats in one voice to two beats in another, or four beats to three, or thirteen to six. Any combination is possible, and any number of meters can be combined. The opening of this chapter describes four simultaneous meters in African drumming. Figure 5.2 shows some examples.

Polyrhythm makes your brain work overtime by demanding more attention than the simple meters found in most music, where sixteenth notes fit evenly into eighths, eighths into quarters, quarters into halves, everything nicely aligned. This orderly arrangement lets the brain anticipate coming notes easily as halvings or doublings of the underlying beat. But when three notes overlay four in a polyrhythm, irregular distances fall between the notes of the two meters. The result is a sort of temporal texture that requires close listening to grasp analytically.

Try making a polyrhythm. Set your left hand tapping: One-two, One-two. Then let loose with the right hand, tapping three times for every two in the left, and starting the first beats together. Did you manage it? Don't feel bad if you didn't. It's terribly difficult for one brain to simultaneously generate two rhythms, even when they are related. For all their skill, even African drummers usually have only one rhythm to carry, though they must coordinate that rhythm with others. In the West, most professional musicians never really learn to produce polyrhythms. When they encounter one, they just keep an eye on the conductor's baton and barrel through in their own time, ignoring the competing meters of other instruments. But musicians who produce more than one voice, by keyboard or a com-bination of percussion instruments, struggle with polyrhythm daily.

Polyrhythm is rare in Western music, yet it has been around for a long time. You'll find instances in the experimental music of the early Baroque, in Mozart and Beethoven, and especially in the music of Romantic com-

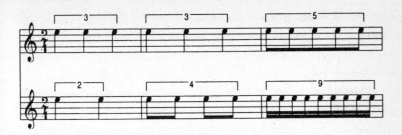

*Fig. 5.2. Examples of polyrhythm*

posers like Schumann and Brahms. In classical music, polyrhythm often is employed ornamentally as a sort of rhythmic bump in the road. But long polyrhythmic passages also appear. There's a good deal of polyrhythm in jazz, but not much elsewhere in the West. It's found extensively in the traditional music of the Middle East, Asia, and above all, Africa.

Sometimes polyrhythm is more subtle. Rather than two rhythmic lines, there's a mere hint of a second one. This is the case with *syncopation,* in which beats are accentuated apart from the regular metrical pattern. Accentuations away from beats are found in all music. We tend to call music "syncopated" when the offbeats are so regular that the listener begins to anticipate them. In essence, the syncopated beats form a second rhythmic line countering the first, a ghost of true polyrhythm. In Western music syncopation is nowhere so pronounced as in the broken rhythms of ragtime—"time in tatters."

Metrical complexity is sometimes compared to harmonic complexity. The parallel is certainly intriguing. Just as scales subdivide pitch space, meter subdivides time. Much music follows simple meter in the same way that harmonically unimaginative music keeps to the tones of the diatonic scale. Rhythmically adventurous music deviates from monotonous meter, whether by additive meter or syncopation or polyrhythm, just as harmonically adventurous music makes use of chromatic scale tones and hierarchies of tonal centers. In this view, complex meter is analogous to harmonic dissonance. Western music explores harmonic dissonance most deeply while certain non-Western cultures have pursued rhythmic dissonance.

This argument is elegant and appealing. Whether it is true or not is another matter. We'll address it later in this chapter.

# Phrasing

Phrasing is nothing like meter. For one thing, its markers are more subtle. Where meter presents a regular, mostly predictable succession of emphasized notes, phrasing constantly varies. It is most easily observed in music that accompanies the natural phrasing of the words of a song. Phrasing is also particularly salient in instrumental music arising from vocal traditions. One reason that a Baroque composer like Vivaldi has such popularity among those who otherwise reject classical music is that the phrasing of his music is completely obvious, and so it is easy for a brain to spot its component parts. Beethoven is harder, and Wagner much harder still. By the beginning of the twentieth century, phrasing became as complicated in its own right as any African polyrhythm. Like complex meter, complex phrasing is only observable by a mind well-steeped in its techniques and conventions.

As phrasing grows in complexity, it ceases to resemble spoken phrases. Successions of short, quick phrases can be woven into undulating textures. Or many longer phrases can be built into an extensive hierarchy as imposing, and as difficult to follow, as a page-long sentence in a Faulkner novel. In contrast to the small, squarish building blocks of meter, phrasing takes on any shape and size. Meter is brick, phrasing is poured concrete.

But why regard phrasing as a kind of rhythm? Because, like meter, it also is devoted to mapping the flow of time in music. If you disrupt a composition's meter by accenting, say, every second beat instead of every third, as it is written, the composition disintegrates before your ears. With related notes no longer heard together, the composition becomes incomprehensible even though it still "has rhythm" in the sense of offering an easily perceived beat. This demonstrates that it is not meter's beating per se that makes it rhythmic, but rather the way it organizes perception. Similarly, when phrasing markers are misplaced, music ceases to make sense as

assuredly as if the outlines of one drawing were superimposed on the shapes of another.

The mechanisms of phrasing are quite different from those of meter. Meter works through predictability. Accentuations that establish meter cause a brain to repeatedly group notes the same way. Melody and harmony must be tailored to fit these time units. Meter is tyrannical in its regularity, but it is sure. In contrast, phrasing largely works through the inherent meaning of the sound it contains. Just as a spoken phrase is finished when something meaningful has been said, musical phrases carry an entire musical idea. Often this idea is a harmonic one. Riding a melodic line, harmony wanders into unfamiliar territory then returns to momentary repose. Upon hearing this resolution, a brain groups the preceding notes, then readies itself to perceive the next progression. Lesser resolutions create lesser phrases that can be built into hierarchies of larger ones.

To understand the importance of meaning in phrasing, consider what happens when the rhythm of speech is upset. Instead of "Four score . . . and seven years ago . . . our fathers . . . brought forth . . ." the words might come out as "Four . . . score and seven years . . . ago our . . . fathers brought . . . forth . . ." It's immediately obvious what's wrong here. Words that combine to form larger meanings aren't spoken together. "Years ago" means something; "ago our" does not. So when we talk about the rhythm of speech, we're talking (partly) about cutting up the flow of words into meaningful groupings. The same is true of musical objects. Wrongly phrased music disintegrates just as assuredly as music played in the wrong meter.

Phrasing can be defined by mechanisms other than harmony, such as by alternating instruments at phrase boundaries, or by contrasting loudness or texture or pitch range. Like meter, phrasing also relies on markers. Subtle pauses, opening accentuations, melodic embellishments—all help announce the beginning of one phrase or subphrase, and the ending of the one that preceded.

When a composer writes masterful phrasing, and musicians successfully render it, every aspect of music is unified in its support. In result, the brain

perceives a series of distinct musical shapes extending across time. By contrasting the contours and sizes of these objects, and their positions in time and pitch space, a composer can lay out an abstract scene much as an artist does on canvas.

These sonic landscapes are quite invisible to those who lack the necessary perceptual skills. A brain must be well versed in harmonic conventions to recognize phrase boundaries. And, perhaps most important, short-term memory must be skillful enough to hold on to complex musical devices for many seconds until every component of a scene is in place. The ear cannot go back to bygone notes for a second glimpse. Memory is music's canvas.

As musical landscapes grow, they rise to the scale of musical *form*. The word "form" is often used in reference to structural recipes. For example, much music—classical and popular alike—conforms to an AABA form in which a theme is presented for a certain number of bars as section A, repeated and developed in section B, contrasted with a second theme in section C, and the tension between the two resolved in section D. Some recipes dictate particular chord changes over precise numbers of bars. This is true of the blues, with its three groups of four bars following a prescribed harmonic progression. Structural recipes of this sort provide composers with a framework for organizing the rigors of composition. Much of history's greatest music is written to such specifications. So is an ocean of bland, paint-by-number tripe.

The word "form" is also used in reference to very large scale phrasing. When meter is made complex, it quickly approaches the limits of perceptibility. A multilevel metrical pattern spanning a whole minute would reach far beyond the carrying capacity of short-term memory, since our brains have little talent for remembering gradations of intensity. In contrast, phrases are formed from aspects of music our brains remember well, including whole melodies and harmonic transitions. So phrasing can be built up into landscapes spanning an entire symphonic movement. It takes a good musical memory to grasp such a landscape, and an absolutely extraordinary musical mind to create one.

In all branches of cognitive endeavor, our highest praise is reserved for

works that build the deepest hierarchies. When these works are scientific theories, they explain the world more comprehensively than lesser ones. When they are works of scholarship, they trace first causes. And when they are works of art, they show us relations far deeper than we are normally able to perceive. In music, it is phrasing that reaches farthest across time to encompass the deepest relations. Thus ingenious phrasing and form, rather than metrical complexity, are extolled as the apogee of musical composition.

Nonetheless, music that emphasizes the rhythm of phrasing still demands a good dose of the rhythm of meter. Meter's role in grouping short successions of notes is invaluable in nearly all music. One reason is that the durations of individual notes, like the tunings of their pitches, are seldom played to perfection. Musical instruments are too ungainly for musicians to get them just right. But meter categorizes note durations so that we find a pleasing evenness in the notes we hear. Just as we perceive any pitch near F-sharp as an instance of F-sharp, any duration close to a quarter note is regarded as instance of one. These categorizations provide the building blocks for the larger rhythmic structures of phrasing.

To understand better the interplay of meter and phrasing, let's return to the example of "The Pink Panther," which we considered in earlier chapters. This tune evinces rollicking drive. People can hardly keep themselves from moving as they sing it. Yet tapping out the underlying beat isn't particularly easy. The rhythmic power lies much more in phrasing than in meter. Figure 5.3 diagrams rhythmic junctures in this theme.

The first four bars form a single phrase built on a melodic contour that, as we saw in Chapter 3, basically describes the rise and fall of an E-minor scale. This phrase constitutes a complete, high-level unit of perception that is shaped by many forces. It is defined by a melodic arch that begins and ends on the same lowest note. It is defined by a harmonic transition from E minor to the high-tension dissonance in the third measure, and then resolution back to the E minor. It is defined by dynamics as a jazz orchestra boosts its volume to emphasize the dissonance, then trails off at phrase end. And it is defined by the internal structure of the phrase, marked in Figure 5.1 (page 123) by short phrase lines nested in larger ones.

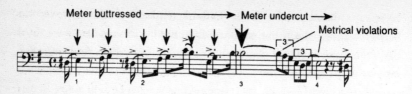

*Fig. 5.3. Rhythmic junctures in "The Pink Panther"*

Regard the hierarchy of subphrases and sub-subphrases in Figure 5.1. The smallest unit of comprehension is the pairs of notes in the first two bars. A brain can hardly attend to these notes separately. They are heard as a unit. These units combine into a larger subphrase defined mostly by melodic contour. And these in turn combine into the large upward-traveling subphrase that approaches the long dissonance in the third bar. This note is strongly accented, and in another context it might mark the end of one phrase and the beginning of another. But its relative dissonance creates harmonic tension that demands resolution. In a sense, the music is holding its breath; the phrase can be complete only when it has exhaled. This happens through the simple subphrase of five notes that leads back to the tonal center at E.

Notice that this final subphrase, where groups of three notes are bracketed by the numeral 3, is a kind of polyrhythm. The markings indicate that all three notes should be played during one beat, instead of the usual two notes. The listener's anticipation of two combines with the actuality of three to produce a sort of implicit polyrhythm. Perceptually, this rhythmic nuance makes the phrase seem to vanish suddenly, as if the creeping panther has ducked out of view.

This polyrhythm gives a brain more to do in each beat, and so intensifies the brain's struggle to perceive. Elsewhere, particularly in the first bar, phrases are shorter and more dispersed, and the brain has less to contend with. Such variations in information flow create their own tensions and releases—a different sort of rhythmic accentuation from the mere variations in loudness that typically define meter.

Composers gain maximum effect by interweaving the tensions created

by music's various aspects. Here, rhythmic tension increases in the second bar, then culminates in the tension of the sudden dissonance in the third bar, a dissonance made all the more powerful by its position at the effective peak of the melodic contour. All three forces are embodied by the same tones, and so they present a seamless musical experience. The listener has no idea that he is being prodded from several directions at once.

Notice that Figure 5.3 shows hardly a trace of the metrical *thump-thump-thump-thump* so common in popular music. Classically trained, Mancini consistently subjugates meter to phrasing. True, the accented notes of the first two bars drop right on the beat. But not every beat is struck, and there's not enough repetition to establish strong anticipation for meter.

Instead, Mancini carefully undercuts the metrical pulse in the third and fourth bars, going out of his way to avoid accentuations. After accenting the long dissonance at the start of the third bar, he carries it over the crucial middle beat of this measure so that it goes unaccented, and only then does he begin the melodic descent through the five notes of the final subphrase. Most important, the melody arrives at the final E just before the beginning of the fourth bar, and so sluffs over this important downbeat too.

By these contrivances, Mancini prevents the listener from chopping his elaborate four-bar phrase into even metrical subunits. When his subphrases match the underlying beat, as in the first two measures, Mancini emphasizes meter. When they don't match, he undercuts meter. In either case, his focus is upon extended phrasing, upon building large-scale musical objects and thereby inducing large-scale musical perceptions.

## The Perceptual Present

Neurologically, there is a world of difference between perceiving a metrical pattern of two seconds and perceiving large-scale forms spanning several minutes. Meter unfolds "before our ears"; its comprehension demands little more than attentiveness. Form makes itself known through a kind of intellectual discovery that demands a well-developed musical memory for sustaining musical fragments over long periods. Two very different notions of time are at work here, one perceptual and one analytical. Yet we use the word "time" indiscriminately, as if the experience of one min-

ute were equivalent to sixty experiences of one second. We need to take a closer look at what we mean by "time" if we are to understand how rhythm gives order to it.

A familiar notion of time is at the tips of all our tongues: a single dimension stretching forward and backward to eternity, its every instant a point of infinitely short duration. Sandwiched between past and future is something called "the present," where experience occurs, including the experience of hearing music. Although we pass our entire lives in the present (for even memories and expectations are experienced there), we can't really put our finger on that moment we call "now." After all, we have no sensors for time as we do for light or sound. There is nothing there to sense. Rather, the psychological experience of time arises from the nervous system's perception of its own interactions with the world. Psychological time is the experience of having experience.

While philosophers and physicists forever argue about the absolute nature of time, neuropsychologists take a more pragmatic view. For them it's nonsense to speak of an infinitesimal present, of a present that is really not there at all. Laboratory work shows that when events occur extremely quickly or extremely slowly the nervous system simply doesn't sense them. Whatever truths the physicist's instruments or the philosopher's deductions may tell, for the psychologist the "present" has a finite, measurable extent. It is the minimum time it takes to sense and perceive and categorize, and it is dictated by the speed at which neurons fire.

This duration is called the *perceptual present*. It's classic definition was given by the American philosopher William James a century ago: "The practically cognized present is no knife-edge, but a saddle-back, with a certain breadth of its own on which we sit perched, and from which we look in two directions in time."

Just how broad is that saddle? How long does it take for immediate experience to fade? Estimates vary widely, from a half second to as much as ten, with most psychologists agreeing that the perceptual present constantly varies in width, but spans about two seconds on average. So broad a range of estimates suggests that different things are signified by the term, that we have little common notion of what we mean by the word "now."

Yet "now" is when we experience music. With a perceptual present of only two seconds, there's little time to directly grasp very much of a composition. We witness only about 1 percent of a three-minute song; then we move on to the next percent (or, more correctly, it moves on to us). Our glimpse of longer compositions is even narrower—perhaps only one five-hundredth of a symphonic movement.

Fortunately, our subjective experience of music does not seem nearly so confined. When we listen attentively, we feel as if long passages present themselves whole to our ears. But it is an illusion, one perpetrated by the twin sisters *memory* and *anticipation*. Memory evokes what has gone by, and anticipation presages what is about to come, especially notes only a beat or two away. Working together, memory and anticipation maintain a sort of map, partial and imperfect, of the composition passing before us. (In Chapter 6 we'll consider the nature of memory and anticipation and see how the two phenomena are closely related.)

When we feel ourselves experiencing long passages of music whole, it is not because the entire passage reverberates in auditory cortex, but because deep relations have been observed in the music, and our brains continue to experience the memory of those relations. Simultaneously, our brains use their understanding of musical style to imagine notes about to arrive.

Musical anticipations also are based in earlier hearings of a particular work. In fact, some music is so complex that it requires several hearings before it can be listened to successfully—that is, before a brain has learned a composition well enough to know which features to attend to, sustain in memory, and anticipate in order to model the composition's deep relations. We all know the experience of inwardly preparing ourselves for a grand musical climax so that it will move us all the more deeply. Thus a composition that at first seems uninteresting may later be overpowering.

It's tempting to think of the perceptual present as a sort of neurological reverberation time for incoming sense data. You hear the beat of a drum, and for some moments afterward that drum beat is still with you, though fading fast like countryside passing by a train window. But the brain is not an echo chamber. Percepts are automatically prolonged for only a very

short time. In vision, an after-image loiters for only a quarter second (a phenomenon dubbed *iconic memory*). Hearing is even less enduring, with sounds typically lingering for a mere eighth of a second (*echoic memory*). These phenomena are relatively rare outside research laboratories, for they occur only when a sight or sound is not immediately followed by another that evicts it from our perceptual machinery.

Rather than regard the perceptual present as a unit of measured time, reverberatory or otherwise, it should be thought of as a span of conception. Our brains make sense of incoming sensation and spot familiar quantities: birds or trees or clouds when we look at the world, trills or arpeggios or chord changes when we listen to music. Brains do their best to detect relations between such observations, finding birds nesting in trees shaded by clouds, or a trill twisting an arpeggio toward a new key.

The number of possible linkages between observations grows exponentially as more observations are collected. There are three potential links among three objects, but forty-five among ten objects. So a brain is easily overwhelmed. It is one thing to remember thousands of observations in long-term memory and call them up one at a time. It is quite another matter to juggle even ten observations at once. This ought to be as true of music as of anything else.

Research has confirmed that we normally handle only about seven observations at any moment, plus or minus two. This seems to be the conceptual capacity of our conscious minds. Very smart minds may handle a few more observations than less adept minds. But great intellectual power arises through the aggregation of many observations into single powerful ones, and not by manipulating dozens of observations simultaneously. Just like the rest of us, Einstein pondered only about seven observations concurrently; but the complexity of those observations must have been mind-boggling. As we'll see in the next chapter, the same was true of Mozart.

It's easy to spot this conceptual limitation in everyday life. For instance, if you've ever transcribed tape-recorded speech, you know how hard it is to recall more than a few seconds' words. We typically can manage only about seven words at a go, not counting marker words like *the* and *was*. To hold longer stretches in mind, you need to make an effort to remember

the *meanings* of short phrases rather than the *sounds* of individual words, thereby building larger observations. Similarly, you'll find that many brain teasers are hard to solve because they force you into a chain of logic that generates more than seven observations to keep track of. With too much to juggle, we start dropping balls. There must be a similar limitation upon the number of musical objects we can follow. If a brain lacks sufficient musical training to quickly reduce the notes it hears to roughly seven events (or fewer), it will not be able to piece together what it is hearing. The musical "now" will collapse, leaving only fragments of understanding, and mostly noise.

In summary, the perceptual present is more a biteful of conception than a biteful of time. It is the unit in which our brains chew on the world. We have the impression that experience runs along evenly from instant to instant, so that one moment's "present" melds with the next in an endless chain. But psychological time actually flows in minute starts and stops as our minds gather observations and then pause to extract their relationships. Though individual observations may pass quickly from consciousness, our minds maintain slower-moving undercurrents of abstract relations for longer periods, which unfold as a sort of temporal landscape.

## Temporal Resolution

Although the span of the perceptual present varies, it can be only so long or short. A slowly arriving chain of events tends to stretch out the perceptual present. But individual percepts may fade before related ones arrive, undercutting the brain's ability to detect relations between them. So a train of musical events can flow so slowly as to be unintelligible, even though the same events would be grasped easily if they only arrived more quickly. Research has shown that even professional musicians fail to recognize well-known compositions when they're played extremely slowly (with proper pitch maintained).

Conversely, a rapid-flow of events can outpace a brain's auditory processing abilities. When a giant canvas by Rubens is reproduced in an art book, every relationship among the painting's contents is preserved. You still see very much the same painting as you would if you were gaping

upward at it in the Louvre. Although scaled down forty to one, the satyr still chases the nymph while Zeus looks on approvingly. But if you were to listen to a Mozart symphony played forty times faster than normal, you'd hear only a roar and a squeal. Even at just twice the usual speed, much of the symphony would verge on noise.

The comparison between painting and music is not fair, of course. Your eyes are free to scan both the original Rubens and its reproduction at roughly the same pace. But music always sets its own rate of observation. When speed is doubled, the brain has twice as much to do in the same period of time.

It's easiest to observe the limits of auditory processing in our perception of individual notes. Laboratory measurements indicate that our auditory systems can easily handle very brief sounds. We need to hear a sound for only about a thousandth of a second to consciously register it. And we're able to detect the separation between two sounds when they're divided by as little as two thousandths of a second.

But sensing a sound is much easier than identifying its various aspects. We begin to detect pitch only after thirteen thousandths of a second, and loudness only after about fifty thousandths—fully a twentieth of a second. At around a hundred thousandths (a tenth of a second), we begin to make sense of timbre. Timbre perception is particularly time-consuming because it takes some moments for early changes in an instrument's overtones to play out, and it is largely these changes that define timbre.

These limitations in perceptual speed mean that notes can come at us only so quickly if we're to be able to pick them out. Chopin's famous "Minute Waltz" is easily grasped when played in sixty seconds, but at thirty seconds it begins to blur into noise. Of course, musicians sometimes spin out notes faster than they are individually intelligible, as when a pianist or harpist plays a glissando (a sweep across many keys or strings). But the result is a single, textured sound, not a succession of individually observed tones.

We encounter similar limitations in our perception of speech. Like the timbre of musical tones, we identify speech consonants in about a tenth of a second. Consonants are combined with vowels, with lots of overlap, to cram only a few words into the span of a second. We have trouble keeping

up when words arrive much faster. Comedians sometimes amuse us by doubling the natural rate of speech, quickly reducing us to exhaustion. So the pace of speech is limited as much by perceptual speed as by our ability to move mouth and larynx quickly.

Analysis of deep relations tends to be more time-consuming than for superficial ones, both for music and for speech. This is true partly because it takes time for all the information pertinent to deep relations to arrive. But deeper relations also appear to be inherently difficult to observe.

This can be true even in basic perception. While a two-thousandth-second gap is enough to let us know that we have heard two sounds and not one, we need a gap almost ten times as long to be able to tell which sound came first. You might think that order of arrival would be evident from the simple fact of succession. But sensing is not perceiving. A brain understands the world by modeling it, and for this it needs time to isolate sounds, objectify them, categorize them. Only then can it build higher-order relations between sounds, mapping out which came first, or which is louder, or which is higher in pitch.

Many listeners have complained that Bach's elaborate fugues fly by too quickly to follow. We readily hear every note, interval, and chord. But the patterns or relations between them come too quickly, at least for the un-practiced ear to keep up with. Again, there's a parallel in speech perception. We have no trouble following a reading of a detective mystery, but can't possibly keep up with a similarly paced reading of, say, Kant's *Critique of Pure Reason*.

## Tempo

This leads us to the matter of music's rate of flow, its *tempo* (from the Latin *tempus*, or "time"). Perhaps no aspect of music performance engen-ders so much strife. Soloists argue with conductors about proper tempo. Students argue with teachers. Ensemble players argue among themselves. And music critics argue with absolutely everyone. What's most remarkable about this conflict is that it often arises from differences amounting to small fractions of the overall tempo. Sometimes, a composition's entire person-ality can be altered by a tempo change of 10 percent.

Tempo matters because the mechanics of music perception are exceedingly sensitive to the rate at which musical structures are presented to the brain. Every aspect of the perception of music—individual tones, their timbre, their groupings, their harmonic relatedness—depend on speed of presentation. When music is played quickly, we may miss detail. But when music is played slowly, the reach of the perceptual present is diminished and we may fail to observe groupings of melody, harmony, and meter.

Tempo cannot be measured merely by counting the number of notes passing by every second. It is the number of renewals of attention that establishes the underlying beat. This means that tempo is generally set by metrical accents. Tempo will seem faster when every second note is accented than when every fourth note is, even though the same number of notes pass before our ears.

Tempo and rhythm are strongly related. Patterns of meter and phrasing determine how musical passages are subdivided, and hence how fast music appears to flow. Toscanini's famous recordings of Mozart seem to hurry by, yet the actual beat is slower than in renditions that seem slow-footed in comparison. The difference is that Toscanini elicited a clean, highly articulated sound from orchestras, showering attention-drawing detail upon the listener so that his mind is made *more* busy, not less.

When you watch a train pull slowly through a station, you see every window. But when the train flies by, you observe only the blur of individual cars. Confronted with more information than it can handle, a brain casts aside detail by forming larger perceptual groupings than it would if information were presented more slowly. It is the overall picture that is given priority.

The same is true in music perception. At a certain speed of presentation, musical objects cease to be observed in their parts and begin to be perceived as textures. Every detail may continue to be experienced at low perceptual levels. Primary auditory cortex still picks out every individual sound. But higher analytical levels are too busy with larger structures to have time to model relations among small elements. Detail remains in your experience, but not *deep* in your experience. So you are aware of a drummer's elaborate patterns but cannot recount them a moment later. The

brain has not modeled relations among the drumbeats, and so has no basis for their reconstruction. Yet without memory of such relations there can be no comparison with what follows, no development, no modeling of deeper relations. Detail is reduced to ornament. Thus a piece can be gutted by playing it too quickly.

Ideally, a brain working at its limits would cope with a 10 percent increase in information (for music, a 10 percent rise in tempo) by attending to only 90 percent as much detail. But music is structured in hierarchies, and so is its perception. When the flow of information at any level of hierarchy comes to exceed the brain's processing powers, there can be a sudden shift in perception toward larger structures. This happens all the time in musical performance. A pianist can play a whirlwind Chopin etude relatively slowly, and you hear staircases of individual notes. But increase the tempo by just a little and the appearance of the etude is abruptly transformed. Notes previously attended individually now meld into contours in which attention is drawn only to peaks and valleys. Physically, the etude speeds up. Perceptually, it slows down.

Tempo constantly fluctuates, even in metrically rigid music such as a march or polka. To some degree these fluctuations are attributable to technical factors. Musicians tend to slow down when the going gets tough, and no musician can hold music at a perfectly constant tempo for long, even when the notes are easy. But most tempo fluctuations are made intentionally. Music just doesn't sound right without them.

The importance of tempo shifts is attested to by the unhappy story of the metronome. The earliest known metronome was first described in 1696. Its hapless inventor, a fellow by the name of Étienne Loulié, earned only derision for his efforts. In an age when musicians were always on the go, his metronome was so large it took a team of horses to cart it around. And what was the point in any case? These were times when most music was written for a specific occasion, with little expectation of another performance. So there was no point in recording a composition's proper tempo, all the more because the composer often doubled as conductor. Even written directions for tempo were rare at this time.

But a century later, in 1816, early in the Industrial Revolution, Johann

Maelzel crafted the first metronome of the kind we're accustomed to. Now composers reacted with enthusiasm. They had become cultural heroes and their music was played far and wide without benefit of their guidance. In short order, metronome markings went on to everything, new and old alike. The aged Antonio Salieri (unjustly remembered for having poisoned Mozart) added metronome markings to the music of Haydn and Mozart as he had heard them conduct it. Never again would there be confusion about the proper tempo!

Then all went wrong. Beethoven was an early victim of metronome mania. He had congratulated Maelzel on his invention and renounced the ambiguous Italian names for tempi (is it allegro? con brio? allegro con brio?). Then he set to work affixing metronome markings to his compositions, including all nine symphonies. After marking the ninth, he misplaced the manuscript in his notoriously untidy apartment. Grumbling, he later marked a second score, then rediscovered the first. Hardly any metronome markings matched between the two versions. The dejected Beethoven lamented, "No metronome at all! Whoever has the right feeling, needs none; and whoever lacks it, has no use for one—he will run away with the whole orchestra anyhow." Beethoven wasn't alone. Wagner once complained about tempo to a conductor only to be told it was his own. And in this century, Stravinsky, Elgar, and others have recorded their own music at tempi different from their metronome markings.

Many reasons have been offered for these discrepancies: a change of mind, different moods on different days, failing hearing, incompetence on the podium. Many metronome markings are truly difficult to explain, Beethoven's in particular. But one reason for a composer's fickleness must be that no one tempo is likely to optimize the perception of every passage in a piece. A fast clip keeps one section hopping, but masks the gorgeous harmonies of the next by sending them to the listener faster than they can be followed. Yet slowing the tempo to favor the second passage may cause the first to stumble all over itself. Musicians accelerate and decelerate accordingly. But to do so is to violate the trains of anticipations established by meter. So tempo fluctuations must be few and gradual. One mark of a

fine composer is the ability to match all writing in a piece to the prevailing tempo.

Although tempo varies within a performance, research has shown that the overall duration of a piece is remarkably constant from rendition to rendition. Ensembles often show deviations of only seconds for performances years apart. These findings are in accord with research showing accurate memory for specific tempi, accuracy that extends even to non-musicians casually belting out their favorite tunes.

In addition to tempo changes between passages, there is a general practice of slowing tempo at the beginnings and endings of phrases. The tempo of spoken language also fluctuates this way, partly to make way for breathing. (We'll consider smaller, "expressive" tempo deviations in Chapter 10.)

Significantly, most physical motions also begin and end relatively slowly. Watch yourself as you walk around your home. There's nothing at all metronomic about your motions. As you cross a room and exit, your pace increases and then slows as you pass through the door, perhaps with a moment's hesitation before regaining velocity along the hallway. You pick up speed as you approach a flight of stairs, pumping out higher energy as you strain harder toward the top, then discreetly relax a bit before regaining your stride across the landing above.

Musicians rightfully call such motion "organic" because it characterizes the movements of living organisms. Only machines make abrupt starts and stops, motions we call "robotic." Such motions not only feel wrong when we perform them, but also look wrong when we observe them. A pianist that plays metronomically moves metronomically. Just the sight is enough to warn that your ears would be happier elsewhere.

Interestingly, as we move through the world we maintain a subjective sense of constant movement. But it's not the velocity of movement that's constant, but rather the level of difficulty of movement. If you were to set a metronome to an average speed and then move to it in lock-step, you'd drag your feet across the center of rooms but spin out at corners, and you'd strain to keep time going up a flight of stairs but trip all over yourself

coming down. By day's end you'd have plenty of bruises to demonstrate the difference between rhythm and beat.

Slow starts and stops are by no means universal in music. But they are found the world over, and are too common to be attributed merely to style. Why do we prefer them? One possibility (to be considered further in Chapter 10) is that we somehow experience music in our muscles, so music must follow the logic of physical movement. Another possibility is that our auditory systems need more time at the beginning of a passage to observe its harmony and meter, and to establish anticipations of notes to come. Conversely, we probably need extra time at the end of a passage to perform a final integration of still-unresolved musical devices. As we've seen, phrasing is normally preceded and followed by pauses that both mark phrase boundaries and allow time for perceptual housekeeping.

## Origins of Rhythm

It's often said that rhythm is music's most "natural" aspect, that it comes to music from pulsations we find in our bodies. This is one of those observations that, like the flatness of the earth, is blatantly obvious and blatantly wrong.

One idea, held for centuries, is that rhythm is founded on heartbeat. In the Renaissance it was believed that music's shortest notes (much longer than today's) were dictated by heart rate. Indeed, the "normal time" (*tempo giusto*) for which much Baroque music was written—76 to 80 beats per minute—corresponds nicely to average heartbeat. But research suggests mere coincidence. Players with higher average pulse rates show no tendency to adopt faster tempi. And a player's considerable moment-to-moment variation in pulse bears no relations to performance tempo changes. Attempts to link musical pulse with respiration rate have been no more successful.

Another view has been that pulse arises from built-in motor routines like walking or sexual thrusting. There's a good deal of automaticity in such motions, arising partly from ancient mechanisms in the spinal cord, and thereby suggestive of the "primitiveness" we like to associate with musical beat. Interestingly, we seem to have a sort of primal memory for

corporeal pulses. For example, a newborn is most easily quieted when rocked up and down at the same rate it experienced its mother walking while in the womb. Nonetheless, like heartbeat and respiration, there is no evidence that music adheres to the rhythms of particular body motions. If there were, short musicians would tend to play faster than tall musicians, since they move their legs more quickly as they walk.

More evidence comes from developmental psychology. If rhythmic skill springs from simple biological processes, even children should be good at it. But just the opposite is true. While infants of only a few months can discern rhythmic changes, they only begin to move to rhythms at the age of two and a half, and display little accuracy until about the age of six. When pre-schoolers are played music and asked to tap its beat, they'll often produce a steady beat that has no relation to the music, gleefully unaware of the mismatch. Other children constantly change tempo, sometimes attaining the proper beat for short periods, but quite by accident. Some tap faster when the music grows louder, slower when it softens. Clearly it takes a lot of learning to produce a "primitive" beat.

Had theoreticians of rhythm read their Plato, they might not have misled us about rhythm's origins. Plato saw that, although our bodies are much like those of animals, we evince far more rhythmic activity and exert far greater control over rhythm in all that we do. He observed that "rhythm comes from the mind and not from the body." As we've seen, rhythm is about grouping, about assembling the world's contents into discernible wholes. It is inherent to all kinds of cognition, not just to music.

But how might rhythm arise from a brain? There's no question that the brain is rhythmic in certain respects. Consider the "brain waves" represented as squiggles across an electroencephalogram (EEG). Though haphazard, brain waves are essentially rhythmic, with different patterns arising from different parts of the brain. But again research shows no simple correlation between brain waves and the pulse of experienced music.

There are, however, a number of so-called *body clocks* built into our brains for timing various biological cycles, most notably for sleep and wakefulness. Most of these clocks are tuned to durations that would be useless to music, and that are inflexible in any case. But recently scientists appear

to have identified a different sort of clock, dubbed the *interval clock,* that can manufacture a wide range of pulses. Brain scans indicate that it employs three brain structures that we'll consider in chapters to come. One is the *basal ganglia,* a mass of neurons that sweeps beneath the cortex and is important in initiating the intentions that precede bodily movement. The frontal lobes are another element, restraining the activity of the basal ganglia and thus possibly setting the pulse rate. The final link are two tiny nuclei called the *substantia nigra,* which are crucial to proper functioning of the basal ganglia. Their malfunction leads to the palsy of Parkinson's disease, a malady of considerable musical interest that we'll scrutinize in Chapter 10. Much of the disability of Parkinson's disease arises from subtle mistimings of movement. Significantly, in experiments requiring subjects to briefly remember pulse rates, normal volunteers can readily track two rates while Parkinson's patients can manage only one. So the interval clock, or some mechanism like it, seems a likely candidate for the biological source of musical rhythm.

If driving beat comes from our brains and not our bodies, why are so many people moved to toe tapping or finger snapping or all out dancing when they hear a favorite tune? *Surely* rhythm is somehow present in our arms and legs and torso.

In contemplating this question, an important point is that what we mean by "arms and legs and torso" are in a sense not "of the body," but rather are "of the brain." All sensations of our limbs, and commands we issue to them, are intermediated by cerebral cortex. Destroy the associated cortex and, from the brain's point of view, the limb effectively ceases to exist. So when we find rhythm "in the body," one part of the brain is merely observing the activities of another part of the brain, albeit indirectly.

Consider this: If you try to remember a face, you'll evoke visual imagery in your mind. Asked to recall the sound of an elephant, you'd hatch a fragment of auditory imagery. But what does time look or sound like? We have no sensors for time, and our brains lack an inherent faculty for imaging temporal sequences. So when a brain needs to make sense of music by establishing a train of temporal anticipations, one way it can represent them is by using the body's well-developed *kinesthetic* imagery. Like mu-

sical sound, body movements unfold across time, so muscular sensations are an apt medium for representing rhythmic patterns.

We do something very like this when we try to remember a phone number for some moments until we can write it down. Most of us can't create a visual image of the number in our mind's eye, or an auditory image of the spoken number in our mind's ear, so we say the number out loud over and over, moving throat and jaw and tongue and lips. No one would claim that language "comes from" the vocal apparatus. It clearly originates in the brain. We merely use the brain's motor system as a means of perpetuating an idea until we no longer need it.

Kinesthetics are not the only way we can represent rhythm. It is in fact a poor way of representing rapid temporal patterns, such as spitfire drumming. Our bodies move too slowly to follow, and the kinesthetic anticipations that control our motor systems can't keep up. Auditory imagery is a better medium for such patterns, although, as we'll see in the next chapter, most brains are not up to the job.

When people insist that rhythm comes from the body, they are really talking about the pleasure they gain by representing rhythm in their motor systems. How this pleasure arises is a different matter from how rhythm itself arises, and one that we'll address in the last chapter of this book.

## Left Brain Dominance for Rhythm

We've seen that the basic perception of harmonic intervals is seated (in most people) in the auditory cortex of the right brain. Rhythmic skill, however, favors the left brain. Recall from Chapter 3 how melodies are better perceived when presented to the left ear, which means that they are predominantly channeled to the right brain. The converse is true for rhythmic patterns, which are perceived more accurately when fed to the right ear, and hence to the left hemisphere.

Experimental data of several kinds support the notion that rhythmic perception and harmonic perception are favored by different sides of the brain. One hint comes from batteries of tests used to measure individual musical skills. It's long been clear that skills group into two categories, one for tonality and one for rhythm, and that the two kinds of skill are only

weakly correlated. This should come as no surprise to musicians, who frequently encounter individuals who are brilliant harmonically but totally inept rhythmically, or vice versa. Of course, training plays a role in any skill. But these test results also hold for people lacking all formal training.

Another clue comes from musical savants, musicians of remarkable raw skill who are mentally retarded (we'll meet them in Chapter 7). A savant can hear a piece once, or only a few times, and then play it by ear; often he'll be able to remember the piece years later with no interim performance. Savants possess a keen ear for harmony and are always endowed with perfect pitch. Yet despite such skills, they generally have a poor sense of rhythm. Even their physical movements tend to be clumsy. Significantly, damage to the left brain appears to be at the core of savant syndrome, just as one would expect if rhythmic skill is centered there.

Further evidence of left-lateralization of rhythm is provided by the unequal skill of the two hands in tapping out rhythms. In most people, the right hand is largely controlled by the left brain, and the left hand by the right brain. If the left brain shows more rhythmic talent, then so should the right hand. This is indeed the case. When non-musicians are asked to reproduce rhythmic patterns, most can tap out a pattern with the right hand while simultaneously tapping a metronomic pulse with the left. But few subjects can do the reverse, turning the hard part over to the left hand, and hence to the right brain. This is true even of left-handed individuals, provided that they showed typical brain lateralization (brain lateralization is reversed in many left-handers). So the rhythmic advantage can't be attributed merely to one hand's superior coordination.

The idea of a left-right split for rhythm and harmony is certainly appealing. It seems to support the popular notion of left- and right-brain personalities. But matters are not so simple.

In earlier chapters we've seen how damage to auditory centers of the right brain can obliterate the perception of harmony and melody. If rhythmic skill is equally lateralized in the opposite hemisphere, then similar damage to the left brain ought to severely impair rhythmic skill. But, broadly speaking, it does not. True, damage to left-brain secondary auditory cortex can greatly interfere with the ability to replicate metrical pat-

terns. But left-brain damage does not wipe out rhythmic skill to the degree that right-brain damage can wipe out harmonic skill. In fact, basic rhythmic abilities may be preserved even when the entire left hemisphere is momentarily disabled by feeding it an anesthetic (sodium amytal) through an artery in the neck.

Rhythmic ability is clearly much less localized than harmonic skill. This means that studies of the effects of brain damage on rhythm are always difficult to interpret and compare. Not only is the precise nature of the damage often unknown, but the definition of "rhythm" varies from study to study. Presumably rhythmic function is so widespread in the brain, and shows such resiliency in the face of brain damage, because time is a factor in all kinds of cognition; in contrast, harmony is solely a property of hearing.

## Rhythm Wars

That rhythm arises from understanding, and not from heartbeat or movement or pulsating neurons, has left us free to develop rhythm in the diverse forms we've witnessed in this chapter, including odd-number meters, syncopation, additive meters, polyrhythm, and extended hierarchies of phrasing. Much music embodies at least a hint of every kind of rhythmic development. But hardly any music exploits all rhythmic forms equally. Why not use them all? The Vienna concert described at the start of this chapter poses a particularly vexing paradox: the metrical impoverishment of Western classical music in the midst of adventurous, high-tech development in almost every other respect.

Classical music was not always this way. European music went through a period of wild experimentation during the late Renaissance, a time of unusual meters and flamboyant polyrhythm. These innovations arose partly in reaction to the stodginess of earlier polyphonic vocal music in which the out-of-sync accentuations of out-of-sync voices produced an all-around rhythmic muddiness. But elaborate meter was abandoned after the Renaissance even though there was no return to traditional polyphony. By the time of Mozart and Haydn, nearly everything was written in drab 3/4 and 4/4 time, with precious little syncopation and polyrhythm. Focus would not return to meter until the twentieth century.

Why did classical composers cast aside earlier rhythmic inventions? The answer seems to lie in the growing obsession with harmony. As the tempered scale came into widespread use in the eighteenth century, composers became as enthusiastic about harmony as explorers on a newfound continent. For the first time their music could freely wander through remote keys and thereby prolong harmonic ideas. Composers delighted in erecting ever-larger harmonic edifices spanning many minutes. Everywhere treatises were written about the theory of harmony; hardly anything was written about rhythm.

But it was really only meter that was neglected. The rhythm of phrase and large-scale form steadily developed toward the bone-cracking pulsations of the Beethoven symphonies and beyond. By the close of the nineteenth century nearly every possible avenue of musical development had been explored: extraordinary harmony on every scale, melodic development of every kind, free-ranging form, endless experimentation with timbre and dynamics. But not meter.

Because most composers employed complex meter and polyrhythm on occasion, it cannot be said they lacked the requisite technique. They simply didn't want these devices in their music. Their reasons may have lain in the inherent trade-offs between metrical complexity and harmonic complexity. The more harmony wanders from its tonal center, the more it requires rhythmic buttressing. As we've seen, tonal centers are reinforced by emphasizing certain notes, and this is best done by making these notes coincide with strong rhythmic beats. But complex meters and syncopation render those beats less predictable and thus less forceful, and that makes the construction of far-ranging harmonies all the more difficult. In essence, composers had to decide between developing harmonic dissonance and developing metrical dissonance. They chose harmony.

It can be argued that this decision was not arbitrary, that harmony inherently holds out more musical potential than meter. This view is founded on the notion that more harmony than meter can be crammed into the perceptual present. Harmony arrives *in parallel* (to use computer parlance). From cochlea to auditory cortex, our brains are designed to hear simultaneous tones and to find relations among them instantaneously.

Meter, on the other hand, is inherently a *serial* phenomenon. Beats arrive one by one and are integrated into a metrical pattern in a second or two. Yet in that same time an entire harmonic progression can unfold—a far more elaborate musical structure than a simple metrical pattern, which is analogous to a single chord in its complexity. An equally complex metrical transformation would require many seconds to play out, and so would be pushed well beyond the confines of the perceptual present. It would lose immediacy and would make heavy demands on short-term memory for its perception. By this reasoning, brains naturally have an easier time with harmony, thus harmonic development can be pushed farther than meter before reaching the limits of comprehension.

Since the turn of the century, there has been a reaction against metrical simplicity in Western art music. Every major composer has experimented with rhythmic devices. But no one knows quite what to think of the results, since every other aspect of music has also been turned on its head. The French composer Arthur Honegger wrote,

> *I myself remain very skeptical about these rhythmic refinements. They have no significance except on paper. They are not felt by the listener. . . . After a performance of Stravinsky's Symphony in Three Movements the players in the orchestra all remarked: "One has no time to listen or appraise. One is too busy counting eighth notes."*

Yet recent composers, sometimes working in traditional tonal harmony, have occasionally found a compromise in which the excitement of metrical dissonance lives in symbiosis with a predilection for long line and large structure (try, for example, parts of John Adams's opera *Nixon in China*, which premiered in 1987). But such compromises are few and far between.

In a television program, two ensembles squared off across a stage, playing in turns. On one side, Seiji Ozawa conducted a symphony orchestra in selections from *The Nutcracker*. In the opposite corner, a jazz band under Wynton Marsalis played a jazz version of the same pieces, composed by Duke Ellington. The difference in the motions made by the two conductors said more than a thousand treatises on rhythmic theory. Ozawa made

long, slow motions with his whole body, matching Tchaikovsky's long phrases; only an unobtrusive waggle of the baton marked the music's inconspicuous meter. In contrast, Marsalis made short, metronomic strokes from head to foot, starting several beats before the players began. Ellington had filled the music with snappy meter, but cut Tchaikovsky's phrases to ribbons by narrowing the listener's attention. Although the concert was held very much in an ecumenical spirit, it only served to point out how much the two kinds of rhythm are at war.

Rhythm wars. On one side, devotees of meter protest that art music is missing an entire dimension, robbing the listener of a kind of rhythmic pleasure that has for many become music's mainstay. On the other side, devotees of classical music complain that the obsession with beat trivializes everything it touches, appealing to our lowest instincts, like greasy food. Where one side sees musical opportunity in metrical patterns, the other finds an idiot's metronome, an unceasing racket that makes no more artistic sense than drawing on graph paper. Where one side finds ultimate musical bliss in the architecture of large form, the other complains of effete over-intellectualization.

As Western pop music floods the world, with its drum machines and giant bass speakers in tow, the advantage is now with those who celebrate meter (usually in a trivial form). Enthusiasts of phrase and form, or just of an old-fashioned melody, are often to be found cowering with fingers in ears, their sole consolation in reflecting upon a tradition that has lasted centuries and survived greater assaults. This battle is far from over.

# 6

From sound...
...to tone...
...to melody...
...to harmony...
...to rhythm...

# ...to composition...

Dowdy and worn, wearing a hang-dog face, Rosemary Brown shuffled along the shabby streets of her South London neighborhood, a middle-aged woman struggling to support her two children on a widow's pension and a part-time job at a school canteen. It would have been a bleak life for Rosemary had it not been for her extraordinary circle of acquaintances. She was a personal friend of Stravinsky, Rachmaninoff, and Debussy; also of Brahms, Liszt, Chopin, Schumann, Beethoven, and Mozart; and Bach and Handel too.

That some of Rosemary's associates had been dead for more than two centuries was no obstacle. She explained that she was *clairaudient,* able to project her hearing to distant worlds, just as *clairvoyants* can project their vision. With pen in hand, she took dictation of hundreds of works from a veritable *Who's Who* of great composers, compositions that were published, performed, and recorded during a brief vogue in the early 1970s.

Rosemary had not always traveled in such good company. Born to penury, she was the youngest child in a large and decidedly unmusical family. Only her mother's amateurish renditions of syrupy Romantic tunes,

beaten out on a battered, broken-keyed upright, gave Rosemary an inkling of music's possibility. Yet somehow music became her obsession.

It was when she contracted a mild case of polio as a child ("I have often had a foot in the next world," she said) that the ghost of Franz Liszt first approached her, explaining that she would have important work to do. Piano lessons began some years later, with Liszt manipulating her hands "like a pair of gloves." And then she began to write down the music that Liszt and others conveyed to her.

Despite these extraordinary events, Rosemary led a quiet, unassuming life, making no effort to publicize her visitations. After all, who would believe her? It was only when an acquaintance from a spiritual healing group asked what she was playing that Rosemary blandly explained, "Oh, I am inspired and I just write as it comes to me." That was the end of Rosemary's obscurity.

Rosemary's apparent psychic powers could be disconcerting. She would chat amiably with unoccupied chairs and would drop comments like "Mr. Bruckner is standing next to you now" or "Oh, I do like his lovely violin concerto" even though the composer had never written one. Her conversations with the dead always took place in English, even with composers who spoke no English during their lifetimes (but who may perhaps have had time for lessons since). Some were close friends, others so remote that Rosemary could not identify them. All, according to Rosemary, are still busy composing (except Debussy, who has switched to painting).

Rosemary began her dictation-taking in earnest in 1965. Lacking all training, she found the process difficult at first, and the early scores were often crude and bereft of markings for dynamics and phrasing. She found orchestration prohibitive owing to the multitude of different staffs, so nearly everything she heard she transcribed for piano. But Liszt reassured her, "You have sufficient training for our purposes." Within three years she had jotted down some three hundred compositions. Later, with outside help, she managed to record Beethoven's Eleventh Symphony (the Tenth, which was left as sketches at his death, apparently has been abandoned). None of this was at all remarkable in the view of the *Psychic News,* which

stated that "It is comparable to what hundreds of other mediums have done—the only difference is that you have some famous composers involved."

Rosemary never learned to play the piano very well; her technique was constrained, her expression wooden. Yet by all accounts her fluency as a composer was astonishing. One filmmaker from the BBC related to Rosemary's biographer that

> I have watched the process many times and have often filmed it. You will know better than I do how normal composition happens: I had certainly never seen anything like the process Mrs. Brown uses. The music literally flows onto the paper in a continuous stream—sometimes both clefs together, sometimes one first and then the other. And all the time Mrs. Brown chats away: "Not so fast; did you say natural or flat? this G or the octave higher?" etc. And as fast as she can write, so it's taken down.

Rosemary explained that communication with Beethoven was especially smooth:

> The notes suddenly started to come very rapidly and I think Beethoven gave me about six or eight bars of left hand straight off. The notes were almost writing themselves, so I think possibly there was some kind of "control" going on. The right hand came immediately afterwards.

But even in death Ludwig remained a difficult character:

> It's a bit tantalizing with Beethoven because he'll have perhaps three or four—even seven or eight—pieces running at the same time. I would like to get one piece completed at a time, but instead I find he'll give a page of one thing and then two pages of something else.

How much was Rosemary Brown's Beethoven like Beethoven, or her Liszt like Liszt? Musicologists scoffed, finding the pieces only mildly char-

acteristic of the composers and much more like each other. Most were short, with a thin melody against an unvaried bass. Her Bach was without counterpoint, her Schumann without thick textures, her Liszt without flourishes. Throughout one finds amateurish harmonies, awkward progressions, poor balance, and naive accompaniments. Said one critic, "All in all the general impression is of transcriptions or improvisations by an innately musical, but rather untutored and certainly technically restricted pianist." Not so, said her admirers, who ascribed the limitations of her works to an untrained mind unable to grapple with the daunting complexities of composition. These were not so much pieces by Beethoven or Liszt, but by Beethoven-Brown and Liszt-Brown.

In truth, Rosemary Brown's music was little better than the efforts of thousands of never-to-be-known composition students. Her notoriety arose not from her music but from the story behind it. That she perceived her musical outpourings as clairaudience was well within family tradition, for her grandmother had claimed to be a psychic, and her mother, a faith healer.

Yet Rosemary Brown's music remains almost as mysterious as if she actually *had* received it from beyond. Although she was familiar with the music of the composers she wrote music for, she was completely untrained and of unexceptional intelligence. She roundly flunked standard tests of musicianship and ear training, tests of the kind required of composition students. And she could hardly play piano pieces other than her own. But somehow her mind was flooded with original music, an apparent instance of large-scale subconscious composition.

Was Rosemary Brown living proof that there really is such a thing as a "muse"—an inner voice that dictates masterworks to composers? If so, why do only a few human beings hear original music in their heads? Are their brains different? In this chapter, we'll explore how great music is brought into the world.

## Child Prodigies

These days there aren't many people around who adhere to the ancient Greek notion of a muse fluttering down from Mount Olympus to whisper

in your ear. We're more likely to credit Rosemary Brown with near-psychotic hallucinations. But a change in terminology does nothing to explain exactly how music abruptly springs into the mind's ear. It's still magic. And that means that we implicitly *do* believe in muses.

Consider the popular conception of Mozart, recently reinforced by the movie *Amadeus*. There he was, penning symphonies at an age when most of us are struggling with our ABCs. When he played the harpsichord, original music flowed in torrents down his arms as he giggled in surprise. And when it came time to score a three-hour opera, well, he just assembled every note in his head, then jotted it all down. Clearly a case of a muse at work.

Make no mistake, Mozart's musical skills were as good as they get. He started playing the harpsichord at three and a year later was memorizing pieces in a fraction of an hour. At five he made his debut, and at six he began his famous tours across Europe, playing at sight, improvising at request in various styles, and generally showing off. These weren't mere gymnastics, for he would play with great feeling. Asked to improvise a "song of rage," the infant Mozart beat the harpsichord in a frenzy, rising from his chair like "a person possessed." Why should we be surprised, then, that so talented a prodigy would begin composing at five, would write his first symphony at nine, and would go on to become one of the greatest of all composers? After all, the boy was clearly brimming with music.

But so were hundreds of other prodigies who went on to produce nothing of value. In fact, history's greatest musical prodigy was not Mozart but the French composer Camille Saint-Saëns. He outstripped Mozart at every turn, starting piano at two and a half and composing at three. At five he analyzed full operatic scores and at ten made his official concert debut, offering any of the thirty-two Beethoven sonatas *from memory* as an encore. And while Mozart shone only as a musical prodigy, Saint-Saëns excelled in every kind of learning, reading and writing by three, fluent in Latin by seven, avidly studying natural history. It was said that from a single reading he would retain for life the contents of a book just as he could the contents of a symphony. Throughout his eighty-six years, he performed and con-

ducted brilliantly, composed prolifically in every form, wrote criticism and poetry and plays, and even dabbled in astronomy and archaeology. He was a perfect 10 in every observable talent.

He also was a failure. Everyone had expected that Saint-Saëns would go on to write music as great as Mozart's. But he didn't, despite a lifetime of trying. His music has largely fallen into obscurity, with occasional performances of his *Organ Symphony* and revivals of his opera *Samson et Dalila*. Today, Saint-Saëns is best remembered for the stately strains of "The Swan" from his *Carnival of the Animals,* a haunting swan song of prodigious talent that somehow went wrong.

How can this have happened? Apparently, all those muse-like qualities aren't enough—even an effortless comprehension of musical structures coupled with a brawny memory and a flare for new ideas. Perhaps the *real* muse lies in a more subtle trait, one that Saint-Saëns (and many lesser prodigies) lacked.

This brings us to history's most puzzling example of great promise gone unfulfilled: Felix Mendelssohn. Like Mozart and Saint-Saëns, he was a fantastic prodigy, performing and composing at an awesomely early age and excelling in academic skills. Most remarkable of all, two compositions dating from his adolescence—the *Octet for Strings* penned at sixteen, and the incidental music for *A Midsummer Night's Dream* written at seventeen— are today numbered among history's masterworks. Although there are a few other instances of great music emanating from a teenage mind (songs by Schubert come to mind), no one, not even the glittering Amadeus, wrote works of such scope and complexity at so tender an age. Here was a boy who clearly had the muse, whatever it may be.

And then he lost it.

Mendelssohn went on to enjoy a fabulously successful career as a composer and conductor. In his day, many regarded him as a worthy successor to Mozart and Beethoven. But acclaim has long since dimmed. Today Mendelssohn is widely regarded as a second-tier romantic composer, always competent, but falling short of his youthful genius. Significantly, shortly before a haggard Mendelssohn succumbed to a stroke at the age of thirty-eight, he commented that his string octet and *Midsummer Night's*

*Dream* music were his favorite efforts. By comparison, Mozart remarked shortly before his death that his favorite was *The Magic Flute,* an opera he had only just written. Both judgments were valid. Mozart had just gotten better and better; Mendelssohn had gotten better and then worse.

How could the dazzling Felix Mendelssohn have gone so wrong? Unlike Saint-Saëns, there can be no question that he possessed every talent necessary for great composition. Nor did he experience a crisis or illness that robbed him of his gift. Apparently the muse is not just rare, but fickle, too.

## Auditory Imagery

Composers are thinkers in sound, and their stock in trade is auditory imagery. They manipulate tones in their mind's ear as accurately as writers manipulate words. Understanding auditory imagery, and its basis in memory, is the first step to comprehending how composers work their marvels.

The American composer Henry Cowell described auditory imagery at its best:

> *The most perfect [musical] instrument in the world is the composer's mind. Every conceivable tone-quality and beauty of nuance, every harmony and disharmony, or any number of simultaneous melodies can be heard at will by the trained composer; he can hear not only the sound of any instrument or combination of instruments, but also an almost infinite number of sounds which cannot yet be produced on any instrument.*

Cowell laid claim to imagery so vivid and precise that he preferred it to actual performances, which he felt achieved hardly a tenth of a composer's deepest intentions. Such extravagant claims ought to be taken with a grain of salt. Research has shown that mental imagery seldom casts more than a frail shadow of reality. So composers go right on attending concerts after they've developed imagery skills.

Nonetheless, it's clear that composers can do something with their brains that most of us can't. True, we all covertly talk to ourselves, so we're well acquainted with *verbal* auditory imagery. And using the same faculty

we can bring a tune to mind by silently singing it. But the ability to hear several voices at once, accurate in pitch and timbre, is rare. It's no wonder we're enchanted when we hear music in a dream. For most of us it is the only experience of vivid musical imagery we'll ever have.

Composers steadfastly insist that they seldom resort to words when writing music. There's little inner dialogue like "Now let me see . . . how about the second inversion of the subdominant chord here, and then a suspension back to the tonic?" The principles of composition can be taught this way, but they're only really useful when they become automatic. It's a bit like learning the fox-trot from maps of footsteps; later, the maps are discarded and your legs just move. And so Cowell reported: "There is a mere semblance of the intellectual in being able to steer and govern the meteors of sound that leap through the mind like volcanic fire, in a glory and fullness unimaginable except by those who have heard them."

Although composers are convinced that musical ideas come to them this way, not all cognitive psychologists buy the idea that we experience imagery as an independent entity that can be examined like a picture and exploited for new information. Some believe that images are a mere by-product of deeper, abstractly encoded processes, and that you won't find anything in an image that you don't already know, that the "perception" of images is an illusion. But many disagree, asking, for example, how it is that we can determine whether the word *kind* rhymes with *wind*. It certainly seems that we "listen" to auditory images to find out.

Recent work with brain scans has confirmed what had long been suspected: imagery "occurs" in parts of the brain concerned with perception. Visual cortex fires up during visual imagery, auditory cortex during auditory imagery. So when a stone-deaf Beethoven wrote his Ninth Symphony, his auditory cortex was in a sense still at work "hearing," although Beethoven's ears no longer supplied that cortex with data about actual sounds.

Further evidence about the cerebral localization of imagery arises when brain damage claims a sliver of sensory cortex. Oliver Sacks relates the story of a painter who emerged from a minor auto accident having lost, on both sides of his brain, the tiny patch of visual cortex that deciphers information

about color. The man abruptly descended into a black-and-white world. What's most interesting is that he not only could no longer *see* color, he could no longer *imagine* it.

Such observations tend to confirm the notion, long held by many philosophers, that imagery is a sort of "perception" in the absence of sensation. As we've seen in earlier chapters, all but the simplest of perceptions are acts of construction. For example, when you look at something, your eyes perform a rapid, largely unconscious series of fixations to gather just the information the brain needs to grasp "chair." This series of fixations is highly selective. Once the brain has gathered enough information to suspect it has encountered a chair, it looks only for characteristics specific to chairs.

This is to say that the brain perceives by anticipation. It formulates perceptual hypotheses, then confirms them. In the view of many cognitive psychologists, imagery arises from the unfolding of such anticipatory schemes in the absence of actual perceived objects. So a composer would imagine an arpeggio by unleashing the perceptual routine that listens to one.

## Musical Memory

If imagery originates from within, then in some sense it must arise from memory. The ancient Greeks understood this well: the nine Muses were the daughters of Memory (the goddess Mnemosyne). Staring into empty space, a composer imagines music by summoning his knowledge of specific musical devices, whether ten seconds or ten years after he has last recalled them. This would seem to imply that ultimately it is *memory* that is the composer's workshop. But it is an idea that explains little, for "memory" is a complex and ambiguous concept, one that has long tormented psychologists.

Most of us conceive of memory as the brain's storeroom, an empty space crammed with facts and faces and phone numbers, some in easy reach just by the entrance, most buried beneath a lifetime's clutter. Someone who "has a good memory" appears to possess a particularly tidy and capacious storeroom.

One problem with this popular conception is that it only considers *long-term* memories of past events. Much of our mental life consists of *short-term* memories of recent experience, memories that we juggle in consciousness for some seconds before they (usually) slip away forever. In contrast, long–term memories are retrievable hours or years later. You can hum a tune just after first hearing it thanks to short-term memory; you'll know it a week later only if it has been passed along to long-term memory. Short-term memory is sometimes conceived as "working memory." It's by short-term memory that composers try out variations on a passage in the mind's ear. It's by long-term memory that some can create finished compositions in their heads before writing them down.

The distinction between short-term and long-term memory is founded in neurology. Research has shown that the frontal lobes juggle the contents of short-term memory. Typically only about seven concepts can be kept going at once; any more and the frontal lobes fumble. On the other hand, long-term memory is supported by a special system involving the middle and lower temporal lobes (below the auditory cortex) and a structure just beneath called the *hippocampus* (Fig. 6.1). Removing the hippocampus renders a person unable to form new long-term memories. But that person will still be able to ponder things in short-term memory.

Neuroscientists have never found a place in the brain where discrete memories are stored. It's been understood for a long time that there is no such thing as a "grandmother cell"—a single neuron (or knot of neurons) that stows your recollections of Grandma. This is because the brain remembers things by categorizing them, not by filing away some sort of true-to-life snapshot. Whatever the brain encounters, whether a sight or sound or smell or sensation, it dissects for its deepest relations, and it is this network of relations that the brain retains. Later, when the brain *re*collects something, it evokes these relations to generate "a memory." This means that memories are not so much *retrieved* as they are *re-created*. Individual memories are processes, not things. Much detail is lost in this mechanism, and research has shown that memory is imprecise and unreliable.

But there are advantages to remembering by abstract categories rather than by snapshots. Categories are flexible. What if all you remembered of

*Fig. 6.1. The hippocampus, crucial to long-term memory*

guitars was embodied in a visual image of one? A snapshot of the front of a guitar wouldn't be very useful for recognizing one from the side or the bottom, or in making sense of a smashed guitar or a guitar only partly in view. But by categorizing the various physical aspects of guitars—the shapes of its parts and the geometrical relations between those parts—the brain can readily identify a guitar in a million situations.

Equally important, the categorization process draws together similar relations from all the brain's experience. So a brain readily understands that a guitar is like a violin in the way it looks, like a harp in the way it sounds, and like both in the way it can be played. All our knowledge is melded together this way. Instead of there being a "grandmother cell," various aspects of Grandma are encoded in many places in the brain, and mixed in with similar aspects of everything else in your experience. Grandma is both everywhere and nowhere. The brain works through such diffuse, abstract hierarchies in almost everything it does.

A composer's knowledge of music is maintained in just such a categorized, highly interrelated fashion. Just as there's no grandmother cell, there can be no "Hey, Jude" cell, or bebop cell, or even a B-flat-major chord cell. All knowledge of musical elements and devices and styles, and of whole pieces, is melded together in the hierarchy of musical categories. The precise nature of these categories is quite unknown.

Happily, we do not have to understand our brains to use them. Com-

posers can navigate the hierarchy of categories, plucking ideas and combining them into musical figures and phrases, cadences and whole compositions. This is no different from the way a storyteller scans his hierarchy of knowledge about the world for ideas. The composer's hierarchy is built up from musical experience; the storyteller's from worldly experience. In either case, countless experiences of many years have been categorized so that they may be remembered. The result is a flexible hierarchy of concepts that can generate not only memories of actual experiences, but also novel combinations of concepts. And so the storyteller knows of birds and lizards and comes up with dragons; and the composer knows the music of Mozart and Wagner, and writes *La Mer*.

As a composer works, only a tiny part of his musical hierarchy is active at any moment in the sense that it is consciously heard as imagery. The composer's focus shifts in and out of the hierarchy, moving from surface details to deeper, more abstract parts of his conception, then back to the surface. Imagery at these deeper levels is more "felt" than "heard." Here the distinction between imagery and abstract thought blurs.

Many parts of the brain are at work as the categorization circuitry generates memories and novel ideas. Certain aspects are localized by sensory modality. Visual cortex plays a role in the categorization of physical objects, auditory cortex in the memory of sounds. Some categorizations are made by function rather than form, so that when we identify tools, for example, parts of motor cortex light up as we think of how a tool is used. Although virtually every part of the brain can be considered a categorization device in some sense, the temporal lobes play a special role as they meld diverse representations and prepare them for long-term memory.

In certain respects a composer's memory resembles a chess master's. Both carry around a vast library of patterns that can be combined in myriad ways to produce one-of-a-kind compositions or chess matches. And both can recall long sequences of these patterns, remembering every chord of a composition or every move of a match. Both are also famed for their imagery skills, whether it be Mozart composing an opera in his head, or Koltanowski playing thirty games at once while blindfolded.

In a classic study, chess masters and novices were asked to memorize

the midgame layout of an actual match. It was found that masters could replicate the entire board perfectly after only a few seconds' viewing, whereas novices recalled only about six pieces. But when the same number of pieces were arranged randomly on the board, in a way that never occurs in chess, the masters performed little better than the novices.

Clearly, the chess master does not in any sense "photograph" the board. Instead, his brain maps relations among groups of pieces, and then relations between those groupings, much as composers' brains group notes into chords, and chords in progressions. When no meaningful relations present themselves on a randomized board, there is effectively nothing for the master to perceive, and thus nothing to remember. But an actual game provides a hierarchy of patterns. Accordingly, when a chess master replicates a board, rather than working row by row he lays out the significant patterns one by one with thoughtful pauses between.

Research shows that chess masters have roughly fifty thousand patterns at their cerebral fingertips. Except for basics, there's little terminology to describe these patterns, so language offers scant help in remembering them. From the chess master's point of view, it's just "one of those" attacking "one of those" while defending "one of those." A composer's vocabulary of musical devices also numbers in the tens of thousands. Music theory gives names to a few—"a raised fifth," "a Picardy third"—but most of the composer's knowledge is entirely informal and better communicated by singing than by speaking.

Significantly, some composers see no value in formal knowledge of the rules of music. Stravinsky claimed to have studied the rules only after employing them instinctively. And Rimsky-Korsakov confessed that he knew nothing of music theory when he was appointed to the University of St. Petersberg, despite having already written many fine works. This should come as no surprise. How many native speakers of English can describe its grammar? And how fluent would a student of English be who laboriously reasoned through the grammar of every sentence? Composing is a matter of doing, not "thinking."

Investigators have estimated that it takes twenty thousand hours of devoted practice to acquire a chess master's repertoire of fifty thousand

patterns. That's a forty-hour week for ten years. Likewise, musicologists speak of the "ten-year rule" for composers, noting that most great composers began writing worthwhile music only after a decade of practice. Mozart started composing at five and turned out his first works of lasting value at fifteen; but the compositions we listen to today were mostly written from his mid-twenties on. It may be that a "twenty-year rule" is closer to the mark.

At first glance, it seems remarkable that a brain can stow away fifty thousand musical devices, or chess positions, or anything else. Yet we all know roughly fifty thousand words in our mother tongue, including thousands of names for persons and places and products. Equally, we easily know fifty thousand features of the streets and buildings we inhabit. In any environment in which we are genuinely engaged, our brains just go on learning and learning and learning.

Although most composers learn to juggle a vast library of musical devices in short-term memory, not all are blessed with equally powerful long-term recollection. Many can manipulate elaborate musical structures in their mind's ear, but can't later recall the details without help from a score. Beethoven is a good example. The imagery he entertained in short-term memory was so clear that he could write breakthrough compositions even after he had gone deaf. Yet his long-term memory was much less capable, and he never went anywhere without paper and pen. By comparison, when Felix Mendelssohn left behind the only available copy of his *Midsummer Night's Dream* music in a London cab, he simply went home and wrote out the entire orchestral score from recollection. That Beethoven was by far the better composer shows that a prodigious long-term memory is a luxury, not a necessity for great composition.

This disparity in memory skills leads us to another important distinction between types of memory: *semantic* and *episodic*. Semantic memory is concerned with the inherent nature of a phenomenon (with "meaning"), episodic memory with actual instances of its occurrence (with "episodes"). Knowing that frogs are slimy is an example of semantic memory; remembering the time someone put a frog in your bed is an example of episodic memory. Similarly, memory of the ways in which drums are used in rock

music is semantic, while memory of exactly how drums were used in a particular song by the Rolling Stones is episodic. The ability to recollect an entire composition note-for-note is the paragon of episodic memory, possibly the most remarkable memory feat in human experience.

Semantic and episodic memory are closely related, the first providing the underpinnings of the second. Mozart composed symphonies (musical episodes) in his head by weaving together basic conceptions (musical semantics). Without a fine-grained library of lucid conceptions, he would have lacked building materials in which to render his designs. So all good composers necessarily possess a rich semantic memory for music. It is skill in remembering assemblages of these concepts that varies.

That a few human beings can remember extremely long sequences of music or language is troubling to some cognitive psychologists. It's hard to believe that even a very smart brain can reduce an entire movement of a symphony to a single, hyper-abstracted conception. Some have suggested that, in addition to conceptual memory, we have a kind of memory based (for music, at least) on tape-recorder-like imagery. In this view, long sequences may be remembered by moment-to-moment association, without the linkages of an abstract hierarchy.

In the next chapter we'll consider some remarkable examples of musical memory that seem hard to explain any other way. But as we'll see, research has not validated the idea of a tape-recorder memory. Rather, we appear to remember long sequences as a combination of the two approaches, aggregating large chunks of music hierarchically, then linking the chunks in a chain so that the experience of one chunk leads by association to the next. It's a bit like the way we make our way around a city, understanding well the layout of shops along individual streets, and knowing how the streets are connected, but lacking a comprehensive bird's-eye view.

## Inspiration

A vast hierarchy of musical concepts is required equipment for composers, yet it is not enough. There are many musicians who possess a robust hierarchy but who are destitute of musical ideas. Only a lucky few can

throw the system in reverse to create something new. Somehow their minds secrete music. Wagner likened it to a cow producing milk; Saint-Saëns to an apple tree producing fruit; Mozart (never wanting for a coarse remark) to a sow pissing.

The phenomenon of musical ideas arriving full-blown in the composer's mind is called *inspiration*. We usually use this word to mean *motivation,* as in "Mary Jo's alluring glances inspired Tom to write a song." But in this instance it keeps its ancient sense of ideas being "blown in" from outside one's mind. This was the inspiration of Pope Gregory, upon whose shoulder a heaven-sent bird was said to have perched and sung songs that he recorded (his actual contribution was to organize the hodgepodge of existing chants and thereby gain credit for them all as Gregorian chant).

There are many tales of sudden inspiration. The common thread is that inspiration cannot be willed, that it just happens. Mozart reported that ideas flowed best when he was alone, "say, travelling in a carriage, or walking after a good meal, or during the night when I cannot sleep." Sometimes ideas would flood his mind like an electrical storm. His barber complained that he would chase Mozart around the room, hair-ribbons in hand, as Mozart ran between keyboard and writing desk. Yet when asked the source of his ideas, Mozart could only reply, "*Whence* and *how* they come, I know not; nor can I force them." Beethoven's explanation was the same: "They come unbidden."

When inspiration is thrown into high gear, the experience becomes religious. Witness Handel, found in tears by his servant while writing the entirety of his *Messiah* during a twenty-four-day mania: "I thought I saw all of heaven before me, and the Great God himself." Or Puccini: "The music of this opera was dictated to me by God. I was merely instrumental in putting it on paper and communicating it to the public." Or Brahms: "I felt that I was in tune with the Infinite, and there is no thrill like it."

Although composers have repeatedly expressed amazement at the suddenness of some ideas, most inspiration occurs far less spectacularly in the course of a day's labor. Often ideas come as fragments that can be melded with others. Listeners tend to assume that finished ideas spring whole into

the composer's mind. But often the components of a musical idea are invented independently, sometimes years apart.

All agree that inspiration dwindles when work is neglected. Stravinsky commented that

> *ideas usually occur to me while I am composing. . . . The uninitiated imagine that one must await inspiration in order to create. That is a mistake. I am far from saying that there is no such thing as inspiration; quite the opposite. It is found as a driving force in every kind of human activity, and is in no wise peculiar to artists. But that force is only brought into action by an effort, and that effort is work. . . . The musical sense cannot be acquired or developed without exercise. In music as in everything else, inactivity leads gradually to the paralysis, to the atrophying of faculties.*

Inspiration is sometimes described as the one aspect of composition that defies explanation. But when imagery is understood as a memory process, and memory as a categorization process, inspiration seems less mysterious. New categories arise naturally as the brain is challenged by new and larger perceptions. And an active mind, driven by the ever-willful frontal lobes, can force-feed the categorization mechanism by repeatedly exposing it to challenging new perceptual paradigms. Ultimately, older conceptions crumble to accommodate new and more powerful ones. The connections between memories are altered, the basis for new kinds of imagery is formed, and new ideas arise.

Composers may understand the categorization mechanism intuitively, trusting it and cultivating it. They appreciate that whatever they introduce into the mechanism will influence all of their ideas. Thus Beethoven once explained that he was avoiding Mozart operas to shelter his originality. Some composers even learn to manipulate the mechanism. Brahms claimed that he would thrust small inspirations out of mind, confident that they would later return as full-blown musical ideas.

All agree that inspiration cannot be willed. Effort is useful only in

training the categorization circuitry. Many of the best ideas appear to arise when the composer is off guard, strolling about town or through the woods. Occasionally ideas arise while on the edge of sleep, or even during dreams. It appears that habits of leisure are important to a composer's success. Non-stop workaholics tend to stifle the muse. Among them were our two wilted prodigies, Mendelssohn and Saint-Saëns.

The muse sometimes exacts a terrible price for its visitations: psychosis. Most severe mental illness, particularly schizophrenia, confers visions upon its victims but cruelly robs them of the personal organization needed to mold visions into art. But manic-depressive syndrome sometimes bestows both ideas and order. It is characterized by long bouts of depression interspersed with weeks of exhilaration and limitless energy. The "Hallelujah Chorus" embodies the spirit of a manic period; it was written during one. But mania is a precarious state characterized by irritability and even paranoia.

Manic depressives score high on creativity tests, so it's no surprise that many have become celebrated creators. Surveys show that about a third of all great writers and artists, and half of poets, showed symptoms of manic depression. It is less common among composers, perhaps because the discipline of composition is too arduous to withstand its caprices. Still, psychologists have divined symptoms of manic-depressive illness in Berlioz, Bruckner, Dowland, Elgar, Gesualdo, Glinka, Handel, Holst, Ives, de Lassus, Mahler, Mussorgsky, Rachmaninoff, Rossini, Schumann, Tchaikovsky, and Wolf.

Extreme manic-depression can produce hallucinations, which may take the form of musical hallucinations in minds trained for musical imagery. Robert Schumann provided a stunning example. His wife's diaries tell how he heard "music that is so glorious, and with instruments sounding more wonderful than one ever hears on earth." A friend reported that Schumann "unburdened himself about a strange phenomenon. . . . It is the inner hearing of wondrously beautiful pieces of music, fully formed and complete! The sound is like distant brasses, underscored by the most magnificent harmonies."

But Schumann's ecstasy was accompanied by equal parts of torture. His wife recalled:

> *In the night, not long after we had gone to bed, Robert got up and wrote down a melody which, he said, the angels had sung to him. Then he lay down again and talked deliriously the whole night, staring at the ceiling all the time. When morning came, the angels transformed themselves into devils and sang horrible music, telling him he was a sinner and that they were going to cast him into hell. He became hysterical, screaming in agony that they were pouncing on him like tigers and hyenas, and seizing him in their claws. The two doctors who came only just managed to control him.*

As Schumann gradually disintegrated toward suicide, he was sometimes plagued by a single tone, occasionally an interval, that refused to go away and prevented him from composing. Toward the end,

> *his auditory disturbance had escalated to such a degree that he heard entire pieces from beginning to end, as if played by a full orchestra, and the sound would remain on the final chord until Robert directed his thoughts to another composition.*

In Schumann's angels we have genuine muses fluttering overhead. Unfortunately, we cannot know the quality of the music they sang, for he was too disorganized to effectively write it down. His ecstasy (and his horror) may well have arisen from enhanced responsiveness to sound rather than the sublimity of the music he heard. Significantly, Schumann's most highly regarded works were largely written early in life before the onset of hallucinations.

## Improvisation

A more mundane form of inspiration stands in stark contrast to Robert Schumann's singing angels: improvisation. Schumann paid dearly for his

conceptions; yet a steady stream of musical ideas appear to flow steadily and effortlessly from a Dave Brubeck or a Keith Jarrett. And so improvisation holds a special place in the popular imagination—the muse tamed and harnessed.

There is nothing extraordinary about improvisation. We all improvise constantly, but in words, not tones. We begin a conversation with a topic, draw in related observations, digress to subtopics, and add moments of emphasis or wit. Likewise, a jazz pianist begins by playing a theme, takes it through variations, weaves in a second theme, attaches ornaments. The conversationalist draws upon a well-organized hierarchy of knowledge about the world, the pianist upon a well-organized hierarchy of musical ideas. In either case, the quality of the performance depends on the depth and flexibility of the hierarchy, and upon the performer's ability to exploit the hierarchy quickly, in real time. You're not allowed to halt a conversation for thirty seconds to conceive your next sentence. You just keep talking, reaching for the best idea that presents itself and stating it in the most eloquent words that come to mind.

Verbal eloquence is hard to come by. Most of us have trouble enough ad libbing coherent sentences, much less polished paragraphs. Musical eloquence is every bit as challenging. So most improvisation is conducted more like storytelling than like spontaneous conversation. The improviser follows a plot line of ready-made melodies, harmonies, and rhythms, and employs a formula for repeating and developing themes (typically a thirty-two-bar AABA form in jazz).

Like a folk tale, the plot line may be passed between generations of performers as a "tune," with ready-made characters (melodies) woven into subplots (themes) that are colored to set the mood (harmonic progressions). What's lacking are the details of the story, and the exact words in which it will be told. The job for storyteller and improviser alike is to fill in the details of the script, adding warts to the witch's nose. Fresh ideas are hard to come by even at this level, and storytellers often resort to clichés. So do improvisers.

With such a blueprint on hand, the improviser can avoid the composer's concern with large-scale and middle-scale structure. He is freed

from the most difficult problems in composing music and can concentrate on music's surface structure, working only at the outer edges of a composition's conceptual hierarchy. It is the difference between designing a house and decorating a room. There's freedom in such constraint. The improviser may wander far and wide, knowing exactly where he must return. (This is not to say that improvisers do not compose at higher levels. But this part is done painstakingly, just like ordinary composition, then brought ready-made to the stage. There's much less that's really new in an "improvised performance" than many listeners assume.)

Not all improvisation is so structured. At an extreme, improvisation can proceed by association from moment to moment, free of any preconceived form, as is the case with "free jazz." Deep structure is inevitably lacking in this style, although some listeners find compensation in the surface originality. Yet even in its apparent chaos, "free" improvisation is constrained. When saxophonist Ornette Coleman spins his wild gyrations, he works from a vocabulary of sounds, and a kind of grammar for juxtaposing them, that has become his musical language. Much of what is "new" follows pathways that have worked in the past. Like all music, it is largely ready-to-play. It cannot be otherwise, for even a well-prepared mind can work only so quickly.

Improvisation is particularly constrained in ensembles. Players clash when they alter harmony or rhythm differently, and recovery is difficult. So players can improvise simultaneously only when the framework is tightly circumscribed, as in early Dixieland jazz, or in the "anything goes" style of recent avant-garde genres. More typically, improvisation rights are passed from instrument to instrument as first the piano, and then the sax, and then the bass, takes its turn.

As performance, improvisation can be a marvel—a conjunction of physical technique, musical understanding, and creative flare. Many of the great composers were famed as improvisers. It was only in the later part of the nineteenth century that the tradition petered out as musical structure became prohibitively complex. Yet, significantly, there are few reports of composers publishing an improvised piece note-for-note. A brain simply can't generate effective deep structures quickly enough. Rather, composers

mine their improvisations for ideas and then develop the ideas methodically. For them, improvisation at an instrument is merely an extension of the improvisations they spawn through auditory imagery all day long.

## Composing at the Piano

Although improvisation yields ideas, there has long been a debate about whether composers should work at a piano. Nearly all of the great composers played a keyboard instrument; some were the finest artists of their day. The piano is the ideal instrument for a composer, letting him play several voices at once, and offering a magnificent repertoire for study and experimentation. Yet Schumann cautioned, "When you begin to compose do it all in your brain. Do not try out the piece at the instrument till it is finished." His concern was that imagery would be stifled, and that inspiration would suffer as a result.

There's also the danger that the physical demands of playing will dominate and debase musical originality. As we'll see in the next chapter, musicians work through a hierarchy of ready-made movements. Thousands of patterns of scales and arpeggios and chord progressions are deeply channeled in their nervous systems. These motions constitute a sort of muscular intelligence that is essential to improvisation. But they also exercise a kind of musical despotism when the patterns assert priority over anything new. A great innovator like Hector Berlioz, one of the few composers who couldn't play the piano at all, summed it up well:

> When I consider the appalling number of miserable platitudes to which the piano has given birth, which would never have seen the light [of day] had their authors been limited to pen and paper, I feel grateful to the happy chance that forced me to compose freely and in silence, and this has delivered me from the tyranny of the fingers, so dangerous to thought, and from the fascination which the ordinary sonorities always exercise on a composer.

The composer Carl Maria von Weber agreed:

*The tone poet who derives his working material from it [the piano] is almost always born poor or on the way to surrender his soul to the common and the ordinary. For these very hands, these damned pianist's fingers, which finally take on a kind of independence and peculiar intelligence through perpetual practice and work for mastery, are stupid tyrants and bullies of the creative impulse. How differently does he work whose inner ear at once discovers and criticizes.*

Yet, in stark contrast, Stravinsky had this to say:

*What fascinated me most of all in the work [of composing* Petrouchka*] was that the different rhythmic episodes were dictated by fingers themselves. . . . Fingers are not to be despised; they are great inspirers and in contact with a musical instrument, often give birth to unconscious ideas which might otherwise never come to life.*

Stravinsky had discovered what every good improviser knows: that the kinesthetic hierarchy by which musicians move their fingers can also be developed to the point that it spontaneously generates new musical patterns, patterns that all but fly from the pianist's fingers. But this alternative form of inspiration appears less robust and flexible than the inspiration of auditory imagery.

Whatever the merits and disadvantages of the piano, almost every composer has relied upon it. Even Mozart declared that he could not compose without a keyboard in the room. As Beethoven deafened, he had a piano made with double the number of strings, and later he played on a stringless piano just for its aid to auditory imagery. Schumann, despite his later criticisms, found many ideas for his best music through piano improvisation. Indeed, the more recent the composer, the more he appears to have used a piano. Ravel was horrified that a composition student worked in silence, wondering how he could discover new sounds. Stravinsky went so far as to say that it was a bad thing to compose without a piano, that the composer must hear what he is writing.

# Working Methods

Most of us carry about contradictory images of a composer at work. On one hand, we imagine a composer breathlessly penning a symphony as if it were phoned in from heaven. On the other, we picture a composer slaving over a stack of manuscript pages, piling correction upon correction with sighs of exasperation. The two views are both correct and incorrect. They characterize every composer partly and no composer entirely.

Mozart is the best know example of a fluent, "inspired" composer. He is idolized today partly because he made composition look so easy, jotting down fistfuls of notes while waiting his turn at billiards. There's no question that he really did work this way, sometimes pouring an entire symphony from his nervous system in a few days. He once wrote:

> *Those ideas that please me I retain in memory, and am accustomed, as I have been told, to hum them to myself. . . . My subject enlarges itself, becomes methodized and defined, and the whole, though it be long, stands almost complete and finished in my mind, so that I can survey it, like a fine picture or a beautiful statue, at a glance. Nor do I hear in my imagination the parts successively, but I hear them, as it were, all at once. What a delight this is I cannot tell! All this inventing, this producing, takes place in a pleasing lively dream.*

It's possible to watch Mozart at work even today. He sometimes ran out of ink while working and had to switch to a different kind. By examining ink patterns, musicologists have discovered that Mozart did not write out finished music bar-by-bar from start to finish. Instead, he began by mapping out the melody and bass lines—perhaps only a quarter of the notes found in the final manuscript. Inner voices were initially left blank and filled in later.

Mozart would not have worked this way if he merely copied a perfectly formed image of a composition from memory to paper. Rather, he began by mapping a composition's structure. Only later did he go back to fill in supporting voices and embellishments that could be written in any

number of ways without changing the basic character of the piece. Significantly, when interior voices were structurally important, as during transitions between passages, Mozart would write out every detail during the first pass.

These observations suggest that Mozart did not necessarily develop note-perfect compositions in memory. Instead, he may have contrived only a composition's basic structure in his mind's ear—its melodies, harmonic sequences, and overall form. Then, in a second pass, and working largely on paper rather than in memory, he could have brought to bear the fabulous technical training for which he was so envied by his contemporaries. He would hammer out the details of chord progressions, instrumentation, and ornamentation as quickly as he could move a pen, just as some writers, knowing just what they want to say, can craft skillful sentences as quickly as they can type. This is, in fact, just the kind of skill that jazz improvisers acquire through years of practice and training, and which they apply in real time to the ready-made structures of popular tunes.

Nor would there have been any point in Mozart deciding upon every note before taking pen to paper. It was only the structural elements that he needed to manipulate over and over in memory until a "finished" composition fell into place. The remaining busywork, improvisational in nature, was most efficiently rendered at the last moment.

This is not to denigrate Mozart's musical memory. He is rightly famed for having once written out from memory the nine-voice choral work *Miserere* after only two hearings. The point is that composers work in pared-down structures, whether in their heads or on paper. The logic of a sixteen-bar phrase might be worked out, and then remembered, as little more than a short theme transformed first one way, then another, following a single harmonic and rhythmic pattern. The composer might conceive the phrase as only a dozen musical objects or transformations; the rest is filler.

## Sketches

In contrast to Mozart's outwardly effortless way of composing, Ludwig van Beethoven stands as music's most distinguished plodder. Working on several pieces at the same time, he would put major compositions through

draft after draft over a period of years. His manuscript pages had so many erasures that patches of paper were glued on them to cover spots worn through. Sometimes he would hang pages on the wall of his study so that he could observe the developing form. For Beethoven, composition was wedded to the written score.

Beethoven once explained to a friend, "I always have a notebook with me, and when an idea comes to me, I put it down at once. I even get up in the middle of the night when a thought comes, because otherwise I might forget it." Today, over five thousand pages of these sketches remain, and they provide a treasure trove of information about how he worked. Some entries are nothing more than melodic fragments. Others resemble the treble-and-bass combinations of Mozart's first pass through a manuscript. Some are experiments in which he tried out different harmonizations or orchestrations on the same theme. And others are finished passages.

Because the sketchbooks are dated, musicologists have been able to reconstruct the complicated histories of many of his major compositions. What's most intriguing is the paucity of progressions from simple to complex in which Beethoven first wrote out a theme, then added a bass line, then harmonization, then ornamentation, then orchestration. Rather, Beethoven would jump from level to level, often working backward from the superficial to the abstract.

In sketches for his *Eroica* Symphony, Beethoven clearly attempted an abstract mapping of the composition's largest structures. As one musicologist put it, he jotted down "any cliché that would mark the place where an idea ought to be." And he juxtaposed passages by content rather than by order. Working this way, Beethoven escaped the conventionality that arises from moment-to-moment association. The symphony built outward from an abstract deep structure whose stark originality forced further innovation at every level up to the surface.

At first glance, Beethoven's sketchbooks could be taken as a crutch for poor long-term memory. He certainly relied upon them as an aide-mémoire. But it's doubtful that anyone, even Mozart, could have accomplished Beethoven's architecture without the help of a written score.

Indeed, research has shown that, contrary to widespread belief, Mozart also resorted to sketches for major works. Although his wife discarded most such "unusable autographs" upon his death, a few have survived to show false starts and corrections much like Beethoven's. No wonder he once complained, "People make a mistake who think that my art comes easily to me."

Not all composers work at such high levels of abstraction. Take Tchaikovsky, who once wrote: "I never work in the abstract; that is to say, the musical thought never appears otherwise than in a suitable external form." So literal was his musical thinking that he once explained that the idea of orchestration (of deciding which instruments would play which parts) made no sense to him. In his mind's ear, every musical idea sprang into existence already played by particular instruments.

This is not to suggest that Tchaikovsky's mind did not function through abstract musical hierarchies. Rather, he relied on automatic operation at more abstract levels, being much less self-conscious of them than Mozart or Beethoven, and thereby much less able to manipulate them. The result was music with splendid surface texture but shallow structure. Tchaikovsky was all too aware of his shortcomings and lamented: "I have always suffered from my want of skills in the management of form . . . my seams showed . . . there was no organic unity. The form of my works will never be exemplary, because although I can modify, I cannot radically alter the essential qualities of my musical temperament."

## The Score

The manuscripts of Mozart and Beethoven demonstrate that the written score is much more than a memory aid. It is a means of posing and solving complex musical problems. It brings the power of visual intelligence to bear, allowing the composer to grasp complex relations as spatial patterns. It provides the blank, as yet unfilled measure as a musical placeholder, as important to music as was the invention of the zero to mathematics. And it helps organize the entire process of composition, subdividing problems into manageable tasks and providing an overview of progress. Just as a skilled architect might be able to model a house in his mind's eye,

but would need blueprints to design a cathedral, so composers require pen and ink to create musical edifices on the scale of a symphony or an opera.

Sheet music is a kind of graph paper representing a peculiar form of space-time. Time flows from left to right, wrapping around from line to line and page to page. And space—in this case, the range of frequencies that constitute *pitch space*—stretches from top to bottom, with "high notes" higher up on each staff. It is not the sort of graph paper that would please a scientist. Time expands and contracts with varying measure size, and pitches are offset by key signatures and various alterations to staffs. Worse, important features like timbre and loudness have no dimension of their own. So every kind of instrument has its own graph, and scores are studded with symbols and words that describe rather than portray.

You might guess that there must have been a clever inventor behind so complex a system. But notation began in the West almost by accident, arising not from music but from written language. In the monasteries of the Middle Ages, scribes toiled over their parchments to preserve the Latin prayers sung in Gregorian chant. Because the monks who chanted the texts often knew little Latin, scribes helped them out by adding an occasional accent mark above syllables. By the eighth century, these accents became wavy lines showing the rise and fall in which a syllable was to be sung.

Gradually, the distance between a marking and its syllable came to indicate the syllable's pitch—the higher the marking, the higher the pitch. Obvious though it may seem to us today, this innovation was a potent breakthrough, allowing scribes to record purely musical information for the first time. But the system was inexact, and a sleepy-headed scribe could sabotage the whole choir. So someone hit on the idea of drawing a horizontal reference line above the Latin text. Markings could be made above, below, or on the line. The obvious next step was to add another line, and then another and another. And so the musical staff was born.

If you've ever visited the medieval wing of an art museum, you've no doubt encountered examples of the sheet music of the day, with staffs of four lines rather than five, overlaid with large block-like notes written in a cursive style. Although these manuscripts lack the refinements of the printing press, at first glance they appear much like today's musical scores.

But look closer. There are no bar lines to mark measures, and the notes have funny shapes, sometimes tilting upward or downward, or swiveling to form a diamond. Odder still, stems may join sequences of notes in a sort of connect-the-dots pattern.

What you see in medieval scores are not notes at all, but *neumes*. Each neume represents several notes that form a melodic figure such as a dip and rise, or a precipitous fall. This whole motion was sung on the Latin syllable to which the neume is tied. Timing and accentuation was left entirely to the natural pace of spoken Latin; there's no meter at all. Try dancing to Gregorian chant and you'll see.

It's interesting to reflect on what this system meant for musical composition, such as it was at that time. Early in the history of Western music, the minimum musical conception was not a single pitch but a group of pitches, a melodic motion, and these must have been the building blocks composers assembled in their minds. As for the notion of rhythmic construction, it simply didn't exist. Ever since, the history of notation has been of increasing flexibility and abstraction.

It was only with the growing importance of musical instruments that scoring was finally divorced from words. Single-pitch notes had appeared by the thirteenth century, and means of notating their durations soon began to evolve. The earliest timing distinctions simply classified notes as long, short, or very short. But as parts overlapped in ever more complex polyphony, timing became important and notes were sliced into halves and quarters and eighths. Interestingly, the means of defining precise durations for notes developed at the same moment in history as mechanical clocks.

Scores were initially a means of communication between composer and performer. But written music also has played an essential role in communicating musical ideas between composers. Printed sheet music made its debut in 1501, a half century after the first Gutenberg Bible. Soon Europe was flooded with scores. In Renaissance times, if a German composer wanted to hear the Italian style, he put on his shoes and walked south. But by the early eighteenth century, Bach could write his *English Suites* and *French Suites* and *Italian Concerto,* each in a foreign style, without ever setting foot outside Germany. Styles that once would have been des-

tined for extinction survived for reference centuries later. And composers could closely study how various musical effects were achieved.

But for all the score's contributions to the composer's powers of memory, imagery, and abstraction, the written note is not without drawbacks. For one thing, music notation tends to discourage complex melodies and rhythms. The pitch glides and wavering voices that are the norm in most of the world's music are nearly impossible to write down. Elaborate metrical patterns fare little better; they can be written, but with such clutter that musicians can hardly interpret them. Many new notation systems have been proposed as music has become more complex. But musicians invest years learning to read standard notation automatically. They understandably resist change.

There's one other disadvantage to the written score, one that arises from its very strength. By promoting abstracted, hierarchical thinking, the score can seduce composers into a theoretical, unmusical approach to composition. Music becomes an exercise in theoretical elegance as the composer builds deep structures more complex than a listener can fathom. He is seduced into working through intellectual analysis instead of auditory imagery. At an extreme, composers like John Cage have treated scores more as exercises in graphic design than as musical blueprints. The result can be a terrible clatter comprehensible only to the initiated few—and arguably pleasurable to no one.

## Musical Creativity

This, then, is how composers realize their extraordinary feats. But knowing how composers work tells us next to nothing about what leads them to compose, and even less about why some succeed and most fail. You'd think that those of great talent would have pondered long and hard about how they could (in some cases) dash off an entire opera in two weeks while nearly everyone around them could hardly whistle a tune. But for the most part we have only paltry fragments from diaries and correspondence to recount how the great composers regarded their talents. Even those who cranked out hundreds of pages of musical criticism—Schumann, Berlioz, Wagner, Debussy—were largely mute on this subject.

Prior to the twentieth century there was much less concern with the notion of "mind," and less proclivity for explaining it. To Bach or Haydn, musical talent was quite literally a gift from heaven, ultimately no more amazing, and no more explicable, than any other cognitive skill. Later, as stronger individualism took hold in the nineteenth century, the myth of the "Inspired Genius" flourished, crediting the composer with an inner spirit. This view, still prominent today, contributes nothing to an explanation of musical genius, merely shifting the source of musical ideas from a hidden place outside the brain to a hidden place within.

For the last century or so, psychologists have studied creative geniuses of every breed in the hope of explaining the yawning disparity between their capabilities and those of ordinary human beings. While all investigators have acknowledged the critical role of upbringing, training, and general intelligence, until recently they've been haunted by the phenomenon of inspiration, and less concerned with the mechanics of building up compositions from slight ideas.

The first widely accepted and supposedly "scientific" explanation of creativity came from Freud, who described an unconscious mind rattled by derailed instinctual drives it could neither contain nor gracefully release, and so directed toward the creative act. Unfortunately, Freud never explained why many such minds end up in a looney bin while a select few produce symphonies. Indeed, he admitted that psychoanalysis was powerless to illuminate how musical ideas arise, or how they are fashioned into compositions. His concern was with *why* rather than *how,* and in the end he succeeded only in providing pseudo-scientific underpinnings for the romantic view of the inspired genius.

Some decades later, the behaviorists provided an altogether different perspective on creativity, one that held sway (in the United States, at least) for half a century. Their view of creativity is well summed up in B. F. Skinner's description of a painter at work: "The artist puts paint on canvas and is or is not reinforced by the results. If he is reinforced, he goes on painting."

Behaviorism does not abide notions of inspiration or planning or experimentation, nor any other subtle workings of a mind conversing with

itself through symbols and images. For all practical purposes, what cannot be externally observed does not exist. In this view, Beethoven wrote his symphonies much in the way one would paint a room, moving from corner to corner. The problem with this analysis is that Beethoven's sketchbooks abundantly demonstrate that he *didn't* and probably *couldn't* work this way. But the behaviorists prospered in the epoch of rats in mazes, where learning and ultimately all behavior were reduced, like lines of falling dominoes, to sequences of associations. As they say: Once you have a hammer, everything starts to look like a nail.

Today's creativity research proceeds with a more balanced view, taking into account many facets of cognition, personality, and life circumstance. In place of a solitary muse, it's now recognized that a composer's success depends on a dozen or more requirements, each of which must be fulfilled in adequate measure. To be outstanding, at least some of the necessary talents and circumstances must near an extreme. And to be a Mozart you must have them all: superb neurology for music, a high overall IQ, thorough training, limitless encouragement, the right kind of personality, with drive, courage, and rebelliousness, and the luck of being born at a time that complements your talents. (Mozart's one failing: a grievous lack of common sense, which destroyed his health and led him to the grave just as his genius came to full blossom.)

Integral to the modern notion of musical talent is the idea that everyone is born to compose. Children are expected to draw pictures and write stories when they're sent off to school. But when it's time for music education (and there isn't much of it these days), the emphasis is on playing music rather than making it up. The assumption seems to be that writing music ought to be the domain of a small elite, like astrophysics or Egyptology.

But developmental psychologists have demonstrated that children readily become little composers when encouraged and supported. In Chapter 3 we saw how eighteen-month-old infants begin to sing spontaneously, just as they begin to babble somewhat earlier. Parents respond to the babbling and it goes on to become speech; they ignore the singing and it stops.

Yet musicality flowers when it is reinforced from an early age. Chil-

dren take naturally to improvisation and composition, readily acquiring pitch-discrimination and other skills needed for writing music. They experiment freely, retaining ideas they've stumbled upon. By the age of four, more than half produce something original. And progress continues right through adolescence. The results are hardly Mozartean. But children's efforts at writing are seldom Shakespearean. The point is that original music arises naturally from minds exercised in it, and not from some muse inhabiting a fortunate few.

## Composers' Brains

It's commonly thought that creative genius springs from a vastly superior brain. If variation in the analytical intelligence measured by IQ tests is largely attributable to biology, why not imagination too? But no one is sure what neurological superiority looks like. It's long been known that there's no simple correlation between brain size and IQ. Even the brains of acknowledged geniuses display no obvious pattern of enlargement, nor a greater density of neurons, nor a faster rate of neuron firing.

This is not to say that all brains appear identical. Far from it: every brain is as different as the face through which it peers out upon the world. The relative proportions of brain parts vary, as do the patterns of convolutions on the brain's outer surface. Most important, the amount of cortex given over to particular tasks can vary considerably. A function taking up a square centimeter in one brain may take up two in another.

Anecdotal evidence suggests that *individual areas* of a brain may indeed function in a superior fashion. There's the case of the talented artist, singularly sensitive to color, who was found to have visual cortex twice the normal thickness. And there's Einstein's brain, which showed double the normal number of neuron-support cells (glial cells) in an area concerned with spatial reasoning. Such observations help explain why talents are often limited to a single domain: the remainder of Einstein's brain was quite ordinary.

That different parts of the brain dominate various musical tasks helps explain why composers excel in some talents and not in others. A minor composer like Respighi was one of the best orchestrators ever, but undis-

tinguished in every other way. Conversely, a great composer like Schumann could hardly write for orchestra at all. Focus and training are factors, of course, but so must be an innate advantage for particular kinds of imagery.

Superior musical neurology may manifest itself as an excruciating sensitivity to sound. It often appears early. The infant Mozart was made sick by loud sounds; Mendelssohn simply cried whenever he heard music. As a child, Tchaikovsky was supposedly found weeping in bed, wailing, "This music! It is here in my head. Save me from it." This passion for sound, even for individual tones, is common enough that German has a word for it: *Hörlust* (roughly, "hearing passion"). But where there is pleasure there is also pain. Ugly sounds become torture. And so Handel would not enter a concert hall until after the instruments had been tuned, and Bach would fly into a rage upon hearing wrong notes.

As we've seen in earlier chapters, auditory areas of the right temporal lobe are particularly important for music perception, and thus for music imagery. Destruction of these areas results in permanent loss of melodic memory. In Chapter 9 we'll consider how, on the opposite side of the brain, these same areas are specialized for language perception, and how the brain is usually enlarged at this point to accommodate this specialization. Moreover, there's considerable variation among individuals in the degree of enlargement of this language center (which might help explain a Dante or a Shakespeare).

What's most important for music in all this is that in 11 percent of the population the language enlargement is on the right side of the brain rather than on the left. Sometimes this turnabout occurs because the whole brain is lateralized in reverse, with normally left-brain functions on the right and vice versa, as is often the case for left-handers. But not always. Some people follow the usual pattern of lateralization and handedness, yet have the language enlargement not in a language area on the left, but in musical areas on the right. It's conceivable that this enlargement could provide the basis for the phenomenal musical memory and imagery of a Mozart, especially if the enlargement is inordinate.

Even if this were true—and it is only speculation—it does not mean

that we've finally located an inborn muse. It's hotly debated whether the differences in Einstein's brain were innate or the result of years of arduous cogitation. The same sort of nature-nurture argument would apply to parts of the brain that might favor musicality. While extra cortex would seem to offer an inherent advantage, there's considerable evidence that the amount of cortex given over to a task is flexible, expanding with increased use. So it would take training, or at least protracted effort, to make use of such a gift. In the end, intellectual power of any kind arises from the laborious creation of networks of neurons. But some people may have a much better substrate in which to etch those networks.

## Composer IQ

So just how smart were the great composers? Intelligence tests are hardly a century old, so there are no test scores for Bach and Beethoven lying about. But that hasn't stopped psychologists from trying to estimate the IQs of long-dead geniuses from reports on their childhood development and other biographical data. One such study ranked Mozart and Mendelssohn at the top of the class with respective IQs of 155 and 150, Handel at 145, Beethoven at 135, Bach at 125, Haydn at 120, and Gluck (the class dunce) at a mere 110. Although such studies are sometimes mocked, there's been a marked uniformity in their conclusions. It's hard to believe that the intricate fugues of Bach originated in a brain not much above average. Yet Bach did not shine in any other way, having evinced no particular flair for ideas of any kind, no particular verbal fluency or wit, nothing.

Compared with other professions, composers don't come across as very smart in these studies. The highest score among them, 155, is barely within the range usually associated with "genius." By comparison, so-called omnibus geniuses like Goethe and John Stuart Mill scored 200. Systematic research on many thousands of musicians has shown that musical intelligence correlates only mildly with IQ (at about .30). One study concluded that the kind of analytical intelligence measured by IQ tests is irrelevant to musical ability beyond a certain base level. Such conclusions seem to contradict a study of university music majors that showed a strong correlation

between IQ and performance in music theory classes. But as we've seen, composers rarely deduce music from a theoretical scheme.

While composers don't need a stratospheric IQ, analytical skills still come in handy. Amidst the flood of auditory imagery, composers must constantly solve problems. Can the notes they write actually be played by musicians? Which instruments will mask the sounds of others? Will widely separated pitches sound in tune? There are also structural problems to grapple with. Fragments of music each have their own idiosyncrasies and they frequently resist seamless joining. Often a solution at one point causes problems elsewhere. Debussy wrote, "It is curious how two 'parasitic' measures can demolish the most solidly built edifice. This is just what has happened to me, and nothing can prevent it, neither long experience nor the most beautiful talent!"

Many people are under the impression that talent for music goes with talent for mathematics. No such link has ever been conclusively demonstrated. The notion may descend from medieval universities, where *musica* was taught beside *mathematica,* emphasizing the arithmetic of harmonic ratios. But mathematical proofs don't much resemble the patterns of a fugue. (A closer link might be with computer programming, which, like music, entails variations on a flow of hierarchical structures.)

Recent research has given new life to the music-math nexus. It has been found that children given music lessons do better in arithmetic than a control group deprived of music education. More remarkably, still-controversial research has shown that college students score higher on certain math tests immediately after listening to classical music (but not after exposure to the much less organized sounds of pop music). The advantage lasted for only about a half hour after listening to the music, and there's no evidence so far that listening to classical music permanently enhances mathematical intelligence. Significantly, the benefit accrues only to problems entailing spatial manipulations—just the kind of reasoning that is dominated by areas of the right brain adjacent to those especially concerned with music perception.

# The Composer's Personality

Personality profiles of the great composers match those of all kinds of creators. They show strong independence in every respect, tending to be solitary and socially reserved, shunning group activities, establishing few close friendships, often going unmarried. This "ego-strength" also manifests itself in a willingness, even an eagerness, to defy tradition. So it's no surprise that outwardly conservative personalities like Haydn and Stravinsky spent their lives joyfully demolishing conventional musical forms.

Those who lose their youthful rebelliousness are in grave danger of losing their talent as well. Such was the destiny of Mendelssohn and Saint-Saëns. After a youth brimming in confidence and daring, Mendelssohn essentially worked himself to death in academic life, all the while becoming more and more conservative in his outlook and more and more detail-oriented in his composing—a perfectionism he described late in life as his "dread disease." Saint-Saëns suffered a worse fate, becoming so reactionary late in life that he schemed to quash the careers of youthful free spirits like Debussy. He once wrote in regret, "I ran after the chimera of purity of style and perfection of form." The innovative Berlioz, who knew Saint-Saëns as a glittering prodigy, was less charitable: "He knows everything but lacks inexperience."

In addition to their all-around rebelliousness, composers tend to be a highly emotional lot. The same studies of creative professions that rank composers relatively low in IQ rank them highest of all professions in emotionality. Not surprisingly, a little emotional wobble makes for good music. One study traced emotion-charged incidents in composers' lives, such as births, deaths, and changes in domicile or workplace, finding that melodies written during tumultuous periods were more original and more harmonically adventurous.

But no particular brand of emotionality is tied to musical greatness. Some, like Brahms and Mahler, were given to depression. (When asked as a child what he wanted to be when he grew up, Mahler replied, "A martyr.") Some, like Rossini and Stravinsky, were obsessive, following rigid work schedules. Others were prone to phobias. Picture Tchaikovsky on the podium, conducting with one hand while grasping his chin with

the other out of fear that his head would fall off. But also picture the perfect equanimity of the mild-mannered Haydn, or the debonair self-possession of Liszt.

If there is one emotional attribute that turns up again and again, it is a fiery temper. That Bach would hurl his wig at fumbling musicians seems entirely excusable when you consider how Handel once lobbed a whole kettledrum across the stage. Beethoven was known to return food to a restaurant kitchen via the waiter's head. Even the urbane Chopin once broke a chair in response to an unfortunate student's playing. And Mahler railed from the conductor's podium so fiercely that he repeatedly had to turn down duel challenges from players. Research has found that uncontrollable anger is common among creative geniuses of all stripes. Always reaching for the impossible, life can be a long series of obstacles and frustrations: financial hardship, endless labor, isolation, the uncertainty of the value of one's work.

Schumann once wrote,

> *People compose for many reasons, to become immortal; because the*
> *piano happens to be open; because they want to become a millionaire;*
> *because of the praise of friends; because they have looked into a pair of*
> *beautiful eyes; or for no reason whatsoever.*

One motive he neglected to mention is a fascination for musical structure. This is different from a love of the experience of music. Composers are entranced by the intricate logic of musical devices, the interplay of rhythm and harmony and tone color. There is something of the watchmaker in them. This trait appears early, for budding composers are seldom content to merely play the music of others. They experiment with it, trying out different approaches, rewriting it. As psychologist Howard Gardner puts it, they begin their careers by *decomposing*. More than any other factor, this inventor's mentality seems to divide composers from performers.

What sort of background gives rise to such a personality? Roughly half of the great composers had parents who were professional musicians. In a few cases they originated from musical dynasties. The most famous is

the Bach family, which over seven consecutive generations produced 64 professional musicians: 1 in the first, 3 in the second, 3 in the third, 10 in the fourth, 18 in the fifth, 23 in the sixth, and 6 in the seventh. It's tempting to conclude that heredity must be hard at work here. But studies of inherited musicality among ordinary musicians have failed to establish a strong link. The reason is that musicality is a mix of talents unlikely to be inherited en masse. At most, there are signs of inheritance of isolated skills like perfect pitch. Studies show that the offspring of talented parents tend to be less talented on the whole, a result that follows the expected regression toward the mean. Even studies of twins have been disappointing. Identical twins actually display less similarity of auditory brain lateralization (ear dominance) than non-identical twins. It's clear that the parent's contribution to musical genius is at least as much nurture as nature.

Many of the great composers received exceptional encouragement and training in childhood. Mozart's father was not only a noted composer and conductor, but also the author of a book on music pedagogy. He gave his son the ultimate musical education, undermining his own career to do so. When on tour he could advertise his "Prodigies of Nature" in the plural, because Mozart's older sister also became an impressive child musician under his tutelage.

But there are also stories of great composers triumphing over adversity. In spite of (or because of) his own success, Johann Strauss, Sr., did all he could to dissuade Johann junior from pursuing music. But to no avail: his son went on to become the better composer. Even more remarkable are talents arising from entirely unmusical families. Leonard Bernstein, a man seething in raw musicality, played no instrument until he was ten and was strongly discouraged by his father from a career in music. Such stories affirm that musicality truly is inborn. Nurture is not enough. Any piano teacher with a stable of ten-year-olds will report that some just haven't got it, despite parents doing everything right.

In the end, it has been the lucky few blessed with both exceptional nature and exceptional nurture that have become music's superstar composers. Their music so dominates recordings and concert programs that the public is left unaware of the thousands of forgotten composers with whom

the greats once shared the stage. Today only about 250 composers are heard in concert. One study of the compositions most popular today concluded that 20 percent were written by only 3 composers (Bach, Mozart, and Beethoven), 50 percent by 16 composers, and 75 percent by 36 composers. Studies of the other arts render similar results.

Where are the great composers of today? Many devotees of classical music feel that very little of quality has been written in recent decades. Not everyone agrees, of course. Some claim that we've had a few good composers and that's as many as any era offers. Others argue that segments of today's popular music, particularly jazz, have taken up the torch that the classical tradition somehow dropped. That few popular composers have generated large-scale scores casts doubt on this view. While recordings can take the place of scores in preserving music, the importance of the score in developing complex musical structures is no different today than a century ago. It shows. Audiences that find communality in the diverse styles of Monteverdi, Mozart, Mahler, and Stravinsky, seldom find a kindred experience in the popular music of today.

It would be nice to believe that the crisis is illusory, that great genius is there but undiscovered. But biography shows that nearly all creative geniuses have been recognized in their own lifetimes, provided they don't die too young. The half century since the Second World War is too long to hide. By comparison, in the fifty years from 1790 to 1840 a dedicated Viennese concertgoer could have heard Mozart and Haydn conducting, attended the opening performance of Beethoven's Ninth, and gone on to hear premieres of much of the best of Rossini, Schubert, Mendelssohn, Schumann, Chopin, and Liszt. Those were the days.

What happened? Some musicologists (such as Donald Plaisants in his book *The Agony of Modern Music*) hold that the composer's changing self-conception from craftsman to self-styled demigod has led to such an emphasis upon originality at any cost that music has been made incomprehensible and unenjoyable. Lacking a popular following, or patronage by the wealthy, aspiring composers end up teaching in universities, where survival may demand adherence to the fads and follies of intellectual bureaucracy. So composers end up writing only to impress each other.

Other critics find fault with music education. Gone are the days when a promising young talent was schooled intensively and broadly from an early age. It is rare today to sing in a choir, learning the logic of the soprano, then the alto, then the tenor, and then the bass as the voice deepens (for males, at least). It also has become rare in our age of perfectionism to study several musical instruments. Nor is the art of improvisation often cultivated. Perhaps most important of all, the invention of the phonograph has meant that few musicians develop the imagery skills necessary to "hear" music by reading scores. The phonograph has been as disastrous to the development of the musical imagination as television has been to the literary imagination. The growing use of synthesizers may only worsen this trend.

Others see a crisis in the very structure of music. They believe that increasing complexity has overwhelmed the intellectual resources of composers and forced them to abandon inspiration for intellectual gymnastics. Some have even argued that the Western harmonic tradition is exhausted, with nowhere new to go.

One explanation that cannot possibly hold water is that a potential Mozart just hasn't been born recently. Today's world offers the affluence, the opportunity, and the sheer numbers of human beings to spawn fifty times as many Mozarts as two centuries ago. By this reckoning we live in a dark age in all the arts.

Perhaps Rosemary Brown was such a Mozart-in-waiting. She certainly must have possessed an extraordinary musical neurology to have been so flooded with spontaneous musical imagery. In another era she might well have blossomed into a fine composer had she grown up in a favorable background (and been male). But you have to wonder whether her muse would have survived a modern musical education had she been more privileged and less daft. Could she have prospered amidst doctrinaire training and frantic competition for grants or tenure? The voice of the muse is soft and delicate, audible only to a mind relaxed and free to drift. Its song is faint in our age of anxiety and distraction.

# 7

From sound ...
...to tone ...
...to melody ...
...to harmony ...
...to rhythm ...
...to composition ...
... to performance ...

The clientele must have been suspicious. At an otherwise ordinary slave auction held in Georgia in 1850, the proprietor offered a black woman and her fourteenth child, a year-old infant thrown into the deal for nothing. Buyer beware: the child was blind. What use could there be in a blind slave? Just one more mouth to feed, one more body to clothe. And this infant acted so strangely! How delighted the proprietor must have been when a price was agreed upon and Blind Tom and his mother were sold to a certain Colonel Bethune.

The Colonel appears to have been a kindly man, for Tom was given the run of the mansion. It soon became clear that this was no ordinary child. For one thing, the boy exhibited an extraordinary sensitivity to sound. When it rained, Tom would feel his way to the attic and bathe in the symphony of patterings on the roof. When the harvest was brought in, Tom groped toward the barn and passed hours listening to the gyrations of the peanut-shelling machine. But most of all, Tom was drawn to the piano in the parlor. He would sidle up to it as the Colonel's daughters practiced, his body writhing to the tones.

When the Colonel heard a Mozart sonata waft up from the parlor late one night, he went to investigate. His daughters ought to have been in bed. There in the darkness was Tom perched before the keyboard, his tiny hands jumping the intervals with hardly an error. Having never had a lesson, Tom had learned the piece by listening to the girls practice. He was four years old.

The household was thunderstruck, and not just because Blind Tom was duplicating the feats of Mozart. The Colonel's purchase had turned out to be severely brain-damaged. Tom could not speak and would remain mute until the age of six. In fact, he could hardly walk. The boy was gravely retarded.

Whether by enlightenment or by enterprise, the Colonel decided that Tom's gifts should be developed. Piano lessons were out of the question, since Tom possessed no attention span to speak of. So the Colonel hired professional pianists to come to the mansion and play. That was all the teaching Tom needed. He began to assemble a repertoire merely by hearing pieces a few times. At the age of six, Tom spontaneously began to improvise. By seven, he was ready for the stage.

Tom's first concert was a sellout. His reputation had already traveled far, and newspapers gave glowing reviews. It was decided that a concert tour was in order, and in the first year Tom (or more correctly, the Colonel) earned what was then the princely sum of $100,000. Four years later he played for President Buchanan in the White House. The year after he made his European debut.

Newspaper accounts suggest that Blind Tom's concerts were bizarre affairs.

*He sat at the piano a full half-yard distant, stretching out his arms full length, like an ape clawing his food; his feet when not on the pedals, twisted incessantly. When given a theme for improvisation, Tom would take some ludicrous posture, expressive of listening, but soon lowering the body and rising on one leg . . . he moves upon that improvised axis like a pirouette dancer, but indefinitely. When Tom finished playing,*

*he would applaud himself violently, kicking, pounding his hands to-*
*gether, turning away to his master for the approving pat on the head.*

Tom's musical memory was at least as good as Mozart's or Liszt's. One estimate placed his repertoire at about five thousand pieces, enough for weeks without repetition. He played Bach, Beethoven, Chopin, Verdi—everyone, and without ever reading a note. Suspecting that he was a trickster, some musicians performed two entirely new compositions for Tom, one of thirteen pages, one of twenty. He replicated both flawlessly after a single hearing. In another test, a composer sat down to play the treble part of a new symphonic piece while Tom was to improvise the bass part on the spot. After managing this feat commendably, Tom fairly shoved the man from his seat and proceeded to play the treble with more brilliancy and power than its composer.

Concerts continued for forty years until the Colonel died. Greatly aggrieved, Tom fell into depression and belligerence, abandoned first the piano and then all society, and died in isolation five years later.

## Musical Savants

Blind Tom was history's most spectacular example of a *musical savant*. A savant's musical abilities differ greatly from the average musician's, demonstrating on one hand how much more there is to musicianship than mere physical prowess, and on the other hand suggesting that great virtuosi like Franz Liszt may have worked in ways quite different from the average musician.

Savants were once called "idiot savants" in a time when "idiot" referred to an IQ below 25, although an IQ from 40 to 70 is more typical. Most are victims of the uncommon syndrome *early infant autism*, which strikes seven children in a hundred thousand. Of these, as many as one in ten is a savant. Prodigious savants like Blind Tom, whose abilities surpass even those of talented normal people, are rarer still; roughly a hundred have been identified in all history. Six out of seven are male. One third are musical. But rare though musical savants may be, they occur frequently

enough, and have been studied closely enough, that certain patterns in their behavior have emerged.

Savants display musicianship skills that would be the envy of any professional: genuine perfect pitch, fine-grained perception, strong aural imagery, and phenomenal musical memory. But while normal musicians acquire such skills through increased intellectual flexibility, savants operate by rigid mimicry. They are sometimes *echolalic,* repeating everything said to them word for word, and they appear to do the same for music. It is not so much that savants possess musical skills as that they are possessed by them.

When a savant plays the piano, it is often with head cocked back, staring into empty space, absorbed in a private inner world where musical objects loom with clarity and persistence. Investigators once thought that savants must have a memory like a tape recorder, for when asked to reproduce a piece, they'll replicate errors of the sort that skilled musicians would automatically eliminate. But further work showed that the savant's understanding is much like a musician's. Both, for example, remember highly structured melodies more easily than random ones. Similarly, in one study a savant vastly outstripped a professional pianist in quickly learning a composition in traditional harmony (Grieg), but couldn't match the professional in a contemporary work of a style the savant didn't know well (Bartók). A tape-recorder memory would have done equally well for both.

In spite of these observations, there's reason to believe that musical savants do experience some sort of imagery-based note-by-note playback. One clue is that some savants have as good a memory for words as for music, even though their command of language is poor. Blind Tom could reproduce a fifteen-minute speech perfectly after one hearing, yet with little grasp of its content. Even more astonishing, he could repeat passages in French and German without knowing a word of either language.

Musical savants are often blind. Blindness heightens attention to hearing, of course, but there is more to this link. Savant syndrome usually results from brain damage sustained in the womb or through premature birth. A particularly strong connection exists between musical savantism and a prenatal syndrome called *retrolental fibroplasia,* in which the fetal brain is starved

for oxygen, and the retina is harmed too. Some researchers believe that the savant's left brain—the seat of both language and reasoning skills—is damaged extensively. According to this hypothesis, much of the right brain survives and assumes cerebral dominance, including those parts of the temporal lobe we've seen to be so important to musical perception and memory. This notion is supported by the observation that savants often have trouble controlling the right side of their bodies, and their rhythmic skills are poor (both abilities are dominated by the left brain). Like a pair of horses harnessed side by side, the two halves of the brain can pull a greater weight when working together, but each half forever constrains the other. It may be that in musical savants the right hemisphere runs free.

Enviably, savants never experience stage fright. Performing at the White House is no different from playing at home. They simply don't care what people think. Such aplomb stems from emotional impoverishment that robs savants of complex feelings. Savants have no concept of inadequacy, or of envy, guilt, despair, or exaltation. And this is why you'll never hear a savant at Carnegie Hall. Their playing is wooden, flat, metronomic, lacking in all expression. One explanation is that severe retardation prevents savants from grasping social situations that give rise to emotion. But savants seem even more emotionally destitute than others of low IQ, and it may be that the emotional centers of their brains are gutted during development. It would be nice to believe that savants, cut off from normal human interaction, turn to music to communicate their feelings. But it's just not so.

Tales like Blind Tom's seem to validate the notion that genius springs forth full-blown. But behind every musical savant is a single-mindedness seldom encountered in normal human beings. Trapped in a mind incapable of the full range of human experience, savants devote themselves entirely to music, and none have ever exhibited great musical skill without years of intense practice. It's hard to explain such obsession in an otherwise disorganized personality. It may be that music is the only part of the world a musical savant can fully experience. This would explain stories of savants who can't pay attention to *Sesame Street* yet sit enraptured by a three-hour opera. But also behind every savant, as for any flowering talent, is an adult offering loving praise and encouragement.

The practice-worn musician who covets the savant's skills would do well to consider the savant's failings. Savants lack a cognitive hierarchy that can juxtapose ideas and meld them into new ones. Their improvisations tend to be variations on existing tunes. Originality of any kind is rare, and genuine composition is virtually unknown. It's clear that savants have a knowledge of musical rules, but it is wholly unconscious. Music simply flows from them. The abstract manipulations that are at the heart of composition are quite beyond a savant. His musical hierarchy is shallow and inflexible.

Still, the very existence of musical savants seems to prove that raw, uncultivated musical *talent* exists as a kind of special intelligence entirely apart from the general intelligence of IQ tests. In this chapter we'll take a stab at a neurological definition of that bedeviling word. We will begin by surveying the numerous skills at work in playing musical instruments, and then will consider in detail just how a brain goes about moving the body in such complex ways. As we'll see, the performer's body is not much like a machine, her mind not much like a tape recorder. Although the neurology is a trifle complicated, it is well worth understanding, for it ultimately embodies all of musical memory and understanding. Only then can we turn to the questions that most interest practicing musicians: Why are some performers so good technically? Why are some able to remember pieces so well? Why are some so able to express themselves?

## Musicianship

Like Dr. Johnson's famous dancing dog, musical savants amaze us not by playing well, but by playing at all. For no human undertaking is so formidable as playing a musical instrument. Athletes and dancers may drive their bodies to greater exertions; scholars may juggle more elaborate conceptual hierarchies; painters and writers may project greater imagination and personality. But it is musicians who must draw together every aspect of mind and body, melding athleticism with intellect, memory, creativity, and emotion, all in gracious concert.

Picture a pianist sitting down to play chamber music. Every muscle in her body is at work as fingers course across the keys. This is not merely

glorified typing. A properly trained pianist plays all at once from fingers, wrists, elbows, shoulders, and spine, every joint in exquisite coordination as legs support and pedal. When the torso sways upon the bench, every joint continuously adjusts its relationship to every other in an enormously complex running calculus. A hair's-width error at the shoulder magnifies to a key's-width error at fingertips; an arm muscle tensed too strongly announces itself as notes in glaring imbalance.

The brain cannot perform such feats simply by issuing a long series of commands like "Elbow left three degrees!" "Index finger down!" "Harder on the brachioradialis!" Accurate movement requires that the brain monitor every result of its efforts in a perpetual loop of feedback and adjustment. For the body is not a precision machine that automatically moves just so far when stimulated just so much. The body is an environment the brain experiences and acts upon. The brain knows this environment far more intimately than it knows the exterior world, of course; it is home territory. But it is an unpredictable environment nonetheless. At the extremes of human performance the brain cannot always be certain of the correctness of its calculations, nor can it know exactly how muscles will perform when asked to make unfamiliar motions or when driven to unusual feats of endurance.

So every sensory system except those for taste and smell is put to work reporting what has happened after a movement is made. Tactile sensations cascade toward the brain, not just from fingertips but also from receptors embedded in every muscle, tendon, and joint. Meanwhile, the visual system runs helter-skelter, one moment decoding dozens of dots on a printed page, the next aligning hands to keyboard, then darting off to gather timing cues from fellow musicians. In parallel, the auditory system parses the incoming flood of sounds into separate streams for the various instruments, gauges their balance and synchronization, and assesses how the particular piano at hand translates motion into sound.

And these are merely the outward manifestations of performance. Within, each activity arises from deep hierarchies of brain activity. Hierarchies of motion cascade through the musculature, generating myriad jabs of the fingers from single complex understandings. In parallel, hierarchies

of musical comprehension lead the ear as it analyzes whole phrases instantly. And hierarchies of visual patterns make the well-practiced score readable at a glance. At higher cognitive levels still, the brain assembles long-term plans of action that shape whole passages and impart a particular style of performance.

Within the brain, every aspect of performance is intertwined with every other. The musician moves her wrist a certain way and begins to expect a certain sound. She watches a fellow musician pluck a violin string and finds herself moving to play an accompanying staccato. She hears a shift in harmony and abruptly changes posture. Lines blur between motion and perception, expectation and experience.

None of this commotion would be worth much were it not for emotions welling up through the mind's floorboards. It is the joy of so pure an expression of emotion that draws musicians to the profession. But emotion also poses dangers to performance. Primitive parts of the brain gorge the bloodstream with chemical messengers that prepare the body for action. As heartbeat and respiration rise, muscles tense and automatic reflexes quicken, unsettling the delicate balance between action and perception. Even as the musician expresses one emotion, she may be gripped by the fight-or-flight response we call stage fright. The brain, as if not busy enough already, must fight its own elemental impulses, and the result may be fearsome writhings and grimaces. No wonder concert artists find more than a few engagements a week grueling. An hour on stage can be like an hour in the ring at a prizefight—sometimes exhilarating, always exhausting.

# Hands

"Oh, I can't imagine how she moves her hands so fast!" exclaims a spectator. Although music-making entails nearly the whole brain moving the whole body, it's the hands we focus upon. And rightfully so. Were it not for hands, music might hardly have evolved beyond song. Nowhere else in nature will you find such agility and flexibility of movement. Hands reside at the farthest reaches of the brain's motor hierarchy—beyond spine and shoulder and elbow and wrist. Any descrip-

tion of the brain's musical abilities must be able to account for all that a musician's hand can do.

We have hands, and not just two more feet, thanks to our arboreal origins. Hands evolved for grasping branches. Earlier, animals could run along branches but not swing between them. The transition from skittering along unidimensional pathways to vaulting continuously through three-dimensional space was a great leap indeed. It required life-and-death accuracy in depth perception, in eye-hand coordination, in balance, in muscular control, in touch. And it required that our brains learn to think about three-dimensional relations quickly and faultlessly. This transition may well have laid the foundation of the analytical intelligence of which we are so proud.

The Japanese have a saying, "Even monkeys fall from trees." They're right. Many monkey skeletons found in the wild display bones that were broken in falls and then healed. These were the lucky ones. Over tens of millions of years, trillions of primates fell to their deaths to drive the engine of natural selection that gave us the hands we bring to a flute or guitar (and the brain circuitry that coordinates eye with hand). Our manual facility lies not just in motions of wrists and fingers, but also in elbows and shoulders that aim the hands so precisely.

Although hands have been evolving for twenty million years, to this day monkeys lack true hands and instead have a sort of foot-hand with a weight-bearing heel. Only the apes—gibbons, orangutans, gorillas, chimpanzees—and humans sport the real thing. A true hand requires a fully opposable thumb, a device that developed as a kind of safety catch. So equipped, an animal can use its hands not just to hang and swivel, but to grab. A thumb imparts the power grip that apes use to climb a vine and that we employ when we open a door. Orangutans, who seldom stray from the tree tops, have opposable thumbs even on their feet. Like double-locking pliers, their fingers jam into a special crease in the palm, forcing flesh upward as fingers press down. And so young orangs can effortlessly hang upside down for hours, tussling and clowning.

But it was apes residing mostly on the ground that evolved the musician's hand. Palms and fingers gradually shortened as there was less need

to snatch branches on the fly. Hollow claws flattened into nails to support pliable, sensitive fingertips. And the thumb lengthened till it closed perfectly with the index and middle fingers. The result was the precision grip we use to pick up a pebble or hold a violin bow.

The skin on our palms and finger fronts (and also the soles of our feet) is unlike skin elsewhere on our bodies. It's covered with minute ridges swirled into patterns. We know these ridges as fingerprints, but it wasn't for crime detection that they evolved. They are treads, not unlike the treads on a tire. Our grasp would be much less firm without them. The swirling patterns ensure a secure grip no matter the direction of push or pull. As with tires, the ridges work best when slightly moist (which is why you may lick your index finger before turning over the next page), so the ridges are speckled with sweat glands. But also like tires, the ridges fail when too wet—a danger to nervous musicians.

Next time you visit a zoo, watch how monkeys use their hands. You'll find that their fingers lack independence, opening and closing like a flexible hook. Apes do much better. Chimps manage a precision grip good enough to capture tasty termites on the ends of twigs. But by human standards even a chimp's motions are clumsy and slow. You might guess that our hands are better engineered, but in fact the designs are almost identical. Our hands are merely shorter and less hairy (our closest fit is actually with the gorilla).

So it's not the architecture of bone and muscle that lets us build violins and play them. It's the neurological control system that matters. The muscles in our hands are supplied more densely and finely with nerves than those of a chimp, our spinal cords more thickly channeled for rapid communication between hand and brain, and most important, our brains more ingeniously designed to generate elaborate hand movements.

Although the hand developed to lift our ancestors high into the canopy, it came into its own only when we took up permanent residence on the ground. No longer would the skills of the trapeze artist determine the hand's evolution. A minor aspect of primate behavior—*culture*—ballooned into *Homo sapiens*'s most notable trait. We began to use our hands to make axes, build fires, stitch together clothes. As we wandered into new envi-

ronments, the things we made, and the manual skills behind them, became essential for survival. And so the evolutionary pressure for a better hand intensified.

Meanwhile we evolved language, another kind of motor skill entailing long sequences of finely coordinated motions. With time, speech became internalized, abstract thought arose, and the nervous system began to observe and manipulate itself. With growing self-consciousness, a new compartment of mind developed, one that could make and enforce long-range plans upon a previously automatic, impulsive nervous system. This *self* (as we sometimes call it) drove human beings to aspire to ever more complex inventions—boats for fishing, nets for trapping game, weapons for battle—and more than ever humans lived and died by their handiwork.

Under such pressures, we eventually developed handedness, a specialization endowing one hand—usually the right—with exceptional dexterity. It is a uniquely human trait. Any dog has a preferred front paw, but neither paw is more capable than the other. Most musicians, however, must forever struggle to bring the weaker hand up to the level of the better.

If nature can make one hand so skilled, why not the other? It's because dexterity comes with a high neurological price tag. There is only so much gray matter to go around, and the brain could not abandon more primitive functions to make room for new ones. Instead, the brain became lateralized, with each side specializing in certain tasks. For most of us, it is the left brain that takes on the newer, higher skills that orchestrate sequences of behavior. Since the left brain controls the right body, most of us are right-handed. Right-handedness is largely a matter of left-brainedness.

## Making Hands Move

These, then, are the sensitive devices that pluck strings, press keys, pound membranes. But how exactly do we move our hands and arms? One of nature's most basic facts is that animals have brains and plants don't. Animals need brains, and much more, because they gather energy by searching for things to eat; plants just lie around sunbathing all day. There's no point in evolving a brain just to look at things and think about them. The whole point of a brain is to move. This isn't very intuitive from a

human perspective. We can use our brains intensely without budging, as when we listen to a favorite recording. But ultimately there is no aspect of our mental life that is not founded upon, and devoted to, motion. Movement is the concern of the whole brain.

Standard neurology textbooks explain that it is the brain's *motor cortex* that sets us in motion. This inch-wide strip arcs from ear to ear across the top of the brain, as shown in Figure 7.1. In the classical view, motor cortex on each side of the brain bears an image of the opposite side of the body, which it dominates. So the left brain moves the right side of the body and the right brain moves the left. Because the brain exerts finer control over certain parts of the body—particularly the hands and face—disproportionately large amounts of motor cortex are concerned with them.

The mapping of body parts to cortex can vary with experience. When a limb is amputated, other parts of the body will gradually take over its abandoned cortex. Conversely, a body part's cortical representation will grow (presumably at the expense of other parts) if it is used intensively. Thus brain scans show that concert violinists have a larger cortical representation for the hand that fingers than the hand that bows.

Such observations suggest a seductively simple view of how the brain moves the musician's body, implying that somehow motor cortex receives instructions from "memory" and translates these into motions, rather like the mechanism that reads a perforated roll in an old-fashioned player piano.

*Fig. 7.1. Motor cortex, seat of simple motions*

At the right moment, an instruction for pressing down a particular finger arrives at the motor cortex devoted to that finger, neurons fire, signals shoot down the spinal cord, muscles contract, a note sounds out. It's an eminently satisfying notion, one that proffers the orderly logic of an auto repair manual: the ignition (motor cortex) sends an electrical message that makes the engine (muscle) turn, and the car (body) begins to move.

Unfortunately, it doesn't take very close inspection to see that the brain cannot work so simply. For one thing, who turns the ignition key? Usually, this job is attributed to "higher brain centers" (which is to say that it is not explained at all). We'll explore this question a bit later. But even at lower levels of motor control, the mechanics of movement are far more complex than any machine and not at all amenable to simple conceptualization.

One problem is explaining how a three-dimensional body can be mapped point-to-point onto a narrow two-dimensional strip of cortex. If we were mere spheres that rolled about the world, we could imagine our skin as a nearly flat sheet that wraps around us and meets in a seam at back. Then it would be easy to unwrap the sheet and map it to cortex. But our bodies display a far more complex geometry, with limbs sticking out, and sublimbs (fingers and toes and various unmentionables) jutting out further still. No such image, like a cartoon character run smack into a wall, overlays the motor cortex. In fact, the mapping of body parts to cortex is quite diffuse, with much overlap. When you wiggle a toe, neurons at one point on the cortex will be especially active, but so will many others quite some distance away.

In any case, why think of motion in terms of visible body parts—that is, in terms of expanses of skin? It's muscles that do the moving. So perhaps the right way to conceive the motor cortex is as a muscle map. Muscle geometries are extremely complex, however, and it's no more obvious how to map muscles to cortex than it is to map gross body parts. And even this conception is off the mark. The motor system doesn't exist to twitch individual muscles; it's there to carry out complete movements encompassing many muscles. This fact is demonstrated by a simple experiment. With palms turned upward, wiggle a finger and watch how muscles and tendons move throughout your forearm. This means that for the motor

cortex, a finger is as large and elaborate as a forelimb. There are no solo performances in the musculature.

So it's quite incorrect to think that a particular spot on the motor cortex controls a particular body part or muscle. As many as a dozen muscles may twitch when only a tiny point on the motor cortex is stimulated with an electrical probe. Even then, single-point stimulations never result in complete movements. It takes the unified action of a substantial swath of cortex to get things done. There's no point on the cortex that lights up to play an arpeggio or a trill, or even to just hit middle C. Single neurons carry only partial information for a motion. It takes a network of many to get work done, and these same neurons will also be involved in quite different movements.

It seems that motor cortex is best described as mapping *types* of basic movements (but not movement sequences, which are pieced together elsewhere in the brain). It appears to be organized not around muscles but around skeletal joints. Devising a typology of movements is quite a challenge. We tend to think about such things from the way they meet our eyes rather than as they occur within our bodies. For instance, we conceive of the bending of an elbow as a change in angle between upper and lower arm. But this is the *the result* of a motion, not a motion's intrinsic nature. To bring about a change in angle, the nervous system must operate in terms of changing rates of muscle contraction and relaxation among combinations of opposing muscles. This means that the motor system thinks in terms of *torque,* not in terms of *push* or *lift* or *grab.*

This conception jibes with findings that individual motor neurons are most strongly tuned to the *direction* of movement. A neuron that fires madly when an arm moves in one direction may hardly murmur when the arm shifts in another, even though the same muscles are at work. Most remarkably, there's considerable evidence that the preferred directions of neurons constantly change, that motor cortex reconfigures itself from moment to moment to suit the task at hand.

Such observations lead us far from the player-piano conception of motor function, where a discrete neural command moves discrete muscles to bend a discrete finger to play an F-sharp. Many levels of complexity are

*Fig. 7.2. Premotor cortex, seat of complex motions*

required to move a three-dimensional body through a three-dimensional world. Confronted with motor cortex containing tens of millions of neurons, neuroscientists hardly know what to look for, let alone how to find it.

## Planning Movements

The labyrinth that is motor cortex serves only to make the simplest of motions. But few motions entail bending just a joint or two. Playing an arpeggio requires layer upon layer of control—control that emanates from other regions of the cortex. A single piano recital (say, of the complete Chopin études) could entail a million joint movements.

Sequences of motions are cobbled together in areas adjacent to the motor cortex and farther to the front of the brain. This *premotor cortex* (Fig. 7.2) contains areas specialized for particular motor subsystems, including for movements of the eyes and the hands. In initiating an action, these areas become active a fraction of a second before motor cortex starts firing commands down the spinal column. In a sense, these areas are the repository of basic performance skills. As we'll see in a moment, several other parts of the brain contribute to any motion. So it's not correct to say that the musician's repertoire of motions is located in premotor cortex. But such motions are largely assembled at this point, calling on other parts of the brain for help.

Music, however, is more than scales and arpeggios. Musicianship rests on the ability to combine the many skills seated in motor and premotor cortex into long passages. Shouldn't there be some part of the brain that is the ultimate repository of whole compositions, the place where instructions for assembling pieces are stored? Let's consider each possibility in turn.

One place to look is a step forward from premotor cortex, where the frontal lobes reside just behind the forehead (Fig. 7.3). This part of the brain is usually credited with advanced planning functions. So it's tempting to regard the frontal lobes as the ultimate executor of our intentions, shouting down commands through layers of middle management until final implementation by motor cortex. In this conception, the frontal lobes would issue a blueprint of a musical passage that lower regions would flesh out into sequences of hand and arm motions.

But experience goes against this view. Victims of severe frontal lobe damage suffer defects of attention and personality, but have little trouble moving around. In contrast, damage to the premotor cortex makes complicated motions all but impossible, and damage to the motor cortex can lead to out-and-out paralysis. So the frontal lobes are definitely not a storehouse of programs for playing songs and symphonies.

Another place to look is the *basal ganglia* (Fig. 7.4), a collection of oddly shaped nerve bundles that loop through the center of the brain, gathering and redistributing information among many parts of the cortex.

*Fig. 7.3. The frontal lobes, seat of abstract planning*

*Fig. 7.4. The basal ganglia, seat of postural motions*

The basal ganglia are especially busy in the moments prior to activity in both premotor cortex and motor cortex. It's clear that they are an important impetus to movement.

It is the basal ganglia that go wrong in Parkinson's disease, whose victims sometimes cannot initiate movements despite firm intention. A Parkinson's patient may stand at a door and just not be able to step through, though his body may be capable of doing so. Some have likened Parkinson's to a whole-body stutter: I w-w-w-want to move. Lacking a coordinated effort, muscles work against each other and movements are slow, jittery, and inexact.

The basal ganglia are hard at work in music making, for they have much to do with managing long sequences of postural adjustments. An audience may focus on flittering fingers, but good musicians work in motions that are much larger and longer, motions that encapsulate all the details of a long passage. It is these large motions that imbue music with line and balance, and the basal ganglia are likely to have much to do with them.

Yet as essential as the basal ganglia are to initiating motions, it can't be said that a musician's knowledge of individual compositions is stored in them. Despite malfunctioning basal ganglia, a Parkinson's patient can conceive the motions he wants to make; he just can't get them going. Similarly, musicians can imagine what they want their arms and hands to do, yet may

*Fig. 7.5. The cerebellum, seat of ballistic playing*

be unable to initiate the proper motions. So the question remains: where lies the conception from which a performance arises?

Another possibility is the *cerebellum,* a fist-sized bulb situated at the back of the head. Trace your spine upward until you can go no further and you'll be pointing to your cerebellum (Fig. 7.5). It's a remarkably uniform structure, rather like a computer memory chip, that has long been recognized as a sort of clearinghouse that considers all movements about to be undertaken and sees to it that everything stays in balance. This is important work. Just holding out an arm can be enough to tip you over. The cerebellum makes you lean slightly to compensate. All this occurs automatically and entirely unconsciously.

As a musician plays, the cerebellum takes on a terrific burden. It's easy to appreciate why. The hand hinges at the wrist, which twists as the forearm bones cross. The forearm in turn hinges with the upper arm, which swivels outward from the shoulder. The shoulder bends in relation to the upper back, which swivels about a flexible spine mounted atop a pelvis that wobbles about on other socket joints, each raised above two more hinges and a flexible foot. When a conductor lifts his baton, all these joints work in unison. If you've ever operated a marionette you know the complexity of these relations. Pull one string and every part of the marionette shifts. Harmonizing the body's motions is a tremendous amount of work, and

the cerebellum, though relatively small, contains more neurons than the rest of the brain combined.

Animals that make fancy motions have large cerebellums. Birds wend their way through windy skies thanks to theirs. But in primates, and especially in man, the cerebellum has ballooned to several times the size required for its traditional role as muscle coordinator. Some neurophysiologists believe that the newest and largest part, the *neocerebellum,* is implicated in all sorts of advanced brain activity, even in analytical thought. Be that as it may, in humans the cerebellum clearly has surpassed its traditional role as servant to the motor system.

The cerebellum appears to be crucial in carrying out movements that are *ballistic,* that is, too quick to be adjusted by feedback. Once initiated, a ballistic movement follows its course, and only afterward does the brain learn what has happened. Accuracy and certainty are sacrificed to the advantage of speed. The workings of the eyes provide a good example. Most eye movements are ballistic, occurring at a pace equal to two complete revolving-door turns per second. In contrast, non-ballistic eye movements are less than a tenth as fast and are less likely to overshoot their target thanks to feedback. What's most interesting is that ballistic eye movements occur entirely outside awareness, building up an impression of a much larger field of high-acuity vision than our eyes actually perceive. In like manner, the cerebellum supplies a wealth of detail to the musician's movements, detail that is not consciously intended.

Ballistic movements are vital to virtuosic musicianship, so much so that it may be the cerebellum that decides whether or not a musician makes it to the concert stage. For the cerebellum is all-important in the kind of playing where notes leap from the body and in which, at least to the musician's conscious mind, playing becomes effortless. Significantly, stimulation of the cerebellum by electrical probe brings about coordinated actions by groups of muscles. It's likely that the difference between a glistening trill and a dull one resides primarily here, and the same is true of hundreds of other details of a musician's technique.

Nonetheless, like every other part of the brain we've considered thus far, it cannot be said that the cerebellum is a repository of specific motor

instructions. Lacking direct pathways to the spinal cord, it works its magic only by modifying activity in the motor cortex and other parts of the motor system. In fact, the cerebellum ceases most activity within a third of a second after input from other parts of the motor system are shut off. Injury to the cerebellum upsets motion but does not arrest it. Instead, a damaged cerebellum delays the onset of movements, robs them of accuracy, and, by pitting one muscle against another, weakens their power. Note that the opposite of these effects—enhanced speed, accuracy, and power—can be taken as a definition of musical virtuosity.

So still the question remains, where in the brain is the knowledge of how to play a piece stored? The answer is clear: it is stored everywhere and nowhere. Knowledge, it turns out, is no more reducible to the firing of a single neural network than complex motions are reducible to the actions of single muscles. Various aspects of motor knowledge are dispersed among several parts of the brain, and represented diffusely in each. Far from working by a top-to-bottom chain of command, the brain churns information through a system of loops, and loops within loops, until centers concerned with every aspect of perception and movement are informed of what is going on and have had their say.

The seamlessness of this integration is attested to by the fact that the brain largely handles arms and hands independently. Each have their own area not just in the motor cortex, but also in the premotor cortex, where complex movements are assembled. Further, the cerebellum appears to oversee detailed movements of the hands, while the basal ganglia dominate the arms. And commands for the two kinds of motion are carried along separate spinal pathways, hands along the sides, arms along the front. Interestingly, there are indications that the brain cranks out commands for arms faster than for fingers, that evolution has given priority to reaching over grasping (what good is a sure grip, after all, when the hand hasn't made it to the branch?). Researchers are flummoxed at how such disparate systems can work together so effectively. But musicians know all too well how poorly coordinated the two systems can be, for finger errors often arise from improper arm movement, and getting the two systems in sync can be terribly difficult.

*Fig. 7.6. Somatosensory cortex, seat of body sensation*

# Sensation

It's tempting to conceive of musical performance entirely as a flow of commands from brain to muscle. But feedback from muscle to brain is just as important. It loops through the *somatosensory cortex* that interprets sensations of touch coming from all parts of the body. This cortex is located in a band running parallel to the motor cortex and just behind (Fig. 7.6). Somatosensory cortex receives a flood of information about every body movement. Messages from stretching skin play only a minor role. Rather, it's information gathered from receptors in muscles, tendons, and joints that matters most.

Particularly important are the millions of tiny *spindles* embedded in muscle fibers. Each spindle contains a minute fragment of muscle that is independently controlled by the motor system. The brain pits the spindle muscles against the surrounding fibers, monitors their performance, and through various comparisons is able to calculate a muscle's length and tension. The result is an interior realm of *kinesthetic* sensation quite as rich as our usual notion of touch, but of which we are generally unaware. A musician's sensation of moving an arm a certain way is built up from such information.

Laboratory work has demonstrated that we can move about fairly well without kinesthetic feedback, but only so long as we can monitor limb

positions with our eyes. Otherwise, errors quickly multiply and we soon lose an accurate body image. An impromptu experiment proves the point. Blindfolded, and relaxing your body as if paralyzed, have someone gently shift the positions of your arms. Then try to touch the tip of your nose. You'll probably miss by a mile. Even with the somatosensory system up and running, physical accuracy is much reduced without the aid of vision.

But what of blind pianists? They work their magic by subtly feeling their way along the keys, as do all good pianists to some extent. Fingerprints help the pianist along. They are as important for enhancing our sense of touch as for tightening our grip. Just by standing out from the skin they increase the skin's surface area. More important, the ridges act like levers as they bend, magnifying the slightest force and projecting it to pressure sensors deep within, which in turn project to somatosensory cortex.

Like motor cortex, somatosensory cortex is linked to the opposite side of the body. It too devotes disproportionate area to particularly sensitive parts of the body, like lips and fingertips. And it also defies reduction to a simple mapping of skin to cortex. Diverse representations of various kinds of sensation are deeply intertwined. Within the resulting hierarchy, some neurons light up with simple sensations of pressure, others only with the detection of edges, others only when the hand encounters a particular texture or hardness or size or shape.

Just behind the somatosensory cortex, and toward the back of the head, the brain assembles incoming sensations into maps of the body and its environment. This is the *parietal cortex*, where information from sight and hearing and touch are drawn together (Fig. 7.7). There are two major subdivisions. To the front, information from muscles and joints forms a map of the body's limb positions and posture. Further back, data from the visual system forms a map of the surrounding world. Since the appearance of the world always depends on the body's orientation toward it, the two systems are inseparable. It is only with the aid of these maps that the motor system can move the body around reliably.

Parietal cortex is studded with movement-specific neurons, many devoted to motions of the arms and hands. Some of these neurons become active not just during motion but also at the mere sight of an object about

*Fig. 7.7. Parietal cortex, seat of body image and spatial orientation*

to be grasped. Such is the degree of integration between the interior and exterior worlds in this part of the brain. It is this part of the brain that unifies the violinist and the Stradivarius (or, on a bad day, that lets the violinist drop the Stradivarius). Victims of parietal damage have trouble reaching and grasping objects. Not only do they miss their targets, but they can't pre-shape their hands to the object they're about to grasp. Such motions, of course, are the stock in trade of instrumentalists.

The parietal lobes have their work cut out for them, for the relationships between our muscles constantly change as we move around. The same bending of an elbow requires quite different motor commands when the arm is overhead, to the side, or folded behind. As any yoga master can readily demonstrate, our bodies can be knotted any which way and still make sense of themselves. But as any concert master can testify, our brains are able to make sense of unusual motions only after much practice.

Parietal cortex has expanded greatly during human evolution. We owe much of our analytical intelligence to it (it was here that Einstein's brain deviated significantly from the norm). With increasing specialization, the tasks of mapping body position and the surrounding world have largely been given over to the right parietal cortex alone. In the left brain, parietal cortex is more concerned with managing *sequences* of activity, particularly language. It is this talent that makes the right hand more skillful than the left in most of us, since the left brain controls the right body. In fact, left

parietal cortex has been shown to be important in sequencing motions involving *both* hands, even though the left brain nominally controls only half the body.

The loop from action to sensation to further action suggests how the body steers itself through the world without requiring a captain at the helm. In parietal cortex, a map of the body meets a map of the world. The coordination of these two maps gives rise (largely through the basal ganglia) to motor plans, which are then played out as actual movements. These movements further alter the body map, and also alter the perceived map of the surrounding world, leading to further motor plans, which drive the body along further still. Action produces feedback that provokes further action.

This view of movement is oversimplified, to be sure. For one thing, it doesn't always account for the precise durations of motions. And it emphasizes automatic motions and so fails to account for niceties like conscious decision-making or highly articulated plans. Nonetheless, it goes far in explaining how a hamster gets around, and even how a musician moves from note to note. Given the complexity of the brain, that's quite a lot.

When a musician learns a piece so that he can play it "automatically," he conditions his motor system so that it reacts to particular bodily sensations in particular ways. Playing one fragment of a composition produces feedback that elicits motions toward the next fragment, creating further feedback and further motions, and so on. The piece is "recorded" in the brain only as propensities to respond in particular ways to particular musical situations. There is no need for an internal blueprint of the piece.

This is not the only way that musicians remember compositions, of course. We'll consider other options in a moment. But amateurs often learn whole compositions in this manner. And all musicians turn to this mechanism for their most basic performance skills, such as playing a trill. The motor system does not look up a "trill routine" and then perform it, like software in a computer. Rather, with practice, trilling becomes a *property* of the motor system.

Musicians sometimes talk of how a piece they have "overlearned" through long study feels as if it were built into their bodies, as if its motions

were as innate as those for walking or chewing. Unlike most other animals, we are born with motor systems containing few pre-programmed ("hard-wired") motions. This leaves us helpless as infants, but endows us with tremendous flexibility in the kinds of motions we can learn with experience. Like the ability to swim or the ability to ride a bicycle, motor learning tends to stay with us even after years of disuse, and a musician may be amazed to find that a long-neglected piece still flies from his arms. But as we shall see, simple motor automaticity is a precarious route to musical attainment.

## Reading Music

There's one motor skill we've thus far overlooked: reading music. With years of practice, reading of any kind becomes so automatic and subtle that it doesn't seem like motor activity. But it's done by moving the eyes. This skill is acquired with difficulty, and some musicians are much better at it than others.

When we view the world, our eyes gather light from an arc spanning 200 degrees from side to side, and somewhat less from top to bottom. This is the *visual field*. Only a small spot at the center of the retina (the *fovea*) is packed densely enough with light-sensing cells to provide the acuity necessary for identifying objects. It spans only 5 degrees of the visual field. The remainder of the retina dispenses only the blur of peripheral vision that alerts us to events requiring the fovea's attention.

Moving in a succession of starts and stops, our eyes scan the world like a video camera in the hands of an amateur. But somehow our brains integrate the chains of fixations into a static, seamless visual field much larger than the few degrees that are actually in focus at any instant. We're given the illusion of viewing most of the world before our eyes all at once, as if the retina were like a sheet of film in a camera. This is possible partly because short-term visual memory echoes recent fixations, and partly because we accept as complete a visual field that is actually only scantily rendered (the long-standing notion that the brain somehow "fills in" the gaps has been thoroughly discredited).

As a musician reads music at normal viewing distance, the fovea em-

Fig. 7.8. The field of view when reading music

braces an area only about one inch in diameter (Fig. 7.8). It absorbs information for a quarter second then jumps to the next fixation in a twentieth second more. A one-inch area is enough to cover roughly one measure on a single staff (but not the multiple staves confronting pianists or conductors).

No matter the number of staves, you might guess that the eyes' fixations would move along steadily from measure to measure. But research has shown that this hardly ever happens. Instead, eye movements follow the structure of the music, centering on musically significant turning points. When a pianist reads a melody supported by chords, eye motions follow the up-and-down pattern shown in Figure 7.9, part (*a*). But when the music is contrapuntal, with two or more voices moving in parallel, the eyes shoot back and forth in the pattern shown in part (*b*).

This shows that in sight-reading, as in all kinds of visual activity, fixations are made intelligently and not by randomly sampling parts of the visual field. One moment's observation incites anticipations of what else must be present, and the brain uses the strongest such anticipations to decide where to most profitably direct the fovea next. Good sight readers instantly grasp music's most important features, and can readily fill in details when they haven't time to grasp all the notes. They tend to look seven or eight notes ahead. By comparison, poor sight readers read no more than three notes in advance, and they make many more fixations than is necessary.

Thus the ability to read music fluently is strongly linked to the ability to understand music fluently. A well-trained musical mind anticipates how

*Fig. 7.9. Eye movements during sight-reading*

rhythmic patterns will be transformed, melodies transposed, chords filled in, phrases concluded. A brain equipped with such knowledge can ignore individual notes and pay attention to larger patterns, and it will know where to point the fovea to gather just the information required to verify that anticipations are correct. We do something similarly when we read a book. A combination of anticipation and peripheral vision tells us that a frequently used word like *the* is coming up, and our foveas skip right over it. This explains why accurate proofreading is so difficult.

There's a good deal of research confirming the role of anticipation in sight-reading. When experienced sight readers are shown traditional music doctored with harmonic errors, they usually correct the errors without noticing them. Often they can't even find the errors when told of their existence. They know how such music should sound and they're able to play it merely by observing its outline rather than every note. Significantly, music that is structurally complex is harder to sight-read, regardless of the number of notes, because it is harder to anticipate. Many pianists who can fly right through Haydn have a bumpy ride with Debussy and crash in flames with Schoenberg.

Masterful sight-reading can be married to sharp auditory imagery to produce a skill that was once quite common: the ability to imagine music by reading its score. This was the only way to experience much of the classical repertoire until the phonograph was invented. The benefits to general musicianship are tremendous. Schumann summed it up well:

*He is a good musician who understands the music without the score,*
*and the score without the music. The ear should not need the eye, the*
*eye should not need the outward ear.*

# Virtuosity

Eye movements are but one more example of the hierarchical control the musician brings to all kinds of motion, whether of hands, arms, lips, or throat. When musicians achieve great speed and precision of movement, we call them virtuosi. A century after his death, Franz Liszt still holds the title as history's most distinguished virtuoso. Tales of his musical prowess can be hard to swallow, yet many have been authenticated. In 1876 he was visited by a certain Otis B. Boise, an American composer with a spanking new orchestral score in hand. Liszt seated himself at the piano, glanced through the pages,

> *and then, with this flash negative in his mind, began the most astound-*
> *ingly coherent rendering. . . . No features of the workmanship, contra-*
> *puntal or instrumental, escaped his notice, and he made running*
> *comments without interrupting his progress.*

It was skills like these that allowed many of the great composers to pursue careers as concert artists even while churning out composition after composition. But most musicians practice long and hard without ever nearing the highest standard. What accounts for this difference?

A common view is that virtuosi are merely born with superior equipment, better bones and muscles and nerves and cortex. Any biologist will tell you that this must be the case to some degree for the simple reason that variability characterizes every aspect of an organism. The question is, how much of the difference between musicians is a matter of raw anatomical might? Most of it? Just a little? There is, after all, variability within variability. Generally speaking, the more important a trait is to survival, the more strongly natural selection optimizes that trait and the less difference there is between individuals. Noses vary a lot in humans; feet much less.

Hands fall somewhere between, with considerable divergence in over-all dimensions and in the relative lengths of the fingers. But what aspect of hand design would natural selection favor? A hand for spear throwing? A hand for fire building? A hand for gesturing? There have been so many important demands made upon hands during our evolution that nature has had to make compromises. This has left us with hands that vary not just in shape but also in the dexterity with which they can perform various tasks. There's no doubt that some musicians have the good fortune of being born with just the right anatomy for their instruments. It takes a great throat to make a great singer. Equally, the physics of levers favors stubby-fingered pianists (in sharp contradiction to the romantic image of the gangly virtuoso).

Yet many virtuosi who lack ideal bodies for their instruments none-theless play with consummate facility. This points to neurological varia-bility as the critical factor in virtuosity. Obviously, sheer speed (what we erroneously call "fast reflexes") is extremely important. But so are other sorts of muscular skill, including the ability to play loudly and softly, and the ability to render the precise timings that make music expressive.

To make matters more complicated, early experience has a profound effect on motor system performance. Three centuries ago the French com-poser François Couperin declared that children should begin studying in-struments by the age of six or seven. Evidence that he was right has been rolling in ever since. Surveys have shown that almost all great violinists started at six or earlier. Similarly, one study found that contestants in a major international piano competition started playing at seven on average. It's also been shown that early training proffers a strong advantage in skills like chord analysis, and that it is essential for the development of true perfect pitch.

Could it be that the brain develops differently in early starters? Today, neuroscientists take for granted the concept of *critical periods* in brain de-velopment. It has long been known that kittens are rendered sightless if they are blindfolded during certain weeks following birth. Crucial struc-tures in the visual system mature during this time, but only if stimulated

by input from the retina. Many other instances of critical periods have since been found, possibly including critical periods in humans for the acquisition of aspects of language.

Recent work with brain scans has confirmed Couperin's advice that musicians should get an early start. It's been found that the bridge between the two sides of the brain (the *corpus callosum*) is 15 percent larger in adults who started playing the piano before the age of eight than in those who started later. Remarkably, pianists who began after this age showed no significant difference from those who never played an instrument at all. This is an astonishing observation. The corpus callosum carries a hundred million nerve fibers, as many as in a hundred optic nerves. A 15 percent increase in its cross-section suggests a vast increase in information flow.

This view of virtuosity as gross neurology is strongly deterministic: the better the wiring, the better the playing; practice reinforces the connections, neglect weakens them; progress is of necessity gradual and grudging. It's a notion that would make perfect sense were it not for one inconvenient fact: many average musicians occasionally play much better than usual. Out of the blue, the hands (or lips and lungs) execute passages with an ease and precision that leaves the player astonished. Or course, we display day-to-day variability in all that we do. But the average jogger does not abruptly begin running four-minute miles. Yet average musicians sometimes manage something very like it. Somehow, the seeming limits of motor system capability abruptly give way.

Such experiences suggest that the better part of virtuosity may have little to do with gross neurological advantage. Instead, virtuosity may depend on how the musician's mind is organized during performance—how the body is comported, how attention is focused, and above all, how imagery is brought to bear. In this view, virtuosity is mostly a matter of abstract planning, not raw muscular control.

The virtuoso develops mental hierarchies that are deep and flexible, hierarchies that are so well trained that they function automatically at superficial levels, freeing the virtuoso's mind to concern itself with larger musical structures. Working with large structures gives the virtuoso time

to consider every musical act before it is made. The musician is no longer chased by the multitude of notes, attention is no longer pulverized by a stampede of details.

It's exhilarating when an amateur plunges into this world. It happens only after assiduous practice manages to strengthen deep portions of the motor hierarchy that generates a piece. Suddenly it becomes clear that a far better technique is in reach, despite glacial progress in daily practice. And miraculously, the coveted physical skill shows itself to be already present, if only the pathway to it could be remembered. The musician finds that the sensation of playing has momentarily mutated: "So *this* is how it feels!"

When asked what it's like to know a piece and play it well, professional musicians often respond, "Oh, I dunno, I just remember it and play it." But when pressed for detail, most report that they experience a mix of different kinds of imagery that anticipate the physical motions they make. They'll hear notes in auditory imagery, see notes as various abstract patterns, feel notes as muscular anticipations. Virtuosi appear to lead with auditory imagery; amateurs hardly ever do. One study found that a majority of classically trained musicians claimed auditory imagery that is very clear, or even as clear as the actual hearing, after listening to a singer accompanied by piano. By comparison, no one from a control group of psychologists could reproduce a piece in their mind's ear.

This is not to say that accomplished musicians experience a din of imagery beside their actual performance. The performer's imagery is a series of fleeting anticipations. We all know the sensation. Imagine looking about your kitchen for a missing salt shaker. Your brain does not generate a high-definition image of a shaker that you'll carry about in your search. There are not enough things that look like salt shakers to make that necessary. All that's needed to prompt your eyes to fall upon the salt shaker is a wispy anticipation of the shaker's approximate size and shape, the sheen of the glass, the whiteness of the contents. A musician works the same way, using fragments of imagery to prompt unfoldings of motor hierarchy, much as occurs from glancing at fragments of the score. Full-blown auditory imagery is likely to occur only in moments of hesitation when there's some

doubt about what comes next and the musician momentarily plays by ear, translating the sounds of notes to the physical motions that will produce them.

But if auditory imagery is normally scanty, how are all the details of a piece remembered? For most musicians, it seems to be *kinesthetic* imagery that is most prominent—a ghostly parade of muscular anticipations. These are the sensations we considered earlier that arise from feedback from the musculature, and that occur in somatosensory and parietal cortex.

Kinesthetic imagery is so much a part of our experience that we seldom notice it. It's most conspicuous when we're held back from initiating an intended motion ("On your mark, get set . . ."). Like visual and auditory imagery, kinesthetic imagery normally occurs in small fragments—fragments that can release motor routines. An impetus toward a minor scale is enough to get the scale played. Also like other forms of imagery, kinesthetic imagery can be cultivated until it is vivid and precise, and until long kinesthetic sequences can be committed to memory.

What is the difference between a kinesthetic image and an ordinary intention to move? Ten cognitive scientists might give a dozen answers to this question. Recall from Chapter 6 that the very notion of imagery is controversial. Imagery seems to occur not as an independent mental faculty, but as an extension of the anticipations required for any cognitive act, whether listening to a song or singing one. To many cognitive psychologists, imagery is nothing more than the enactment of such anticipations in the absence of actual perception or actual motion. Since activity in motor cortex is always preceded by activity in premotor cortex, the basal ganglia, and other parts of the motor system, the idea of anticipation preceding movement fits well with the facts of neurology. All complex actions require anticipation to see them through, whether a footstep, a spoken phrase, or an arpeggio. This is really saying nothing more than that deep levels of hierarchy must become active before more superficial levels can set the body in motion.

Recall, also, that brain scans suggest that imagery emanates from perceptual cortex—visual imagery in visual cortex, auditory imagery in auditory cortex, kinesthetic imagery in somatosensory cortex. So motor

anticipations have more to do with "passive sensation" than "active intention." This notion is consistent with the idea that complex motions are launched only after the parietal lobes have prepared maps of the body and its environment. It is a notion that supports an idea music teachers constantly try to convey to their students: that virtuosity is attained not by exertion of will, but by relaxed contemplation of music's deepest structures. Rather than attempt to force the motions made by superficial levels of motor hierarchy, the virtuoso focuses upon the deep levels of sensation that give rise to movement. As the psychologist Fritz Perls put it, "Trying fails, awareness cures."

## Memorization

The virtuoso's reliance upon hierarchy explains how some musicians can memorize complicated works so quickly. In the last chapter we saw how memories are generated from deep hierarchy. They are not snapshots but reconstructions. Conversely, memorization is a matter of deconstruction. The virtuoso is able to quickly abstract a small number of intertwined patterns among the notes of a long passage, reducing the passage from many notes to only a few musical devices.

It is telling that many amateur musicians simply cannot memorize compositions. Lacking a structural understanding of a piece, they rely upon a score to lead them from one ingrained note to the next. Even when the importance of imagery and hierarchy is explained, most have no idea how to develop such skills, much less the patience and discipline to recommence playing in an entirely different manner.

The diversity of imagery poses tantalizing questions: Do musicians who have a strong memory favor certain kinds of imagery? If so, can a music student improve his or her memory by shifting emphasis from one kind of imagery to another? And to what extent are we free to choose the kinds of imagery at work in the rough and tumble of actual performance? Because each kind of imagery appears to arise from a particular part of the brain concerned with perceiving or analyzing the world, this is tantamount to asking whether musicians should favor certain parts of the brain over others.

Consider the paradox of Sergei Rachmaninoff. Like Mozart and Liszt (as well as some quite undistinguished musicians), he could play whole compositions after a single hearing, transcribing them on the spot if necessary. As a student, he mastered the Handel Variations of Brahms, a twenty-two-page warhorse, in just two days. Yet when Rachmaninoff decided to earn his living as a concert pianist, he practiced for two years before he dared go on stage. "Sergei was always practicing," said his good friend Vladimir Horowitz.

How can this be? One possibility is that Rachmaninoff did not really know the pieces he was able to play fluently after so little exposure. He had merely moved the score from one form of representation on score paper to another form of representation in his head, whether visual or auditory or conceptual. When he played, he was in effect reading from this internal score. But a sight-read performance, even an expert one, is always disappointing, because the musician has not yet learned to shape the notes into larger structures.

What, then, constitutes knowing a piece? Must a continuous, deep kinesthetic hierarchy unfold to be able to play virtuosically and with expression? After all, performance is ultimately a matter of physical motion. Any mental representation other than a kinesthetic one presumably would require translation into the language of movement. Wouldn't performance be more spontaneous, and the musician's mind less cluttered by detail, if that translation were out of the way?

The experience of the pianist Glenn Gould seems to confirm this view. He, too, could grasp a composition's structure almost instantly, clocking in little time at the keyboard before going on stage or into the recording studio. He liked to say that he didn't have a "practice relationship" with the piano. Yet Gould acknowledged that he practiced a good deal in his mind. For instance, at the age of twenty-seven he calculated that he had played the fifth Bach partita roughly five hundred times, mostly while driving or walking around town. Significantly, this process seems to have been largely kinesthetic. One acquaintance described how Gould paced about his dressing room before performing a concerto, humming the melody, conducting with his nose, and poking at imaginary keys in midair.

Another clue to the kinesthetic nature of Gould's musical memory was his aggravating habit of singing along as he played. He drove recording engineers mad. During one session, a sound-absorbing wall was erected around his chair. At another, he wore a gas mask purchased at an army surplus store. What he could not do was play without humming. "It's a terrible distraction that I don't like either," he said. "I wish I could get rid of it, and I would if I could, believe me; but I can't."

Significantly, many virtuosi claim to have no need to warm up. Most musicians find that it takes some minutes of playing before arriving at their best level, as if to realign the nervous system for the task at hand. Of course, a warmup is necessary if the hands and arms are cold, since muscles must be literally warm to work well. Glenn Gould would soak his arms in hot water just before going onstage. But he had no need of warming up at a keyboard. His musical hierarchies were so well primed for the approaching concert that no warm-up was necessary.

There's a contradiction in this, for it seems to imply a kind of automatism. Yet music teachers forever caution their students against automatic playing. Every performer knows the experience—the blank gaze, the sensation of time suspended, the surprise of finding that the piece has finished and that it is time for a sheepish bow. This kind of playing proceeds with little awareness of the audience or of the music itself, like a typist copying pages without comprehension of their content. There's no guiding imagery, no deep conception of the piece. Instead, a long chain of moment-to-moment kinesthetic associations leads the hands between notes. Any break in the chain and the musician is lost.

But this is not the automatism of virtuosi. They perform with high-strung awareness of an unfolding hierarchy, often played out in auditory imagery. Such playing is anything but robotic. Every motion is governed by abstract structures from deep within a hierarchical representation of the piece. Working from such a map, exceptional musicians can enter a piece at any point from memory, or even transpose a piece to another key, and they can readily modify superficial aspects of performance, such as fingerings. By comparison, the poor musician's automatism is rigidly uniform from performance to performance. He remembers pieces as long chains of

superficial features. Overburdened with detail, he can enter the piece from memory at only a few points. And details like fingerings, and even expressive nuances, are locked in place.

# Talent

Of course, there's much more to fine musicianship than barreling through memorized notes. We demand subtleties of expression. We demand interpretations that bring out the largest and deepest relations among musical structures. And we demand that ineffable balance among every aspect of timing and emphasis that we call "taste." These qualities boil down to the single, amorphous notion of musical *talent*. Some people just seem to have it, others clearly don't.

Psychologists have squabbled for decades over whether intelligence can be summed up as a single phenomenon, and the same goes for musicality. But while analytical intelligence can at least be approximated by an IQ score, musical talent can be tested only as a hodgepodge of skills: the discrimination of shades of pitch and loudness, memory for melodies and rhythms, the ability to identify changes in successive phrases.

Critics have argued that high scores on such tests predict only the success of a musical hack. In their eyes, deep talent is a unified phenomenon, a true musical intelligence that can only be observed through actual performance. Significantly, laboratory tests show that skills tend toward two groupings, one for fine analysis of pitches and chords, another for rhythm and dynamics. As we've seen in earlier chapters, this is just the division of skills found between the right and the left brain.

Is it the musician's personality that makes him musical? When personality inventories are given to groups of classical musicians, the results are unsurprising. There's a strong show of "superego strength" that propels them through long hours of practice, and high scores on tenacity, independence, and self-confidence. There's no surprise in this, since the musician's life is far from a conventional one, and these qualities characterize all risk-takers. It's only the quality of "tender-mindedness"—a sensitivity to emotional expression in not just music but all of the arts—that sets musicians apart. But all kinds of artists score high on this factor, and it fails

to explain why some turn to music when others turn to painting or dance or literature.

Musicians also tend to be androgynous, meaning not that they dress in unisex clothing and wear medium-length hair, but that they eschew society's usual gender roles. The men are on average more sensitive, the women more forceful. Anyone who has mastered an instrument understands why. In virtuosity, the musician at once commands the notes and is ravished by them. Studies show that androgyny increases with time in the profession.

Like composers, professional musicians score lower on IQ tests than other professionals of comparable level. Students at top music academies average an IQ of 130—well below what you would find in elite programs for many other disciplines. Moreover, the range of general intelligence is much greater among music students (IQs from 93 to 166 at one prestigious school). This does not mean that musicality is somehow incompatible with general intelligence, but only that it is independent enough of IQ that individuals of lower IQ can rise to high professional status (whereas in other professions they generally cannot).

What is it, then, that leads some musicians to develop deep hierarchies while others hardly scratch beneath the surface? Undoubtedly, inherent neurological advantage makes the task of hierarchy-building much easier for some. Neurology conducive to auditory imagery is a great boon, as would be robust parietal lobes adept at planning out movement sequences. But music teachers tell tales of talented students falling far short of their early promise. Somehow they do not develop properly. Certain aspects of playing become overemphasized while others are neglected. The source of the problem is clear. Deep hierarchies evolve only when the musician practices the right way.

Perhaps the greatest enemy of musical virtuosity and expressiveness is a sort of "typist mentality," in which attention is forever directed toward the correctness of individual notes. When musicians narrow the scope of their intentions and perceptions, they end up producing a long succession of individual figures ununited by deep relations—in a word, a *mosaic*. In contrast, virtuosi appear to nurture deep relations by directly cultivating

their imagery. Such relations are amorphous, and unlike individual notes and figures, they can be difficult to envision.

In the short run, emphasizing deep relations makes progress difficult to verify and difficult to display to others, so most musicians opt for the immediate rewards of note-perfect playing. Moreover, deep relations can't be read from a score with the ease of individual notes, but must be rediscovered each time the musician returns to a passage, and this makes practice all the more exhausting. Virtuosi sometimes claim that if you can only *intend* the deep relations of the music you're trying to perform, like a map unrolling before you as you play, the notes will more or less happen on their own (although technical polishing is still usually necessary). It takes great patience, and indeed a leap of faith, to work this way.

Researchers have found marked differences between the practice styles of amateurs and virtuosi. Amateurs tend to play long passages straight through, stopping to repeat faulty notes several times when they encounter them. Virtuosi concentrate on fragments, seldom playing the entire piece, and they correct wrong notes by playing them in the context of a larger phrase. They understand that the cause of a bad note often lies not in the motions for that note, but in the motions for the notes around it. And so they correct wrong notes by working on the relations between notes, by reorganizing the deeper levels in the motor and conceptual hierarchies from which the notes arise. In so doing, they deepen these hierarchies and make them more self-aware and manipulable.

The sheer quantity of practice is also important. To no one's surprise, studies have found a strong correlation between quality of performance and amount of practice. At one noted conservatory, the best violinists had practiced 7,400 hours prior to entry; the average, 5,300 hours; the worst, 3,400 hours. The best players practiced at the same time every day, practiced in the mornings, and took few or no days off. Studies of athletes have found similar trends, with the superstars typically practicing a quarter more than those an echelon below. Still, it's worth noting that many musicians practice for decades without becoming virtuosi. In some cases, thousands of hours of additional practice have little effect on overall virtuosity or expression.

Is it possible to play well without practicing at all? The great violinist Fritz Kreisler claimed he had never practiced, even as a child. Conversely, at forty-six, Jascha Heifetz estimated that he had played the violin for 100,000 hours, roughly an eight-hour day six days per week from early childhood. More common (and more credible) are the cases of virtuosi who practiced incessantly in youth and hardly at all later. This was true of the first great instrumental virtuosi, Paganini and Liszt. It appears that once a motor hierarchy has been well established and can carry out any command, it requires only the occasional performance as a refresher. Everything else—memorizing and experimenting and interpreting—can largely be accomplished through mental imagery.

Few professionals rise to this level. It's not obvious why. Even if exceptional neurology is required, there ought to be more instances of such talent just by the sheer force of numbers. But there aren't. Is the problem in early training? We've seen that there's great advantage to starting young. But the young are highly malleable in every way. In their first years at an instrument they acquire a conception of what it is like to play an instrument, and they carry this conception through a lifetime. If this conception is amiss—and it often is, partly because children are seldom taught by the best musicians—a lifetime of misdirected effort will ensue.

Most musical instruments are tremendously complex, much more so than a cursory inspection would suggest. Just getting a squeak out of a clarinet, just finding middle C in a stretch of eighty-eight piano keys, is an overwhelming task for a young mind. To make matters worse, most children start playing music from written scores. They struggle to decode our elaborate system of notation even before they can handle written language. The sheer technical difficulty of all this turns music-making into gymnastics. Many never find their way to a more musical way of playing. They become Blind Toms, but without the spectacular memory.

Happily, there is no crisis of musicianship in our time as there is of composition. Talent and virtuosity abound. But this occurs in spite of the poor standards of musical education found almost everywhere. Countless billions of music lessons are bound to lead to something. But they haven't led to a society of amateurs—*lovers* of making music—as was once the case

among certain social strata. The phonograph has made us lazy, made us fat with other people's music-making, and perhaps worst of all, made us perfectionists about performance. And so struggling with an instrument has lost its charm. Perhaps if we were better listeners the playing would follow. That is the concern of the next chapter.

# 8

<div style="text-align:center">

From sound...
...to tone...
...to melody...
...to harmony...
...to rhythm...
...to composition...
...to performance...

# ...to listening...

</div>

*In the New Guinea rain forest,* visitors from afar enter a Kaluli longhouse singing and dancing. Through tremulous voices and swaying hips they pay homage to their host's clan, its territory, its ancestors. The audience is greatly moved and soon tears begin to flow. After a while, it becomes too much. Distressed at having been made to feel such sorrow, some jump up to take their revenge, grabbing torches from the walls and scorching the musician-dancers on their arms and shoulders. But the performers do not flee. In fact, they show no sign of pain, but only greater musical intensity. The singing and dancing and weeping and wounding goes on all night, and by dawn the exhausted performers bear second- and third-degree burns. These they will display as an emblem of musical prowess when they return home, a sort of perpetual applause. But before departing, the performers must first pay compensation to their hosts for having made them cry.

*In Frankfurt*, an opera by the contemporary American composer John Cage is under way. Titled *Europera*, it consists of a random assortment of sixteen-bar swaths taken from older, out-of-copyright operas. Exits, en-

trances, all aspects of the composition have been determined by chance throws of the sacred I Ching. As one diva arrives on stage by jeep, another leaves in the belly of a giant fish. Arias are sung from inside bathtubs, coffins, garbage pails. One enterprising singer wields a fishing pole at the front of the stage, hoisting her catch from the orchestra pit. This goes unnoticed by the players, who sit on a hydraulic platform that rises and falls unpredictably. In fact, most of the scenery is continuously shifting in and out, up and down. Lest the audience doze off, at the denouement a zeppelin is launched above the stalls. The opera is a huge success and companies around the world clamor to restage it.

*In Zaire*, a tribunal opens in a Bambala village. Its purpose is to settle a lawsuit, and the litigants will each present reasoned arguments. But the outcome may depend less upon their skills as lawyers than as musicians. For they are required to *sing* their cases. The plaintiff intones, "I am like the dog that stays before the door until he gets a bone." The defendant retorts, "Nobody goes both ways at the same time. You have told this and that. One of the two must be wrong. That is why I am attacking you." There's order in this court but very little quiet, for the families of the two litigants join in spontaneously, echoing the high points like a Greek chorus. This harmonious conflict will continue all afternoon, and when the village elders finally pronounce their verdict, the chief will broadcast the decision far and wide—by drums.

*In downtown Los Angeles*, a car passes through a bustling neighborhood. It would go unnoticed were it not that it has been audible from quite some distance, first as rumbling ear canals, then quivering gooseflesh, then jarred entrails, then rattled bones. Only as the car nears does it becomes clear that it is a kind of music that it expels, music whose energy is bottled up in bass tones too low to carry melody or harmony. The barrage of sound emerges not from inside the car, where it is relatively quiet, but from the car's trunk, where giant bass speakers project toward the street. The music is powered by smoldering amplifiers and a phalanx of lead-acid batteries: great expense has gone into this concert for the unwilling. Yet, as much as bystanders may cringe and grimace, they endure the slap in the face and shy away. The message is hostile. Better keep back.

*In the Australian outback,* an aborigine returns from a most unusual adventure: a trip to London. He is immediately surrounded by family and friends who clamor for every detail of his journey. And so he produces his diary, a very long song he has composed day after day and committed to memory, its verses and intonations recounting every experience. His audience finds nothing unusual in this. For centuries, aboriginal Australians have devised complex songs that describe the stark terrain they inhabit, songs that anyone can use as a kind of map. The voice rises and falls with arpeggios as it describes a mountain path, only to flatten into a monotone when the landscape bottoms out into a vast basin. Subtlety is required, for the desert landscape may extend for miles without prominent features, and travelers can die if a song misdirects them. So songs mimic minute details of the landscape, even the sounds of footsteps on particular kinds of soil. How much easier it is to describe the infinitely varied landscape of a European city! This traveler's song concludes with instructions for passing through Heathrow Airport.

These examples from around the world remind us that music is not always, or even usually, something that we listen to for pleasure. Particularly in modern industrial societies, music is *everywhere* and embedded in *everything*. We wake to music on our clock radios, then use it to gather energy over breakfast, to pacify ourselves through rush hour, to anesthetize ourselves through work, and to relax at day's end. And we are bombarded by uninvited music. An hour's television viewing is accompanied by dozens of tunes designed to draw adrenaline or tears or consumer dollars. Music has been used to make factory workers produce more widgets and to make chickens lay more eggs. It has been employed for healing and hypnosis and pain reduction and as a memorization aid. We dance to music, shop to music, clean house to music, exercise to music, make love to music. Yet only occasionally do we sit down and intently *listen* to music.

A visiting Martian might conclude that any species that so surrounds itself with music would be devoted to performing. But this is not the case. The more we are surrounded by music, the less we participate. In pre-technological societies, the line between music-making and music-

listening is ill defined. As we shall see in Chapter 10, music began as chant in which everyone joined. Just clapping along is a kind of musicianship, creating sound for all to hear. Dancing, too, can be a sort of music-making, as motions of body mimic motions of sound. Musical specialists appeared only later as hard-to-play instruments began to accompany the singing voice.

But in industrialized society, specialization has separated the performer and the listener. We experience music through *concerts,* an institution only a few centuries old and still unknown in some parts of the world. Even the recordings we listen to are a sort of ersatz concert. Concerts take many forms—the jazz club, the big band dance, the rock extravaganza, grand opera—yet have much in common.

In this chapter we'll consider how a brain poses itself to receive musical sound. There are so many approaches to listening to music, and music has been designed in so many ways to meet these approaches, that some eth-nomusicologists have declared that there is no universal phenomenon of "music." We cannot consider every culture's musical habits here. But as it happens, virtually every approach to music is found in modern industrial society. And so we'll begin with a quick survey of how music has been heard in the West in recent centuries, and then we'll turn to the question of how it is that music can be appreciated in so many ways.

## Concerts

Today we are so accustomed to hearing music all day long that it is hard to appreciate how rare it once was to hear a skilled performance. To a peasant of the Middle Ages, music rarely amounted to more than work songs of the field and lullabies of the hearth. Music more complex than a bare melody was encountered only at church or at annual fairs where wandering minstrels appeared. Any musical sound, no matter how crudely performed, must have been as delicious as the meats and candies enjoyed only on festive days. But such eager ears were necessarily unsophisticated ears. A brain lacking musical experience is necessarily a brain lacking musical perceptiveness.

It was in the drawing rooms of the aristocracy that music progressed.

Concerts were the perfect excuse for an all-night soiree, and having a first-rate private orchestra became a top status symbol. But until the seventeenth century, public concerts as we know them today were virtually unknown. In England, the first on record took place in 1672 (thirteen years before the birth of Bach and Handel) through the efforts of an enterprising violinist named John Banister. Until this time, there was simply no way for someone of low birth to hear serious music other than church music.

It was opera that moved performance from the corner of the parlor to the formal stage. Originally the orchestra resided behind curtains at the back. If the orchestra was short of players, a singer might make an elegant exit, grab on to his wig, and rush madly to the rear, where he would pick up an instrument and join in. When the orchestra moved out front—at around the time of Louis XIV—it was still a slapdash affair, with no set floor plan and with parts of the score allotted to whatever instruments were available. Silence reigned in the audience only when royalty was present. On any other occasion, a concert resembled a fairground, with people talking, eating, reading, even playing cards. The performers apparently harbored no resentment, for they also jabbered away, among themselves and even to friends in the stalls.

Until the nineteenth century, concert programming was haphazard. Even a celebrated composer like Handel had to be as much an entrepreneur as a musician to survive. He kept a sort of running inventory of his own writings and those of others, adapting them on the spot to the latest libretto, often without credit to those from whom he had "borrowed." The public demand for new operas was as insatiable as our demand for movies today, so there was no time to write a fresh score for each new production, which typically lasted only a few weeks. Even when a successful opera was revived, it would be unlike the original. And so today's "authentic" renditions of Baroque operas are necessarily reconstructions.

The art of conducting was still very much in its infancy at this time. In its earliest manifestations, a choral conductor would wander about the choir whispering instructions to individual performers as they sang. Later, ensembles were led by a violinist occasionally waving his bow. In time, several musicians might face the ensemble to lead individual sections. But

as music became more complex, control had to be turned over to an individual whose sole task was to lead. By the early days of grand opera, a conductor might pound a large wooden staff to keep time (a practice that so engrossed the French composer Lully that he wounded his foot and died of blood poisoning). Only in the nineteenth century did the conductor take up first a scroll of score paper, and later a baton, to stand directly before the orchestra. Oddly, the first modern conductors faced outward toward the audience, lest they appear rude.

Public concerts begin to achieve a mass following only in the nineteenth century, when the Industrial Revolution produced an affluent merchant class devoted to amusement, self-improvement, and recreational social climbing. Nearly every city boasted an opera house, usually small and unprepossessing by today's standards, and everybody who was anybody would attend each new production. Small, poorly trained orchestras would have to prepare for one opera after another to keep the house full. Performance standards were commensurately abysmal—not that anyone but the conductor much cared. The audience desired only to hear highly paid star singers, who orbited the European circuit in a whirlwind. Only when these stars appeared on stage, often with each singing in his or her own language, would the crowd quiet down. Rivalries between singers became choice material for gossip, and no musical event was so celebrated as a midstage fistfight between contending sopranos.

No composer's music was sacred amidst these follies. Theater posters of the day proudly proclaimed that the latest production of Mozart's *Don Giovanni* had been "improved," with parts rewritten or replaced, and all manner of "corrections" made. The worst offenders were the piano soloists, who felt obliged to impose their personal stamp upon older compositions through incessant improvisation and embellishment. But mostly they played their own music, which usually was quite awful. The latter half of the nineteenth century became the age of the virtuoso *as* composer *as* hero *as* sex symbol. Athleticism was so highly prized that audience members would sometimes stand on their seats the better to watch piano passages rendered in thundering octaves. Liszt would alternate between two pianos so that everyone would have a chance to watch his hands. Delicate

women swooned, but later found the strength to yank out piano strings as souvenirs.

To hear such stories, you might think that today's solemn presentations have entirely forsaken the spirit in which the music was written. But composers appear to have consistently opposed such excesses. Handel threw temper tantrums when people talked during rehearsals. Mozart fulminated against violinists' syrupy vibrato, Beethoven against players' unconcern for accuracy, Rossini against singers' vulgar embellishments. As conductor, Mahler locked out latecomers till intermission, put an end to audience applause between movements, and ignored the clamor to repeat popular arias. Even the ever-extravagant Liszt turned in note-for-note renditions in his old age. Today's performances of old compositions may be unlike their premieres, but they are probably just what the composer wanted.

Today, we're much amused by such tales, smug in our sense of superiority. Yet a circus atmosphere is still very much the norm in concerts for popular music. It is only in the realm of art music that audiences are so restrained that a sneeze draws the opprobrium of the entire hall. Elsewhere, audiences often talk and mill about, eat and dance, and cheer on their favorite musicians. For their part, musicians continue to play mostly their own music, and always bring an individual stamp to the tunes of others. In this respect, it is the rock concert that is truly "classical."

In the second half of the nineteenth century, art music concerts began to resemble those of today. To be sure, many customs of the past remained. A concert might last several hours, with the featured soloist appearing more than once, sometimes just to improvise. The orchestra would lie idle for long periods as smaller ensembles interspersed chamber works among symphonic ones. But as concerts shortened and became increasingly formal, audiences quieted and then were *expected* to be quiet. The house lights were first turned off under Wagner, leaving nothing for a brain to watch but moving musicians and conductor, nothing for a brain to hear but unblemished sound.

# Changing Technology

By the year 1877, a concertgoer would spend an evening at the symphony much as we do today. We would be fortunate to have such a musical year as 1877 in our time. In Moscow, Tchaikovsky's *Swan Lake* premiered (unsuccessfully); in Paris, Saint-Saëns's *Samson et Dalila;* in Vienna, Brahms's Second Symphony. In London, Gilbert and Sullivan's new song "My Name Is John Wellington Wells" was all the rage. And in New York, Harrigan and Hart introduced the cake walk to minstrel shows with their hit *Walking for Dat Cake.* But the most significant musical event of that year took place far from any concert hall. It was the invention of a toy— a large empty cone linked to a tiny figure of a man holding a saw. When someone shouted into the cone, sound gathered at a membrane and started the little man sawing. It was an ungainly invention with negligible commercial prospects, and it might well have gathered dust had its creator been a less talented man. But his name was Thomas Edison.

Edison watched the man moving in proportion to the volume of his voice and the proverbial light bulb (which he would invent the following year) lit up. He'd already been at work devising a means of recording telegraph messages on paper discs. Why not record sound? The sound-gathering cone was fitted with a cutting needle that prodded a cylinder covered with tinfoil. As the cylinder was cranked by hand, the needle engraved a thin spiral groove whose width varied with the amplitude of the incoming sound wave. When the process was reversed, with the cylinder pushing against a needle that vibrated a membrane, the sound magically reappeared. Not a man of high artistic sensibility, Edison recited "Mary Had a Little Lamb" as history's first recording.

Three years later, Edison's invention recorded the Paris premiere of Wagner's opera *Parsifal.* But Edison was not the least bit interested in music. He called his invention a "talking machine" and saw it as a way of immortalizing the voices of great men. This was not to be, for the cylinders wore out quickly. So he patented his device as an office dictating machine, dubbed the "ideal amanuensis." With only about a minute's recording time, this most remarkable musical instrument passed its early years as an oddity, a status symbol. But soon Alexander Graham Bell would improve

on Edison's design by coating the cylinders in wax. Patent granted! Never to be outdone, Edison feverishly returned to his invention, improving the stylus. Now cylinders could be played many times. But Edison still saw only an office machine.

It was not until 1897, twenty years after Edison's first inspiration, that the Victor and Columbia companies marketed the first machines specifically designed for music: the *gramophone* (still named after speech; the *phonograph* would not appear until later). There was little to listen to, and cylinders were expensive. The problem was that cylinders could not be mass-produced. Musicians would play with all their might into the cones of a dozen recording machines, and then would repeat the performance for the next batch, on and on hundreds of times to meet demand. Because discs could be stamped out, they quickly rose in competition with cylinders, and by 1903 the first complete opera was recorded, Verdi's *Ernani*, on a mere forty single-sided platters.

Audio technology has come far since: the electric phonograph in 1925, the long-playing record in 1948, stereo in the '60s, the tape cassette during the '70s, the compact disc in the '80s. But these were mere additions of quality and convenience to the real breakthrough: the first mass marketing of gramophone discs. It was that moment that changed music listening forever. Edison had done for music what Gutenberg had done for words, creating mass audiences for musical ideas. His invention would completely alter our relationship with music.

With the recording of sounds, and later the broadcasting of sound through the air and even to astronauts on the moon, music took on all the characteristics of mass affluence. Before, concertgoers were slaves to the conductor's taste, hoping to hear a favorite composition once in twenty years, and never granted the luxury of hearing it enough to understand it deeply. Now anyone could *own* music and indulge in a cherished piece over and over. Before, music was scarce and terribly expensive. Starved ears sought pleasure in anything that came their way. Now, the listener's favorite music was always in reach, and a flip of a switch could cut short his exposure to new musical ideas. Most important, where before music often drew undivided attention, now it became so common that it could

be used as a sort of decoration—something to be noticed but not really observed.

Background music is nothing new. Chronicles tell of it in ancient Rome and before. Actually, the very notion of background music could not exist until the solemn concert sanctified the idea of foreground music. The difference is that today background music is as free as air, where before it was an extravagance of the rich. By having music available everywhere and always, it has shifted from its former primary role as a source of pleasure and become foremostly a mood enhancer. None of this is novel, but the degree to which it has become the norm has changed everything. Where music once nourished a healthy appetite, whether in the concert hall or the village square, now a perpetual banquet of song serves only to soothe a blunted palate. We live in an age of widespread musical obesity.

## Hearing and Listening

When we experience music in the background, we passively *hear* and do not actively *listen*. What does this mean? Recall from Chapter 1 that incoming sound is extensively processed in the brain stem. By itself, this primitive neural circuitry allows us to discriminate frequency and loudness and location, and it sharpens the edges of individual sounds. Most cognitive scientists believe that auditory processing is entirely unconscious at this level—not just automatic, but wholly separate from the experience we associate with "me." This notion is buttressed by phenomena like *blindsight* in which a victim of brain damage has no conscious experience of vision whatsoever, yet can pass certain primitive visual discrimination tests thanks to still-functioning visual centers in the brain stem. We can as blindly experience music in the brainstem. Broadly speaking, at this level of analysis, every part of a sound is given equal weight.

But sounds may be tremendously complex, presenting the brain with a rush of information too great to handle. In our earlier consideration of concert halls, we saw how just a single chord emanating from an orchestra consists of hundreds of frequency components, and that it swims in a sea of thousands of reverberations from tones sounding in the moments before. When a chord is combined with many others and laced together by a

melody, with a dozen kinds of rhythmic markers at every turn, and constant variations in tempo for phrasing and expression, the brain has a job to do that by all rights ought to be impossible. Yet we have very little trouble making sense of a Brahms symphony, which may not even sound all that complex.

Clearly, the brain is a master of simplification. But to simplify so much information flowing so quickly is a tremendous burden. Frequencies combined one way at one moment must be combined another way the next. And musical phrases can wander in as many directions as pieces in a game of chess. All this occurs amidst the frightful inaccuracy in tuning and timing that is the norm in musical performance—and that sounds just fine to our ears.

We triumph over this chaos not by passively *hearing* with our brain stems, but by actively *listening* with cerebral cortex, which searches for familiar devices and patterns in music. Listening is led by anticipation. Even when a piece is entirely new to our ears, we make sense of it by perceiving constituent parts that we already know well. A musical object is not so much something that strikes our brains as something that our brains reach out and grab by anticipating it.

Broadly speaking, we anticipate only what we already know. We recognize—*re*-cognize—musical devices. This means that in various ways we remember these devices from prior experience. Thus memory is essential to music perception.

Psychologists sometimes draw a distinction between "expectation" and "anticipation." When we expect something, we await its exact replication. And so if you know a particular song by heart, you expect its exact notes. On the other hand, you can anticipate even music you have never heard before by counting on it to follow rules of musical structure and style. Expectation is specific; it coincides with the *episodic memory* we encountered in Chapter 6. Anticipation is general and coincides with *semantic memory*. The more daring music is, the harder it is to anticipate and the more you need to hear it several times before you can properly expect its twists and turns.

There appears to be no clear demarcation between passive, automatic

processing of sound of the kind typified by the brain stem, and the active, predictive processing of cortex. This is because many operations of auditory cortex seem to be just as automatic and unconscious as in lower-brain structures. As we've seen, primary auditory cortex automatically exaggerates certain frequencies of incoming sound while suppressing others. It combines frequencies by "sharpening the edges" of their groupings while slighting elements between those edges (visual cortex does much the same for the enormously complex patterns that strike our retinas). Much of this processing seems to have little to do with prior experience. Rather, it follows innate grouping mechanisms, joining sounds by whether they start and stop together, or whether they change properties slowly and smoothly, as most natural sounds do. Especially important for music, auditory cortex automatically groups the overtone series that arise naturally from simple vibrating objects.

This automaticity extends beyond the identification of individual sounds to form basic groupings of many sounds. In Chapter 3, we saw such mechanisms at work in the rules of Gestalt psychology. For example, by the *Law of Proximity* a brain tends to group nearby objects, such as a bunch of grapes. When this rule is applied to music, where "proximity" means nearness in time, adjacent notes tend to be grouped as a melodic line. But other grouping mechanisms are also at work and one can override the other. And so the *Law of Similarity,* which states that similar objects are grouped even when far apart, may cause nearby notes to group into separate lines when they're played by two different instruments. Basically, the brain assumes that the simplest solution is the most likely one.

A simple experiment demonstrates the reality of such mechanisms. In a dark room, two lights are placed side by side and flashed in alternation. At slow speeds they look like a single light moving back and forth. But at higher speeds they appear as two stationary, blinking lights. This *phi phenomenon* apparently occurs because beyond a certain rate of flashing the brain decides that an object cannot move quickly enough to account for flashing in both positions. Something very like this happens in music. We know from experience that almost any instrument, including the human voice, requires more time for large leaps in pitch than it does for small

(a)                                                        (b)

*Fig. 8.1. The scale illusion*

movements to nearby tones. When a leap occurs relatively slowly, we hear it as coming from one voice. When it is quick, we perceive two voices.

Music must be designed in accord with such automatic mechanisms. Otherwise the brain will fail to replicate the composer's intention. In a classic study, different melodies were played in each of a subject's ears using tones of the same quality, loudness, and duration. The patterns of the two melodies are shown in Figure 8.1, part (a). But the listener does not hear the irregular contours of each line. Instead, the brain interchanges notes from the two lines to form the simplest possible contour, that of two scale lines coming together and then parting, as in (b). This *scale illusion* is remarkable considering that each melody is initially directed predominantly toward its own side of the brain, where it is to some degree processed independently of the other. Yet the brain still recombines the notes. In fact, the pull toward order and regularity is so strong that the illusion occurs even when the two melodies are played on different instruments. Composers have long known of this illusion, sometimes devising an otherwise unplayable passage by distributing its notes among several players.

Phenomena like the scale illusion occur automatically in low-level auditory processing—processing for which our brains have sufficient capacity to work *in parallel* so that they can accommodate every low-level relationship between all of the frequency components all at once. So our brains more or less take in everything at the lowest levels of perception. The whole visual field finds its way to visual cortex, and our ears' entire sonic range reaches auditory cortex. But it is one thing to decipher a

sound's frequency components, and quite another to detect the changes among changes among changes that characterize, say, the whinny of a horse. A brain has a much harder time when it begins seeking higher-level relations among basic sonic entities. Such relations are more complex and no doubt harder to model, and the number of possible linkages grows rapidly. There's not nearly enough cortex available to consider every possibility. This would require the ballooned heads sported by aliens in science fiction movies.

Because life bombards us with far more information than our paltry brainpower can handle, a brain must pick and choose. We automatically *hear* every note or simple figure, but must *listen* for larger structures. Just as when it plays chess, a brain can no longer consider every move at deep levels of musical analysis. It must work in *serial* rather than *parallel* fashion as it apportions scarce neurological resources first to one aspect of a composition and then to another. In a word, the brain must work *strategically*. In chess, strategy means anticipating patterns in play whose outcome the player knows through long experience. In music, it means anticipating musical devices in the accustomed style. The brain does this by applying its highest-order circuitry selectively to just a part of incoming information, switching its exposure from moment to moment as circumstances require. This is to say that at higher levels of analysis, the brain starts paying *attention*.

## Attending to Music

The notion of attention, although familiar to us all, has long been a point of contention among cognitive psychologists. Theorists explain attention differently, and attribute it to different sorts of mental activity. One thing that attention should not be confused with is *arousal*, which refers to a nervous system's general level of activity. Daydreaming at the opera is a problem of attention; sleeping at the opera is a problem of arousal.

Attention refers to a nervous system's exposure to sensation. The notion of attending to something is clear enough in a lizard. When its eyes are fixed on a moth, it's a safe bet that it is attending to its next meal. But the idea of attention becomes more complicated in a multilevel mam-

malian mind, and terribly complex in the symbol-clogged minds of human beings. Much of a human brain's experience is of the activities of other parts of the brain. This is particularly true at the highest levels of information processing, levels that we call analytical. These can be turned upon internal imagery so intently that we become momentarily blind to experience right before our eyes, even though low-level processing in visual cortex continues as usual. At the highest level of cognition, we always view the world through a narrow telescope, always labor under a kind of tunnel vision. Even when our eyes are focused wide, we're able to consider only a few aspects of the scene before us at any moment, able to model high-level relations of only one kind though many other sorts of observations lie in wait.

The same is true in listening to music. As complex music passes before our ears, we incessantly shift focus between its many aspects, always on the lookout for the most crucial features, those that form the "edges" of musical objects. And so we attend most intently to melody at the peaks and valleys of its contour, most intently to harmony at crucial shifts of key, most intently to rhythm when metrical patterns are violated or when phrases begin or end. Our brains model relations among these junctures and hold them for some seconds in expectation of finding similar elements with which to fashion still higher relations. The notes between are still heard at low levels in the auditory system, but go unmodeled at higher levels. Accordingly, when the average listener is asked to recall a piece moments after hearing it, he'll be able to recount only the most prominent features, for it is only these that the brain has modeled.

As our attention darts around the musical landscape, we tend to spend disproportionate time among high notes. You might assert that this is perfectly natural, since this is where the melody normally lies. But composers could just as well write melodies at middle or low range (and they sometimes do). Perhaps the most cogent line of explanation for this phenomenon has to do with the nature of language—that the range of frequencies where most melodies lie is also the range in which speech consonants release most of their energy. As we saw in Chapter 1, the ear has evolved

to augment sounds in this range, and our attention may habitually turn toward them.

Next in importance to our attention is the bass line. Most listeners are unaware of their sensitivity to bass notes, partly because bass lines are seldom written as interesting melodies (and generally can't be, owing to the inherent dissonance of intervals at low frequencies). Nonetheless, our brains latch on to bass tones as a kind of foundation on top of which harmony is built. Bass tones carry much energy, and they project a strong, extensive series of overtones that sets a framework against which higher tones are heard. Composers have long understood that a carefully crafted bass line can propel a composition forward, while a poor one will leave it becalmed. Bass tones are lumbering beasts of burden that pull along the entire harmonic edifice.

Together, the bass and treble lines bound music. As outer edges they form a sort of skin around musical sound. This is probably another reason why our brains pay so much attention to them, since perception is mostly concerned with defining edges and corners. The middle voices play a much less important role in most listening. In harmonically uninspired composition, these voices are simply filler, supporting obvious harmonic transitions made by the bass line. It's only in harmonically complex music that a listener may focus upon inner voices. It's often where the action is in really good music.

For centuries, composers have argued about whether even a well-trained ear can follow more than one voice at once. There's a good deal of recent evidence suggesting that it can't. When subjects hear two unrelated melodies at once, they'll subsequently be able to identify only one. The same is true for simultaneous spoken messages. It appears that the problem lies not in tracking several sensory inputs at once, which the brain can handle quite well. Rather, it is faculties for higher-level processing that are overburdened by multiple messages. It's only when two entirely different kinds of information arrive at once that the brain can handle both by devoting different resources to them. Thus, some musicians can play their instrument while holding a conversation—but only so long

as both tasks are fairly automatic. A difficult spot in either activity will draw the brain's highest-level processors to its aid, and the second activity will falter.

This is a good example of laboratory evidence contradicting subjective experience. Anyone with a good ear has a strong sense of simultaneously following the multiple voices of a fugue as they arise and twist and turn. But the lines are not followed in such a way that they could be individually recollected to a clipboard-carrying researcher. Rather, the listener's attention darts to and fro among only the most important features of each line, observing the openings and closures of phrases, and the peaks and valleys within those phrases. In so doing, the brain builds a map of relations between voices, with parallel flows of anticipations implicitly filling in spots that have not been explicitly attended to.

This is exactly how we view a group of dancers on stage. We don't watch one dancer the whole time, and couldn't (had we the memory) report every step that dancer has taken. Instead we follow the patterns that are formed as dancers interact, focusing upon the relations between them. Since all are dancing in the same style, there's no need to gather information of every change in every pattern of motion. Our brains can make good enough guesses about what is happening in the unobserved. And so we leave a dance concert with abstract memories of the total picture, but relatively poor memory of individual detail. Since the deepest pleasure resides in the deepest relations, we feel fulfilled by the concert although we've had time to closely observe only a small fraction of it.

Perception at this level entails a good deal of guesswork. This may not seem very "scientific" on the part of the brain. But *guessing* is what cognition is all about: an ongoing series of anticipations of what is happening in the brain's environment. Nothing prevents the brain from drawing erroneous relations between sound components that are in fact unconnected. Sometimes it does. But the information gathered by one moment's anticipations underpins the anticipations of the next. Errors tend to multiply, perception fails, and we try a different strategy.

Let's consider how a brain might anticipate the notes of Henry Mancini's "The Pink Panther," which we've analyzed in earlier chapters. The

melody begins as pairs of notes (*da-Dah! da-Dah!*) with pauses between (Fig. 8.2). We hear the first pair and don't know what to expect next. But the second pair is enough to suggest a continuation of these pairings (much as two points define a line) and also a rising melodic contour. Sure enough, the next bar delivers more pairings that rise higher and higher in pitch. And so anticipation is not only satisfied but intensified.

Yet the second bar is not without violation of anticipation. The rate at which the pairings arise abruptly doubles, and this increases tension and fosters the anticipation that the tune might accelerate further. Only five beats into the piece, the composer has enhanced "interestingness" by establishing a trend and then interrupting it. But the deviation is restrained. Simultaneously, other aspects of anticipation are met without surprise as harmony rests in the same key, notes stay paired, and contour keeps rising. By reinforcing some anticipations while violating others, the composer ensures that there will be an adequate flux of anticipations to violate in bars to come.

Violate them he does. In the third bar, Mancini suddenly slams on the brakes and sends melodic contour skidding across a sharply accentuated, long-held note. At the same juncture, harmony shifts toward pronounced dissonance. And all this happens on the downbeat of the third bar, a point of particularly strong rhythmic focus. The violation is abruptly resolved two beats later, when harmony returns to the underlying key and melodic

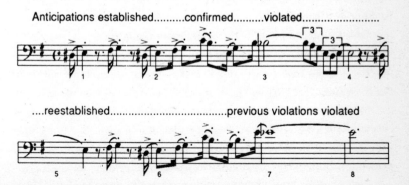

*Fig. 8.2. Listener anticipation in "The Pink Panther"*

contour slides back to its starting point. This signals the end of a musical object, of a phrase.

Larger-scale anticipations can bridge elements divided by several bars, or even by whole symphonic movements. When Mancini repeats the first four bars almost note-for-note in the fifth through eighth bars, the listener carries along an "echo" of the first four in short-term memory—an echo not just of the individual notes, but of all the relations observed among them. At every level in the hierarchy of integration, our brains look for difference and similarity. Where we find difference, we unearth relations between what was expected and what has occurred—relations that can in turn be anticipated and violated at higher levels of understanding. When we find similarity, trains of anticipation are reinforced, making their ultimate violation all the more powerful.

Consider the four pairs of notes in the second bar. The first two pairs point the listener's attention along an ever-rising trajectory. But Mancini inserts a kink into the contour, taking a downturn on the third beat then rising again. The melody would have worked by rising steadily upward, and indeed this is just what happens when it is repeated in the sixth bar. But Mancini is holding back, and thereby building larger musical structure. When you come to the sixth bar, you'll remember the violation of the second bar and expect it to happen again. Instead the melody shoots straight upward so that experience exceeds expectation, propelling the listener forward and intensifying the surprise when harmony swerves toward dissonance a beat later. In this way, the composer violates anticipations one moment in order to intensify their fulfillment the next.

Not everyone will hear "The Pink Panther" in the way Mancini intended. When a *Pink Panther* movie makes its way to a remote village in China or India, listeners will hear the same notes, but are apt to anticipate the wrong sorts of relations among them. Similarly, our listening strategies go awry when we encounter music that is entirely alien. We bring to it anticipations tailored to Haydn and Sinatra, and try to assemble non-existent melodic lines, non-existent meters, non-existent tonal progressions. With a little luck, we'll find a way of relating elements of the music into pleasing experience. More often we fail at every attempt, find only

the noise of relationlessness, and declare that the music has little melody or harmony or rhythm—in a word, that it "makes no sense." It's as if we bring the rules of chess to a game of backgammon.

We suffer similar difficulties when we encounter unfamiliar styles of music in our own culture. Listening to cool jazz as if it were country and western is a big mistake. But we're more likely to muddle through than we are with Indian or Chinese music. With repeated exposure we may learn to like a new style of Western music; hardly anyone crosses the abyss to full appreciation of the music of a distant culture.

Much of the problem in cross-cultural appreciation lies in the fact that low-level, automatic perceptual mechanisms are differently trained in the world's diverse musical traditions. As we saw in earlier chapters, a brain accultured to Indonesian music does not categorize scales and harmonic intervals the same way we do. Our hard-won categorization abilities are at the lowest level of acquired response to music. These skills are learned, yet become as automatic to perception as shoelace tying becomes to movement. High-level attention cannot penetrate deeply enough to adjust these automatic mechanisms. And so we simply can't listen to an Indonesian scale without trying to perceive it as an out-of-tune Western scale. Perceptiveness for Indonesian music comes slowly, if at all, as auditory cortex acquires new flexibility through long exposure.

## Cognitive Preference

Four friends watch a movie and then talk about it in four quite different ways. The first dwells on costume and decor, the second on twists of plot, the third on character development, the fourth on cinematography. People react to music with similar bias. We each have our own listening style, a tendency to attend to certain features of music while neglecting others. Some people are especially drawn to melody, others to harmony or meter or phrasing and form. Everyone hears each aspect to a degree, of course. There is no rigid typology of listeners. Yet listening styles are often easily observed. Call it "cognitive preference"—a penchant for certain types of music because their structure complements particular listening skills. This is not to be confused with preference arising from personality and social

background, a matter we'll turn to in a moment. Let's consider each kind of listening bias, starting with melody.

After years of conservatory training, and aeons of practice, a young musician can rightfully bask under Auntie Gertrude's praise following one of those depressing living room demonstrations of what Junior has been doing instead of going to engineering school. After the usual effusive praise, "I can't imagine how you move your fingers so fast," comes the inevitable question: "How many songs do you know?"

Songs? *Songs?* Fugues, yes. Nocturnes or waltzes or sonatas, yes. But songs? Yet, for Auntie Gertrude, as for most of the world, music *is* melody, and counting melodies is tantamount to counting compositions. Throughout the world, melodies constitute the basic unit of musical experience, if only because most people cannot remember much more than a melodic contour. Many people become engrossed in music only when they covertly (or not so covertly) sing along.

It is not surprising that the average listener is so attuned to melody. As we saw in Chapter 3, melodic contour is our first musical competence. It has much in common with the prosody of spoken language, in which we are all experts. Melody is the one kind of musical device that nearly anyone can make sense of, and perhaps more important, that nearly anyone can remember and reproduce. This orientation has meant that popular music is a world of three-minute compositions, since simple melody writing generally can't be stretched out much longer.

Melody listening usually means word listening. Ask someone about her favorite song and she's as likely to recite its lyrics as to hum the tune. Although melodies can as readily be played on instruments as sung, almost all popular music goes for the words. For most people, "music" is as much about poetry as about tonal sound. In fact, studies show that untrained listeners usually can't recall melodies without bringing lyrics to mind, yet can readily recognize lyrics apart from their melodies. It's for this reason that so little music crosses linguistic borders. Americans will listen to English rock, but not French or German or Japanese rock in which the words can't be understood. (True, American rock manages to travel far and wide,

but so do most other trappings of American youth culture: blue jeans, Coca-Cola, Hollywood movies.)

When music is banal, its only redemption rests in its words. Words also provide a welcome memory aid for the musically undeveloped mind. So popular music sees to it that words are intelligible by emphasizing consonant sounds. In contrast, art music emphasizes vowels, subordinating intelligibility to the overall harmonic good. Audiences for art music don't expect much from words, and they gladly listen to songs in languages they cannot understand.

Harmony listening is more difficult. Chapter 4 explained how Western harmony originated from counterpoint, the interplay of multiple voices. Although pure counterpoint has been out of vogue for more than two centuries, it still is at the heart of harmonic practice. Elaborate harmony is comprehensible only when successions of chords are heard as multiple voices. Thus harmony requires the sophistication of polyphonic listening. Along with preference for harmony comes a taste for instruments played with "good tone" to produce a lucid chorus of overtones. Noise-laden instruments like the electric guitar are anathema to the harmony listener.

As we've seen, harmony became the obsession of Western classical music. But harmony tends to be simple in most popular music. Chord changes are predictable and infrequent as inner voices shadow the leading melody rather than strike off on their own. Not surprisingly, studies consistently show that perceptiveness for complex harmony is the rarest of listening skills, with wide disparities between professional musicians and ordinary folk. This should come as no surprise, since fine-grained harmony perception develops later than other skills, arriving only in early adolescence, if ever. Those who fail to grasp harmony can be quite uncomprehending of harmony-oriented music. Like someone color-blind viewing a Monet ("It's just a haystack. What's the big deal?"), their musical world is in black-and-white.

Other listeners show a strong bias toward meter, toward music that "has beat." As we saw in Chapter 5, complex meter is rare in Western music of any kind, even jazz. For a steady diet of syncopation, additive

rhythm, and polyrhythm, you must turn to the music of Africa or India. Though drummers sometimes tap out complicated patterns in Western music, the effect usually amounts to nothing more than texture. Nonetheless, many listeners boast that their music "has rhythm," referring to its emphasis of meter rather than its metrical complexity. For these listeners, music is foremostly a device for making their bodies pulse. This pleasure (which we'll consider in Chapter 10) appears to be gradually gaining priority over the pleasure of melody.

Allegiance to the second kind of rhythm, phrasing, is rarer. Recall that phrasing, like meter, organizes music by marking spans of time. Built up into hierarchies, phrasing merges into large-scale form to create a panorama in sound. This is the ultimate aim of art music and, by its standards, the final measure of greatness. It is a bust of Beethoven—and not of Tchaikovsky or Gershwin or John Lennon—that sits on so many pianos because it was he who devised the deepest phrasing hierarchies ever ("as if phoned in from heaven," as Leonard Bernstein put it). Devotees of phrasing and form will forgive clumsy orchestration, uninspired melodies, drab beat, even lame harmony, if somehow a composer can find a way to these large structures. For them, to listen to music is to fly over a landscape of infinite variation and surprise. By their lights, most popular music is as tedious as Iowa cornfields.

Music's many genres are each oriented to a different mix of these four basic kinds of listening (and to many lesser factors as well). When a jazz artist insists that "rhythm is the heart of music," he merely proclaims his allegiance to meter, and he plays and conducts and writes music to emphasize this focus. Devotees of classical music are just as biased, but toward harmony and form.

Why does one listener zero in on meter while another makes straight for melody or harmony? Exposure is surely one reason. Early training teaches us to observe particular features of music. Thereafter we seek out like-minded music and acquire an ever better ear for its traits. This circularity leaves many listeners almost deaf to whole musical dimensions that were neglected in early experience.

But acculturation is not all. In earlier chapters we've seen how normal

biological variability extends to the dimensions of every part of the brain. No brain is proportioned exactly like any other, and broadly speaking, more circuitry makes for greater perceptual skill. Without doubt, some people are better constituted for listening to harmony, or to meter. Considering the multitude of individual modules that make up the auditory cortex, each devoted to a particular kind of sonic relationship, and each varying in capability from person to person, it's reasonable to believe that an individual could have a biological predilection for particular aspects of music. The composite balance of skills would form a musical personality unique to an individual, although subject to the tyranny of the bell curve, which dictates that most people will be fairly similar, just as they are in general personality. Mozart summed it up quite nicely:

> But why my productions take from my hand that particular form and style that makes them Mozartish, and different from the works of other composers, is probably owing to the same cause that renders my nose so large or so aquiline, or, in short, makes it Mozart's, and different from those of other people.

None of this explains why we prefer particular compositions among the many that complement our individual musical personalities. The blend of individual musical history and individual auditory neurology helps explain enthusiasm for a particular performer or composer. But it doesn't explain why we like one piece by that person and not another.

Individual compositions succeed or fail by "interestingness," a concept lacking in scientific rigor but affirmed by every concertgoer's yawn. Research on melody preference has consistently shown that we like melodies that are slightly challenging to the ear, that go just beyond the expectations we have been taught by prior musical experience. It's a bit like a tennis player's always preferring to play with someone slightly better. But when melody (and music in general) is too challenging, our brains rebel. It's no fun *never* returning the ball. Music beyond our grasp is not music at all. Our brains fail to draw together underlying relations, and we experience little more than high-quality noise.

Interestingness can be analyzed in terms of information content. In this context, "information" refers to any aspects of a passage that are not strongly implied by the musical conventions of the time the passage was written. Easily anticipated notes contribute little to the total information conveyed by a passage. For instance, each successive note in a scale is readily anticipated and provides no new information, so scales are boring. In contrast, a sudden shift to a remote key is full of surprises and gives the listener something to respond to, increasing the information a composition conveys.

Scholars have attempted to quantify the information content of melodies of different genres of music. This is done partly by counting features like leaps and syncopations, and also by assessing the amount of dissonance in a melody's underlying harmony. To no one's surprise, the melodies of much popular music tend to score quite low in information content, which helps explain why so much pop music sounds the same. An extreme case would be the mood-conditioning, utterly featureless music played in supermarkets, music that is written expressly to *not* draw our attention. Its information content is essentially zero. At the opposite extreme is a good deal of twentieth-century art music that audiences generally detest. In theory, the information content of such music is very high. But whether by inept ears or by inept composition, few people can grasp this music's deep relations. Studies show that listeners almost always prefer music with too little information over music containing too much. It has also been found that people tend to prefer increasingly complex, information-laden music as they grow older and their listening skills improve. The reverse case, where listeners go from preferring complex to simple music, is virtually unknown.

## Musical Preference

In recent years, shop owners have found that broadcasting classical music onto the street drives away drug dealers. And Mozart has been played in malls to flush out loitering teenagers. But research shows that it takes hard rock to drive out rats (as General Noriega learned when the U.S. Army dislodged him from his hiding place by blasting heavy metal). Mu-

sical preference is odd indeed. Some people blithely claim to
anything put before their ears. (Really? Tibetan chant? Bar
Others are almost as versatile, but firmly reject individual gen
like very little, but often appear to enjoy their music with exceptional
intensity. Jazz aficionados stare down devotees of country and western;
rockers of one taste mock rockers of another; classical music lovers shun
just about everybody.

What is musical taste, and why do some people carry it to such ex-
tremes? We use the word "taste" not just as explanation, but for justifi-
cation. One person prefers mangoes, another chooses papaya. Because both
fruits are equally rich and equally nutritious, we regard preference as en-
tirely arbitrary, as literally a matter of taste. But musical taste is far more
complicated, for we are drawn to music for many reasons. It is wrong to
assume that music meets our brains only as patterns of sound, that psy-
choacoustics and perceptual psychology alone can account for music's lure.
And so a penchant for aspects of melody or harmony or rhythm or form
is not nearly enough to explain the vast diversity in musical preference.

Taste begins with the listener's notion of the role music should play
in life. For many people, musical function surpasses all considerations of
musical quality. Says folksinger Pete Seeger, "The important thing is not,
'is it good music?,' [it's] 'what is the music good for?' "

Before all else, people use music for mood enhancement. Psychologists
have long known that different personality types are attracted to different
kinds of drugs, legal and illegal. There's a parallel here. We "take" a certain
kind of music to steer our central nervous systems toward a particular
condition: hard rock as the frenzied rush of cocaine; easy-listening genres
as a martini; cheery supermarket Muzak as a pick-me-up cup of coffee;
cool jazz as a laid-back marijuana high; the far-flung landscapes of classical
music as the fantasy realm of psychedelics. We'll explore how music influ-
ences mood in Chapter 10.

Moreover, we listen to music for the experience of its meaning, for
what it "says" to us. Although some musicologists have denied that music
can be meaningful, few listeners would agree. Somehow, music expresses
things, tells a story. How music is able to do this is a question we'll turn

to in the next chapter. Such listening can require as much focus as a Shakespeare play, and most people spend little time relating to music this way.

Listeners also turn to particular genres of music for their external meaning, their social symbolism. What better way to indulge aristocratic pretensions than to strut about in time to a Haydn symphony? And what better way to assert independence from tyrannical parents than to bombard them with Megadeth? The symbolism of art music and rock music, as for many other genres, is played out in live concerts, which can evoke a microcosm of social relations as we would like them to be.

Some social critics have judged the symphony orchestra to be the epitome of capitalist oppression. A strict hierarchy is observed throughout. As ruling aristocrat, the conductor leads compliant musicians, who in turn lead a compliant audience. The orchestra itself is stratified, with the pecking order among the strings clear for all to see. Everything is uniform and formal, from the penguin tuxedos to the prescribed moments of applause. Specialization and expertise reign. The music is written by expert composers and performed by expert musicians. The audience has no part in production; it simply consumes what is offered. In short, the orchestra is a music factory. It is appealing imagery for its often well-heeled audience, relaxing after a long day in their managerial duties.

By comparison, a rock concert is all barricade and guillotine. Its every symbol is of rebellion against hierarchy. Players interact among themselves and with the audience in stringent egalitarianism, conveying by smiles and greetings that the concert is a pleasurable social engagement for them, that in the audience they are among friends.

Rock is also profoundly anti-intellectual. The use of a score is unthinkable in a rock concert; the inability to read music is worn as a badge of honor. Performances are made to appear spontaneous, with much pretense of improvisation. Nothing is to appear to have been rehearsed; virtuosity must seem inborn and not acquired. It is no surprise that rock music is the first important genre of music in history to be composed and performed largely by young people for an audience of young people. Its images reflect the concerns of youth, and it accepts aging players only so long as

they maintain the trappings of the young. "Hope I die before I get old," sings the Who.

Neither portrait is very complimentary, and this only goes to show how extreme music's social symbolism can be. Happily, individuals can be drawn to music *in spite of* its outward symbolism.

People also are attracted to genres of music that serve a particular function in their lives. Someone fancies reggae because she likes to dance to it. Someone dotes on opera for the cult of personality. Someone goes to jazz clubs to enjoy the antics of unplanned improvisation. Someone goes to musicals out of a penchant for theater. There are lots of draws.

Yet despite all these factors, research shows that most people largely make their personal musical choices for reasons that are neither "personal" nor "musical." Rather, they listen to conform, taking on music as an emblem of social solidarity with their peers, each generation adopting its own conspicuously different styles. There are many exceptions of course, but the gross statistics are damning. Most people acquire their musical taste during adolescence among friends of the same age, and they carry early preferences right through to the grave. This powerful force overrides considerations of individual neurology and personality. It is a shocking observation, or at least ought to be, given the complexities of music perception. By all rights, any group of twenty teenagers ought to prefer twenty kinds of music.

Some social psychologists have gone so far as to suggest that we "imprint" to a preferred musical style during early adolescence, much the way young animals imprint upon their mothers, forming an attraction that will never leave them. If this is so, then our brains may literally develop toward a particular musical style during the final years of normal musical development (from about age ten to twelve.) This is not saying much more than that neurons form connections as we learn, and those connections tend to dominate all further perception. Once one way of listening is established, it is applied to all kinds of music, which are accepted or rejected by how well they fit. Neurons are quite capable of branching toward further connections that could accommodate a wider range of musical understanding.

But why bother? In the modern world, it is as easy to reject an uncomprehended genre of music as to turn a radio dial.

It's fair to object that every generation confronts a different world, and with a different perspective that becomes embodied in new music. The rustic naïveté of the beer hall polka is long gone, and so is the optimistic worldview of the Las Vegas crooners. But history does not stand still; the world goes right on changing through our individual lives, and we change with it. Forests have fallen to print a vast literature on the psychology of life stages. Yet as much as we change with age, out musical taste generally remains stagnant. Most of us stick with what we know, much as we do with the sorts of food we eat and clothes we wear. Dumb habit is the main reason, of course. But habit alone does not entirely explain our listening habits. We are also made narrow by approaching music too passively. By shunting music to the background, we do not meet and overcome new perceptual challenges, and so discover nothing new.

## Expert Listening

Given the great diversity of approaches to music, it is remarkable that we so readily assume that others share our own experience. If an audience leaves a movie with clashing impressions, think how much wider must be the gulf left by a concert. We share a common apprenticeship in our experience of the world, but not of music. One person listens exclusively to pop, another only to the classics. One regards music as decoration, another consults it like a Delphic oracle. One can hardly sing an eight-bar melody, another can reproduce whole sonatas from memory, whether by keyboard or in lucid imagery.

Clearly, listening is a skill—a *performance* skill in which the listener inwardly reproduces many features of a piece by anticipating them, and thereby better prepares himself to perceive them. As the myriad tones of a composition scoot by, an expert listener rounds them up with the proficiency of a sheepdog attending its flock. The musical mind is constantly on the run, seldom able to tackle all before it, ever reliant upon good judgment of where to expend its efforts. A listener's perfect performance,

much like a musician's, is a matter of striking a balance among the many ways a piece can be attended to.

Expert listeners perceive large musical objects. Chord progressions, rhythmic devices, conventions of style—all are so deeply ingrained that just a hint is needed to start anticipations rolling. These anticipations derive from prior experience, experience that has molded the mechanisms of attention to embody conventions of harmony and rhythm and style. And so the expert ear implicitly brings an extensive library of musical ideas to its listening.

The expert listener's powers of anticipation can be taken one step further by committing the structure of individual compositions to long-term memory, cultivating a repertoire of pieces one knows how to follow well. Such knowledge is normally fragmentary. Rare indeed is the listener who can play a piece note-for-note in his mind's ear, or plot out its score. But with repeated exposure a listener acquires a map of a composition's main events. With hundreds of signposts foreseen, the listener can unleash his anticipations early and accurately, negotiating a composition's twists and turns with the finesse of a motorist traveling a familiar mountain road.

Anticipation frees a mind from surface detail, allowing it to probe for deeper relations. As we saw in Chapter 5, to go beyond surface levels of hierarchy is to observe musical structures that unfold beyond the span of the perceptual present. At deep levels of hierarchy, the listener can no longer count on the "reverberation" of auditory cortex to bring together musical elements. Thus short-term musical memory becomes important. The expert listener does not merely perceive notes passing by, but totes along armfuls of fragments for use moments later.

These memories are largely the responsibility of the frontal lobes, which act upon auditory cortex to maintain observed relations for many seconds when they would otherwise fade away. The frontal lobes glow brightly in brain scans of short-term-memory tasks. As we've seen, attention is also managed largely by the frontal lobes. In fact, the two phenomena of short-term memory and attention are closely linked, each being founded upon anticipation.

This activity comes at a price. The frontal lobes are chiefly a control

center for other parts of the brain, a nexus of planning, of effort, of discipline, of will. They are the taskmaster behind mental labor. Thus expert listening is always effortful. Compared to more passive listening, it is the difference between watching a dance from the sidelines and taking part. It may be work, but is a joyous expenditure of energy.

By forcing an impulsive and unruly brain to hold still, the frontal lobes serve the dual role of disciplinarian and teacher. Their repeated exertions gradually renovate the way auditory cortex processes incoming sound, so that what at first is difficult to perceive later becomes automatic. As a mind gradually becomes more musically perceptive, complex patterns begin to make their way as readily as a flighty melody. Attention is no longer called to surface detail, and so is freed for the enchantment of deep relations.

Such sophistication necessarily involves greater left-brain involvement. This is a theme we've encountered again and again in past chapters. The right-brain penchant for contour and pattern takes music perception only so far. Complex compositions, with interweaving themes in several voices, requires the sequencing talents of the left brain. By treating music as an assemblage of fragments, the left brain is able to model relations between widely separated moments, and thereby to look deeper into its hierarchy than the present-bound right brain.

Finally, expert listening requires expert music. Considering the vast range of musical experience—in how we perceive music, choose it, use it, count upon it—it is tempting to conclude that any music ought to be as effective in its own way as any other. As Big Bill Broonzy put it, "They're all folk songs—I ain't never heard a horse sing." But they're most certainly *not* all folk songs—not a Bach fugue, not big band jazz, not an Indian raga. Music that is painstakingly invented is quite different from popular genres that make no attempt at relational depth and consist mostly of moment-to-moment variations on a simple theme. A brain cannot know the pleasures of deep relations when there are none to be observed.

A *New Yorker* cartoon spoofs the publishing industry with a fake advertisement for "Ambient Books," extolled as having "No beginning . . . no middle . . . no end . . . Just bunches of sentences written to soothe and relax the reader." One title is *Pretty Flowers* ("There's pink ones and white

ones. There's some yellow ones. Look, more white ones. Could those be rhododendrons?"). Another best-seller: *The Ocean* ("Two little waves. A medium-sized wave. Six itsy-bitsy waves. A large wave. Here comes another medium-sized wave"). We laugh, but much popular music amounts to little more. What is rare is music that tells a story, that brings a multitude of themes and devices into elaborate and unpredictable interplay, like characters in a good novel—in a word, music that is *literature* and not mere genre writing. Lacking long exposure to such music, many people remain unaware of the limitations of the music they listen to, and haven't a clue about what music can be. Their unskilled ears make so little sense of complex music that they can only conclude that their own music must be superior.

Happily, any ear can learn to probe deeper if only an effort is made. It's not always easy. In the name of self-improvement, today's symphony audiences sometimes sit through premieres of contemporary works they can hardly stomach, suffering harmonies that sound consistently dissonant, rhythms without apparent pattern, and a dearth of melody. To this the public responds with remarkable passivity, applauding politely to celebrate the end of their suffering. One is reminded of Suetonius's description of concerts given by Nero, to which no invitation dared be declined:

> No one was allowed to leave the theater during the emperor's recitals, however pressing the reason, and the gates were kept barred. We read of women in the audience giving birth and of men being so bored from the music and the applause that they shammed dead and were carried away for burial.

Although the modern exercise of subjecting captive audiences to music they do not comprehend may be misconceived, there is something admirable in such blind submission to musical authority. In a world where so many people are oblivious to quality in music, even hostile toward the very idea of quality, it is refreshing to see people recognize that music can contain more than first meets the ear, and that it is worth the effort to learn to listen more deeply.

Following the premiere of his great opera *Don Giovanni*, Mozart heard that the emperor had criticized it thus: "That opera is divine. I should even venture that it is more beautiful than [*The Marriage of*] *Figaro*. But such music is not meat for the teeth of my Viennese." The composer quietly replied, "Give them time to chew on it." Alas, taking time is not a virtue of our age. It is so much easier to switch to another channel, to pop in a different CD. But ultimately music cannot become—never has become and never will become—any better than its audiences are able to listen.

From sound...
...to tone...
...to melody...
...to harmony...
...to rhythm...
...to composition...
...to performance...
...to listening...

# ...to understanding...

It is, by Earth time, A.D. 3,721,479, and the citizens of the planet Phyxis are elated: the appearance of a UFO has been confirmed. Reconnaissance craft speed toward a glistening speck in the sky, only to find a gangly spider of metal beams, which they deliver to the planet's leading research institute. There, scientists gather around, fluttering their wings in astonishment. Other alien objects have been encountered during the long history of Phyxis, but nothing so primitive as this. Archaeologists decide that the object must be a spacecraft launched by a civilization only just beginning to reach out from its home planet.

By the fact that this spacecraft has approached at low velocity through a vast expanse of empty space, it is certain to be very, very old. Although its skin has been pockmarked by cosmic dust, somehow the craft has managed to avoid a major collision during the aeons since it drifted from its

solar system. Indeed, the spacecraft remains in such good condition that an insignia of alternating red and white stripes remains, and one side displays some sort of inscription in indecipherable characters:

VOYAGER 2

Inside an aluminum plate affixed to one side of the craft, the scientists discover a gold-covered disc engraved with a fine spiral groove. Accompanying artifacts are soon recognized as examples of yet another ancient technology: a stylus and cartridge. Surely, this disc must contain information about the civilization that had launched the spacecraft on its lonely journey. This is a first.

As a computer decodes the disc's data, the Phyxians marvel at pictures of the inhabitants of the planet of origin, in diverse dress and habitat. They find crude maps apparently pointing the way to the home solar system. And there is something that might be a representation of genetic material. There also are sounds. Some are squeals and yowls that appear to be instances of spoken language. But others are harmonically simple and highly structured. Music! They've sent music!

The Phyxians are great enthusiasts for music, drawing upon some 730,000 years of cumulative repertory. It is only natural that they, like any other reasonably intelligent beings, would indulge themselves in this passion. They live in a physical world where vibrations are everywhere, so their vibration sensors have evolved to the point where almost anyone can develop a good antenna for music. And because their lives unfold in time, their nervous systems are well designed to observe changing patterns of any kind. With tremendous excitement, Phyxians in all crawls of life tune in for the first broadcast of alien music.

At first they are disappointed by short fragments of simple tunes. But then they encounter a long, extraordinarily well-organized composition, its several voices interlaced in earnest conversation. The Phyxians listen again and again. This is as close as they will ever come to knowing what it is like to be another kind of intelligent creature in a far-off world.

# Meaning

If someday *Voyager 2* is intercepted along the trajectory it was launched in 1977, there will be no way for its finders to know that the long sequence of sounds was made by a pianist named Glenn Gould playing a fugue by Johann Sebastian Bach. There will only be a web of tonal relations to consider, without any notion of eighteenth-century musical style, or of the society the music sprang from, or of what it is like to be a human being. Could a Phyxian possibly understand this music, no matter how intelligent and musically experienced?

The answer to this question depends on what you mean by "understand." Anyone can read a musicological explanation of how Chinese opera is structured, but no one would mistake this for comprehension of Chinese opera. Clearly, the Phyxian who "understands" Bach must experience the music *directly*. But the notion of "direct experience" doesn't take us far. Anyone can directly experience a recording of a Chinese opera without making any sense of it at all, hearing only noise where others would gain intense pleasure. In one case the music *means* something to the listener, in the other case the music appears to have little meaning at all.

"Meaning" is one of those fuzzy concepts that keep philosophers in business. It has no simple explanation that satisfies even a grudging majority. Every hypothesis sooner or later (usually sooner) meets with an irreconcilable counterexample. Tempers flare: "But you don't understand what I *mean*!" Even when a definition holds up well, the question of the "meaning of meaning" lies in wait as a favorite exercise in conceptual self-cannibalization.

But this is no debate akin to counting angels dancing on the head of a pin. Our minds swim in a sea of meaning. Not just, "What does the word *callipygous* mean?" but "What was that noise in the shadows?" "Is the lilt in her voice a sign of disapproval?" "Does the empty platform signify that the train has already gone?" Psychology cannot go far without a workable theory of meaning. Lacking one, there's no way to describe how the brain ties together its diverse activities. Purpose and meaning are insepa-

rable. We need to stop and ask what "meaning" means before we can look for it in music.

In older theories of meaning, something has meaning when it somehow represents our experience of the world or of ourselves. A brain witnesses the representation and associated circuitry lights up. This is evident in our understanding of words. We hear the word "tiger" and respond by activating circuits that categorize cats and that form myriad associative links to jungles and creeping paws and pith-helmeted hunters. The representation acts as a kind of artificial environment that elicits tiger-specific reactions despite the absence of an actual tiger. In principle, the conceptual network activated in a brain that hears the word "tiger" is also active in the brain that speaks the word "tiger." So meaning serves to transfer cognitive states between brains. Meaning would seem to be foremostly about communication.

This sort of explanation for the meanings of nouns is seductively simple, but hardly adequate. For one thing, language expresses meanings for abstractions; "a tiger" does not mean the same thing as "the tiger." Equally, there are many words like "pejorative" and "obfuscating" that have no concrete referents in the external world. Meaning can also be metaphorical, as when someone says "He's a real tiger," an expression in which meaning is further conditioned by context ("He's a real tiger, watch out!" versus "He's a real tiger, you ought to get to know him!"). Meaning can even be derived from the mere fact that the speaker has chosen to mention a tiger (say, at a conference on species extinction).

Working in tandem with verbal meaning is *intonation*. We seldom speak words in the flat tone we associate with computer-generated speech. Rather, we accent and modulate consonants and vowels to express myriad shades of emotion and intention. Some of these meanings are explicit: shouts of anger or cackles of levity. Others are more subtle, such as the Marilyn Monroe breathiness that emulates a lover's closeup whisper in the ear. But much intonation is quite beyond categorization. Yet it is meaningful nonetheless, as shown when it is altered by some kinds of brain damage, particularly to the right hemisphere, which result in jarringly "unnatural" speech. As words combine into sentences, intonations meld into

*prosody,* the "singsong" of language. And so every statement has at least two meanings: a verbal meaning that in some sense describes the speaker's experience, and an intonational meaning that reflects the speaker's feelings about that experience.

To make matters more complicated still, we often extract meaning from the world when there is no communicator and no act of communication: we draw inferences. When we wonder, "Oh no, does this mean that Senator Snorkel is going to lose the election?" our concern is with consequences, just as when someone warns us about an approaching tiger. But in this case meaning results from our interaction with the world, and different meanings would come our way if we interacted differently.

Is music's meaning as complicated? Unquestionably. In the last chapter we saw many instances where we extract meaning from music that has nothing to do with the music's notes. We find meaning in performance ritual. Meaning in the applause we award. Meaning in the fact of singing a church hymn. Meaning in sharing music with friends.

But what of music's innermost meaning, the meaning conveyed purely by patterns of sound? Intuitively, we feel certain that this kind of meaning has something in common with saying "tiger." The composer assembles notes that represent some kind of understanding, and after much ado these notes make their way into our brain, where their passage brings about a similar understanding. We say that the music "speaks to us."

Unfortunately, the similarity of music with language stops there. We can almost never point to the external world and say, "This music represents that," the way we can say "tiger," then point to one in the zoo. True, a programmatic piece like Debussy's *La Mer* ("*The Sea*") somehow sounds like the play of frothing surf. But little music is of this kind. In any case, had Debussy named his composition *The Waterfall* our mental imagery would gladly tag along. The American composer Aaron Copland liked to recount how he conceived the title *Appalachian Spring* for his famous tone poem only after he had finished writing it. Thereafter he was forever congratulated for having captured the essence of Appalachia in May.

Language avoids such ambiguity. Call a tiger a giraffe and no one is fooled. Indeed, if you hear the word "coatimundi" and are unaware that

it refers to a kind of South American raccoon, your brain will hardly re-spond at all. No image comes forth, no web of associations, nothing. The word simply has no meaning for the listener. In contrast, virtually all music bears at least some meaning to a brain. Even music that we don't much understand, say, Chinese opera, sounds like *something* to us, although the apparent noise content is high.

## Parallels Between Music and Language

Although minds communicate through many sorts of symbols and gestures, only language and music—whatever their differences may be—operate on a large scale and in great detail. And while lesser forms of communication are found throughout the animal kingdom, only human beings are capable of producing and comprehending music and language. That these two discrete abilities should appear side by side strongly suggests they must be related. Since language seems by far the more useful of the two, it also seems a good bet that language may have developed first, with music branching from language only after much of the hard evolutionary work had been done.

This idea is made all the more appealing by the fact that a brain's language skills are focused in the left hemisphere, while the functions of parallel areas of the right brain have remained relatively mysterious. These areas differ somewhat in gross anatomy and in the kinds of neurons they contain. But basically the right brain bears areas similar to the language structures of the left. Yet the right brain is mute. Some call it "the silent hemisphere." Given the parallel appearance of language and music in hu-mans, is it not reasonable to assume that the right brain speaks a musical language while the left brain speaks a verbal one? After all, we've seen how right-brain auditory areas favor tonal analysis just as left-brain auditory areas favor speech consonants. What could be more elegant?

Another hint is that the inherent musicality of language is largely han-dled by the right brain. We hardly ever speak in a monotone. Instead we bring intonation to individual words and an overall prosody to sentences that makes all speech a kind of song. Most remarkably, when severe left-brain damage wipes out most language skill (a syndrome called *aphasia*),

many patients are still able to sing the words to songs they know well, although they can no longer speak them. Rote expressions like greetings and profanities, which are more performed than spoken, may also be preserved. Clearly the right brain has an affinity for the musical aspects of language. Did these features further evolve till we could produce symphonies, just as primitive spoken language evolved till we could produce novels?

To find out whether music derives from language, we need to cover a lot of ground. First we'll turn to the question of how language is structured and whether music resembles it. Then we'll take a look at the distribution of language and music skills in the brain. This requires an appreciation of what it means for a cognitive skill to be "localized." For that we'll digress a bit to see how neuroscientists obtain information about localization. Finally, we'll consider what happens to language and to music when particular brain regions are damaged.

The association of music with language is an ancient one. When Saint Augustine wrote his *De Musica* in the fifth century, it was chiefly about poetry. No wonder. Both music and language are about long, highly organized streams of sound. There are no equivalent sonic entities in human experience or in the natural world (not even the hours-long songs of whales, which have turned out to be no more complex than birdsong). We learn to understand both music and language merely by exposure, and to generate sentences and melodies without any formal training in their underlying rules. Both seem to be "natural," built-in features of our nervous systems.

Phrasing may be the closest parallel between music and language. As we saw in Chapter 5, phrasing divides long streams of sound into comprehensible chunks. Laboratory work confirms that our brains treat musical phrases and spoken phrases similarly, suspending comprehension as a phrase arrives, then pausing to gulp the whole thing down. One study showed that listeners have much more trouble finding a two-note sequence when it straddles two phrases; the mind simply doesn't want to hear the two notes together. Similar results come from a technique devised for linguistic research called *click migration*. Subjects are asked to recall the syllable at which a click was made in a sentence. Often, they'll report a midphrase click as occurring at phrase end, the point at which the brain firmly decides

what the phrase has meant. It's been found that clicks similarly migrate to the ends of musical phrases.

The phrasing of musical instruments can sound a lot like the phrasing of speech. We're all familiar with occasions when instruments seem "to talk." The best example is the famous *talking drums* of western and central Africa. These are skillfully crafted and played to approximate speech sounds, even matching the pitch height of certain tonal languages. Other instruments, such as the *masengo* and *endingidi* fiddles of East Africa, can even imitate human vocal timbre, and are sometimes used to communicate messages as "words."

But what constitutes a word in ordinary music? Is it an individual note? A grouping of notes? Speech sounds like "ch" and "ah" have no meaning until combined into words, and then their meaning is very stable. Metaphor aside, the word "giraffe" always refers to a long-necked quadruped, and never to a washing machine. But in music, a single D-flat can stand as an entire musical assertion in one context, yet in another it makes sense only as part of a musical figure. Unlike language, music seems to be meaningful at every level of analysis, and meaningful in the same way.

Because there are no musical words, there can be no musical parts of speech. We lack equivalents to nouns and verbs and adjectives in music, even by analogy. So as much as we would like to regard a melody as a kind of sentence, there can be nothing like a language's grammar in music. The grammars of natural languages are designed for exactitude. Particular kinds of words in particular forms and sentence positions generate precise meanings. Changing the form or order of words in a phrase is apt to render the phrase incomprehensible. But musical phrases are highly malleable and tolerant of ambiguity. A melody turned one way rather than another may be less pleasing, but it is still "meaningful." Indeed, unlike ordinary language, music thrives on the violation of rules. Linguistic validity is usually all-or-nothing; musical validity is more a matter of degree.

And what of musical styles? Are they dialects? If George Washington were alive today, he would have no trouble comprehending American English. He would sometimes find the things people say strange, but their sentences would make perfect sense grammatically. However, with his ears

attuned to marches and minuets, he wouldn't have a clue how to regard Debussy, let alone Bartók. If music has a grammar, is it really so flexible that it can be radically transformed in the course of a few generations and still be understood? Spoken language could not possibly evolve so quickly, and its grammar is notoriously resistant to tampering.

Translation is another problem. Almost anything that can be said in Arabic can be faithfully translated into Chinese or Finnish or Navajo. Can everything "said" by a Beethoven symphony be translated into country and western or Motown? It doesn't seem so. In language, meaning is largely distinct from dialect. But in music, meaning appears to be partly embodied in the idiom of its expression.

Another way music diverges from language is its use of multiple voices. If a lone melodic line constitutes a complete musical statement, then shouldn't four lines overlapping in a fugue be equivalent to four simultaneous conversations? Research has affirmed that we cannot possibly follow several lines of speech. Yet music poses no particular problem. When tones overlap, we hear chords. But when words overlap, there is only confusion.

None of these objections bode well for the idea that music descends from language. Language is a sharply defined phenomenon. We show every sign of long evolution to support it, with specially designed mouths, throats, and respiratory systems, and well-defined centers in the left brain. Consequently, all human beings display a high level of competence in speech. But our bodies display no obvious specializations for music, and competence varies immensely. Most significant, few people generate musical expressions in the way that everyone constantly generates sentences. If music descends from language, why are we so mute?

Despite the weak link, parallels between music and language are still very much a topic of research. The reason is that both language and music are founded on *generative* hierarchies. These hierarchies start from a *surface structure* consisting of patterns of notes or words that make melodies or sentences. In the levels beneath, relations among the surface patterns, and relations among such relations, extend downward in increasing abstraction. At bottom resides a hierarchy's *deep structure,* a stripped-down representation of fundamental properties. It is at these deepest levels that we under-

stand and remember and reason. And it is from these quintessential representations that we generate further surface representations, whether improvising on a guitar or telling a story.

Since the late 1950s, the generative grammars proposed by Noam Chomsky have dominated linguistic theory. Chomsky has described many of the rules we use when we represent an understanding as a sequence of words. We might say "Jack played the guitar" or "The guitar was played by Jack," using different rules to generate different surface representations of the same deep structure. The choice of rules is particular to the language you speak, such as English or Swahili, and, according to Chomsky, such rules draw on a universal grammar from which all languages spring and no language can go beyond. Although this universal grammar has so far defied full description, Chomsky believes it is hardwired into our brains, the result (presumably) of hundreds of thousands of years of evolution.

Curiously, a sort of generative grammar was devised for music a half century before Chomsky set to work. The German musicologist Heinrich Schenker analyzed music from its surface to its presumed deep structure, and concluded that every "good" composition ultimately derives from the notes of a single underlying chord that forms the deepest tonal center. The entire composition becomes essentially an elaboration and prolongation of that chord. The hidden transformations of this chord become music's background, its *Ursatz,* from which all surface notes are ultimately generated. While Chomsky devised forking diagrams that explain the structure of spoken phrases, Schenker drew up scores with an extra staff for the *Ursatz.*

Schenker believed that a kind of universal grammar restricts what music can be, and that he had discovered rules of that grammar. But music is so much more flexible than language that his claim is far weaker than Chomsky's. His theory was based on the study of hardly a dozen great composers, almost all German. And it is almost entirely a harmonic analysis, with scant consideration of rhythm. While Chomsky's linguistics can readily be adapted to Old English or to Javanese, Schenker's analysis is flummoxed by medieval European music, not to mention Indonesian gamelan music.

In the final analysis, these two pioneering theoreticians had quite dif-

ferent concerns. Chomsky's work centers on the analysis of individual sentences. It falters when meanings are implied by preceding sentences, or embedded in the circumstances of conversation. Schenker approached music the other way around, focusing on the structure of whole compositions and paying little attention to the workings of individual melodies and rhythms. His disciples have since attempted to address these shortcomings by crediting the listener with a culture-bound "lexicon" of musical devices. But the difference in the two approaches remains, further attesting to the incongruity of music and language.

## Mapping Music in the Brain

It's clear that linguistic analysis can't be of much help in establishing a link between music and language. Happily, neuropsychology offers another avenue of approach. Many aspects of language are highly localized in the brain. When damage occurs to language areas and language fails, we can look to see if music fails too. Conversely, when musical skills vanish through neurological misfortune, we can observe the well-mapped language areas and find out if they are intact.

This strategy would be elegantly straightforward if only *anything* having to do with brain function were elegantly straightforward. But as we'll see, it's often hard to figure out what has gone wrong in a brain. And analysis is further complicated by the ambiguity of *lateralization*—the distribution of functions between the hemispheres.

Lateralization manifests itself as physical difference between the two sides of the brain. At front, the brain is significantly larger on the right side in areas concerned with emotional response. At the rear, it is the left hemisphere that is enlarged, primarily to make more room for structures concerned with language. Lateralization is apparent in more than just gross anatomy. The thickness of cortex may vary between parts of the two sides. And there can be substantial biochemical differences between the hemispheres, so much so that psychoactive drugs may favor one hemisphere. Lateralization also extends to certain inner brain structures.

A good deal of nonsense about brain lateralization has appeared in the popular press in recent years, usually along the lines that the left brain is

coldly analytical and the right brain mystically intuitive. Such descriptions typically extol vast untapped potential in the supposedly underutilized right brain. It's suggested that if you are a "right-brain personality," untold genius may be lurking within. Such descriptions are naive in the extreme, being predicated on a misconception of what lateralization is all about.

Central to the idea of lateralization is the notion that each side of the brain dominates certain activities. But dominance does not mean absolute control. Neither side of the brain holds exclusive sway in any function. The left brain scores higher than the right on various language-processing tasks. It's 90 percent better at recognizing words, and about 70 percent better at identifying meaningless syllables or backward speech. Conversely, the right brain scores higher on certain musical tasks, although the disparity between the two hemispheres' abilities is less pronounced than with language. The right brain is about 20 percent better at identifying melodic patterns, and merely 10 percent better at recognizing non-speech sounds like laughter or animal calls. Although language is nearly always significantly lateralized, many subjects show no lateralization at all for music. So it is flatly wrong to conceive of music as channeling exclusively to the right brain and language to the left. Both sides are kept busy by any kind of task.

Although processing is shared between the two hemispheres, some functions are so strongly lateralized that only one side of the brain can manage them on its own. Proof comes from the famous "split brain" patients who have had the bridge between the two hemispheres (the *corpus callosum*) severed to counter debilitating epilepsy. In one case, a seventeen-year-old patient was tested shortly before surgery and found to evince the usual left-hemisphere superiority for speech sounds and right-hemisphere superiority for tones. After surgery, the left brain showed itself nearly incapable of identifying tonal sounds at all, while the right brain had become equally inept at identifying speech sounds. Results like these indicate that much processing, as of vowel sounds in the right brain, is useful only when it can be shared with the hemisphere it subserves. And so very little is left of language following severe left temporal lobe damage, and very little remains of harmony and melody perception following right temporal damage.

Perhaps the most useful generalization about the roles of the two sides of the brain is that the left brain is particularly concerned with modeling relations between events across time, while the right brain favors relations between simultaneously occurring events. In its role as a temporal sequencer, the left hemisphere specializes in not just the grammatical transformations of language, but also trains of analytical thinking, successions of complex physical movements, and the perception and generation of rhythmic patterns. All these abilities unfold over time. In contrast, the right hemisphere is expert at modeling spatial relations, body position, and the relations among concurrent sounds, including musical chords. These skills focus on assembling pieces into an instantaneous whole.

This dichotomy is clear in left-right preferences for music processing. In earlier chapters we've repeatedly encountered music-processing tasks that are favored by one side of the brain or the other. We've seen that harmonies tend to be better recognized by the right hemisphere and that rhythm is favored by the left. Both skills are roughly centered in the same areas of temporal cortex, although harmony is much more strongly localized than rhythm.

We've also seen that formal music training encourages analytical perception of music, analysis in which musical elements are related through a hierarchy of sequences. This sort of analysis is the specialty of the left brain. So it is not surprising that professionals tend to be left-dominant for tasks that non-expert listeners handle mainly in the right brain.

Interestingly, dominance in melody processing goes to the right hemisphere, despite the fact that melodies unfold across time and thus might be considered just the sort of serial process for which the left hemisphere is specialized. The right brain is not unaware of temporal relations, but merely inept at modeling them in complex hierarchies. It can compare a melody's notes even though they do not occur simultaneously, sustaining harmonic relations for the fraction of a minute needed to trace the shape of a melodic contour. But when melody appears as a long thematic development spanning many minutes, it is the left brain that dominates (provided it is well enough trained to know how).

Recall that a melody's notes are largely perceived as offsets not from

each other, but from an underlying tonal center. Melody is a *harmonic* phenomenon. Even with simple melodies, the right-brain advantage disappears when non-harmonic melodies are encountered, as in some contemporary music. Nor does the right brain show any particular talent for melody when it encounters an unfamiliar harmonic system, such as Indian sitar music.

Note that nearly all research charting the brain's musical behavior has been performed on Western subjects, usually well educated, and using musical examples from the so-called common practice period of Western music (eighteenth and nineteenth centuries). No one knows how differently the brains of an average Indonesian or Nigerian might function listening to their own music—if indeed their brains would function differently at all. This is to say that no one knows the extent to which music lateralization is conditioned by experience. Because brains are so idiosyncratic in their behavior, effective studies require large data samples from many subjects. The opportunity for such research is fast disappearing as cheap electronics take Madonna and Michael Jackson to remote villages across the globe. Soon there will no longer be human beings who have not been substantially exposed to the Western harmonic system and the Western way of structuring music.

On the whole, too much is made of lateralization, if only because some perfectly normal individuals are hardly lateralized at all. There's more to be gained by understanding the parceling of the brain from front to back, and from center outward, than from side to side. Besides, most of the cognitive skills of which we are most proud and most want to understand are hardly localizable in any sense. They are achieved by momentarily bringing together various brain modules designed for low-level processing of various sorts, modules that a moment later may be assembled in a different way for different ends. We can point at a scan of a brain analyzing simple chords and say, "There!" But there is no lone brain center for following counterpoint or phrasing or large-scale form. We possess a brain module for harmonic analysis because tens of millions of years of natural selection favored a brain that could make sense of animals' calls. We lack

a module for counterpoint because it is an entirely artificial experience for which we could not have evolved.

## Watching Music in the Brain

If we're to discover brain modules devoted to high-level musical relations, and to compare them with modules concerned with language, we need a way of watching the brain as it processes complex sound. Brain scans would seem to fit the bill. You can hardly open a magazine these days without encountering one of these brightly colored pictures of a brain in action, glowing crimson where the brain is most active, pitch-black where it appears idle. Neuroscientists joke that soon they won't be able to publish anything that is not accompanied by a scan or two. People want to *see* the brain at work. There's something about the fiery colors that suggests a gleaming soul, as if at last we can step back and regard ourselves. Yet scans oversimplify and mislead.

To understand exactly what scans show, it's worth a quick look at how they are made. There are a number of technologies, but all scans concerned with brain function (as opposed to anatomy) measure how much biochemical energy different parts of the brain consume as they carry out particular cognitive tasks. So most scans monitor the consumption of blood sugar—*glucose*—across the cortex. In *positron emission tomography* (PET) scans, a minute quantity of radioactive substance is introduced into the subject's bloodstream, and this radiates outward from the brain, more where capillaries dilate to increase glucose supply, less where the brain is relatively inactive and little glucose is required. A second imaging technique, *functional magnetic resonance imaging* (fMRI), uses powerful magnets to cause hydrogen atoms to emit radio waves whose density varies with cerebral blood flow.

All scans require that a ring of sensors surround the subject's head and that the subject remain very still while the scan is made. It's a bit like early photographs, for which subjects had to stand like statues while the shutter was open. This means that scans report a composite of some seconds of brain activity. An activity that begins in auditory cortex, then taps the

parietal lobes, and then calls on the frontal lobes, appears with all three regions glowing together and no record of the sequence of activation. Spatial resolution is not much better. Because every part of the cortex radiates in all directions, the ring of sensors is struck by a blur of information. Computers work miracles making sense of this data, but the results are coarse. Ideally, scans would track the performance of tiny slivers of cortex, but they cannot.

Scans look a lot like photographs or X rays, and it's easy to forget that they are actually drawn by computers. A computer builds a three-dimensional map of the brain, assigns arbitrary colors to the various levels of glucose uptake, then draws a representation of the brain from the desired perspective. In doing this, all sorts of adjustments must be made. For one thing, most brain images represent an average of a number of trials. This is necessary because the brain varies its response to the same task, partly in response to recent experience, partly because the brain is a chaotic system, operating more like a raging river than a Swiss watch.

In another adjustment, the computer removes the brain's background activity from the scan. This is done by taking shots of the subject's brain at rest and subtracting the recorded levels of glucose uptake from those measured when a particular cognitive task is scanned. Finished scans give the impression that most of the brain is idle much of the time, as if only the auditory cortex is busy at one moment, only the visual cortex at another. Actually, the entire brain is constantly at work (it consumes nearly a quarter of all the calories you eat). So the brightly colored regions of scans are merely areas of heightened activity. The red herring here is that by showing only areas of relatively high activity, we're led to assume that functions are entirely lateralized, when in fact there may be only a slight preference for one hemisphere over the other. The degree to which activity on both sides of the brain is represented in scans depends on how the computer is instructed to draw the brain.

Finally, the computer fits the adjusted data to a standard brain model. All brains differ in size, in relative proportions, and in their pattern of furrows. In order to compare scans from different brains, they must be fitted to a common mold. This is no simple matter. Some kinds of scans

only show where activity is occurring in the head without providing an image of the brain. So often a scan showing brain activity must be combined with a different kind of scan showing brain anatomy. Even then, the precise localization of functions varies from individual to individual.

All this means is that a scan is more a portrayal of brain function than a picture. Music flies by as the data used to fabricate scans trickles in. Vast amounts of brain activity are averaged into single blobs of color.

Scans can also be misleading in a more subtle way. A number of studies have shown that brain activity sometimes *decreases* when highly intelligent people are given a "brain-teaser" to solve. It is the *less* intelligent who knit their brows and burn up lots of glucose. So the intensity of glucose uptake is not necessarily a measure of comprehension. This is not to suggest that Einstein's brain was in perfect repose as he did his calculations. But it does mean that there are problems in comparing skilled and unskilled responses to the same stimulus. That highly trained musicians show commensurately more left-brain activity in processing music does not mean that the right-brain is slacking off. While the average listener's right brain struggles with complex chords, the professional's right hemisphere might make easy work of the chords and thereby consume less glucose. So brain scans displaying larger blobs of fiery red do not necessarily indicate superior comprehension.

Although there's a good deal of work under way today to improve the quality of scans, much work in music perception has focused instead on the *evoked potentials*—"brain waves"—measured by electrodes placed on the scalp. Traditional electroencephalograms (EEGs) take readings from only a few points on the head. But modern techniques array a dense grid of electrodes over the entire skull. The resulting flood of data is fed through computers to ferret out subtle responses to discrete musical events. This approach surpasses scans in temporal resolution, resolving changes in average electrical activity at the same clip that notes shoot through a brain. But there's a commensurate decline in spatial resolution, since readings reflect average electrical activity over a relatively large swath of cortex.

Lacking any entirely suitable technique for observing the brain in action, all mappings of brain function should be taken with a grain of salt. To point to a crimson patch on a PET scan and say, "Grammar is here,"

or "Absolute pitch is here," is like pointing to China on a globe and saying, "Buddhism is here." Buddhism is indeed centered in China, but so is acupuncture and scroll painting. Pointing to China tells you almost nothing about the nature of Buddhism. Similarly, scans do a wonderful job of showing the general distribution of functions. But they are poor tools for elucidating exactly how the brain works.

## Amusia

Fortunately, neuroscientists have one more ploy for understanding how music relates to language and whether music's meaning arises from the same parts of the brain as linguistic meaning. Before the invention of brain scans and other techniques for probing the working brain, neuroscientists faced a seemingly insurmountable quandary. Their only access to the most protected of all bodily organs was by surgical mayhem, which is acceptable only for non-human subjects. Yet the brain function of humans is so drastically different from that of any other animal that even the most invasive research on animals yields little of interest concerning a brain's most complex activities, such as language or music. In the early days of neurological research, the most informative animal research entailed removing selected portions of cortex, healing the animal, and then assessing the animal's performance in carefully prepared tests. It's not the sort of experimentation for which many human subjects would volunteer.

Nonetheless, nature cruelly provides neuroscience with unwilling human subjects. Every year, millions of human beings lose fragments of cortex through strokes or accidents or gunshot wounds (trench warfare was an especial boon to neuroscience). Such random damage is not always useful for scientific inquiry, but sometimes it is confined to particular areas of interest.

When a brain is maimed in a way that interferes with musical skill, the victim is said to suffer from *amusia* (*a*-music like *a*-tonal). Neuroscience offers many such terms: aphasia for the collapse of language, alexia for the inability to read, apraxia for movement disorders. "Amusia" is perhaps the least specific of all such syndromes, referring to any upset in perceiving, comprehending, remembering, reproducing, reading, or performing mu-

sic. Neuroscientists feel uncomfortable with so broad a definition, but it reflects the generality by which music operates in the brain. Unlike language-robbing aphasia, which generally arises only from damage to a few sites in the left hemisphere, amusia may stem from damage to many parts of the brain in either hemisphere.

Amusia is as complicated as music itself. In earlier chapters we've witnessed a brain sense, perceive, analyze, associate, remember, plan, produce, originate, and notate each aspect of music, whether harmony, melody, meter, or larger form. Each of these aspects is a potential target for amusia. In rare instances, amusia can rob its victim of just a sliver of musical experience, chipping away at long-term memory for melodies, for example, or the ability to identify particular timbres. Far more often, amusia swoops upon a brain like Horsemen of the Apocalypse, obliterating most or all musical experience, often as part of general neurological calamity.

Oddly, amusia often goes undiagnosed. When a human being is stricken by aphasia and can no longer speak, everyone notices and everyone cares. But for most of us music is a private affair. If music abruptly begins to sound like only so much grating and squeaking following a stroke in old age, the problem may be attributed to failing hearing or mere loss of interest. Except in rare cases where amusia appears in musicians or composers, it is invisible, just as music listening is invisible.

Neurologists draw a line between the *receptive amusia* of jumbled listening and the *expressive amusia* of dislocated performance. A victim of receptive amusia can have trouble following pitch contours, hearing chord structure, identifying instrument sounds, or remembering melodies or rhythmic patterns. A victim of expressive amusia may readily enjoy all these aspects of music, but fails utterly when asked to reproduce them by singing or tapping. In either case, neurologists must struggle to figure out exactly what has gone wrong. Is someone deaf to melodies because tones are no longer heard, or is it a problem of linking tones together? Does someone fail to sing a favorite tune because memory refuses to produce the notes, or is the problem in forming words?

Pity the poor neurologist who must make sense of all this. Amusia is most illuminating about the nature of music when it occurs apart from

other kinds of brain damage. But this rarely is the case. And since amusia is often accompanied by aphasia, its victims may not be able to report what has happened to them. In any case, few amusiacs possess the training necessary to analyze their own musical experience and explain it to others. And so, in the end, neurologists are left with a very small number of "useful" cases of amusia, mostly among musicians. Research tends to be anecdotal, and individual cases are hard to compare.

We've seen in earlier chapters how, in most people, the right brain favors the analysis of harmony and melodic contour, and the left brain shows special talent for processing rhythm. Auditory brain damage tends to afflict only one side of the brain. It is the rare accident that damages both temporal lobes without destroying all between and killing the victim. So there tends to be a broad distinction between *amelodia,* the loss of right-brain melodic skill, and *arhythmia,* the loss of left-brain rhythmic skill. Of course, harmonic skill is also right-dominant and suffers along with melody. But harmonic ability is harder to assess. While anyone can hum a tune or tap a rhythm, few amusiacs know how to produce harmonies. Thus the loss of harmonic ability is barely studied, but is assumed to disappear along with melody. Our reliance on words to remember melodies further complicates analysis.

Even harder to get at are the added dimensions of musical perception that training endows upon the left hemisphere. For example, we saw in Chapter 3 how professional musicians are so analytical in their perception of melodies that the left brain becomes dominant. In principle, a victim of left-hemisphere damage could lose this skill and revert to simple, right-brain contour listening. The patient would be amusic, but would be unaware of any change except a general decrease in musical pleasure.

Amusia can work its deeds from the lowest levels of perception to the highest levels of musical analysis. When damage occurs near the top of the hierarchy, musical life may largely remain intact. When damage occurs at the bottom, nothing may be left to build on and musical experience can be utterly obliterated. In the worst case, primary auditory cortex is shattered. When visual cortex at the back of the skull is destroyed, the victim is left completely blind even though the eyes continue to function. An

equivalent deafness arises from damage to primary auditory areas. The ear "hears," but the brain does not.

True amusia begins with damage to secondary auditory cortex. Sometimes the problem is in assembling the parts of a sound so that even slowly changing sounds blur. In other cases, individual sounds are distinctly heard but can't be identified. If the sound is a spoken word, it may appear as if from an unknown language. If the sound is environmental, whether the whoosh of water or the clatter of dishes, it may be impossible to recognize. And if the sound is musical, the listener may be unable to peg it to a particular instrument. These are instances of *agnosia* (pronounced *ag-noshia*), a state of impaired knowing. Typically, agnosia for the sounds of language arises from damage to the left brain, and agnosia for environmental and musical sounds from the right brain. But the distinction is often clouded.

In another form of musical breakdown, the victim goes on possessing all the low-level skills required for musicianship, but can't pull them together. One professional musician underwent surgery for protracted pain and depression, with removal of parts of the cortex surrounding the bridge between the two hemispheres (a *cingulotomy*). These structures are closely tied to the frontal lobes which, as we saw in the last chapter, are essential for carrying out long sequences of activity. Not surprisingly, the musician lost the ability to follow through on any kind of musical performance, even though all the component skills remained intact. She could no longer play her instrument, learn new pieces, improvise, compose, or read scores. In fact, she could no longer even *listen* to music, for this too requires an elaborate organization of anticipations. Most tellingly, the patient also complained that she could no longer participate in conversation, or follow stories, or play games like chess and gin rummy. She had suffered a global loss of self-organization. Her case demonstrates how music can require our highest intellectual abilities, and how music must share parts of the brain with other activities.

Music can also fail when emotional life is quashed. This happened to a professor of music who suffered a massive right-brain stroke. With left hemisphere intact, he retained his intellectual abilities and soon returned to teaching, conducting, writing books, and studying new languages (al-

though partial paralysis undermined his skills as a performer). Yet musically he was a broken man. As we'll see in the next chapter, the right hemisphere is particularly important in emotional life. With such extensive damage on this side of the brain, the professor lost pleasure in music, and complained that his conducting lacked verve. To make matters worse, the damage extended into parts of the right parietal lobe essential for spatial reasoning. The professor could no longer use perspective when drawing, and he constantly became lost in his hometown. Similarly, he had trouble laying out music on a page, and he couldn't manipulate musical devices that many composers conceive spatially, such as complex meters and elaborate interplay of voices. The professor found that his musical experience was trivialized, that his brain could no longer model high-level musical relations. He wrote,

> The compositional process for me at this time seems to lack a Gestalt. Notes are correct, orchestration skills are very much intact and show no diminution. Content, however, is dull, lifeless (soulless). Since the compositional process has for me been one of working at several levels of the on-goingness of the melodic, harmonic, rhythmic flow simultaneously and keeping track of the various factors, I find that I am not able to maintain a thread of continuity and must work in small segments which, while appropriate and significant in themselves, do not interrelate with each other.

History's most eminent amusiac was the composer Maurice Ravel. He was fifty-eight when progressive left-hemisphere damage wiped out an area of the cortex where the temporal lobe meets parietal cortex. The ultimate result was *Wernicke's aphasia*, a syndrome that allowed him to continue hearing and speaking words perfectly, but which robbed him of the ability to understand how words fit together in sentences. Ravel's ailment first announced itself through spelling errors in his letters. Soon he could neither read nor write—he had become *alexic*—although spoken language was fairly well preserved for a while. Inevitably, his problem spilled over into composition. The musical patterns of the right brain could no longer be

translated into musical symbols by the left. After two futile months trying to begin a new opera, Ravel lamented to a friend that it would never be written, and he passed the last four years of his life unproductive and miserable.

Strangely, Ravel was still able to work on his opera, but only in his head. He had lost the complex skills required to objectify musical imagery and convey it to paper. Music that had long resided in memory was similarly incarcerated. He could sing or play only a few bars even of his own compositions. The problem was not one of physical control. Ravel could still play any scale up and down a piano keyboard. Nor was memory a problem, for he continued to point out subtle errors when his own music was played to him. Rather, like the college professor we considered a moment ago, Ravel had suffered a blow to the high-level skills that sustain complex activities over long periods. This ability may be the trait that most distinguishes us from other animals. So poor Ravel lost much more than his profession.

By all rights, amusia ought to arise primarily from damage to the right hemisphere, which is the center of tonal perception. But amusia hardly ever occurs without some loss of language skills. In fact, many neurologists long believed that amusia was a left-brain phenomenon, so strong is the link with aphasia. In a case like Ravel's the link is clear. Left-brain analytical structures subserving language are brought to bear in performing and writing music. Destroy those structures and both language *and* music suffer.

But how can amusia-causing *right-hemisphere* damage also take a toll on language? One reason is that the two temporal lobes communicate fiercely, and failure on one side can make the other stumble. But there are also aspects of language that rely on the right brain. The perception of vowel sounds is one example we've already encountered. The right brain also plays a part in the high-level reasoning that underlies grammatical statements. Thus the right-parietal damage sustained by the music professor rendered him unable to follow complex conversations.

The strong link between amusia and aphasia has been taken by some as proof that music is an outgrowth of language. But there are a number

of cases of amusia on record that are entirely free of aphasia. Conversely, there are many cases of aphasia where there is no amusia. In psycho-parlance, the two phenomena are *doubly dissociated,* with neither necessarily leading to the other. This fact leads other theoreticians to suggest that music is entirely independent of language. Convinced that our brains are specially wired for language, some even argue that our brains must also be specially wired for music, that somehow human beings have *evolved* for music (we'll ponder this notion in the next chapter).

One shortcoming of this controversy is its lack of a stable definition of "music." Our brains clearly have a propensity for some sorts of musical activity, such as hearing chords. But other musical activities are just as obviously forced upon a brain by training. This is equally the case of language. We readily learn to speak, but reading and writing are artificial activities civilization has imposed upon our neurology, and skill varies much more than for speech. So Ravel's left-brain "amusia" is for a kind of musicality quite different from the college professor's right-brain "amusia." It's plain that even universal skills like perceiving melodies involve a more natural right-brain dominance for contour perception, and a training-based left-brain dominance for interval identification. Analysis is also complicated by the fact that individuals encode certain kinds of high-level information differently. One person might remember a chord as an aural image, another as a visual image, another by its verbal name.

It seems that there can be as many origins of amusia as there are brain regions that participate in perceiving or making music. Low-level skills tend to favor the right temporal lobe; higher-level skills, the left. But highest-level musical skills may make use of structures on either side of the brain, structures applied sometimes to music, sometimes to language, and sometimes to a host of other undertakings. All in all, the cerebral setup for music is far more diverse and changeable than that for language.

Does this mean that music is not founded in language? In the final analysis, the answer depends as much upon what you mean by "language" as upon what you mean by "music." Clearly, music does not symbolize human experience in the way language does. If the two have a common bond, it must be in their generative nature. Yet as we've seen, generative

theories of language and music don't have much in common. We've turned to neurology for help, seeking cortex that serves both language and music. But we've found that the deeper levels of understanding at which music seems most "meaningful" are the least distinctly mapped. Moreover, language areas themselves have proven to be less certainly mapped than brain scans imply. As language invisibly blurs with "thinking" and "understanding," its neurological underpinnings become as ambiguous as music's. Parts of the left hemisphere that many neurologists think of as "language areas" also light up in brain scans that monitor different sorts of activities, such as the sequencing of body movements—activities which are themselves generative processes. Since we cannot say precisely where either music or language begin and end, the link between the two is made even more obscure.

## Musical Meaning

We shouldn't be surprised that music bears so little resemblance to language, either in form or in neurology. After all, language is devoted almost entirely to representing the contents of the world, something music hardly ever does. Rather than portray events in the world beyond our skin, music seems to reenact experience *within* the body. This idea is familiar in the adage that music is a "language of the emotions." But music seems to go beyond emotion, since much of its pleasure derives merely from perceiving patterns. How such patterns reflect our inner experience may tell us much about music's meaning.

Consider the patterns found in "The Pink Panther," which we've analyzed in various ways in earlier chapters. Figure 9.1 interprets some of these patterns. What sort of meaning do they embody? Most people wouldn't regard this as highly "emotional" music in the sense that it transports us to emotional extremes like exuberance or melancholy. Somehow it moves us, but not to wrenching extremes.

One way of regarding this tune is as an imitation of a panther stalking its prey, first tentatively tiptoeing, then suddenly freezing, then diving for cover. Someone hearing this tune for the first time, without knowing its title or the animated character in the opening titles of a Peter Sellers movie,

Panther creeps.................................freezes...dives for cover

*Fig. 9.1. Representation of stealth in ''The Pink Panther''*

probably wouldn't guess that it accompanies the antics of a feline biped. But that person might very well say that the music "creeps along." Is "The Pink Panther" an example of program music, music that represents patterns of animal motion just as Debussy's *La Mer* represents crashing waves? Or does the music embody something more abstract—the quintessence of stealthiness perhaps?

One characteristic of stealthy behavior is the change in timings of bodily movements. Normally we move along continuously and regularly. But in stealth we alternate between restrained motions, sudden bursts of speed, and no motion at all. All these characteristics can be interpreted as variations of timing, which is to say that stealth is primarily a *rhythmic* phenomenon. Stealthy patterns of timing can be experienced in a number of ways. We can feel these timings in our bodies when we creep up on something, or see these timings in a panther's movements as it stalks its prey, or hear these timings when something approaches us in the dark. However, rhythm is not the only aspect of music at work here. Harmony lurches into dissonance to mimic the panther's sudden alarm. Rising dynamics reinforce this effect. So does melodic contour.

Can we say that stealthiness is the "meaning" of this tune? Not in the sense that the music symbolizes stealth in the same way that an arbitrary collection of spoken sounds symbolizes them. This music *mimics* stealth; it doesn't *name* it.

In the early days of film before the advent of talkies, pianists would accompany the events on screen, working from a "fake" book filled with themes purported to describe a particular mood or activity. Some themes were overtly emotional, such as "anger" and "consolation," but others represented what we would think of as physical activities such as "climb-

ing" and "hard work," and some represented feelings that seem neither emotional nor functional, such as "confusion" and "weariness." Such music is by definition *programmatic*—it is written to represent something happening in the world. And because of the way such music is employed, we tend to listen to it programmatically: we watch the villain fall from a cliff and the accompanying music sounds like falling; we see a panther creep along and the music sounds like creeping.

But programmatic music does not lose all meaning when we hear it on its own without knowing what it is supposed to represent. And the meaning we discover is likely to correspond to the composer's intentions. Within a particular musical tradition, no one would interpret a theme titled "Grief" as being joyous. Asked to guess the music's intended meaning, we might overlook grief, but would surely settle on something grief-like, something full of internal strife and pain, such as "agony" or "dying." A title seems not so much to define a composition's meaning as to define its meaning more precisely. It tells us what kinds of anticipations will be rewarded by the piece, and so helps us listen to it more successfully, particularly on the first hearing.

Then why not name all compositions? Clearly, because we do not have words for everything music has to say. Mendelssohn put it this way:

> *People often complain that music is too ambiguous, that what they should think when they hear it is so unclear, whereas everybody understands words. With me it is exactly the opposite. . . . The thoughts that are expressed to me by music I love are not too indefinite to be put into words, but on the contrary too definite.*

Mendelssohn's observation brings us back to the question of how music relates to language. Language describes the world about us with great precision. It provides names for tens of thousands of phenomena that we can readily observe with our eyes and ears. But language is extremely crude in describing our interior feelings—not just of mood and emotion, but of all the bodily sensations we experience as we move through the world.

Language is impoverished in this way not because human beings

haven't cared to express their interior life. We've been composing poetry for millennia, trying to squeeze more meaning out of the languages at our disposal. The problem is that most internal events are structured differently from most external ones. Think of what it is like when someone is "embarrassed" or is "in a snit" or is "being sociable." It is all but impossible to subdivide such experiences into constituent elements. Every sensation continuously melds and flows into another. There are few well-defined starts and stops, few "edges." The interior world of feelings does not consist of *things* arrayed in particular positions in space and time. Rather, it is a world of *turbulent flow*, where diverse intentions course through the channels of our nervous systems.

Because turbulent systems lack stable subdivisions, we can't point and say "that is a *blah*," for a moment later the *blah* will become a *bleh*, and then a *pleh*. We're able to reduce interior experience only to broad categories that are stable enough to deserve a name like "wrath" or "whimsy."

Significantly, when we encounter turbulent flow in the world outside our bodies, we can't describe it with language either. Most of us would do pretty well describing the design of a house. But what of the swirling patterns of water in a stream? We'd be hard put to effectively describe even the patterns of one moment, let alone an ongoing flux. If forced to make a representation of a stream, we would abandon language and would draw pictures instead, preferably a continuous animation. And when someone asks us to describe the stream, we would explain that verbal description isn't up to the job, and instead would simply show the animation.

It's just the same for music. Music mimics experience rather than symbolizes it, as language does. It carefully replicates the temporal patterns of interior feeling, surging in pitch or volume as they surge, ebbing as they ebb. It leads opposing forces into battle and then to reconciliation. Or it just moves in interesting ways. Because music can bring only a few parallel voices to its portrayal of such complicated events, it greatly simplifies the experience it mimics, drawing outlines that are only occasionally filled by a dash of orchestral color. The composer's challenge is to pinpoint these outlines amidst swirling experience.

It's important to recognize that music represents many kinds of interior

feelings, not just overtly emotional ones (we'll consider the nature of emotion in the next chapter). It can mimic not just the panther's fury, but also what the panther feels as it walks or jumps or climbs. This is accomplished by replicating the rhythms of such motions, by modulating harmony to imitate the body's stresses and releases, and by making melody follow the geometry of physical actions.

But what of musical motions that are less well defined? A Bach fugue usually sounds like only so much slinking around. It moves, but not in a familiar way. Yet we are still able to partake of its motions. How can this be? Ultimately, our feelings, including the feelings that arise from physical activity, must be reducible to a vocabulary of underlying processes. As we saw in Chapter 7, neurophysiologists have a terrible time formulating descriptions of even simple body movements. No one has yet isolated the brain circuits for even the most basic motions, the twists and prods and leverings that are combined into full-fledged behaviors like climbing or running. In so far as music can model these processes, it can assemble "movements" (as they are called in a symphony) of any kind, describing a scurrying centipede at one moment, a soaring dove the next, and then a beast that has never existed. And so music can show us what it's like to dive like an osprey or bound like a kangaroo, or for that matter, what it's like to melt or spin or blossom or explode.

If music describes essential mental processes, then shouldn't all human beings have an intuitive understanding of the music of all cultures? This question would seem to pose a challenge to the view of musical meaning presented here. But as we've seen in earlier chapters, music always exists as a confined system of relations, of conventions for how melodies and harmonies and rhythms are to be composed. Certain elements imply other elements, and so force the mind toward the anticipations that let us perceive large musical structures. Without such a system, any musical event would be equally probable at every moment and we would forever be in the position of a child learning to hear music for the first time. So music's meanings, its motions and emotions, must necessarily be expressed through the devices of musical custom, and will be perceived only by those steeped in those customs. Whether particular musical systems are inherently better

than others at expressing certain kinds of interior experience is an open question.

What would this mean for the Phyxians as they try to make sense of the Bach fugue that happens upon their planet? In order to have any chance at all of comprehending it, they would first need to accustom themselves to our scale system and the basic harmonic relations built upon that system. Prolonged exposure ought to do the job. A harder problem would be dealing with the stylistic conventions of the music. A Bach fugue requires the anticipation-generating memory of an expert listener, a memory shaped by long experience. Without it, a Phyxian wouldn't know the style's probabilities, and so wouldn't make the necessary anticipations, and so couldn't experience the meaning-laden violations of anticipations. The Phyxian would experience only a long stream of individual notes and none of the fugue's deep structure. But how can a Phyxian come to understand the probability relations of an entire musical culture from only one piece? It's hard to imagine.

But let's assume that the Phyxians are very clever and manage to deduce many harmonic and stylistic rules from this one fragment, much as a paleontologist reconstructs a dinosaur from a single bone. And let's say they devise artificial examples of the alien music and listen again and again until perception becomes automatic. What would they then *understand*?

Oddly, it is at the highest levels of music comprehension that the Phyxians might have the best chance of success. For they surely would have generative minds themselves. Space and time are, well, *everywhere* and *always*. And so everywhere and always, intelligence ought to consist of the same sorts of cognitive skills. No matter where it is found in the universe, an intelligent mind will model as much as it can of objects in space and of events across time. Moreover, a mind will have to do this through generative hierarchies, partly for succinctness, so that a brain can be relatively small and energy-efficient, and partly because it is only in deep abstraction that the diverse contents of experience can be drawn together.

And so the Phyxians ought to be able to observe the patterns of a fugue once they've learned how to categorize and group its tones. Since their brains would control and observe their bodies just as ours do, they

also would experience an interior realm of "feelings," and they doubtless would share with us many patterns of movement. So once they've learned how to listen to Earth music, they ought to find much that is familiar in its patterns. That these patterns are not language-like and do not encode information about the world of their origin is to the Phyxians' advantage. As they listen, they need not wonder "What does that correspond to" as they would for the language sounds also found on *Voyager 2*'s platter. But would the Phyxians *really* understand this music? Would they grasp the fugue's expression of emotion? Would they find pleasure in what they hear? Might the fugue lead them, too, to ecstasy? These matters are the focus of the next and final chapter.

# 10

From sound...
...to tone...
...to melody...
...to harmony...
...to rhythm...
...to composition...
...to performance...
...to listening...
...to understanding...

# ...to ecstasy

Frances D. was having one of her crises. No sooner would she begin to move than her body would abruptly freeze like a statue, gluing her feet to the floor. Her eyes would lurch to left and right, then suddenly lock in an interminable stare. With lips pursed tight, she would grind her teeth uncontrollably against already raw gums. Sometimes she would find herself repeating the same word hundreds of times. On occasion her throat would close as if her body had forgotten how to breathe, leaving her to wait in red-eyed terror for relief that came as an explosive shriek. Those who tried to help were rebuffed: "Oh, oh, oh, oh! . . . Please don't . . . I'm not myself, not myself . . . It's not me, not me, not me at all."

Hers were particularly severe and gruesome symptoms of Parkinson's disease, a malady in which two tiny bundles of neurons at the brain's core fail in their job and intentions can no longer be reliably translated into actions. As the disease sets in, usually over the course of years, the patient

finds that he or she can no longer glide from movement to movement. Motions become inaccurate and jerky, can't get started, or won't stop once they've begun. The conscious mind goes right on *intending,* shouting out its commands. But a mutinous body refuses to listen.

Oliver Sacks tells the story of Frances D. in his marvelous book *Awakenings.* He describes her in her mid-sixties, an exceptionally intelligent and personable woman who battled her demon with rare courage. The causes of Parkinson's disease are obscure, but in this case the culprit was clearly a bout of encephalitis during adolescence. Though the worst of her crises were rare, Frances D. lived every moment of her adult life constrained by Parkinson's, as if harnessed to a phantom cart that one moment would lag, then would suddenly stop, then would shove her forward. There is no cure for this all too common malady, and some of the drugs that alleviate its symptoms can as readily worsen them.

Yet Dr. Sacks discovered an extraordinarily effective treatment for Frances D.'s symptoms—*music.* As he described it,

> One minute would see Miss D. compressed, clenched, and blocked, or jerking, ticcing, and jabbering—like a sort of human bomb; the next, with the sound of music from a wireless or a gramophone, the complete disappearance of all these obstructive-explosive phenomena and their replacement by a blissful ease and flow of movement as Miss D., suddenly freed of her automatisms, smilingly "conducted" the music, or rose and danced to it.

Sacks discovered that many Parkinson's patients responded to music this way. In fact, just the *thought* of music could do the job. One patient was able to "play" whole compositions by Chopin in vivid mental imagery. The moment she began, her grossly abnormal EEG (her "brain waves") would abruptly turn normal as her Parkinson's symptoms vanished. Just as abruptly, every symptom would return the moment her clandestine concert drew to a close.

Unhappily, music makes fickle medicine. The patient must be musically sensitive to begin with, and has to be in the right mood if the music

is to take hold. And it must be just the right sort of music. Sharp percussive rhythm can make a patient jerk like a marionette, while monotonous crooning proves too flimsy to do much good. Frances D. complained that she could not abide such "banging" or "slush." What's needed is moderately paced, *shapely* music played in flowing legato, music with a pronounced beat, but beat embedded in rolling melody.

Music can help a Parkinson's patient only when it is of a kind that suits his or her taste. Classical music might work wonders for one patient, while only country music touches another. This shows that music does not function passively as a medicine, but requires that the patient participate by generating a flux of musical anticipations, much as any good listener does.

Significantly, it is the fulfillment of anticipations that goes wrong in Parkinson's disease. As we saw in Chapter 7, the brain makes the body move not merely by shouting commands down the corridors of the nervous system, but also by anticipating the sensations that will result from those commands. We project a flux of such anticipations before us in whatever we do, testing them against incoming sensation. When the two mismatch strongly, we stop in our tracks much like a Parkinson's patient.

Consider this. When you sip a beer, you normally taste it only after anticipating its flavor. If someone has slipped you apple juice instead, you'll initially react with revulsion and the normally sweet juice will taste sour. Have someone (you trust) feed you different foods while you're blindfolded. The confusion and anxiety you'll feel shows how experience arises from the interaction of anticipation and sensation.

Everything we do, including grasping a moment of music, commences with a kind of fleeting hypothesis that is confirmed or disconfirmed; every subtle mismatch is countered by adjustments to the next anticipation. We perceive music only as well as we can predict what's coming, for to predict is to model the deep relations that hold music together.

Music's movement is more perfect than a body's. Physically, we fumble through a world of inelegant, discontinuous activity. For instance, it would be all but impossible to turn the act of cooking dinner into an artful dance. The motions are too varied and discontinuous. But well-crafted music creates the very world it travels through, meeting every anticipation

with a graceful resolution, and raising new anticipations at every turn. While physical movement is choked with starts and stops and stumbles, music establishes a continuous flux, and does it in perfect proportions. Good music hardly ever stops, and great music is all but unstoppable; the flux of anticipations is too powerful to be cut short without jarring a sensitive listener. And so the experience of music is an entirely artificial one, its qualities almost unknown in daily life apart from special moments when things come together just right. It is this perfectibility that makes music art.

From this perspective, it is easy to see how music momentarily reassembles the shattered motor systems of Parkinson's patients. Obviously, music doesn't repair the faulty neurons that give rise to the disease. Rather, music overcomes Parkinson's symptoms by transporting the brain to a higher than normal level of integration. Music establishes flow in the brain, at once enlivening and coordinating the brain's activities, bringing its anticipations into step. By so doing, music provides a stream of intention to which a Parkinson's patient can entrain his or her motions. Sacks writes of the "kinetic melody" that plays out in all our bodies as we move about the world, and to which Parkinson's patients have been struck deaf. Music briefly restores that melody, at least for those sorts of activities that are themselves flowing and "musical."

Sacks found that things other than music could also unshackle Parkinson's patients. Just the sight of someone walking was enough to liberate some from their frozen stance and get them moving. One patient explained that he would get about town by "hitch hiking" rides on passersby, watching their legs to make his own follow. The sense of touch also can do the job. An otherwise crippled patient found he could gracefully ride a horse by absorbing the animal's movements. Another would maneuver a sailboat by interacting with the motions of hull and boom. But in every case, the observed movements had to flow, had to be "organic." Mechanical movements inevitably led to disaster, as did those that entailed abrupt starts and stops, such as driving an automobile.

The magic that music works on Parkinson's patients is no different from the magic it works on us all. It lifts us from our frozen mental habits and makes our minds move in ways they ordinarily cannot. When we are

embraced by well-written music, we experience understandings that out-strip those of our mundane existence, and that usually are beyond recollection once the music stops (unless we recall the music itself). When the sound stops, we fall back into our mental wheelchairs.

To say that music makes our minds momentarily more capable is to say that it makes us more intelligent. This is not mere hyperbole. As we saw in Chapter 6, subjects who have just listened to Mozart do better on some kinds of reasoning tests than those who heard no music, or who listened to unchallenging popular music. Sacks tells of a severely retarded patient with an IQ below 20 (100 is average) who was able to perform multistep tasks only in the presence of music. By its careful design, music organizes a brain in a way that ordinary, chaotic experience cannot.

In this chapter we'll consider how music takes hold of us and why it is able to affect us so deeply. There are three important questions to consider. First, how is it that music elicits emotions from us? Second, how is it that music gives us pleasure? And third, what is happening in our brains when music leads us to the threshold of ecstasy? As we'll see, these questions are closely related, for emotion, pleasure, and ecstasy are allied. Along the way, we'll encounter some related matters: Why did music evolve? What is the difference between "intellectual" and "emotional" music? Why do we take pleasure in music that elicits negative emotions like melancholy or violence? And why does music seem so much more "immediate" than the other arts?

## The Origins of Music

In modern society at least, music is an entirely optional aspect of human existence. Many people lead a long, happy life hardly indulging in music at all. Devotees of music cannot help but pity such people, as the sybarite pities the cloistered monk, deeming life without music as a world without sunshine.

It is remarkable that something so powerful as music is so unnecessary. Sex is also powerful yet optional (if uncomfortably so), so music is not alone. But the reasons for the power of sex are perfectly obvious. We need to reproduce. From this basic need, humans have developed no end of silly

things like girlie magazines and high fashion, things that exert a strong
on us by tapping into primal urges. Similarly, a taste for fine wines derives
from a need for nutrition, and a penchant for sunbathing derives from a
need to stay warm.

But what possible biological utility can there be in listening to pat-
terned sound? As pure information, music provides no physical service to
our bodies. And as information that is artificially contrived, music seldom
tells us anything about the world that would aid our survival. If we are to
understand how music takes hold of us so powerfully, we need to start by
asking why music evolved in the first place.

In the late 1980s, French archaeologists explored prehistoric caves in
southwestern France in a unique way—by *singing*. They discovered that
the chambers with the most paintings were those that were the most res-
onant. This startling insight suggests that caves were the sites of religious
ceremonies involving music. The incantations of the Cro-Magnons may
have been as sophisticated as the surrounding artwork, accompanied by
flutes and drums and whistles.

Clearly, music is very old. That it is found in every culture in the
world, no matter how technologically primitive, indicates that music is
something that humans come by fairly easily. The discovery of bone flutes
in prehistoric dwellings suggests that musical development has been a cul-
tural priority for tens of thousands of years. By antiquity, music had blos-
somed into myriad styles. The Bible is studded with references to music,
and musical instruments appear again and again in the painting, pottery,
and sculpture of classical art. Alas, no efficient notation system was devised
that would convey the sounds of the ancients to our ears today.

What was the first music like? In particular, did it emphasize rhythm
or melody, tapping or singing? In his book *Rhythm and Tempo,* musicologist
Curt Sachs wrote,

> When Hans von Bülow, the great conductor and pianist, boldly decreed:
> "In the beginning was rhythm," he took advantage of the prerogative of
> so many pointed sayings to be pithy, impressive, and unfounded. Orga-
> nization of rhythm came long, long after men—like the birds—had

*given melodic shape to mirth and to mourning. As long as singers stand*
*alone, without other voices or instruments to join, the urge for strictness*
*in rhythm and tempo is very weak.*

Sachs was unhesitating in his opinion because in decades of ethnomusi-
cological research he seldom encountered "the mechanical discipline" of
Western rhythmic conventions in the traditional cultures he had studied
in the Americas, Asia, the Pacific, and even Africa.

Yet rhythm is often described as music's most essential trait, since
music unfolds across time, and time is rhythm's domain. A drummer can
tap out complex rhythms that everyone agrees are a kind of skeletal music,
and she does this without playing tones. Where there are no tones there
is no pitch, and without pitch there is no melody. For this reason (the
argument goes) rhythm can exist without melody, and so rhythm must
precede melody in our experience.

All evidence contradicts this logic. Not only is strict meter rare among
traditional cultures, it is virtually unknown in the early history of Western
music. As we saw in Chapter 4, our eight-century-old musical tradition
evolved from chant that had little rhythm beyond the prosody of language.
Some musicologists believe that even that paragon of metrical music, the
supposedly "primitive" drumming of black Africa (which in fact is highly
technical), is actually a relatively recent development, one that may have
been seeded by contact with the metrically rich music of the Middle East.

Developmental psychology also offers clues about music's evolution,
on the assumption that cultures are likely to discover first what comes most
easily to human beings. In Chapter 3 we saw how children acquire music
initially as melody, often by emphasizing the natural intonation of lyrics.
Early melody is unstable, following no strict beat and wavering in pitch
level. Rhythmic regularity comes years later, and a true sense of harmony
later still.

Sachs describes what may be the precursor of melody as "tumbling
strains." These are single, drawn-out noises that ethnomusicologists have
sometimes encountered in technologically primitive cultures:

*Its character is wild and violent: after a leap up to the highest available note in screaming fortissimo, the voice rattles down by jumps or steps or glides to a pianissimo respite on a couple of the lowest, almost inaudible notes; then, in a mighty leap, it resumes the highest note to repeat this cascade as often as necessary. In their most emotional and least "melodious" form, such strains recall nearly inhuman, savage shouts of joy or wails of rage and may derive from such unbridled outbursts.*

But why would human beings expend energy on making such sounds? Civilization has led men to indulge in all sorts of useless activities. But in prehistoric societies everything served survival one way or another. Many suggestions have been made for music's survival value. Charles Darwin believed that music evolved for courtship, pointing to a much greater difference in the frequency range of male and female voices than can be accounted for by body size alone. But such narrow explanations do not account for music's presence in every aspect of life.

Because music is possible only in very intelligent brains, one approach to understanding how we developed music is to ask why we evolved so large a cerebrum. Increasingly, anthropologists have come to regard the benefits of *social interaction* as the driving force behind the explosion in human brain size. Where once scholars emphasized the value of a large brain in building tools, now they extol the virtues of cooperation in hunting, fighting, food sharing, and above all, in child rearing.

Cooperation is not easily achieved. Animals are overwhelmingly self-interested. Those that triumph in life's competitions live on to spread their genes to future generations, so that their characteristics triumph in the species as a whole. Individual self-sacrifice for the good of all is rare among animals, if only because there is always advantage in taking more than one gives. An organism must be able to look far into the future, and to remember far into the past, to make possible the give-now-and-receive-later calculus of cooperation. Only the symbolic minds of human beings are up to the job.

Above all else, cooperation entails trust. Human beings must constantly reassure one another that each is equally committed to the common good.

We exchange symbols of our concern in a thousand ways, from a polite hello to a cheer at a political rally. The rituals of cooperation are everywhere and bear constant repetition. Those who fail to participate, or who do so half-heartedly, earn suspicion and resentment in excess of what seems warranted. But it is the whole community that is at stake, not merely a moment's pleasantness.

In the view of many anthropologists, music first evolved to strengthen community bonds and resolve conflicts. This idea is anything but far-fetched. Many animals employ their vocal apparatus to convey fine gradations of emotion and intention. When one dog whines in submission to another, it is voicing a kind of melody that cements a social pact. As humans evolved language, with intonation inherent in every word, it seems inevitable that formal expressions of emotion would gradually coalesce into something like melody. After all, ritualized displays of emotion often appear in traditional cultures as stereotyped physical motions—little dances performed to demand or threaten or assuage or reassure. Why not ritualized motions of the voice as well?

If music arose to strengthen social bonds and settle conflicts, it owes its existence to the emotions. For it is by exercising or assuaging emotions that we establish rapport with other human beings. Somehow music embodies emotion. We must now turn our attention to how this is possible.

# Emotion

We tend to think of emotion as a grab bag of specific feelings like anger and grief and joy, feelings that we've all observed in animals and that seem to be "primitive." Not surprisingly, neurologists seeking emotional centers in our brains first found them at the core, beneath the cortex in regions that evolved far earlier. Parts of this *limbic system* can be stimulated to abruptly move an animal to emotional extremes like rage or terror. In contrast, such raw emotional response cannot be elicited anywhere from the cortex.

In recent years, cognitive psychologists have for the most part roundly rejected older notions of emotion. While they acknowledge the existence of primitive mechanisms for fight and flight, emotion is now seen as crucial

to *reasoning,* a notion that flies in the face of traditional ideas of emotion as "irrational." This approach has spawned any number of theories about emotion. Some see emotion as a means of weighting the attention given to incoming experience; others see emotion as directly instigating thought. But one view fits musical experience particularly well—so well, in fact, that music ought to be taken as evidence of the theory's validity. This is the "discrepancy theory," which regards emotion as a reaction to unexpected experience. We'll see how it works in a moment.

One reason for the changing view of emotion is the gathering evidence that victims of emotion-related brain damage lose the capacity for self-organization. This is particularly true when the right frontal lobe is injured—a part of the brain closely linked to the limbic system and crucial to emotional life. People become emotionally unresponsive when this part of the cortex is damaged. They often seem to not care about their infirmity, and may even deny that anything has gone wrong. By comparison, a victim of left frontal lobe damage retains his emotionality and so reacts to his condition with despair.

Why are the frontal lobes important to emotion? We've encountered them a number of times in earlier chapters, and have seen how they are crucial for planning long sequences of activity. The frontal lobes are the brain's disciplinarian. They hold the reins on other parts of the brain, which otherwise would meander in their activity, always following the direction of least resistance, always tending toward habit. When we daydream, we free-associate while our frontal lobes slumber. But when we work, the frontal lobes constantly rein in parts of our minds to stop them from wandering from the task at hand.

The frontal lobes are also active in constructing short-term memories. Recall that they do this in cooperation with sensory cortex. When we hold the image of a guitar in our imaginations, the image is constructed in visual cortex, but sustained by frontal cortex, which prevents it from fading away. Similarly, it is frontal cortex acting on auditory cortex that lets us hold musical anticipations for many seconds as we await their resolution.

We've also seen that the frontal lobes are the main control center for attention, deciding which part of the world we will set our eyes upon, or

which aspects of music we will immerse ourselves in. Frontal lobe damage almost always results in a short attention span, an inability to concentrate.

Planning. Short-term memory. Attention. At first glance, these three frontal lobe functions can seem like diverse activities that just happen to be packed into the same brain region. But on closer inspection it turns out that they are facets of the same basic phenomenon of *restraint*. Planning restrains our brains from wandering from a chosen path of activity. Short-term memory restrains sensory cortex from moving on to different imagery. Attention constrains the kind of sensory data admitted to sensory cortex.

At any given moment, our brains can process only a tiny slice of the torrent of experience that comes our way; our bodies can carry out only one action of the hundreds possible; our intellects can model only one fragment of reality amidst infinite possibility. There is no point in possessing the marvelous resolving power of our visual and auditory cortex, the vast categorization abilities of our temporal lobes, or the astonishing analytical skill of our parietal lobes, if these mechanisms are applied to trivial ends. A nervous system must always be on the lookout for *the most important* activities to which to devote itself. This is the ultimate purpose of emotion.

In his book *Descartes' Error,* Antonio Damasio describes a patient with right frontal lobe damage who suffered from emotional "flatness," but who otherwise retained every cognitive skill. Intellectually, his high IQ remained intact. Yet this patient could not hold down a job for the simple reason that he could not keep his eye on a goal. He would devote himself with great energy to trivial aspects of his work. He had lost the ability to pick and choose.

Some theoreticians believe it is the job of the limbic system, helped along by the frontal lobes, to make such decisions. Although we think of "decision making" as the highest of cognitive feats, it is a necessary activity for any organism that must make its way through a complex world. So it is only natural that decision making would be centered in one of the oldest parts of the brain.

In considering in Chapter 6 how memory works, we encountered one important component of the limbic system, the *hippocampus* (it's shown in Figure 6.1). While memories are not "located" in the hippocampus, this

structure appears to decide what parts of experience we will remember over the long term. So the hippocampus is deeply intertwined with the temporal-lobe categorization apparatus that melds different kinds of experience. With thousands of possible behaviors before us at all times, we can't consider each in turn. Rather, the limbic system brings our aggregate knowledge of the world to bear as it simultaneously weighs the importance of every factor, thereby steering us toward the most appropriate activity. This is done in close consultation with cortex, which provides detailed analysis of what is happening in the world, and of what possibilities are available.

The ability to focus on a goal is something we more strongly associate with motivation than with emotion. To be "motivated" means to have a plan and to follow through on it. In that we have plans for most things that we do, we are constantly in a state of motivation. It takes motivation to cook dinner and even to eat dinner. We do not think of ourselves as being particularly motivated in such activities because they are commonplace, and because they are so filled with habit that they more or less carry themselves along once we get them started. So normally we reserve the word *motivation* for plans that go against the grain and so require a lot of frontal lobe effort to see through.

In the view of many psychologists, "emotion" is a special case of motivation. We carry out plans by anticipating desired results and seeking to satisfy those anticipations. You reach for a ten-dollar bill in your wallet first by anticipating its existence and then by moving a hand toward it. But anticipations are not always met. You may find that the ten-dollar bill is missing, and will be annoyed or even furious. Or you may find that you have much more money than you thought, and will be pleased or even overjoyed. The neutral state in which you find the anticipated ten-dollar bill draws no particular response, and is a simple instance of satisfied motivation. But the other two cases draw a strong response because there has been a marked mismatch between anticipation and reality. Such discrepancies are believed to be the basis of emotion, of *e*-motion (from the Latin *exmovere*, to "move away").

It has often been remarked that there is no such thing as a neutral

312 Music, the Brain, and Ecstasy

emotion. All emotions are either negative or positive. Negative emotions arise when experience falls short of anticipation. You expect your car to start and it doesn't. You expect your cat to greet you at the door and find out that it has been run over. Conversely, positive emotions come about when experience exceeds anticipation. You expect to work all day but are given the day off. You expect to pay a lot of money for something and find that it has been marked down. Because most anticipations are minor ones, and most discrepancies are small, little of our emotional life registers as surges and outbursts. Most emotion bobs up and down as small waves on a sea of motivation. But we experience a feeling of well-being when small positive emotional events occur continuously, and we become depressed or irritable when a train of small negative events accost us.

From these principles, it's easy to see how music generates emotion. Music sets up anticipations and then satisfies them. It can withhold its resolutions, and heighten anticipation by doing so, then to satisfy the anticipation in a great gush of resolution. When music goes out of its way to violate the very expectations that it sets up, we call it "expressive." Musicians breathe "feeling" into a piece by introducing minute deviations in timing and loudness. And composers build expression into their compositions by purposely violating anticipations they have established.

Musical expression is forever at odds with musical structure. Every deviation from an anticipation tend to weaken subsequent anticipation and thereby undercut the impact of further deviations. A momentary shift in tempo brings a tinge of emotion, but at the price of undermining the overall sequence of rhythmic anticipations that keep a piece moving along. When too many deviations fall together, the listener loses track of the underlying meter and ceases to anticipate coming beats forcefully. Similarly, using too many non-scale tones (chromatic tones) tends to obscure tonal centers so that harmonic resolutions lose their impact. For composer and performer alike, music-making is always a tug-of-war between the maintenance of underlying musical structure and the indulgence of musical deviations. With too much deviation, music becomes cloying and incoherent. With too little, music becomes cold and mechanical.

The idea that negative emotions arise from unmet anticipations might

resolve the longstanding debate over why chords built on major triads sound "happy" while chords built on minor triads sound "sad." Many critics have insisted that such distinctions must be entirely culturally determined, pointing to the very different responses sometimes elicited from non-Western listeners. Still, that an Indonesian might find a minor chord "happy" does not necessarily mean that emotional response to chords is wholly arbitrary. The Indonesian brings a different harmonic paradigm to his listening—one that is not centered on triads—and so he anticipates harmonic relations in a different way. Within that context, a minor chord might entirely meet his expectations and so would sound "happy." Yet minor chords might still be *necessarily* unhappy within the triad-based Western harmonic system because they violate anticipations established by that system. The overtones produced by minor triads do not overlap as well as those of major chords, and so minor triads are inherently filled with conflict—that is, with violations of the overtone series that is so important to our harmonic system.

More than a few musicologists have wondered why we continue to find music expressive after we have heard a piece a few times and know where its expressive deviations will fall. Shouldn't we begin to expect a composition's deviations automatically, and so cease to be affected by them?

One explanation is that musical systems, including conventions of harmony and form, constantly reinstate standard expectations. We are taught and retaught that one chord naturally leads to another. The underlying logic of the overall harmonic system forces our expectations along certain lines, no matter how many deviations we have previously encountered. So violations of standard expectations continue to be expressive.

Some psychologists have suggested a neurological basis for this phenomenon. On the assumption that our brains are naturally predisposed to certain musical structures, they posit that modules of cerebral cortex devoted to particular kinds of processing can't help but function in terms of the anticipations and resolutions they were designed for. A module that plots out temporal patterns has no choice but to anticipate the next beat as being in time, no matter how many times it has heard that beat arrive

late. This view springs from a widely held conception of the cortex as an aggregate of "dumb" modules that work automatically on trivial tasks, with intelligence emerging from their combined action.

When music becomes extremely regular, our brains reject it. A good example is provided by computer-generated music in which tempo and loudness are perfectly constant. Such music provokes anxiety in the musically sensitive. One explanation of why we reject strict tempo, and even perfect tuning of instruments, is that our nervous systems attend most closely to things that change. Put differently, our brains *habituate* (stop responding) to things that don't change. As we walk through a familiar room, we are more or less blind to its contents. Our visual systems sense every wall and chair, but take little conscious notice. Instead, the brain saves its attention for things that are new and not well understood.

Habituation occurs in all parts of our experience, and at all levels. A flashing display on a VCR soon ceases to draw our attention. So does a perfectly even beat in music. We still hear every feature of the sound, of course, because habituation is never total. But the beat is less forceful than it would be if it were varied slightly. One cause of this phenomenon may be temporary neural exhaustion when the same brain circuits are activated again and again. Slight variation overcomes this failing. And so a continuous pitch is made more engrossing by slightly varying its frequency and loudness through vibrato.

In spite of the many ways in which music can violate anticipations, not all music is expressive. For instance, a good deal of Baroque music moves along like a precision timepiece, having been written for eighteenth-century minds enamored of order and self-possession. Such music evinces a certain liveliness, but not the emotional drama that so dominates music written a century later. Yet we're still drawn to this "intellectual" music despite its lack of overt emotionality.

The attraction of such music seems to reside in the elegance of its patterns. We admire it as pure structure. It is a familiar enough experience. Think of how we appreciate a building solely on the basis of the patterns it delivers to our eyes, patterns formed by windows and columns and lintels. There's little in such experience that we would call emotional. We merely

enjoy the experience of tracing the patterns with our eyes and perceiving the deep relations among the various parts. We'll as readily admire the shape of an elegantly crafted chair or vase, again without a hint of emotional extreme.

Yet analyzing the mechanics of emotion or of auditory pattern does not explain why we are drawn to such experiences. It's to that question that we must turn next.

## Pleasure

One evening, the French composer Hector Berlioz began weeping openly in his seat at a concert. A gentleman beside him kindly inquired whether he ought not withdraw to the lobby. Berlioz's face twisted in astonishment as he snapped, "What? Do you think I come here for pleasure?"

But of course he *did* come for pleasure. One way or another, everyone seeks pleasure of some kind in music, and rejects music that does not provide it. What's odd is that Berlioz could find such extreme pleasure in music steeped in melancholy and grief—just the sort of experience we would describe as "unpleasant" and "unpleasurable" in daily life.

Remarkably, "pleasure" is a concept seldom encountered in neuroscience or even in psychology. There's hardly a book written on the subject. In fact, few texts even list pleasure in their indexes, let along devote a chapter to the topic. Although our days are filled with pleasures large and small, few thinkers have known what to make of pleasure, have known how to make it fit with concepts like seeing or remembering or intending. Unlike the objects of the external world that scientists are so adept at studying, pleasure resides deep in our bodies and our being, has no sharp edges and never stands still, making it all but impossible to back away and assess objectively. Like the feeling of "self," we just can't put a finger on pleasure.

We take pleasure in sunshine's warmth, in a crossword puzzle, in a filet mignon, in a Renoir, in driving skillfully, in fixing a broken chair. What can there be in common among such diverse things? Each of these activities plays out in a different reach of the nervous system. Some have

to do with sensing, some with doing, some with reasoning. Yet we find pleasure in them all.

A single activity may proffer many kinds of pleasure. We considered music's panoply of pleasures in Chapter 8. We can be ravished merely by the beauty of an instrument's sound. We exult in the constructs of melody and harmony and rhythm and—in some genres—the travelogue of large-scale form. We swoon to music's emotionality. And we derive pleasure from music's "meaning," whether inherent in the sound or expressed through lyrics or the symbols of performance and participation. All these pleasures unfold side by side, with different genres of music emphasizing different delectations. And so "the pleasure in music" is as complicated as music itself.

Opposite every kind of pleasure is a kind of pain: the body's agonies against the body's raptures, biting cold against caressing warmth, bitterness against deliciousness, stenches against fragrances, ugliness against beauty, grief and anxiety against joy and serenity.

In the classical notion of pleasure and pain, an organism strives to maintain equilibrium (homeostasis) with its environment. Pain occurs as it deviates from equilibrium and pleasure occurs as it returns. For instance, when cold threatens body temperature, it registers as unpleasantness that can become wrenching pain if carried to an extreme. Conversely, we feel immediate pleasure in warming up from being cold. Pleasure results not from the warmth per se, but in the approach to ideal body temperature. Too much warmth can also upset equilibrium, and a different kind of discomfort or outright pain will set in. So pleasures are not absolute but rather are always relative to an equilibrium point. The same taste or feeling or sight or sound that is pleasurable in one context can become painful in another.

This conception of pleasure and pain is elegant and far-reaching, suggesting that pleasure and pain are intrinsic to the nature of all experience. But the whole matter is confused by certain special instances of pleasure and pain that our nervous systems appear to be specially designed to accommodate. While the moderate pleasure of sunbathing arises naturally from the need to keep warm, the stabs and explosions of sex clearly extend

far beyond the normal duties of skin. Conversely, we possess well-defined pain receptors in our skin that respond to chemical clues that the body has been hurt, receptors that have nothing to do with the normal experience of touch. The brain provides special pathways for these systems, and there are points in the brain that can be stimulated to alleviate pain or to thrust an animal into a state of bliss.

The brain has ways of moderating these special systems, tempering pain when it becomes so active as to be crippling. Special neurons produce substances called *endorphins*, which resemble opiates and which act on neurons in the brain's pain pathways, reducing their activity and thereby alleviating subjective pain. If endorphins are released when there is no pain to be counterbalanced, a euphoria results that is much like that produced by drugs like morphine. In fact, the opiates to which drug addicts are so devoted work their magic by approaching the same neurons influenced by the brain's own endorphins.

These two conceptions of pleasure—as a return to biological equilibrium, and as a reward system for special behaviors—are far from adequate for explaining much of the pleasure in our lives. We don't take pleasure in playing chess because of a deep-seated chess-drive common to all humans. And it's hard to see how playing chess brings basic physiological systems around to equilibrium. It turns out that the usual conceptions of pleasure can't account for most of the pleasures we seek. A perfectly contented individual may start playing chess or chatting about politics or strumming a guitar not to relieve underlying stress or pain, but merely to become even more contented. And so the special systems for pain and pleasure mislead our thinking by encouraging us to view pleasure and pain as unusual experiences that descend upon us like doses of magic potions, rather than as being inherent in all conscious experience.

Clearly, we need to view pleasure and pain more broadly. One way of regarding pleasure of any kind is to see it as inherent in the satisfaction of anticipations. This is a variant on what philosophers call "motivational" theories of pleasure. We've seen how our nervous systems forever model the world they perceive, spawning a flux of anticipations at every level of perception and action and understanding. Stress and anxiety occur to what-

ever degree reality collides with anticipations, making the brain struggle to quickly reassess the world in a way that makes sense (that is, in a way that can it be anticipated more successfully). Conversely, perfectly fulfilled anticipations are resolved without friction, and this resolution is what we call pleasure. Even "animal" pleasures like sex and eating fit this conception in that they are led by strong anticipations ("desires") that become intensely pleasurable upon their fulfillment.

This conception implies that pleasure is really no more than a retreat from pain, and so suggests that our lives must be pretty distressing for us to find so may opportunities for pleasure. On the surface, life's moment-to-moment pains don't seem so grand; but then neither do life's moment-to-moment pleasures. The world is an untidy place. Where we would like to find simple patterns and deep connections, we encounter complexity and conflict and confusion. And so all ordinary existence is accompanied by a certain amount of strain. When trains of anticipation go consistently well, we register the pleasure of well-being. When resolution is consistently rocky, we register broad anxiety. Only in a handful of activities, including music and the other arts, do our minds partake of experience that is so perfectly organized that every anticipation is roundly satisfied, filling us with intense pleasure.

The matter of pleasure and pain is complicated by the fact that most activities take place at many levels in the nervous system. Someone derives pleasure from cooking, but not from the sting of peeling onions. And the pleasure of cooking may be overshadowed if the cook had anticipated going to a party that night but had been disappointed. Similarly, in music we encounter pleasure or distress in the quality of a clarinet's tone, in the melody it plays, in the harmony that supports the melody, in the rhythm that drives it all along, and in many other factors we've touched on in earlier chapters. When we speak of "the" pleasure of music, we are actually referring to the sum total of all music's pleasures and disappointments, a sort of running average of the good and the bad.

From this standpoint, it's easy to see how we take pleasure in musical devices. As music's promises (anticipations) are fulfilled, we experience pleasure; as they are betrayed, we feel anxiety or worse. When skillful

composition arouses strong, far-reaching anticipations, intense pleasure accompanies their fulfillment; by comparison, the weak anticipations generated by poor composition hardly touch us.

Yet the deepest pleasure in music comes with deviation from the expected: dissonances, syncopations, kinks in melodic contour, sudden booms and silences. Isn't this contradictory? Not if the deviations serve to set up an even stronger resolution. Banal music raises common anticipations then immediately satisfies them with obvious resolutions. There's pleasure to be had, but it is the pleasure of the bread roll, not of caviar. Well-written music takes its good time satisfying anticipations. It teases, repeatedly instigating an anticipation and hinting at its satisfaction, sometimes swooping toward a resolution only to hold back with a false cadence. When it finally delivers, all resources of harmony and rhythm, timbre and dynamics, are brought to bear at once. The art in writing such music lies less in devising resolutions than in heightening anticipations to preternatural levels. If this process sounds as much like the recipe for good lovemaking as for good music-making, it's because the nervous system functions the same way in all its reaches. The same basic mechanism applies to all pleasures, artistic and otherwise, for the simple reason that this mechanism *is* pleasure.

Consider harmony. Once we've mastered the harmonic system of our culture and know how to follow tonal centers and anticipate harmonic resolutions, we bring a flood of anticipations to all our listening. Particular chords lead in particular harmonic directions, and so long as harmony travels in that direction we register immediate pleasure. Conversely, an inappropriate change of key can be quite jarring, even painful. However, carefully controlled dissonances are frequently employed to postpone the resolution of harmonic anticipations, and thus to make them larger, sometimes integrating many smaller anticipations into a towering hierarchy. Most such dissonances are related to the underlying harmony so that they will not be too jarring. They do not so much violate anticipations as reshape them.

Melodic pleasure arises in similar fashion, but through the anticipation of melodic contour. When contour rises and falls "naturally"—that is, in

ways that we anticipate—we register pleasure; when contour wavers reck-lessly, we register distress as our brains struggle to make sense of the patterns before them. To some degree, melodic anticipations originate from the Gestalt rules we considered in Chapter 3. But anticipations also arise from a culturally acquired vocabulary of melodic devices.

The role of anticipation in rhythmic pleasure is equally clear. We enjoy meter by anticipating a train of pulses. Any sudden deviation in tempo, or in the number of beats per measure, sends our nervous systems reeling. But carefully controlled syncopations can set us up for a pleasurable reaccen-tuation of the underlying beat.

The rhythm of phrase is more elaborately constructed, relying on a panoply of cues that make us strongly anticipate phrase boundaries. Com-posers meticulously construct sequences of evolving phrases, each suggest-ing the next, but sometimes deviating toward the unexpected, then moving to reaffirm the overall form.

This way of thinking about pleasure may explain the surge we feel in the climax of a Beethoven symphony, but what of the "simple" pleasure we find in the individual sounds of instruments. Because the experience of music arises as our brains model hierarchies of relations among sounds—hierarchies that are "invisible" in the sense that they can't be readily shared with others, or even described to oneself—it's impossible to sort out the degree to which the pleasure we find "purely" in instrumental sound ac-tually arises from surrounding musical relations. Any three notes on a viola can sound uninteresting when heard as the violist tunes up, yet might ravish us when they appear at the climax of a piece. Although pleasure appears to be embodied in the "sound" of the notes, it mostly resides in high-level relations that we keenly experience, but to which we bring little self-awareness.

Still, just a lone note from a viola can bring bliss to a keen ear. How is this possible? In truth, no one has a clue. But it's likely that, at the micro-scale of music cognition where auditory cortex assembles individual sounds, somehow anticipations are suggested and fulfilled, but too quickly to be consciously observed. Significantly, we find no pleasure in a pure-

frequency tone generated by a computer. Lacking variation of any kind, such sounds have no basis for generating anticipations. As we saw in Chapter 2, musical sounds are complex, constantly changing entities of many undulating components. The architecture of such sounds varies with the skill of the musician. We celebrate a violist who "has good tone." Somehow, through years of practice, such a violist learns to tease sounds of a particular structure out of the strings. He does this without understanding how, just as we tie shoelaces without having to think about it. Conversely, a novice violist can torture a sensitive ear by producing sounds that are "grating"— that is, sounds broken into disconnected segments, where one moment does not lead to the next, where every nascent anticipation is foiled.

Music's large structures can as readily result in wincing pain. When a well-trained but overambitious composer generates strong anticipations and then fails to deliver on them, we're soon in agony. Most such music quickly disappears from the concert repertory. But new music often inflicts pain upon its audiences until they learn how to anticipate it properly—or until they realize that the fault is not theirs and that the composer has failed to achieve his aims.

We also experience pain in music—even very good music—when we apply the wrong vocabulary of devices to it and anticipate it wrongly. Thus one style of melody will be pleasurable to those who are well-acquainted with its twists and turns, but unpleasurable to those who bring to the melody a different style of anticipation that produces one jarring mismatch after another.

Such arguments may clarify how we derive pleasure from musical emotionality, but they don't explain why we seek out the experience of *negative* emotions in music, such as melancholy or grief or violence. After all, most of us prefer to avoid negative emotional states in our daily lives. But in music we somehow enjoy such experiences—and not as remote spectators, as one might view a Shakespearean tragedy, but by being made to feel melancholic or grief-stricken or violent, as if something unpleasant had happened to us.

In his *The Critic as Artist,* Oscar Wilde wrote:

*After playing Chopin, I feel as if I had been weeping over sins that I had never committed, and mourning over tragedies that were not my own. Music always seems to me to produce that effect. It creates for one a past of which one has been ignorant, and fills one with a sense of sorrows that have been hidden from one's tears. I can fancy a man who had led a perfectly commonplace life, hearing by chance some curious piece of music, and suddenly discovering that his soul, without his being conscious of it, had passed through terrible experiences, and known fearful joys, or wild romantic loves, or great renunciations.*

Wilde alludes to the reputed "meaning" of music that we considered in the last chapter. As we saw, most compositions lack a specific, agreed-upon reference to the contents of the world. But when we bring our own life situations to music, we can make of music what we will. Music idealizes emotions negative and positive alike. By so doing, it momentarily perfects our individual emotional lives. The "meaning" we feel is not in the music as such, but in our own responses to the world, responses that we carry about with us always. Music serves to perfect those responses, to make them beautiful. By so doing, music imparts dignity to experience that often is far from dignified. And by imparting pleasure even to negative emotions, music serves to justify sufferings large and small, assuring us that it has not all been for nothing.

Wilde could not be more wrong about how a man "who had led a perfectly commonplace life" would be propelled to such emotional extremes. Music most affects people who already have a deep emotional existence. It is the force of our own lives that drives musical anticipation, and our own joys and pains that are rewarded by musical resolutions.

For a specific example of how music creates emotion and pleasure, let's take a last look at Henry Mancini's "The Pink Panther" (Fig. 10.1). In Chapters 3 through 5 we saw how Mancini directs melody, harmony, and rhythm toward a point of high tension at the start of the third bar as the tune plateaus on a long, accentuated dissonance. This note violates several kinds of anticipation. Melody suddenly stops accelerating and freezes. Melodic contour ends its overall rise. Harmony veers from the

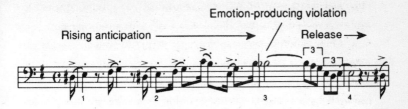

Fig. 10.1. Emotion in "The Pink Panther"

prevailing tonal center. Meter pounces on a strong accentuation. And phrasing that is formed largely by melodic contour ends its accelerating pattern of stealthy footsteps, first in twos and then in fours. For a moment the music becomes motionless, much as a stalking cat might.

What is the emotional content of this music? And wherein lies its pleasure? Clearly, this theme is not constructed from the regular, predictable patterns that characterize "intellectual" music. This fragment is filled with violated anticipation and so emotional tension, tension that peaks on the long dissonance in the third bar. Yet it's hard to characterize the nature of the emotion other than as a rising sense of apprehension. None of the usual monikers from our inventory of emotions—joy, grief, triumph, whatever—make a good match for what we feel when we listen to this passage.

Nonetheless, it makes perfect sense to call the experience of stealth "emotional" even though we don't normally think of it that way. We're quite accustomed to feeling the emotional content of stealth when we have occasion to sneak around. We make motions that alternate between jarring restraint and sudden overreaching, all the while violating the normal pacing of physical movement. And so we experience little bouts of the pain of constriction and the pleasure of leaping. Notice that we *feel* stealth by moving in certain ways with certain timings; when music follows similar patterns, it *sounds* stealthy, just as the pink panther's slinking around *looks* stealthy.

It would seem that what this theme generates is not a statement produced by a "language" of emotions, but rather by a "language" of physical

movement, a language that sounds "emotional" when anticipations are consistently violated, and merely "intellectual" when they are not. It is a language in which sonic objects move together in time, much as body parts move together as we navigate the world. No wonder music makes us want to dance.

From this perspective, we see emotion as *overlaying* music's fundamental representations of motion, of modulating musical shapes just as it modulates physical movements. "The Pink Panther" shows this by sounding not just stealthy, but also *funny*. Of course, it's hard not to be amused by a hapless kitty-cat (a pink one at that) doing its pantherine best at passing for a human being—a King of the Jungle forever on the run. But we would find levity in this theme even without its cinematic associations. There's something going on here, some sort of contrast of opposites that's found in all humor. The timings of the panther's creeping are modified in ways that are contradictory, making our hero seem both courageous and cowardly at the same time, and thus ridiculous. It is these timings of timings—higher temporal relations imposed upon lower temporal relations—that give the theme its emotional color and make it more interesting to listen to.

## Music and the Body

The conception of pleasure as the satisfaction of anticipations accounts for the pleasures of the mind, such as we find in music or playing chess—pleasures that the usual body-oriented notions of pleasure cannot begin to explain. Nonetheless, most pleasure feels bodily to us, including much pleasure in music. When a good ear follows good music, somehow even the deepest and most abstract relations seem to find expression in the body. Music lovers speak of feeling not just pulsating beat in their muscles and bones, but also melodic contours, harmonic transitions, dynamic shifts—phenomena that by all rights ought to be entirely "mental" and not at all "corporeal."

This is really very odd. In earlier chapters we've watched music flow through auditory cortex. This cortex is densely connected to other parts

of the temporal lobes and with the frontal lobes, but not with the motor cortex that moves our muscles or the somatosensory cortex that monitors sensations in skin and tendon and muscle (both kinds of cortex were discussed in Chapter 7). So why would sound register as physical sensation? It's one thing when a sudden loud sound makes us shrink in fear. Such translation of sound to body sensation is obviously a manifestation of built-in patterns of self-defense and flight. But there is no obvious evolutionary reason why the intricate patterns of sound that make up music should continuously unfold in our musculatures.

Clearly, if music does not channel directly to our muscles, then we must consciously put it there. It seems that we use our musculatures to *represent* music, modeling the most important features of musical patterns by means of physical movements large and small. At one extreme, we bounce up and down to a pulsing beat. At the other, we are immobile yet are racked by anticipations of movement, experiencing the impetus toward motions that we do not actually initiate.

Kinesthetic anticipations reside so deep in our existence that we hardly notice them. Yet they are easy enough to observe. Just sit still and imagine the physical feeling of starting up your car. You can feel the key sliding into the ignition, the touch of the gear shift, the pull of the emergency brake, all without the slightest outward movement. Watch yourself listening to music and you'll find similar sensations at work—an invisible dance.

Notice that we do not always appreciate music kinesthetically. When we're not musically engaged, we can hear a piece in its every detail in a way that seems entirely mental and not at all corporeal. Yet on another, more musical day we'll be swept away by the same piece, covertly dancing it out from head to foot.

This view is necessarily speculative, since there is no science of muscular representation. For that matter, there is no hard-and-fast typology of physical movements or of musical devices by which we could compare sonic and somatic experience. Yet it is easy to imagine two functions that such representation would serve. First, representation provides a sort of notation system in which we momentarily inscribe features of music as it

passes by, and thereby more easily remember those features over many seconds. Again, it's simple to watch yourself doing this, encoding musical trajectories as muscular tensions and holding them until they are resolved.

A second function of muscular representation is to amplify our experience of music. Musical patterns that produce emotion and pleasure are replicated in a second, particularly extensive neural system—the motor system—and so emotion and pleasure arise in this second medium as well as in the direct experience of sound. Recall from Chapter 2 how the sound of a violin string is slight on its own but is boosted to great volume by transmitting the string's vibrations to the violin body. In like fashion, we use our bodies as resonators for auditory experience. The listener becomes a musical instrument, places himself in the hands of the music, allows himself to be played.

But why do we represent music as kinesthetic patterns and not, say, as visual patterns? Some people do in fact register sound as sight. In a rare phenomenon called *color hearing,* the senses become crossed and every musical sound is shadowed by colorful, formless visual imagery. And so Franz Liszt would instruct an orchestra, "Please, gentlemen, a little bluer if you please. This key demands it." Like the corporeal representation of sound, color hearing clearly increases musical pleasure. When a patient of Oliver Sacks's lost his color vision, and color imagery too, his color hearing disappeared and he was dismayed to find that a dimension of musical experience had vanished, that his pleasure in music had diminished. But color hearing does not appear to represent deep musical structure very well. It is more of an entertainment, a light show, than a continuation of musical experience. Color hearing is an involuntary phenomenon that just happens to people. It is devoid of the anticipations by which we assemble larger musical structures. By comparison, our bodily representations of music are filled with intention-driven expectation. And the body is expert in timing and in molding temporal shapes.

Interestingly, a recent trend in the theory of emotions rests on the idea of bodily representations of cognitive processes. This is the *somatic marker hypothesis* recently popularized in Damasio's *Descartes' Error.* The idea is that our brains induce pleasant or unpleasant bodily reactions to all sorts of

experiences, and that these reactions work as a sort of reward system that encourages us to pursue certain behaviors and to avoid others. According to the theory, it is by summing up such reactions that we're able to make quick judgments in situations where reasoning would proceed too slowly or wouldn't work at all. The gazelle registers a pleasurable somatic marker upon seeing tasty tendrils in the woods, but also registers an unpleasurable somatic marker as it associates woodlands with predators, and on balance decides that the tendrils are not worth the risk. We experience something similar when we ponder whether to play hooky from work. What's enticing about this theory is that it suggests that we've a long-evolved neurology for the explicit muscular representation of emotion.

However our bodily representations of music are achieved, they may be responsible for boosting our pleasure all the more by causing our brains to churn out the opiate-like endorphins we considered earlier. Psychologists have long used a substance called Naloxone to treat drug addicts by blocking opiate receptors in the brain. With all receptors occupied, opiates can have no effect and the subject experiences no opiate high. Endorphins can also be blocked this way. One inspired scientist decided to investigate whether endorphins were active during music listening by administering Naloxone to a group of listeners. As is standard practice, some were given a placebo to be sure that any effect on listening is truly attributable to the Naloxone. Sure enough, those who received the Naloxone reported a substantially reduced pleasure in the music they heard while the control group experienced all the usual musical thrills. So music is capable of delivering pleasure at virtually every level of our being.

# Ecstasy

When pleasure reaches to extremes, we sometimes describe it as "ecstasy." But ecstasy can be more than extreme pleasure, more than merely raising gooseflesh. Ecstasy melts the boundaries of our being, reveals our bonds to the external world, engulfs us in feelings that are "oceanic."

A defining trait of ecstasy is its *immediacy*. Ecstasy is not some splendid event, like a ravishing sunset, that happens in the external world before our eyes and ears. Ecstasy happens to our *selves*. It is a momentary trans-

formation of the knower, not merely a transformation of the knower's experience (although exceptional experience is often required to bring ecstasy on).

Music seems to be the most immediate of all the arts, and so the most ecstatic. Like the Parkinson's patient we met earlier, music possesses us. As trumpeter Henry "Red" Allen put it, "It's like somebody making your lip speak, making it say things he thinks." Such possession is most evident when a piece seems to take hold of our bodies and make us move. We "get into" the music's rhythms and harmonic cadences and feel compelled to see them through. It is not absolute possession of course. Someone's shout of "Fire!" is exorcism enough to shift our attention elsewhere. Nonetheless, once we are engulfed in music, we must exert effort to resist its influence. It really is as if some "other" has entered not just our bodies, but our intentions, taking us over.

Is there something about hearing that is more immediate, more possessing, than the other senses? Neurologically, the auditory system has no special status. It is but one more sensory system supplying information to cortex. The auditory system is, in fact, smaller in its dimensions than the visual system, in which each eye projects a million fibers to the brain, in contrast to the mere thirty thousand from each ear. And visual cortex is more extensive than auditory cortex. Yet it is hard to think of any visual experience, artistic or otherwise, that is as overwhelming as music (not counting visual experiences that elicit powerful *non-visual* associations, as when someone beholds a charging elephant).

The power of sound cannot be explained merely by the power of music's structure, for there are plenty of non-musical sounds that cut deeply. The infamous case of chalk squeaking across a blackboard is example enough. The screech of the chalk is not very loud in the scheme of things, so its intensity cannot be the culprit. And while the sheer ugliness of the sound is hard to match, there are plenty of sights that are equally ugly, but somehow do not reach to our core and cause us such pain. For pain it is. Inordinate noise has been used as an instrument of torture for centuries, and is disallowed by the Geneva Conventions. On the other

hand, it is hard to imagine extracting a spy's secrets by showing him the collection of the Museum of Contemporary Art.

Where lies sound's advantage? Surely in the fact that sound unfolds across time, that it *moves*. As we've seen, movement is any nervous system's *raison d'être*. Our intentions are ultimately an impetus toward movement. And intentions are what we're referring to when we say "I." They are "myself." Music arrives in our nervous systems and causes our brains to generate a flood of anticipations by which we make sense of melody and harmony and rhythm and form. By eliciting these anticipations, music entrains the deepest levels of intention, and so takes us over.

Another of Oliver Sacks's Parkinson's patients told of how strongly an external force could supplant her own faulty intentions and make her move:

> *When you walk with me, I feel in myself your own power of walking.*
> *I partake of the power and freedom you have. I share your walking*
> *powers, your perceptions, your feelings, your existence. Without even*
> *knowing it, you make me a great gift.*

Music was equally potent:

> *I partake of other people, as I partake of the music. Whether it is*
> *others, in their own natural movement, or the movement of music itself,*
> *the feeling of movement, of living movement, is communicated to me.*
> *And not just movement, but existence itself.*

This woman was truly possessed. "When you go away I am nothing again," she lamented. Isn't this just how we feel when a powerful composition rolls to an end? A fellow named Wolfgang Amadeus Mozart somehow ratcheted himself up to the point that he could create an artificial world of perfect proportions and exceedingly deep relations, found a way to embody those relations in sound, and jotted them down for future generations. The sounds began as intentions at the core of his nervous

system, and after much ado they are replicated, however imperfectly, in other nervous systems centuries later. We switch on a CD player and this man's ghost steps right into our bodies. It is surely as close as any human being can come to immortality.

Yet when music brings us to ecstasy, it is doing more than just moving us around. It propels us for some seconds to a kind of experience we hardly glimpse in our daily lives. It is powerful and extremely pleasurable. But above all, it is *beautiful*.

Claude Debussy once commented that there's more to be gained by watching the sun rise than by listening to Beethoven's *Pastoral* Symphony. Happily, his convictions didn't stop him from composing. Debussy may have once found his greatest bliss in a sunrise, but he knew perfectly well that sunrises are usually bland, and that human beings usually respond feebly to sunrises, even extraordinary ones.

In contrast, music, and art in general, provides the mind with carefully ordered experience—an ever-perfect sunrise. In daily life, a brain does its best to make sense of a disorderly world. It easily finds the most superficial relations among the objects it encounters. But a brain doesn't often encounter immaculate deep relations in the world around it for the simple reason that there are few that are readily perceived. The world is too messy. A flock of squawking birds produces all the individual notes of a symphony, but not in an ordered hierarchy of groupings.

The experience of unsullied order persisting simultaneously at every perceptual level may be taken as a working definition of the word "beauty." When events in everyday experience come together perfectly, we're apt to exclaim "Beautiful!" and to register the pleasure of anticipations perfectly met. Conversely, when the mind thrashes about trying to find order where there is none, its clashing anticipations elicit the tangible pain of ugliness. Like pleasure, we seem to notice beauty only when it occurs at deep levels of understanding. A simple square proffers only a smidgen of beauty; an arabesque pattern, much more. Greater beauty usually arises with greater complexity. Sometimes, however, a composer finds ways of constructing and sustaining deep relations even in a "simple" melody, rather as Picasso could suggest a whole figure by a single line. As

always, we are able to perceive only the kinds of relations our particular musical culture has instilled, so in this sense, beauty very much remains "in the ear of the beholder."

Many people say that it is beauty alone that draws them to music. But great music brings us even more. By providing the brain with an artificial environment, and forcing it through that environment in controlled ways, music imparts the means of experiencing relations far deeper than we encounter in our everyday lives. When music is written with genius, every event is carefully selected to build the substructure for exceptionally deep relations. No resource is wasted, no distractions are allowed. In this perfect world, our brains are able to piece together larger understandings than they can in the workaday external world, perceiving all-encompassing relations that go much deeper than those we find in ordinary experience. Thus, however briefly, we attain a greater grasp of the world (or at least a small part of it), as if rising from the ground to look down upon the confining maze of ordinary existence.

It's for this reason that music can be transcendent. For a few moments it makes us larger than we really are, and the world more orderly than it really is. We respond not just to the beauty of the sustained deep relations that are revealed, but also to the fact of our perceiving them. As our brains are thrown into overdrive, we feel our very existence expand and realize that we can be more than we normally are, and that the world is more than it seems. That is cause enough for ecstasy.

## What Might Music Yet Become?

Can music become something more than it has been in centuries gone by? Certainly there are any number of yet uninvented styles that might come our way. But whether the overall power of music can be augmented is another matter.

New technology has always played a role in propelling music toward innovation, and we live in a period of rapid change in music technology, change that follows a century-long lull. Although computer-controlled synthesizers still have a long way to go before they can match an instrumental performance, they offer new vistas. One possibility is that we may

learn how to cook up excruciatingly pleasurable timbres. Certainly the technical means are in place, because some kinds of synthesizer can generate any possible sound. But there are far too many alternatives to try them all and listen for the good ones. Instead, we'll need to derive sounds from principles of pleasure and beauty. We have no such analytical science yet, so no immediate prospects.

Another option is to go on inventing more devices of melody and harmony and rhythm, as composers have for centuries. Could the music of the future be based on yet-undiscovered constructs? In terms of our traditional conception of music, probably not. Countless thousands of composers have spent their lives searching for new devices, and the rate of innovation has slowed to the point where it is almost impossible to concoct a worthwhile harmonic progression or metrical pattern that has not been heard before. No matter how large the continent, sooner or later every corner will be explored.

Yet recent technology makes new varieties of musical device possible. Computers can interleave sounds in ways too intricate for performers to coordinate, and can continuously combine sounds of diverse pitch and intensity that no player could manage. Synthesizers can also meld ("morph") sounds. The very idea of the discrete musical note could give way to more ethereal sonic entities. There seems to be particular opportunity for new kinds of musical texture.

But beautiful timbres and compelling devices are not the stuff of musical greatness. As we've seen, it is the largest structures that matter and that are the hardest for human beings to invent and to comprehend. Can large-scale musical form be pushed any further than it has been already by Bach and Beethoven? Can sounds somehow be arranged so that a brain is driven to perceive relations even deeper and more encompassing than those of the most powerful musical climaxes to date?

To ask such questions is to ponder whether human beings will somehow find a way to augment their intelligence in the years ahead. It's conceivable that the world is already well-populated with brains able to make sense of music that goes a step or two or three beyond the best of Beethoven. But it's hard to imagine a human mind going any further in writing

great music. As it is, our finest composers have been preternatural prodigies who were superbly trained and steadfastly dedicated to their craft. How can a human being do any better?

One possibility is that artificial intelligence will come to our aid, as computers search through possible patterns of sound for yet-undiscovered architectures of ecstasy. But again, this can only happen when someone postulates hard-and-fast descriptions of the principles by which music thrives, a precise typology of musical devices. Perhaps what music needs now is not so much another Beethoven as an Isaac Newton of the mind who could systematically describe music's deepest relations and make them analytically approachable. Yet even the greatest theoreticians need data, and there is still much work to be done in musicology, psychology, and brain science. Then perhaps—just perhaps—music will become even more powerful than we have known it.

It will be all but lethal if it does.

# Glossary

## A

*Absolute pitch*.   The rare ability to identify particular pitches as instances of particular notes. An absolute-pitcher can hear a tone and say, "That's an A-flat!"

*Additive meter*.   In rhythm, meter that constantly changes time signature, say, from five beats per measure to three beats per measure and then back to five.

*Amusia*.   The loss through brain damage of one or more musical skills, whether those required for listening to music, such as the ability to hear harmonic intervals, or those required for making music, such as reading musical scores.

*Aphasia*.   The loss through brain damage of one or more skills required to speak or understand language.

*Arpeggio*.   A kind of scale that employs (usually) only the notes of a triad. For example, a C-major arpeggio consists of C, then E, then G, then the next highest C, and so on up or down several octaves.

*Auditory cortex*.   Cerebral cortex devoted to processing sound. Broadly speaking, it consists of primary auditory cortex for identifying individual sounds, and second auditory cortex for detecting relations among sounds.

## B

*Bar*.   A span of music defined by a certain number of beats. In 6/8 time, a bar contains six beats, each an eighth note long.

**Basal ganglia.**   Bundles of neurons (nuclei) that extend beneath cerebral cortex, processing inputs from many parts of the brain. The basal ganglia play an important role in executing complex motions.

**Brain stem.**   A bulging segment at the top of the spinal cord, filled with bundles of neurons that perform basic tasks. Information from the ears is processed in this part of the brain before it moves on to the cortex.

## C

**Cadence.**   The resolution of a harmonic progression back toward a tonal center—that is, from tension to repose.

**Categorization.**   The perception of a range of stimuli as a single identity. For example, sounds of the frequencies 438, 440, and 442 cycles per second are all heard as an instance of the note A.

**Chord.**   Any combination of simultaneous tones. Two tones alone are normally referred to as an *interval,* although many musicologists regard intervals as a kind of chord.

**Chromaticism.**   Harmony that makes much use of the five tones in an octave that are not part of the prevailing scale, tones that tend toward strong dissonance.

**Chromatic scale.**   A scale consisting of all twelve tones in an octave. Unlike the *diatonic scales* that are the basis of most Western music, chromatic scales are not inherently tonal and have no key.

**Cochlea.**   A minute organ in the *inner ear,* encased in bone and adjacent to the *middle ear,* which converts sonic energy into nerve impulses.

**Complex meter.**   Meter that continuously changes the number of beats per measure or the pattern of accentuations in a measure.

**Component.**   A part of a sound. A tone's components include the individual frequencies of a *fundamental* and its *overtones.*

**Consonance.**   Harmony in which simultaneous sounds "go well" together with minimal tension.

**Contour.**   The shape made by a melody as it rises and falls in pitch.

**Contrapuntal.**   Composition that makes use of *counterpoint.*

**Cortex.**   The outer surface of the brain—the "gray matter"—that processes information supplied by structures below.

*Counterpoint*.   A style of composition in which two or more simultaneous melodies are combined in a harmonically pleasing way.

# D

*Diatonic scale*.   A Western scale of seven tones chosen for optimum consonance from the twelve tones available within an octave. An ordinary C-major or C-minor scale is a diatonic scale. Compare to *chromatic scale*.

*Discrimination*.   The ability to perceive that two nearly identical stimuli are different.

*Dissonance*.   Harmony in which simultaneous sounds are "discordant" and demand resolution to *consonance*.

*Drone*.   One or more tones played continuously throughout a piece to establish a tonal center. Also refers to instruments that produce such tones.

# E

*Electroencephalogram (EEG)*.   A measurement of the average electrical activity of the brain at a point on the cortex. In common parlance, EEGs measure "brain waves."

# F

*Fifth*.   The most common interval in Western harmony, extending from the start of an octave to its frequency midpoint.

*Formant*.   A range of frequencies that an instrument or voice amplifies through resonance.

*Frequency*.   The rate at which a sound wave vibrates; the number of cycles per second of a sound wave.

*Frontal lobe*.   Parts of the cortex behind the forehead or above the eyes. The frontal lobes modify the function of other parts of the brain and are concerned with planning, directing attention, and sustaining short-term memories.

*Fundamental*.   The lowest, and generally loudest, pitch of the many that constitute a tone.

# G

*Gamelan*.   A traditional Indonesian (Javanese and Balinese) orchestra of gongs and bells.

# H

**Hair cell**.    A special kind of neuron found in the *cochlea* that projects small "hairs" that are vibrated by sound to stimulate the neuron.

**Half step**.    The distance between two adjacent notes among the twelve that fill an octave. From C to C-sharp is a half step. In contrast, a "whole step" refers to a distance of two half steps, as from C to D.

**Hemisphere**.    One half of the brain, either left or right.

**Hippocampus**.    A relatively old part of the brain situated within each *temporal lobe* and concerned with attending and remembering.

# I

**Imagery**.    Any cognitive sensation that occurs in the absence of an external stimulus. For example, visual imagery of an apple can occur "in the mind's eye" without seeing an actual apple.

**Inner ear**.    The part of the ear that translates sonic energy into neurological activity. Identical to the *cochlea*.

**Interval**.    Any combination of two tones. Also refers to the distance between two tones. The interval from C to the G above spans seven half steps (that is, seven steps along a keyboard).

# K

**Key**.    A reference to the scale upon which prevailing harmony is constructed. A minuet in G minor mostly employs the seven notes of the G-minor scale, with special emphasis on the harmonically dominant notes of that scale.

**Kinesthetic**.    Of or relating to the sensations of movement.

# L

**Lateralization**.    The distribution of dissimilar functions on different sides of the brain. For example, language is usually lateralized on the left hemisphere, while tonal hearing is lateralized on the right.

**Limbic system**.    A collection of primitive structures deep in the brain that are important in emotion, attention, and memory.

**Lobe**.    A large section of cerebral cortex loosely defined by the overall form of the brain. See *frontal lobe, parietal lobe,* and *temporal lobe*.

**Localization**.    The process of identifying the direction a sound arrives from, and possibly its distance. Also, the topography of functions in cerebral cortex.

**Long-term memory**.   A memory that can be retrieved long after the experience that gave rise to it took place. Ideally, long-term memories are permanent, in contrast to short-term memories, which perpetuate immediate experience but perish when attention is turned elsewhere.

# M

**Measure**.   A bar of written music. In 3/4 time, a measure contains three beats, each a quarter note long.

**Meter**.   Regular patterns of pulsing in music, usually made by accentuation. The most common meter in Western music is 4/4 time, in which every fourth beat is emphasized.

**Middle ear**.   A collection of three minuscule bones (the *ossicles*) that communicate sonic energy between the eardrum and the *cochlea*.

**Module**.   A parcel of cortex devoted to a particular function. A module of visual cortex might concern only the processing of color information; one of auditory cortex might focus on relative rates of frequency change among simultaneous sounds.

**Motor activity**.   Any brain activity that stimulates muscles to move the body.

**Motor cortex**.   A band of cortex arching from ear to ear across the top of the brain. It processes relatively simple commands that are sent to muscles.

**Motor system**.   The system of brain structures, including motor cortex, the basal ganglia, the cerebellum, and many smaller elements, that work together to move the body, maintain posture, and so forth.

# N

**Neuron**.   A nerve cell consisting of a body and fibers projecting to other nerve cells, fibers that in some instances span the breadth of the brain or the length of the spinal cord. What we normally call "nerves" are merely such fibers conveying messages between neuron bodies.

**Nucleus** (plural: **nuclei**).   A large bundle of neurons interconnected to perform a specific function.

# O

**Octave**.   The interval formed by a note and its closest equivalent, as from middle A to the A above. Frequency doubles (or halves) between octaves.

*Octave equivalence*.   The propensity of the auditory system to hear pitches of double or half the frequency as having the same inherent quality. Thus the frequencies 220, 440, and 880 all sound like A.

*Ossicle*.   Any of the three minuscule bones that transmit sonic energy across the *middle ear* from the eardrum to the entrance of the *cochlea*.

*Overtone*.   One of a series of frequencies that join a *fundamental* to make a musical tone. When a musician plays middle C, you hear the fundamental frequency of that note, but also the C an octave above, the G above that, and so on. Most overtones are faint, and then tend to fuse perceptually with the fundamental.

# P

*Parietal lobe*.   Cerebral cortex, situated above and behind each ear, that is concerned in the left brain with grammatical and analytical reasoning, and in the right brain with spatial reasoning.

*Perceptual present*.   The span of events that our brains can perceive directly, without recourse to recalled imagery.

*Phrasing*.   The combination of musical events into complete "statements." Individual phrases often rise to a point of tension and then resolve back to a state of repose. Several smaller phrases can combine to form larger ones.

*Pinna* (plural: **pinnae**).   The visible, horn-shaped outer ear that collects sound and funnels it down the ear canal.

*Pitch*.   The perceived sensation of frequency. A sound wave whose frequency is 440 cycles per second is perceived as the pitch we call "middle A." A change in frequency is not always accompanied by an equal change in perceived pitch, so the two terms are not equivalent.

*Pitch space*.   The range of frequencies an auditory system can learn to categorize. Although human hearing extends from 20 to 20,000 cycles per second, our effective pitch space reaches only to about 4,000 cycles per second, or some seven octaves.

*Polyrhythm*.   The use of different meters among simultaneous musical lines. Usually the meters follow the same underlying pulse, but with one accentuated, say, every third beat, one every fourth, and so on.

**Premotor cortex**.  A collection of cortical modules that reside between the frontal lobes and motor cortex. They assemble sequences of simple motor commands into complex movements.

**Primary auditory cortex**.  Cerebral cortex that receives input from the ears via the brain stem and pieces together individual sounds. It is located on the top-center of the temporal lobes.

**Program music**.  Music written to mimic events in the world, such as the dance of a fountain or the approach of a locomotive.

**Prosody**.  The "singsong" inflections of pitch and accentuation in spoken language that convey shades of intention and emotion.

**Pythagorean scale**.  An early form of the Western twelve-note scale devised by repeatedly dividing octaves.

# R

**Relative pitch**.  The ability to identify the interval between two sounds. Most of us identify the notes of melodies and chords as distances between pitches rather than as particular frequencies (see *absolute pitch*).

**Resonance**.  The sympathetic vibration of an object with impinging sound, thereby amplifying that sound (or certain frequency components of the sound).

# S

**Scale**.  Any convention that divides an octave into a number of pitch compartments (or *categories*).

**Secondary auditory cortex**.  A collection of cortical modules adjacent to *primary auditory cortex* and chiefly concerned with detecting relations among multiple sounds, whether simultaneous or successive.

**Short-term memory**.  Memory of experiences that have only just happened, and which may or may not be perpetuated as *long-term memories*.

**Sitar**.  A traditional Indian string instrument, normally played with the accompaniment of a drone and drums.

**Somatic**.  Referring to sensations arising from the body, including sensations from viscera, from the skin, and from joints and muscles.

**Somatosensory cortex**.  A strip of cerebral cortex arching from ear to ear that interprets sensations from skin, joints, and muscles.

**Synapse.**    The point of connection between adjacent nerve cells.

**Syncopation.**    In meter, a consistent accentuation that does not fall on a main beat.

# T

**Tempered scale.**    A scale in which notes are evenly spaced in frequency.

**Tempo.**    The rate at which music pulses. Tempo is usually specified in terms of beats per minute.

**Temporal lobe.**    Cerebral cortex spanning each side of the head. It performs a number of functions, with auditory processing on top, long-term memory and categorization at center and bottom, and emotional functions toward the front.

**Timbre.**    (Pronounced *TAM-ber*). The characteristic "sound" of an instrument or voice. A trumpet sounds like a trumpet, and a violin like a violin, largely because their timbres differ. Timbre varies by the rates of onset and decay of overtones, and their relative intensities.

**Tonal center.**    The first note of the scale that underlies prevailing harmony. The note G is the tonal center in the key of G major, which predominantly uses the notes of the G-major scale, especially those of the G-major triad.

**Tonality.**    The dominance of tonal centers in harmony.

**Tone.**    A kind of sound made by musical instruments, voices, and certain simple shapes. It consists of a relatively loud *fundamental* frequency and a series of softer *overtones* that are related to the fundamental in a way that causes them to fuse into a single perceived sound.

**Tonic.**    The first note of a scale. In harmony, to "return to the tonic" generally means to return to a composition's current *tonal center,* that is, to resolve back to a point of least harmonic tension.

**Transcription.**    Rewriting music for different instruments, as when a symphony is transcribed for piano solo.

**Transposition.**    The act of shifting music up or down in pitch. We transpose a song when we sing it "higher" or "lower."

**Triad.**    A three-tone chord comprising the first, third, and fifth notes of a diatonic scale. Standard Western harmony is based on triads.

*Trill*.    A rapid alternation between two adjacent notes. This glistening "sound effect" serves to create harmonic uncertainty.

V

*Vibrato*.    Rapid wavering between a note and a pitch slightly higher or lower.

*Voice*.    Any of two or more simultaneous, interrelated lines of music. Nearly all music consists of multiple voices, including a bass line, treble line, and parts between.

# Notes

## Chapter 1 From sound . . .

Page 5. Keats: From his poem "Ode on a Grecian Urn."

16. Hearing loss: H. D. Hood, "Deafness and Musical Appreciation," in Critchley and Henson, 1977, page 323.

19. "if anyone shouts": Critchley and Henson, 1977, page 341.

20. Localization: For an overview, see Yost and Nielsen, 1985, page 151.

22. Directionality of the pinna: Aitken, 1990, page 88.

23. Localization in owls: Gill, 1990, page 168.

25. Brain stem nuclei: For an overview, see Popper and Fay, 1980, page 96.

## Chapter 2 . . . to tone . . .

Page 30. *Parasaurolophus:* Norman, 1985, page 123.

46. Concert halls: For an overview, see Rossing, 1990, page 457.

52. Auditory cortex: Aitkin, 1990.

52. Frequency mapping of cortex: Popper and Fay, 1980, page 383.

53. Cortical columns: Squire, 1987, page 72.

## Chapter 3 . . . to melody . . .

Page 58. Beatles: *Los Angeles Times,* August 15, 1985. Page 1.

61. Melody in children: Shuter-Dyson and Gabriel, 1981, page 105.

69. Australian aboriginal groups: Dowling and Harwood, 1986, page 93.

77. Indian scales: Dowling and Harwood, 1986, page 115.

80. Gestalt laws: For an overview, see Gregory, 1987, page 288.

81. Interpolated tones: Dowling and Harwood, 1986, page 125.

81.  Perceiving melodies as rhythms: Dowling and Harwood, 1986, page 179.

82.  Debussy: Cooke, 1959, page 176

82.  Wagner: Quoted in Schonberg, 1981, page 230.

83.  Right-hemisphere advantage: Gazzaniga, 1984, page 93.

84.  Left-hemisphere dominance in professionals: Caplan, 1980, page 196.

85.  Melody rules: Delamont, 1965, page 63.

## Chapter 4 ... to harmony ...

Page 91.  Exposition Universelle: Sorrell, 1990, Chapter 1.

92.  Sir Francis Drake: Sorrell, 1990.

92.  Erik Satie on Debussy: Morganstern, 1956.

99.  Hindemith: Quoted in Plaisants, 1955, page I08.

112.  Children's awareness of harmony: Shuter-Dyson and Gabriel, 1981, page 149.

113.  Tone deafness: Obler and Fein, 1988, page 140.

113.  Absolute pitch: For overviews, see Shuter-Dyson and Gabriel, 1981, and Révész, 1954.

117.  Alicia de Larrocha: Dubal, 1984, page 132.

118.  Tonality in popular music: Norton, 1984, page 271.

## Chapter 5 ... to rhythm ...

Page 121.  African drumming: Based on Brandel, 1973.

124.  Chunking: For an overview, see Ellis and Hunt, 1993, page 82.

136.  James: Quoted in Dowling and Harwood, 1986, page 179.

138.  Echoic memory: Baddeley, 1976, page 237.

143.  Metronome: For an overview, see Dorian, 1942.

144.  "No metronome at all!" Dorian, 1942, page 199.

146.  *Tempo giusto:* Sachs, 1953, page 33.

147.  Rhythm in children: Davies, 1978, page 190.

147.  Plato on rhythm: Quoted in Sachs, 1953, page 38.

147.  Relation of musical rhythm to body rhythms: Critchley and Henson, 1977, page 207.

150.  Savants and rhythm: Miller, 1989, page 100.

153.  Honegger: Quoted in Plaisants, 1955, page 135.

153.  Ozawa and Marsalis: Wynton Marsalis television series on music, PBS, 1995.

## Chapter 6 ... to composition ...

Page 155.  Rosemary Brown: Parrott, 1978.

158.  Musical prodigies: Révész, 1954, page 145.

159. "a person possessed": Critchley and Henson, 1977, page 176.

161. "The most perfect [musical] instrument": Mursell, 1937, page 271.

162. "There is a mere semblance of the intellectual": Mursell, 1937, page 271.

162. Painter's auto accident: Sacks, 1995, page 3.

167. Chess masters: Discussions in Howe, 1990, and in Sloboda, 1985.

167. Stravinsky on rules of composition: Lawrence, 1978, page 50.

167. Rimsky-Korsakov on rules of composition: Mursell, 1937, page 282.

168. Mendelssohn writing from recollection: Critchley and Henson, 1977, page 16.

170. "say, travelling in a carriage": Ochse, 1990, page 194.

170. "I thought I saw all of heaven": Quoted in Critchley, 1977.

170. "The music of this opera was dictated to me": Quoted in Feder, Karmel, and Pollack, 1990, page 185.

170. "I felt that I was in tune with the Infinite": Quoted in Feder, Karmel, and Pollack, 1990, page 185.

171. "Ideas usually occur to me": Lawrence, 1978, page 51.

172. Candidates for manic-depressive illness: Jamison, 1993, page 269.

172. "music that is so glorious": Quoted in Mursell, 1937, page 271.

172. "unburdened himself about a strange phenomenon": Quoted in Ostwald, 1985, page 205.

173. "In the night, not long after we had gone to bed": Quoted in Jamison, 1993, page 207.

173. "his auditory disturbance had escalated": Quoted in Ostwald, 1985, page 4.

174. Theory of improvisation: For an overview, see Sloboda, 1985, page 138.

176. "When you begin to compose": Mursell, 1937, page 127.

176. "When I consider the appalling number": Schonberg, 1981, page 154.

177. "The tone poet who derives his working material": Quoted in Mursell, 1937, page 278.

177. "What fascinated me most of all": Quoted in Gardner, 1993, page 220.

177. Mozart composing by a piano: Mursell, 1937, page 279.

177. Ravel horrified at composition student: Cook, 1990, page 197.

177. Stravinsky on composing without a piano: Copland, 1939, page 25.

178.  "Those ideas that please me": Qouted in Ochse, 1990, page 194.

178.  Mozart's ink: Sloboda, 1985, page 113.

180.  Beethoven's sketches: Sloboda, 1985, page 104.

180.  "I always have a notebook with me": Quoted in Solomon, 1977, page 80.

180.  "any cliché that would mark the place": The musicologist was Donald Francis Tovey. Cited in Cook, 1990, page 209.

181.  "People make a mistake": Quoted in Rowley, 1977, page 39.

181.  "I never work in the abstract": Quoted in Mursell, 1937, page 270.

181.  "I have always suffered from my want of skills": Quoted in Sloboda, 1985, page 120.

182.  History of written music: For an overview, see Rastall, 1982.

185.  "The artist puts paint on canvas": Quoted in Hargreaves, 1986, page 152.

186.  Composition by children: Gardner, 1983, page 290.

188.  "This music! It is here in my head": Quoted in Schonberg, 1981, page 379.

188.  Language enlargement on the right side: Webster, Popper, and Fay, 1992, page 17. Reference is to the planum temporale, which is larger on the left brain in 65 percent of cases, the right brain in 11 percent, and neither in 24 percent.

189.  Composers' IQs: Ochse, 1990, page 105.

190.  "It is curious how two 'parasitic' measures": Quoted in Morgenstern, 1956, page 330.

191.  Tchaikovsky grasping his chin: Schonberg, 1981, 379.

192.  "People compose for many reasons": Quoted in Morgenstern, 1956.

192.  Decomposing: Gardner, 1983, page 290.

193.  The Bach family: Critchley and Henson, 1977, page 405.

193.  Lateralization in identical twins: Shuter-Dyson and Gabriel, 1981, page 182.

194.  The 250 composers: Ochse, 1990, page 56.

# Chapter 7 ... to performance ...

Page 196.  Blind Tom: Treffert, 1989, page 190.

198.  Early infant autism: Treffert, 1989, page xxvi.

204.  Evolution of the hand: For an overview, see Napier, 1993.

207.  Motor cortex: For an overview, see Asanuma, 1989.

220. Eye movements in reading music: Sloboda, 1985, page 69.

223. "He is a good musician": quoted in Critchley and Henson, 1977, page 13.

223. "and then, with this flash negative": Schonberg, 1987, page 176.

224. Couperin on children: Lawrence, 1978, page 30.

226. Auditory imagery in professionals: Deutsch, 1982, page 398.

229. Rachmaninoff's abilities: Schonberg, 1981, page 537.

229. Gould: McGreevy, 1983.

231. Musicians' personalities: Shuter-Dyson and Gabriel, 1981, page 88.

232. Musicians' IQs: Shuter-Dyson and Gabriel, 1981, page 77.

233. Hours of practice: Howe, 1990, page 92.

## Chapter 8 ... to listening ...

Page 236. New Guinea rain forest: Dowling and Harwood, 1986, page 233.

236. *Europera:* Kostelanetz, 1989, page 67.

237. Bambala village: Brandel, 1973.

238. Australian outback: Wills, 1993, page 146.

239. History of public concerts: For an overview, see Crocker, 1966.

243. Edison: Rowley, 1977, page 132.

247. Phi phenomenon: Sloboda, 1985, page 159.

248. Scale illusion: Deutsch, 1982, page 102.

259. *Mozartish:* Révész, 1954, page 143.

260. Mozart at malls: *The New York Times,* July 23, 1994.

261. Seeger: Spoken during a televised PBS folk music program.

266. Ambient Books: *The New Yorker,* June 26 and July 3 (combined issue), 1995, page 140.

267. Suetonius: Thomas, 1979, page 461.

268. "the teeth of my Viennese": Lebrecht, 1985, page 64.

## Chapter 9 ... to understanding ...

Page 270. *Voyager 2:* Sagan, 1980.

273. Copland: Spoken during a PBS television *Modern Masters* documentary.

276. Talking drums: Davidson, 1966, page 149.

278. Schenker: For a theoretical overview, see Salzer, 1952.

279. Lateralization: For a recent overview, see Hellige, 1993.

280. Left- and right-brain auditory dominance: Kolb and Whishaw, 1980, page 341.

283. Scanner technology: For an overview, see Posner and Raichle, 1994.

289. Professional musician: Tedd Judd, "The Varieties of Musical Talent," in Obler and Fein, 1988, page 144.

289. Professor of music: Gazzaniga, 1984.

290. Ravel: Critchley and Henson, 1977, page 82, and Cytowic, 1993, page 16.

# Chapter 10 ... to ecstasy

Page 305. French archaeologists: Iégor Reznikoff and Michel Dauvois.

305. Bülow: Quoted in Sachs, 1953, page 35.

306. "tumbling strains": Sachs, 1962, page 51.

307. Darwin: Corballis, 1991, page 269.

309. Discrepancy theory of emotion: Izard, Kagan, and Zajonc, 1984, page 266.

309. Frontal lobes: For an overview, see Fuster, 1989, or Stuss and Benson, 1986.

310. Limbic system in decision making: Cytowic, 1993.

315. Berlioz: Lebrecht, 1985, page 118.

317. Endorphins: For an overview, see Levinthal, 1988.

317. Motivational theory of pleasure: Edwards, 1967, vol. 6, page 344.

326. "a little bluer": Révész, 1954, page 129.

326. Sacks's patient: Sacks, 1995, page 3.

327. Naloxone: Levinthal, 1988, page 178.

328. Henry "Red" Allen: Williams, 1987, page 11.

# Bibliography

Aiello, Rita, and John A. Sloboda. *Musical Perceptions*. Oxford: Oxford University Press, 1994.

Aitkin, Lindsay. *The Auditory Cortex: Structural and Functional Bases of Auditory Perception*. New York: Chapman and Hall, 1990.

Ardila, Alfredo, and Feggy Ostrosky-Solis, editors. *The Right Hemisphere: Neurology and Neuropsychology*. New York: Gordon and Breach, 1984.

Asanuma, Hiroshi. *The Motor Cortex*. New York: Raven Press, 1989.

Backus, John. *The Acoustical Foundations of Music*. New York: W. W. Norton and Company, 1977.

Baddeley, Alan D., Barbara A. Wilson, and Fraser N. Watts, editors. *Handbook of Memory Disorders*. New York: John Wiley & Sons, 1995.

————. *The Psychology of Memory*. New York: Basic Books, 1976.

Barbizet, Jacqus. *Human Memory and Its Pathology*. San Francisco: W. H. Freeman and Company, 1969.

Barlow, H. B., and J. D. Mollon. *The Senses*. Cambridge: Cambridge University Press, 1982.

Bekker, Paul. *The Orchestra*. New York: W. W. Norton & Company, 1936.

Berlin, Edward A. *Ragtime: A Musical and Cultural History*. Berkeley: University of California Press, 1980.

Berry, Wallace. *Structural Functions in Music*. New York: Dover Publications, 1987.

Bianki, Vsevolod L. *The Mechanisms of Brain Lateralization*. Philadelphia: Gordon and Breach Science Publishers, 1989.

Block, Richard A. *Cognitive Models of Psychological Time*. Hillsdale, N.J.: Lawrence Erlbaum Associates, 1990.

Boden, Margaret A. *The Creative Mind: Myths & Mechanisms*. New York: Basic Books, 1990.

Boyd, Jenny. *Musicians in Tune: Seventy-five Contemporary Musicians Discuss the Creative Process*. New York: Simon & Schuster, 1992.

Brandel, Rose. *The Music of Central Africa: An Ethnomusicological Study*. The Hague: Martinus Nijhoff, 1973.

Brindle, Reginald Smith. *Musical Composition*. Oxford: Oxford University Press, 1986.

———. *The New Music: The Avant-garde Since 1945*. Oxford: Oxford University Press, 1975.

Broughton, Simon, Mark Ellingham, David Muddyman, and Richard Trillo, editors. *World Music: The Rough Guide*. London: Rough Guides Ltd., 1994.

Buser, Pierre, and Michel Imbert. *Audition*. Cambridge, Mass.: MIT Press, 1992.

Butler, David. *The Musician's Guide to Perception and Cognition*. New York: Schirmer Books, 1992.

Caplan, David, editor. *Biological Studies of Mental Processes*. Cambridge, Mass.: MIT Press, 1980.

Carse, Adam. *The History of Orchestration*. New York: Dover Publications, 1964.

Cazals, Y., and K. Horner. *Auditory Physiology and Perception*. Oxford: Pergamon Press, 1992.

Clynes, Manfred, editor. *Music, Mind, and Brain: The Neuropsychology of Music*. New York: Plenum Press, 1982.

Cook, Nicholas. *A Guide to Musical Analysis*. New York: George Braziller, 1987.

———. *Music, Imagination, and Culture*. Oxford: Clarendon Press, 1990.

Cooke, Deryck. *The Language of Music*. Oxford: Oxford University Press, 1959.

Cooper, David. *A Companion to Aesthetics*. Oxford: Basil Blackwell, 1995.

Cooper, Grosvenor W., and Leonard B. Meyer. *The Rhythmic Structure of Music*. Chicago: University of Chicago Press, 1960.

Copland, Aaron. *What to Listen for in Music*. New York: McGraw-Hill, 1939.

Corballis, Michael C. *The Lopsided Ape: Evolution of the Generative Mind*. Oxford: Oxford University Press, 1991.

Critchley, Macdonald, and R. A. Henson. *Music and the Brain*. Springfield, Ill.: Charles C. Thomas, 1977.

Crocker, Richard L. *A History of Musical Style*. New York: McGraw-Hill, 1966.

Cytowic, Richard E. *The Man Who Tasted Shapes*. New York: Warner Books, 1993.

Dallin, Leon. *Techniques of Twentieth Century Composition*, third edition. Dubuque, Iowa: Wm. C. Brown Company, 1974.

Damasio, Antonio R. *Descartes' Error: Emotion, Reason, and the Human Brain*. New York: G. P. Putnam's Sons, 1994.

Dancy, Jonathan, and Ernest Sosa. *A Companion to Epistemology*. Oxford: Basil Blackwell, 1993.

Davidson, Basil. *Kingdoms of Africa*. New York: Time-Life Books, 1966.

Davies, John Booth. *The Psychology of Music*. Stanford: Stanford University Press, 1978.

Delamont, Gordon. *Modern Harmonic Technique*. New York: Kendor Music, 1965.

Del Mar, Norman, *Anatomy of the Orchestra*. Berkeley: University of California Press, 1981.

Deutsch, Diana, editor. *The Psychology of Music*. New York: Academic Press, 1982.

Donald, Merlin. *Origins of the Modern Mind: Three Stages in the Evolution of Culture and Cognition*. Cambridge, Mass.: Harvard University Press, 1991.

Dorian, Frederick. *The History of Music in Performance: The Art of Musical Interpretation from the Renaissance to Our Day*. New York: W. W. Norton and Company, 1942.

Dowling, Jay W., and Dane L. Harwood. *Music Cognition*. Orlando, Fla.: Academic Press, 1986.

Dubal, David. *Evenings with Horowitz*. New York: Birch Lane Press, 1991.

———. *Reflections from the Keyboard: The World of the Concert Pianist*. New York: Summit Books, 1984.

Dudai, Yadin. *The Neurobiology of Memory: Concepts, Findings, Trends*. Oxford: Oxford University Press, 1989.

Dufallo, Richard. *Trackings: Composers Speak with Richard Dufallo*. Oxford: Oxford University Press, 1989.

Durant, Alan. *Conditions of Music*. Albany: State University of New York Press, 1984.

Edwards, Paul, editor in chief. *The Encyclopedia of Philosophy*. New York: Macmillan, 1967.

Ellis, Henry C., and R. Reed Hunt, editors. *Fundamentals of Cognitive Psychology*. Madison, Wis.: Brown & Benchmark, 1993.

Farnsworth, Paul Randolph. *Musical Taste: Its Measurement and Cultural Nature*. Stanford: Stanford University Press, 1950.

Feder, Stuart, Richard L. Karmel, and George H. Pollack, editors. *Psychoanalytic Explorations in Music*. Madison, Conn.: International Universities Press, 1990.

Frith, Simon. *Sound Effects: Youth, Leisure, and the Politics of Rock 'n' Roll*. New York: Pantheon Books, 1981.

Fuster, Joaquin M. *The Prefrontal Cortex*. New York: Raven Press, 1989.

Gardner, Howard. *Art, Mind, & Brain: A Cognitive Approach to Creativity*. New York: Basic Books, 1982.

———. *Creating Minds*. New York: Basic Books, 1993.

————. *Frames of Mind: The Theory of Multiple Intelligences.* New York: Basic Books, 1983.

————. *The Mind's New Science.* New York: Basic Books, 1985.

Gazzaniga, Michael S., editor. *Handbook of Cognitive Neuroscience.* New York: Plenum Press, 1984.

Geschwind, Norman, and Albert M. Galaburda. *Cerebral Dominance: The Biological Foundations.* Cambridge, Mass.: Harvard University Press, 1984.

Gill, Frank B. *Ornithology.* New York: W. H. Freeman and Company, 1990.

Gregory, Richard L., editor. *The Oxford Companion to the Mind.* Oxford: Oxford University Press, 1987.

Griffin, Donald R. *Listening in the Dark: The Acoustic Orientation of Bats and Men.* Ithaca: Cornell University Press, 1986.

Gulick, Lawrence W., George A. Gescheider, and Robert D. Frisina. *Hearing: Physiological Acoustics, Neural Coding, and Psychoacoustics.* Oxford: Oxford University Press, 1989.

Hale, John. *The Civilization of Europe in the Renaissance.* New York: Atheneum, 1994.

Handel, Stephen. *Listening: An Introduction to the Perception of Auditory Events.* Cambridge, Mass.: MIT Press, 1993.

Hargreaves, David J. *The Developmental Psychology of Music.* Cambridge: Cambridge University Press, 1986.

Hecaen, Henri, and Martin L. Albert. *Human Neuropsychology.* New York: John Wiley & Sons, 1978.

Hellige, Joseph B. *Hemispheric Asymmetry: What's Right and What's Left.* Cambridge, Mass.: Harvard University Press, 1993.

Hindemith, Paul. *A Composer's World.* New York: Anchor Books, 1961.

Howe, Michael J. A. *The Origins of Exceptional Abilities.* Oxford: Blackwell Publishers, 1990.

Hugdahl, Kenneth. *Handbook of Dichotic Listening: Theory, Methods and Research.* New York: John Wiley & Sons, 1988.

Isaacson, Robert L. *The Limbic System.* New York: Plenum Press, 1982.

Isaksen, Scott G., editor. *Frontiers of Creativity Research: Beyond the Basics.* Buffalo, N.Y.: Bearly Limited, 1987.

Izard, Carroll E., Jerome Kagan, and Robert B. Zajonc. *Emotions, Cognition, & Behavior.* Cambridge: Cambridge University Press, 1984.

Jackendoff, Ray. *Languages of the Mind: Essays on Mental Representation.* Cambridge, Mass.: MIT Press, 1992.

Jamison, Kay Redfield. *Touched with Fire: Manic-Depressive Illness and the Artistic Temperament.* New York: The Free Press, 1993.

Jones, Mari Riess, and Susan Holleran, editors. *Cognitive Bases of Musical Communication*. Washington, D.C.: American Psychological Association, 1992.

Kandel, Eric R., and James H. Schwartz. *Principles of Neural Science*. New York: Elsevier/North-Holland, 1981.

Kitterle, Frederick L., editor. *Hemispheric Communication: Mechanisms and Models*. Hillsdale, N.J.: Lawrence Erlbaum Associates, 1995.

Kolb, Bryan, and Ian Q. Whishaw. *Fundamentals of Human Neuropsychology*. New York: W. H. Freeman and Company, 1980.

Kosslyn, Stephen M., and Olivier Koenig. *Wet Mind: The New Cognitive Neuroscience*. New York: The Free Press, 1992.

Kostelanetz, Richard. *On Innovative Music(ian)s*. New York: Proscenium Publishers, 1989.

Krumhansl, Carol L. *Cognitive Foundations of Musical Pitch*. Oxford: Oxford University Press, 1990.

Lawrence, Ian. *Composers and the Nature of Music Education*. London: Scolar Press, 1978.

Lebrecht, Norman. *The Book of Musical Anecdotes*. New York: The Free Press, 1985.

———. *The Maestro Myth*. New York: Birch Lane Press, 1991.

Levenson, Thomas. *Measure for Measure: A Musical History of Science*. New York: Simon & Schuster, 1994.

Levinthal, Charles F. *Messengers of Paradise: Opiates and the Brain*. New York: Doubleday, 1988.

Lieberman, Philip. *The Biology and Evolution of Language*. Cambridge, Mass.: Harvard University Press, 1984.

Livesey, Peter J. *Learning and Emotion: A Biological Synthesis*. Volume 1, *Evolutionary Processes*. Hillsdale, N.J.: Lawrence Erlbaum Associates, 1986.

Lockspeiser, Edward. *Debussy*. New York: Collier, 1951.

Luce, Duncan R. *Sound and Hearing: A Conceptual Introduction*. Hillsdale, N.J.: Lawrence Erlbaum Associates, 1993.

Luria, Aleksandr Romanovich. *Higher Cortical Functions in Man*. New York: Basic Books, 1980.

———. *The Working Brain: An Introduction to Neuropsychology*. New York: Basic Books, 1973.

McAdams, Stephen, and Emmanual Bigand. *Thinking in Sound*. Oxford: Oxford University Press, 1993.

McGreevy, John. *Glenn Gould, by Himself and His Friends*. New York: Doubleday, 1983.

McNaughton, Neil. *Biology and Emotion.* Cambridge: Cambridge University Press, 1989.

Maconie, Robin. *The Concept of Music.* Oxford: Clarendon Press, 1990.

Macphail, Euan M. *Brain and Intelligence in Vertebrates.* Oxford: Clarendon Press, 1982.

Mandler, George. *Mind and Body: Psychology of Emotion and Stress.* New York: W. W. Norton and Company, 1984.

Mavromatis, Andreas. *Hypnagogia.* London: Routledge & Kegan Paul, 1987.

Mellers, Wilfrid. *Music in a New Found Land: Themes and Developments in the History of American Music.* London: Faber and Faber, 1987.

Meyer, Leonard B. *Emotion and Meaning in Music.* Chicago: University of Chicago Press, 1956.

———. *Explaining Music: Essays and Explorations.* Berkeley: University of California Press, 1973.

Miller, Leon K. *Musical Savants: Exceptional Skill in the Mentally Retarded.* Hillsdale, N.J.: Lawrence Erlbaum Associates, 1989.

Moore, Brian C. J. *An Introduction to the Psychology of Hearing.* New York: Academic Press, 1989.

Moore, Douglas. *A Guide to Musical Styles.* New York: W. W. Norton and Company, 1962.

Morgenstern, Sam, editor. *Composers on Music: An Anthology of Composers' Writings from Palestrina to Copland.* New York: Pantheon Books, 1956.

Mursell, James L. *The Psychology of Music.* New York, W. W. Norton and Company, 1937.

Napier, John. *Hands.* Princeton: Princeton University Press, 1993.

Nichols, Roger. *Debussy Remembered.* Portland, Oreg.: Amadeus Press, 1992.

———. *Ravel Remembered.* New York: W. W. Norton and Company, 1987.

Norman, David. *The Illustrated Encyclopedia of Dinosaurs.* New York: Crescent Books, 1985.

Norton, Richard. *Tonality in Western Culture.* University Park: Pennsylvania State University Press, 1984.

Obler, Loraine K., and Deborah Fein, editors. *The Exceptional Brain: Neuropsychology of Talent and Special Abilities.* New York: Guilford Press, 1988.

Ochse, R. *Before the Gates of Excellence: The Determinants of Creative Genius.* Cambridge: Cambridge University Press, 1990.

Olson, Harry F. *Music, Physics and Engineering.* New York: Dover Publications, 1967.

Ostwald, Peter. *Schumann: The Inner Voices of a Musical Genius.* Boston: Northeastern University Press, 1985.

Parrott, Ian. *The Music of Rosemary Brown*. London: Regency Press, 1978.

Pattison, Robert. *The Triumph of Vulgarity: Rock Music in the Mirror of Romanticism.* Oxford: Oxford University Press, 1987.

Pierce, John R. *The Science of Musical Sound*. New York: Scientific American Books, 1983.

Pinker, Steven. *The Language Instinct: How the Mind Creates Language*. New York: William Morrow and Company, 1994.

Plaisants, Donald. *The Agony of Modern Music*. New York: Simon & Schuster, 1955.

Popper, Arthur N., and Richard R. Fay, editors. *Comparative Studies of Hearing in Vertebrates*. New York: Springer-Verlag, 1980.

———. *The Mammalian Auditory Pathway: Neurophysiology*. New York: Springer-Verlag, 1992.

Posner, Michael I., and Marcus E. Raichle. *Images of Mind*. New York: W. H. Freeman and Company, 1994.

Radford, John. *Child Prodigies and Exceptional Early Achievers*. New York: The Free Press, 1990.

Rastall, Richard. *The Notation of Western Music*. New York: St. Martin's Press, 1982.

Restak, Richard. *The Brain Has a Mind of Its Own*. New York: Harmony Books, 1991.

Révész, G. *Introduction to the Psychology of Music*. Norman: University of Oklahoma Press, 1954.

Rorty, Amelie Oksenberg, editor. *Explaining Emotions*. Berkeley: University of California Press, 1980.

Rosenzweig, Mark R., and Arnold L. Leiman. *Physiological Psychology*. Lexington, Mass.: D. C. Heath and Company, 1982.

Rossing, Thomas D. *The Science of Sound*. New York: Addison-Wesley, 1990.

Rowe, Mark, and Lindsay Aitkin. *Information Processing in Mammalian Auditory and Tactile Systems*. New York: John Wiley & Sons, 1990.

Rowley, Gill, editor. *The Book of Music*. London: New Burlington Books, 1977.

Sachs, Curt. *Rhythm and Tempo: A Study in Music History*. New York: W. W. Norton and Company, 1953.

———. *The Wellsprings of Music*. New York: Da Capo Press, 1962.

Sacks, Oliver. *An Anthropologist on Mars*. New York: Alfred A. Knopf, 1995.

———. *Awakenings*. New York: HarperCollins, 1973.

Sadie, Stanley, and Alison Latham. *Stanley Sadie's Music Guide*. Englewood Cliffs, N.J.: Prentice Hall, 1986.

Sagan, Carl. *Cosmos*. New York: Random House, 1980.

Salzer, Felix. *Structural Hearing: Tonal Coherence in Music*. New York: Dover Publications, 1952.

Salzman, Eric. *Twentieth-Century Music: An Introduction*. Englewood Cliffs, N.J.: Prentice Hall, 1974.

Schaefer, John. *New Sounds: A Listener's Guide to New Music*. New York: Harper & Row, 1987.

Schonberg, Harold C. *The Great Conductors*. New York: Simon & Schuster, 1967.

———. *The Great Pianists*. New York: Simon & Schuster, 1987.

———. *The Lives of the Great Composers*. New York: W. W. Norton and Company, 1981.

———. *The Virtuosi*. New York: Random House, 1988.

Schullian, Dorothy M., and Max Schoen, editors. *Music and Medicine*. New York: Henry Schuman, 1948.

Scruton, Robert. *Kant*. Oxford: Oxford University Press, 1982.

Seashore, Carl E. *Psychology of Music*. New York: Dover Publications, 1967.

Shuter-Dyson, Rosamund, and Clive Gabriel. *The Psychology of Musical Ability*. London: Methuen, 1981.

Sloboda, John A. *Generative Processes in Music*. Oxford: Clarendon Press, 1988.

———. *The Musical Mind: The Cognitive Psychology of Music*. Oxford: Clarendon Press, 1985.

Solomon, Maynard. *Beethoven*. New York: Schirmer Books, 1977.

———. *Mozart: A Life*. New York: HarperCollins, 1995.

Sorrell, Neil. *A Guide to the Gamelan*. London: Faber and Faber, 1990.

Sorrell, Neil, and Ram Narayan. *Indian Music in Performance: A Practical Introduction*. Manchester: Manchester University Press, 1980.

Springer, Sally P., and George Deutsch. *Left Brain, Right Brain*. San Francisco: W. H. Freeman and Company, 1981.

Squire, Larry R. *Memory and Brain*. Oxford; Oxford University Press, 1987.

Squire, Larry R., Norman M. Weinberger, Gary Lynch, and James L. McGaugh, editors. *Memory: Organization and Locus of Change*. Oxford: Oxford University Press, 1991.

Stein, Barry E., and M. Alex Meredith. *The Merging of the Senses*. Cambridge, Mass.: MIT Press, 1993.

Storr, Anthony. *Music and the Mind*. New York: Ballantine Books, 1992.

Stuessy, Joe. *Rock & Roll: Its History and Stylistic Development*. Englewood Cliffs, N.J.: Prentice Hall, 1990.

Stuss, Donald T., and D. Frank Benson. *The Frontal Lobes*. New York: Raven Press, 1986.

Sudnow, David. *Talk's Body: A Meditation Between Two Keyboards*. New York: Penguin Books, 1979.

———. *Ways of the Hand: The Organization of Improvised Conduct*. New York: Harper & Row, 1978.

Thomas, Hugh. *A History of the World*. New York: Harper & Row, 1979.

Thompson, Jack George. *The Psychobiology of Emotions*. New York: Plenum Press, 1988.

Tighe, Thomas J., and W. Jay Dowling. *Psychology and Music: The Understanding of Melody and Rhythm*. Hillsdale, N.J.: Lawrence Erlbaum Associates, 1993.

Toch, Ernst. *The Shaping Forces in Music*. New York: Dover Publications, 1977.

Treffert, Darold A. *Extraordinary People: Understanding "Idiot Savants."* New York: Harper & Row, 1989.

Van de Castle, Robert L. *Our Dreaming Mind*. New York: Ballantine Books, 1994.

Vincent, Jean-Didier. *The Biology of Emotions*. Oxford: Basil Blackwell, 1990.

Walker, Alan. *Franz Liszt: The Virtuoso Years, 1811–1874*. London: Faber and Faber, 1983.

Walker, Robert. *Musical Beliefs: Psychoacoustic, Mythical, and Educational Perspectives*. New York: Teachers College Press, 1990.

Wallin, Nils L. *Biomusicology: Neurophysiological, Neuropsychological and Evolutionary Perspectives on the Origins and Purposes of Music*. Stuyvesant, N.Y.: Pendragon Press, 1991.

Webster, Douglas B., Arthur N. Popper, and Richard R. Fay, editors. *The Mammalian Auditory Pathway: Neuroanatomy*. New York: Springer-Verlag, 1992.

Weisberg, Robert W. *Creativity: Beyond the Myth of Genius*. New York: W. H. Freeman and Company, 1993.

Williams, Martin. Companion booklet to *The Smithsonian Collection of Classic Jazz*. Washington, D.C.: The Smithsonian Collection of Recordings, 1987.

Wills, Christopher. *The Runaway Brain: The Evolution of Human Uniqueness*. New York: Basic Books, 1993.

Yost, William A., and Donald W. Nielsen. *Fundamentals of Hearing*. New York: Holt, Rinehart and Winston, 1985.

Zechmesiter, Eugene B., and Stanley E. Nyberg. *Human Memory: An Introduction to Research and Theory*. Monterey, Calif.: Brooks/Cole Publishing Company, 1982.

# Index

Page numbers in *italics* refer to illustrations.